The Routledge Reader in Politics and Performance

The Routledge Reader in Politics and Performance brings together for the first time a comprehensive collection of extracts from key writings on politics, ideology, and performance.

Taking an interdisciplinary approach to the subject, and including new writings from leading scholars, the book provides material on

- transdisciplinary performance theory and practice
- theatre games and practical techniques
- critical theories of and for performance
- performance in cross-cultural contexts
- intercultural perspectives and issues of post-coloniality
- power, politics and the theatre
- sexuality in performance
- corporeality in live and mediated performance

Extracts include seminal writings by: Antonin Artaud, Sally Banes, Eugenio Barba, Cicely Berry, Augusto Boal, Bertolt Brecht, Peter Brook, Judith Butler, Marvin Carlson, Sue-Ellen Case, Elin Diamond, Coco Fusco, Jerzy Grotowski, Stuart Hall, Tony Kushner, Patrice Pavis, Richard Schechner, Rebecca Schneider, Eve Kosofsky Sedgwick, Konstantin Stanislavski, Raymond Williams.

Lizbeth Goodman is Senior Lecturer in Theatre and Performance Studies and Director of the Institute for New Media Performance Research at the University of Surrey. She is the author of *Contemporary Feminist Theatres* (1993), and editor of *Feminist Stages* (1996), the *Routledge Reader in Gender and Performance* (1998), and *Literature and Gender* (1996).

Jane de Gay is Lecturer in English at Trinity and All Saints, University of Leeds, and was previously Research Fellow attached to the Gender, Politics and Performance Research Project at the Open University. She is sub-editor of the *Routledge Reader in Gender and Performance*.

The Routledge Reader in Politics and Performance

Edited by

Lizbeth Goodman
with Jane de Gay

London and New York

Contents

Preface xi
Acknowledgements xiii
List of contributors xvii

Sarah Daniels
FOREWORD xxv

Lizbeth Goodman
INTRODUCTION 1

PART ONE
Practice to theory: Theatre games 15

1 Clive Barker
 INTRODUCTION TO PART ONE 17

2 Jerzy Grotowski
 TOWARDS A POOR THEATRE⁺ 21

3 Konstantin Stanislavski
 TOWARD A PHYSICAL CHARACTERIZATION* 28

4 Augusto Boal
 THE STRUCTURE OF THE ACTOR'S WORK* 32

5 Cicely Berry
 VOICE AND THE ACTOR* 37

6 Eugenio Barba
 THEATRE ANTHROPOLOGY* 41

PART TWO
Critical theories and performance 47

7 Stephen Regan
 INTRODUCTION TO PART TWO 49

8 Raymond Williams
 DRAMA IN A DRAMATIZED SOCIETY* 55

9 Marvin Carlson
 RESISTANT PERFORMANCE* 60

10 Elin Diamond
 PERFORMANCE AND CULTURAL POLITICS* 66

11 Christopher Innes
 AVANT GARDE THEATRE: THEMES AND DEFINITIONS* 70

12 Stuart Hall
 DEVIANCE, POLITICS, AND THE MEDIA* 75

PART THREE
Theorizing and playing: intercultural
perspectives 83

13 Christopher Murray
 INTRODUCTION TO PART THREE 85

14 Peter Brook
 THE WORLD AS A CAN OPENER* 90

15 Bertolt Brecht
 ALIENATION EFFECTS IN CHINESE ACTING+ 94

16 Antonin Artaud
 'MISE EN SCÈNE' AND METAPHYSICS* 98

17 Patrice Pavis
INTERCULTURAL PERFORMANCE IN THEORY AND
PRACTICE* 102

PART FOUR
**Power, politics, and the theatre: political
theatres in cross-cultural contexts** 107

18 Nike Imoru
INTRODUCTION TO PART FOUR 109

19 Awam Amkpa
COLONIAL ANXIETIES AND POST-COLONIAL DESIRES:
THEATRE AS A *SPACE OF TRANSLATIONS* 116

20 Gordon McDougall
REVOLUTION AND RE-CREATION 123

21 Coco Fusco
THE OTHER HISTORY OF INTERCULTURAL PERFORMANCE* 130

22 Baz Kershaw
PERFORMANCE, COMMUNITY, CULTURE* 136

PART FIVE
Sexuality in performance 143

23 Katharine Cockin
INTRODUCTION TO PART FIVE 145

24 Leslie Hill
SUFFRAGETTES INVENTED PERFORMANCE ART 150

25 Joseph Bristow
SEXUALITY* 157

26 Jeffrey Weeks
THE PARADOXES OF IDENTITY* 162

27 Judith Butler
CRITICALLY QUEER* 167

28 Andrew Parker and Eve Kosofsky Sedgwick
 SEXUAL POLITICS, PERFORMATIVITY, AND PERFORMANCE* 172

29 Tony Kushner
 COPIOUS, GIGANTIC, AND SANE* 178

PART SIX
Performance theory, live arts, and the media 181

30 Janet Adshead-Lansdale
 INTRODUCTION TO PART SIX 183

31 Alan Read
 THEATRE AND EVERYDAY LIFE* 189

32 Richard Schechner
 APPROACHES TO PERFORMANCE THEORY* 194

33 Colin Counsell
 SIGNS OF PERFORMANCE* 202

34 Susan Leigh Foster
 CHOREOGRAPHIES OF GENDER* 208

35 Sally Banes
 ENVOI: RECENT DEVELOPMENTS IN DANCE* 213

PART SEVEN
Political theatres, post-coloniality, and
performance theory 219

36 Phillip B. Zarrilli
 INTRODUCTION TO PART SEVEN 221

37 Helen Gilbert and Joanne Tompkins
 POST-COLONIAL DRAMA: THEORY, PRACTICE, POLITICS* 229

38 Miki Flockemann
 SOUTH AFRICAN PERSPECTIVES ON POST-COLONIALITY
 IN AND THROUGH PERFORMANCE PRACTICE 235

39 Ian Watson
 TOWARDS A THIRD THEATRE* 241

40 Sally Ann Ness
 OBSERVING THE EVIDENCE FAIL: DIFFERENCE ARISING
 FROM OBJECTIFICATION IN CROSS-CULTURAL STUDIES
 OF DANCE* 248

PART EIGHT
Post-linearity and gendered performance
practice 255

41 Susan Kozel
 INTRODUCTION TO PART EIGHT 257

42 Rebecca Schneider
 SEEING THE BIG SHOW* 264

43 Nick Kaye
 TELLING STORIES: NARRATIVE AGAINST ITSELF* 270

44 Sue-Ellen Case
 THE COMPUTER COMETH* 277

45 Richard L. Loveless
 TIME PAST ... TIME PRESENT ... TIME FUTURE:
 RE-ENVISIONING THE AESTHETIC IN RESEARCH FOR
 HUMAN PERFORMANCE 283

46 Lizbeth Goodman
 THE POLITICS OF PERFORMATIVITY IN THE AGE OF
 REPLAY CULTURE 288

 Adeola Agbebiyi
 OPEN AIR THEATRE: A PERFORMANCE POEM BY WAY
 OF AN AFTERWORD 295

 Bibliography and suggested further reading 299
 Index 313

* Extracts from longer, previously published pieces.
⁺ A previously published piece reproduced here in its entirety.

Preface

■ Lizbeth Goodman

THIS BOOK HAS GROWN AND DEVELOPED OVER A PERIOD OF TEN YEARS. Clive Barker and I first discussed the enormous subject of 'world theatres' with Talia Rodgers back in 1989. We thought long and hard about editing a series of books for Routledge, tentatively called 'New World Theatres', and considered a number of major authors and titles for possible inclusion. We attempted a number of formulations of the series brief, but in the end we decided not to run with it. It was too huge, and too disparate a field. It could include almost anything on the one hand, but could exclude most titles on grounds of 'non-marketability' or 'political diffusion' on the other. As the series sat in our respective filing cabinets, ideas for collecting and editing materials for presentation to students began to filter up. It took many more years to find the extracts, and the work of Jane de Gay has been enormously valuable in the last few years of the book's evolution. Clive and Talia both helped to give it life, though, and so it is with enormous gratitude and a sense of 'rightness' that the book is being published by Talia Rodgers, with the introduction to Part One written by Clive Barker. We got there in the end. But then, the Reader is only a beginning: a crystallized, miniature model of the grand plans we made.

The idea for the book developed under the aegis of the 'Gender/Politics/Performance' Research Project, for which support was awarded by the Open University (thanks to Wendy Stainton Rogers) back in 1993. That GPP Project supported many research trips and, crucially, provided funding for Jane de Gay's work on this and numerous related publications. That project

evolved, and became the OU/BBC Gender in Writing and Performance Research Group in the mid–late 1990s, with members contributing from around the world. Many of those members are represented in these pages. Their ideas have been discussed at numerous seminars and meetings (real and virtual) over the years.

While that research group was disbanded when I left the OU at the end of 1998, the dedication of its many members and supporters has survived and been sparked again by the move to a new location offering real support, both financial and intellectual. We still work together in many forums, and our many publications can be found in a wide variety of journals and publishers' lists. It is enormously pleasing to have so many of the members of that group represented in these pages, as they were in the sister volume, *The Routledge Reader in Gender and Performance* (1998). This book will be used in teaching at the University of Surrey's School of Performing Arts, in the Department of Theatre and Performance Studies (host to the Institute for New Media Performance Research, to which several authors in these pages are actively contributing).

Thanks to all those who have worked so hard and produced so much, on the stage and on the page. This one's for you.

Acknowledgements

THE OPEN UNIVERSITY ARTS FACULTY RESEARCH COMMITTEE FUNDED secretarial help with this volume: thanks to Anne Ford and David Rowland for support. Thanks to Cheryl-Anne O'Toole for typing and other secretarial assistance, and to Gill Spanswick for typing. Many people also provided assistance in contacting authors and copyright-holders: special thanks to Sharon Carnicke, Ray Cunningham, Nick Hern, Peter Hulton, and Kim Morrissey.

Introductions to Parts One to Eight and all new chapters copyright of the authors, 2000: 'Foreword', Sarah Daniels; 'Introduction', Lizbeth Goodman; 'Introduction to Part One', Clive Barker; 'Introduction to Part Two', Stephen Regan; 'Introduction to Part Three', Christopher Murray; 'Introduction to Part Four', Nike Imoru; 'Colonial Anxieties and Postcolonial Desires: Theatre as a *Space of Translations*', Awam Amkpa; 'Revolution and Re-creation: The Theatrical Metaphor', Gordon McDougall (based on a chapter from 'The Theatrical Metaphor', unpublished thesis, 1972); 'Introduction to Part Five', Katharine Cockin; 'Suffragettes Invented Performance Art', Leslie Hill; 'Introduction to Part Six', Janet Adshead-Lansdale; 'Introduction to Part Seven', Phillip Zarrilli; 'South African Perspectives on Post-Coloniality in and through Performance Practice', Miki Flockemann; 'Introduction to Part Eight', Susan Kozel; 'Time Past . . . Time Present . . . Time Future: Re-envisioning the Aesthetic in Research for Human Performance', Richard L. Loveless; 'The Politics of Performativity in the Age of Replay Culture', Lizbeth Goodman (based on material from *Sexuality in Performance*, Routledge, 1999); 'Open Air Theatre: A Performance Poem by Way of an Afterword', Adeola Agbebiyi.

The following extracts were reprinted with permission: 'Towards a Poor Theatre', Jerzy Grotowski, tr. T.K. Wiewiorowski, from *Towards a Poor*

Theatre, ed. Eugenio Barba, preface by Peter Brook (Holstebro: Odin Teatrets Forlag, 1968; London: Methuen, 1969), © 1968 Jerzy Grotowski and Odin Teatrets Forlag, previously published in *Odra* (Wroclaw, 1965), *Kungs Dramatiska Teaterns Program* (Stockholm, 1965), *Scena* (Novi Sad, 1965), *Cahiers Renaud-Barrault* (Paris, 1966), and *Tulane Drama Review* 35 (New Orleans, 1967); 'Toward a Physical Characterization', Konstantin Stanislavski, from *Building A Character*, tr. Elizabeth Reynolds Hapgood (London: Methuen, 1968), © 1987; 'The Structure of the Actor's Work', Augusto Boal, from *Games for Actors and Non-Actors*, tr. Adrian Jackson (London and New York: Routledge, 1992); 'Voice and the Actor', Cicely Berry, from the introduction to *Voice and the Actor* (London: Virgin, 1993), © Cicely Berry 1973, published by Virgin Books, an imprint of Virgin Publishing Ltd; 'Theatre Anthropology', Eugenio Barba, from the introduction to *A Dictionary of Theatre Anthropology: The Secret Art of the Performer*, by Eugenio Barba and Nicola Savarese, tr. Richard Fowler (London: Routledge, 1991); 'Drama in a Dramatized Society', Raymond Williams, from *Writing in Society* (London: Verso, 1983), originally delivered as Williams's Inaugural Lecture as Professor of Drama, University of Cambridge in 1974, and published by Cambridge University Press; 'Resistant Performance', Marvin Carlson, from *Performance: A Critical Introduction* (London: Routledge, 1996); 'Performance and Cultural Politics', Elin Diamond, from the introduction to *Performance and Cultural Politics*, ed. Elin Diamond (London: Routledge, 1996); 'Avant Garde Theatre: Themes and Definitions', Christopher Innes, from *Avant Garde Theatre 1892–1992* (London: Routledge, 1993); 'Deviance, Politics and the Media', Stuart Hall, from *The Lesbian and Gay Studies Reader*, ed. Henry Abelove, Michèle Aina Barale, and David M. Halperin (London: Routledge, 1993), originally published in *Deviance and Social Control*, ed. Paul Rock and Mary McIntosh (London: Tavistock, 1974); 'The World as a Can Opener', Peter Brook, from *The Shifting Point: Forty Years of Theatrical Exploration, 1946–87* (London: Methuen, 1988), © Peter Brook, reprinted by permission of HarperCollins, a version of this piece was originally published in *The New York Times*, 20 January 1974; excerpt from 'Alienation Effects in Chinese Acting', Bertolt Brecht, from *Brecht on Theatre: The Development of an Aesthetic*, ed. and tr. John Willett (New York: Hill and Wang/London: Methuen, 1964), originally published as 'Verfremdungseffekte in der chinesischen Schauspielkunst', in *Schriften zum Theater* (Berlin: Suhrkamp, 1957), translation © 1964, 1992 by John Willett, reproduced by permission of Hill and Wang, a division of Farrar, Strauss and Giroux; '"Mise en Scène" and Metaphysics', Antonin Artaud, from *Complete Works*, tr. Victor Corti (London: Calder and Boyars, 1968–74), repr. in *Artaud on Theatre*, ed. Claude Schumacher (London: Methuen, 1989), originally published in *Nouvelle Revue Française*, 221, 1 February 1932; 'Intercultural Performance in Theory and Practice', Patrice Pavis, from the introduction to *The Intercultural Performance Reader*, ed. Patrice Pavis (London: Routledge, 1996); 'The Other History of

Intercultural Performance', Coco Fusco, from *English Is Broken Here: Notes on Cultural Fusion in the Americas* (New York: New Press, 1997); 'Performance, Community, Culture', Baz Kershaw, from *The Politics of Performance: Radical Theatre as Cultural Intervention* (London: Routledge, 1992); 'Sexuality', Joseph Bristow, from *Sexuality* (London: Routledge, 1997); 'The Paradoxes of Identity', Jeffrey Weeks, from *Invented Moralities: Sexual Values in an Age of Uncertainty* (Cambridge: Polity, 1995) Copyright © 1995 Columbia University Press; 'Critically Queer', Judith Butler, from *Bodies That Matter: On the Discursive Limits of 'Sex'* (New York: Routledge, 1993), © 1993, reproduced by permission of Taylor & Francis Group; 'Sexual Politics, Performativity, and Performance', Andrew Parker and Eve Kosofsky Sedgwick, from the introduction to *Performativity and Performance*, ed. Andrew Parker and Eve Kosofsky Sedgwick (New York: Routledge, 1995), © 1995, reproduced by permission of Taylor & Francis Group; 'Copious, Gigantic, and Sane', Tony Kushner, from *Thinking About the Longstanding Problems of Virtue and Happiness: Essays, a Play, Two Poems, and a Prayer* (London: Nick Hern, 1995), first published in the *Los Angeles Times*, 25 April 1993; 'Theatre and Everyday Life', Alan Read, from *Theatre and Everyday Life: An Ethics of Performance* (London: Routledge, 1993); 'Approaches to Performance Theory', Richard Schechner, from *Performance Theory*, revised and expanded edition (New York: Routledge, 1988); 'Signs of Performance', Colin Counsell, from *Signs of Performance: An Introduction to Twentieth-Century Theatre* (London: Routledge, 1996); 'Choreographies of Gender', Susan Leigh Foster, from *Signs* 24, 1 (University of Chicago, Winter 1999); 'Envoi: Recent Developments in Dance', Sally Banes, from *Dancing Women* (London: Routledge, 1997); 'Post-Colonial Drama: Theory, Practice, Politics', Helen Gilbert and Joanne Tompkins, from *Post-Colonial Drama: Theory, Practice, Politics* (London and New York: Routledge, 1996); 'Towards a Third Theatre', Ian Watson, from *Towards a Third Theatre: Eugenio Barba and the Odin Teatret* (London: Routledge, 1993); 'Observing the Evidence Fail: Difference Arising from Objectification in Cross-Cultural Studies of Dance', Sally Ann Ness, from *Moving Words: Writing Dance*, ed. Gay Morris (London: Routledge, 1996); 'Seeing the Big Show', Rebecca Schneider, from *The Explicit Body in Performance* (London: Routledge, 1997) (a version of this chapter was previously published as 'See the Big Show: Spiderwoman Theater Doubling Back', in *Acting Out: Feminist Performances*, ed. Lynda Hart and Peggy Phelan (Ann Arbor: University of Michigan Press, 1993)); 'Telling Stories: Narrative Against Itself', Nick Kaye, from *Postmodernism and Performance* (Basingstoke: Macmillan, 1994); 'The Computer Cometh', Sue-Ellen Case, from *The Domain-Matrix: Performing Lesbian at the End of Print Culture* (Bloomington and Indianapolis: Indiana University Press, 1996).

Where editing of the text of extracts was necessary, editorial changes are marked with bracketed ellipses or square brackets. American spelling is used for American organizations, British spelling for British organizations.

ACKNOWLEDGEMENTS

Wherever possible, changes have been made with the agreement of the authors. Editors' notes are identified: all unattributed notes are the original authors'. Every effort has been made to obtain permission to reprint all the extracts included. Persons entitled to fees for any extract reprinted here are invited to apply in writing to the publishers.

Contributors

Janet Adshead-Lansdale is Head of the School of Performing Arts at the University of Surrey. She is author of three published books, including *Dance History* (1983, second edition 1994) and a forthcoming book on intertextuality and dance.

Adeola Agbebiyi (stage-name Adeola Martin) is a writer/performer, currently touring with a show for children. She appeared in and co-devised the polyvocal poetry work *Fo(u)r Women*, and has written and performed an album of her own music. She is working on an album of songs for the millennium and lives in London with an active imagination.

Awam Amkpa is a playwright, director, and film scholar. Originally from Nigeria, he did his PhD at Bristol University and spent many years teaching in England. He currently teaches cultural theory, dramaturgy, and theatre history at Mount Holyoke College in Massachusetts, USA. He is the author of a forthcoming book titled: *Overpowered but not Tamed: Theatres of Colonial and Postcolonial Societies*.

Antonin Artaud (1896–1948) was a French actor, director, playwright, and performance theorist. His plays include *Jet de Sang* (1925) and *Les Cenci* (1935), and he also wrote the screenplay for the surrealist film, *La Cocquille et le Clergyman* (1927). He put forward the concept of the 'theatre of cruelty' in works such as *The Theatre and its Double* (1938).

Sally Banes is the Marian Hannah Winter Professor of Theatre and Dance Studies at the University of Wisconsin-Madison, and a past president of the Society of Dance History Scholars. She is the author of several books on

dance and performance art, including *Dancing Women: Female Bodies on Stage; Subversive Expectations: Performance Art and Paratheater in New York 1976–85; Greenwich Village 1963: Avant-garde Performance and the Effervescent Body; Writing Dancing in the Age of Postmodernism; Terpsichore in Sneakers: Post-Modern Dance;* and *Democracy's Body: Judson Dance Theatre 1962–64.*

Eugenio Barba founded the Odin Teatret in Oslo in 1964 (which has been based in Holstebro, Denmark, since 1966) and has directed many productions with the company. A pioneer in the field of 'theatre anthropology', he founded the International School of Theatre Anthropology (ISTA) in 1979. His books include *The Floating Islands*, *Beyond the Floating Islands*, *The Paper Canoe*, and the first book about Jerzy Grotowski.

Clive Barker is a veteran of Joan Littlewood's Theatre Workshop and a world-renowned expert on theatre games (see his classic text *Theatre Games*, Methuen, 1976). He also edits the *New Theatre Quarterly*.

Cicely Berry is Voice Director for the Royal Shakespeare Company and has instructed several generations of actors and directors. Her publications include *Voice and the Actor* (1993).

Augusto Boal is a renowned Brazilian theatre director and theorist. His books include *Theatre of the Oppressed* (1974) and *Games for Actors and Non-Actors* (1992).

Bertolt Brecht (1898–1956) was a German playwright, poet, and director, who founded the Berliner Ensemble in East Germany in 1949. He was a prolific critic and theatre theorist, noted for developing the idea of the 'alienation effect'. His forty plays include *The Threepenny Opera* (1928, with music by Kurt Weill), *Mother Courage and her Children* (1941), *The Resistible Rise of Arturo Ui* (1941), and *The Good Person of Sezchuan* (1943).

Joseph Bristow is Professor of English at the University of California, Los Angeles. He previously taught at the University of York, England. He is the author of several books, including *Effeminate England: Homoerotic Writing after 1885*, and is joint editor of *Nineteenth-Century Women Poets: An Oxford Anthology*.

Peter Brook is director of the International Centre of Theatre Research in Paris, and an advisory director of the Royal Shakespeare Company. He has directed more than 50 productions since 1946, including *Love's Labour's Lost* and *Titus Andronicus* (with Laurence Olivier), and his celebrated RSC productions of *Marat/Sade* and *A Midsummer Night's Dream*. Since moving to Paris in 1970, he has directed *The Ik, Ubu, The Conference of the Birds, The Cherry Orchard, The Mahabharata, Woza Albert!, Qui est là,* and *Happy Days,* as well

as a number of Shakespeare plays. His books include *The Empty Space*, *The Shifting Point*, *There are No Secrets*, and *The Open Door*.

Judith Butler is Maxine Elliot Professor of Rhetoric and Comparative Literature at the University of California, Berkeley. She is the author of *Gender Trouble* (1990), *Bodies that Matter* (1993), *Excitable Speech* (1997), and *The Psychic Life of Power* (1997).

Marvin Carlson is the Sydney E. Cohn Distinguished Professor of Theatre and Comparative Literature at the City University of New York.

Sue-Ellen Case is Professor in the Department of Theatre and Dance at the University of California, Davis. Her book, *Feminism and Theatre,* was the pioneering text in that field. Subsequently, her article 'Towards a Butch–Femme Aesthetic' opened the debates on lesbian role-playing. She has served as the editor of *Theatre Journal* and has edited several anthologies of plays and feminist critical work on the theatre. Her latest work includes her book *The Domain-Matrix: Performing Lesbian at the End of Print Culture* (Indiana University Press, 1996), and an article in *Modern Fiction Studies* which takes a feminist perspective on hypertext.

Katharine Cockin is Lecturer in English at the University of Hull. She is the author of *Edith Craig (1869–1947): Dramatic Lives* (Cassell, 1998) and a number of essays on women's writing, modernism, and women's suffrage. She has contributed an essay on 'Women's Suffrage Drama' to *The Women's Suffrage Movement*, ed. Maroula Joannou and June Purvis (Manchester University Press) and an essay on the history of women in theatre to *The Routledge Reader in Gender and Performance*.

Colin Counsell is a Senior Lecturer in Theatre Studies at the University of North London. His publications include writings on theatrical modernism, performance analysis, and the formation of early modern performance space. He is currently researching the semiotics of the moving body, and co-editing, with Laurie Wolf, a performance analysis reader for Routledge.

Sarah Daniels is one of Britain's leading female playwrights. Her work includes *Masterpieces*, *Byrthrite*, *The Devil's Gateway*, *Neaptide*, *Beside Herself*, *The Gut Girls*, and *The Madness of Esme and Shaz* (all published by Methuen). Daniels was the first woman to have a lesbian play (*Neaptide*, 1986) staged at the Royal National Theatre, while her *Masterpieces* is one of the most frequently performed feminist plays in many cultures.

Elin Diamond is Professor of English at Rutgers University, Newark. Her newest book, *Unmaking Mimesis: Essays on Feminism and Theater* was published by Routledge in 1997.

Miki Flockemann lectures in the English Department at the University of the Western Cape, South Africa. Her publications include comparative studies of the aesthetics of transformation in writings by women from South Africa and elsewhere in the African diaspora, and recent trends in South African performance.

Susan Leigh Foster is a choreographer, dancer, and writer, and a member of the Department of Dance at the University of California, Riverside. She is the author of *Reading Dancing: Bodies and Subjects in Contemporary American Dance* (University of California Press, 1986) and *Storying Bodies: Ballet's Choreography of Narrative and Gender* (Indiana University Press, 1996). She is also the editor of *Choreographing History* and *Corporealities* (Routledge, 1995).

Coco Fusco is a New York-based interdisciplinary artist and writer. She is the author of *English Is Broken Here: Notes on Cultural Fusion in the Americas* and editor of the forthcoming *Corpus Delecti: Performance Art of the Americas* (Routledge, 2000).

Helen Gilbert teaches drama and theatre studies at the University of Queensland, Australia, and directs experimental performance work. She has published a number of critical articles on post-colonial drama and performance theory. Her most recent book is *Sightlines: Race, Gender and Nation in Contemporary Australian Theatre*.

Lizbeth Goodman is Director of the Institute for New Media Performance Research (INMPR) and Senior Lecturer in Theatre and Performance Studies at the University of Surrey. Until 1998, she was a Lecturer and Chair of the Gender in Writing and Performance Research Group at the Open University. Her books include *Contemporary Feminist Theatres* (1993) and *Sexuality in Performance* (1999).

Jerzy Grotowski (1933–99), the renowned Polish theatre director, founded the Theatre Laboratory in 1962. There he pioneered the concept of 'poor theatre', presenting experimental versions of *Akropolis*, *Dr Faustus*, *The Constant Prince*, and *Apocalypsis cum figuris*, among other works. From 1969–78, he travelled widely, staging 'Paratheatre' events including *Vigil*, *The Mountain of Flame* and *Tree of People* in several countries, and from 1976–82, worked in Poland with an international group of collaborators on the 'Theatre of Sources' project. He left Poland in 1982, and subsequently researched and taught at Columbia University and the University of California, Irvine, and established a Workcenter at Pontedera, Italy. His influential ideas on directing and theatre-making were published in *Towards a Poor Theatre* (1968).

Stuart Hall recently retired as Professor of Sociology at the Open University. Among his many publications are: *Representation: Cultural*

Representation and Signifying Practices (1997), *Questions of Cultural Identity* (1996), and *Resistance through Rituals* (1991).

Leslie Hill is an internationally recognized writer and performer whose work has been widely shown in a variety of venues across the USA and UK and commissioned by major institutions such as the Arts Council of England, the Scottish Arts Council, and the Institute for Studies in the Arts, Phoenix. Hill is artistic director, with Helen Paris, of curious.com performance and multimedia company, whose recently staged productions include 'BULL', 'Random Acts of Memory', and 'Three Semi-Automatics Just For Fun' and whose major internet projects exploring the notions of place and 'placelessness' include 'I never go anywhere I can't drive myself ', and 'Leftbank Café'. Hill is currently a Resident Artist Fellow at the Institute for Studies in the Arts and Senior Lecturer in the Theatre Department of Arizona State University.

Nike Imoru is an actor, director, and choreographer. Her research covers theatre, race, gender, and critical theories. She has worked as a director, actor, and academic in Africa, Europe, and the UK where she was a Lecturer in Theatre at the University of Leeds. She holds a lectureship at the University of Hull and, at the time of writing, is teaching at Western Washington University, Washington State.

Christopher Innes is a Distinguished Research Professor at York University, Ontario, and a Fellow of the Royal Society of Canada. He is the General Editor of the Cambridge 'Directors in Perspective' series, as well as one of the editors for *Modern Drama*, and has published widely on twentieth-century theatre: his most recent books being *Modern British Drama 1890–1990* (1992), *Avant Garde Theatre 1892–1992* (1994), *The Theatre of Gordon Craig* (1998) and *Twentieth-Century British and American Theatre: A Critical Guide to Archives* (1999).

Nick Kaye is Professor of Drama, University of Manchester. His books include *Postmodernism and Performance* (1994), *Art into Theatre: Performance Interviews and Documents* (1996), and *Site Specifics: Performance, Place, and Documentation* (forthcoming from Routledge).

Baz Kershaw trained and worked as a design engineer before reading English and Philosophy at Manchester University. He has worked extensively as a director and writer in community and radical theatre, including shows staged at the now legendary Drury Lane Arts Lab. He was the founder-director of the first rural multi-media community arts team and the first reminiscence theatre company, Fair Old Times. He is co-editor of *Engineers of the Imagination: the Welfare State Handbook* (Methuen, 1990), and author of *The Politics of Performance: Radical Theatre as Cultural Intervention* (Routledge, 1992), and *The Radical in Performance: Between Brecht and Baudrillard* (Routledge, 1999).

He has taught in a number of universities in the UK and elsewhere, and is currently Professor of Drama at the University of Bristol.

Susan Kozel is a performer, writer, and researcher, specializing in the hybrid region of dance and digital technologies. She lectures and performs internationally, and writes for a range of journals including *Dance Theatre Journal*, *Writings on Dance*, and *Archis*. She is a founder of Mesh Performance Partnerships (*http://www.mesh.org.uk*), a member of the artists's studio HEAR/d London, and a lecturer for the Department of Dance Studies of the University of Surrey.

Tony Kushner is a playwright whose works include *A Bright Room Called Day* (1986), *Angels in America* (1989), and *Millennium Approaches* (1991).

Richard L. Loveless is Director of the Institute for Studies in the Arts (ISA) at Arizona State University, which he founded in 1991. His work is primarily concerned with transdisciplinary projects that combine artists with scholars in other fields of inquiry. These projects take the form of interactive performance works, artificial life environments, and collaborations with scholars in the fields of medicine, engineering, and architecture. His ideas can be found in his anthology, *The Computer Revolution and the Arts*; in *Leonardo*; *Art 21: NEA Proceedings*; and many other publications.

Gordon McDougall is Principal of the Guildford School of Acting and has taught at the Universities of Waterloo (Ontario), Oxford, Alberta, California, Pittsburgh, and Perugia, Carnegie Mellon University, King Alfred's College (Winchester), and RADA. He has directed over 120 plays, and has been Artistic Director at the Traverse Theatre, the Stables Theatre, Manchester, the Oxford Playhouse Company, and the Citadel Theatre in Edmonton, Canada, and for seven years was a producer and director for Granada Television. He has written two books as well as numerous critical works, dramatic translations, and adaptations.

Christopher Murray is Associate Professor of English at University College, Dublin, and former Director of the Drama Centre there. He is author of *Twentieth-Century Irish Drama: Mirror up to Nation* (Manchester University Press, 1997).

Sally Ann Ness is Associate Professor of Dance at the University of California, Riverside. Her book, *Body, Movement, and Culture: Kinesthetic and Visual Symbolism in a Philippine Community*, won the 1993 De la Torre Bueno prize for the year's most distinguished work of dance scholarship.

Andrew Parker, Professor of English at Amherst College, Massachusetts, is the author of *Re-Marx* and co-editor of *Nationalisms and Sexualities* and *Performativity and Performance*.

Patrice Pavis is a Professor at the University of Paris, VIII. He is the author of *Theatre at the Crossroads of Culture* and *Dictionnaire du Théâtre* (which has been translated into several languages), and editor of *The Intercultural Performance Reader*.

Alan Read is Professor and Chair of Drama and Theatre Studies at Roehampton Institute, London. He is the author of *Theatre and Everyday Life: An Ethics of Performance* and editor of *The Fact of Blackness: Frantz Fanon and Visual Representation* (Bay Press, 1996), and *Spaced Out: Architecture, Art, and the City* (Athlone, 1999). During the 1980s he was Director of Rotherhithe Theatre Workshop, a neighbourhood theatre space in a converted warehouse building in the docklands area of South East London, and in the 1990s Director of Talks at the Institute of Contemporary Art, London.

Stephen Regan is Lecturer in Literature at the Open University. He has edited the *Year's Work in English Studies* and *The Year's Work in Critical and Cultural Theory*. He has published work on Yeats and Larkin and is editor of *The Eagleton Reader* (1997) and *The Politics of Pleasure: Aesthetics and Cultural Theory* (1992).

Richard Schechner is University Professor and Professor of Performance Studies, Tisch School of the Arts, New York University. He is the editor of *The Drama Review* and author of numerous books, including *The Future of Ritual*, *Performance Theory*, *Environmental Theater*, and *Between Theater and Anthropology*. He was the founding director of The Performance Group and is the founding artistic director of East Coast Artists. His productions include: *Dionysus in 69*, *The Tooth of Crime*, *Mother Courage*, *Faust/gastronome*, and *Three Sisters*.

Rebecca Schneider is Assistant Professor of Performance Studies with Cornell University's Department of Theater, Film, and Dance. She is the author of *The Explicit Body in Performance* (Routledge, 1997) and is working on a second book titled *Playing Remains*. She is also co-editing an anthology forthcoming from Routledge entitled *Directing Reconsidered: Essays on Twentieth-Century Directing Theory and Practice*. Schneider has published essays in several anthologies and journals, and is a contributing editor to *TDR: The Drama Review*.

Eve Kosofsky Sedgwick is Distinguished Professor of English, CUNY, New York, and the author of *The Coherence of Gothic Conventions*, *Between Men: English Literature and Male Homosocial Desire*, *Epistemology of the Closet*, *Tendencies*, and *Fat Art, Thin Art*.

Konstantin Stanislavski (1863–1938), was a Russian actor, director, and teacher. He was one of the most important contributors to the modern

theatre's approach to performance, notably for his invention of and teaching about 'method acting'. His books include *An Actor Prepares* (1936).

Joanne Tompkins teaches drama and literature at the University of Queensland. She researches in the area of post-colonial, intercultural, and multicultural theatres.

Ian Watson heads the Theatre and Television Program at Rutgers University, Newark. Apart from *Towards a Third Theatre*, he has published many articles on Barba's work, in publications such as *New Theatre Quarterly*, *The Drama Review*, *Modern Drama*, *The Latin American Theatre Review*, and *Gestos*. He is at present editing a collection of essays on interculturalism in Barba's work.

Jeffrey Weeks is Professor of Sociology and Dean of Humanities and Social Science at South Bank University, London. He is the author of numerous articles and books on the history and social organization of sexuality, including *Sex, Politics, and Society* (1981), *Sexuality and its Discontents* (1985), *Against Nature* (1991), *Invented Moralities* (1995), and *Making Sexual History* (1999). He is currently completing a book on 'Families of Choice'.

Raymond Williams (1921–88) was Professor of Drama at the University of Cambridge from 1974–83. His work covered media studies, cultural criticism, politics, and literary studies, and he frequently sought to forge pioneering connections between these fields. His ground-breaking *Culture and Society* (1958) is said to have influenced the rise of cultural studies as an academic discipline in the 1960s. His other books include: *Drama from Ibsen to Eliot* (1952), *The Long Revolution* (1961), and *The Country and the City* (1973).

Phillip B. Zarrilli is Professor of Theatre and Performance Studies at the University of Surrey. His numerous books include *When the Body Becomes All Eyes: Paradigms, Practices, Power in Kalarippayattu* (Oxford University Press, 1998), and *Kathakali Dance-Drama: Where Gods and Demons Come to Play* (Routledge, forthcoming).

Foreword

■ Sarah Daniels

L AST YEAR I HAD PROOF, IF ANY WERE NEEDED, THAT I AM NOW MIDDLE AGED and perceived as such. A friend and I were going to see the play *Shopping and Fucking* by Mark Ravenhill. I'd not seen this friend for a while and we were hoping to be able to catch up over a drink afterwards, so I asked the young woman at the box office what time it finished. On being told that the show would end at about half past ten, I jokingly asked if we could just see the shopping then. Leaning forward slightly, she said solemnly, 'I'm sorry but you can't. I'm afraid they're all mixed up together.'

I was reminded of this when I was asked to write the foreword to this book because my first reaction was: 'I'm sorry, but I can't.' If you write about life, doesn't that always include politics? And as a performer inter-preting text, whether scripted or self-devised, aren't some of your decisions political? I know it's simplistic, but aren't they all mixed up together? Or didn't they used to be? To put it another way, isn't money or the lack of it the deciding factor behind theatre production now and wouldn't this book sell more copies if it were called 'How to Pull Punters and Patrons'? Because politics, in relation to theatre, seems now to be thought of as a dirty word.

The play of mine which is still most frequently performed by students is *Masterpieces*, often attacked for being 'issue-based', blatantly trying to change the prevailing perception of pornography as harmless fun, and worse, for being 'political'. Those attacking it seem to expect me to want to defend it

against their accusations. I can't. It is all those things. It was meant to be all those things.

So concerned was I about the issues and about the play being misinterpreted or misunderstood that it would be accurate to call the result a scream of rage. I don't think now that being so driven to expose injustice in such a raw way produces the best, most artistic writing but neither do I believe that it should be dismissed as invalid. As I've got older I've learnt to trust myself more, to worry less about what others choose to repudiate and, although I'm embarrassed to admit it, I still have the chorus to one of Tracy Chapman's songs pinned to my notice board:

> Hunger only for a taste of justice,
> Hunger only for a world of light
> For all that you have is your soul.

Another dirty word in the commissioning editors' and marketing managers' dictionary compiled by the brothers Hype and Spin is 'worthy', which appears to be synonymous with political, politically correct, and loony. I have often been told while trying to present ideas: 'We don't want to make it worthy.' And while I realize that even the most banal story told well is more satisfying than a profound one told badly, do people really want drama that is unworthy, i.e. empty, pointless, and irrelevant?

So little new work is done in Britain today, so few risks are taken because the marketing people believe that audiences will only part with their cash for safe, non-controversial, dazzling but all too often empty spectacle. Yes, I understand that money-making ventures are just that, but what excuse have the subsidised theatres got for putting on old musical after old musical? The Thatcher years forced many theatres and writers out of business and the threat of closure hangs over the heads of many who hung on – but for how long and at what cost? What chance has any playwright got to be 'political' and to survive as a playwright in this age?

Presumably the managers of subsidised theatres would say that if they didn't make money they would lose their subsidy and that judging by the box-office queues, people obviously want to see old musicals. And if they do, because we live in a democracy, does that make it OK? If a majority of the public expressed a wish for the return of public hanging, would that make the spectacle of premeditated murder acceptable? Then again, imagine the venue which got that contract. They'd never have to worry about funding or sponsorship again.

. . . And I might have left it there if it hadn't been for my visit last week to the Tricycle Theatre to see *The Colour of Justice* which is the theatrical portrayal of the Stephen Lawrence Inquiry superbly edited by Richard Norton-Taylor and performed with ensemble integrity by the actors. The single set

is far from dazzling, by virtue of its authenticity. And the show has been consistently sold out. The queue for returns is long, it's transferring to the West End and it will be shown on BBC2. I take this as evidence that people are still hungry for the truth, still seek to be illuminated rather than dazzled. When at the end of the piece the actors playing the members of the Inquiry are asked by the actor playing the chairman to stand for a minute's silence to respect the life of Stephen Lawrence, the audience stands too.

Theatre can make life matter. And now, even though I'm middle aged, and I no longer want to scream at an audience, I still long to be part of that process that tries collaboratively to reach out and touch them – and I don't mean just for money.

London, January 1999

INTRODUCTION

■ Lizbeth Goodman

PART I: THE POLITICS OF 'POLITICS OF PERFORMANCE'

THIS IS A TEXTBOOK FOR TEACHING AND LEARNING.
But as those two terms have become so highly politicized in recent years,
it may be less 'political' or polemical to say that this is a book designed for
guided student use. Within the Gender in Writing and Performance Research
Group (at the OU/BBC, 1993–98), we set out to find and demonstrate connec-
tions between the political issues of daily life and their forms of expression
in the theatre. The framework for understanding what is meant by the term
'theatre' has been extended over time to include non-theatre spaces, site-
specific performance work, live art, dance, and other time-based art forms
including some element of 'the performative'. In selecting material for this
book, however, we recognized that a general agreement on what 'theatre'
might involve and include was not widely shared. In the 1960s, 1970s, and
early 1980s, for instance, it was not uncommon for the theatre to be used
as both an art form and a platform. But as the Thatcher years got fully
under way, British theatre and politics began to diverge as companies needed
to get 'bums on seats' in order to keep the theatres open; 'political theatre'
became unfashionable, in part because it was more difficult to fund. Of course,
individual theatre-makers in Britain retained their political stance, and some
managed to build and sustain successful careers. But there was a real sense,
towards the end of the twentieth century, in which 'political theatre' as a
form was thought to be dying. And within the broad cultural movement that

1

can be termed the 'postmodern', divisions between disciplines have been challenged. Previously perceived boundaries between 'entertainment' and 'political action', between the theatre itself as a formal institution and what goes on in other public spaces, have blurred significantly. Theatre, in other words, came in some circles to be seen as an art form but not a platform, or space for representation of pressing political concerns. In selecting and editing material for this Reader and in choosing authors to write introductions to the eight parts, then, we were charged with the task of finding ways to show that performance is, and always was, a means by which discourses of ideology and politics are communicated and promoted.

Further, the relationship between disciplines within the performing arts is examined in this book, through a series of articles and arguments that develop across the thematic areas of focus for individual chapters. The articles included consider dance and movement, languages and body language and gesture in performance, installation art, and media performance, as well as 'drama' and 'theatre'. All of these forms produce work that might be called 'political performance'. Yet each author included here discusses her or his own notion of the 'political' and of the field of 'performance'.

The Menu

Each extract included in this book was selected three times over: first it was suggested by me, then sub-edited by Jane de Gay, then sent out to the editors of the eight parts for their comments. The part editors were selected not only for their status as informed colleagues whose ideas would enrich the book, but also for the variety of their political perspectives, performance approaches, theoretical stances, cultural and generational differences. We wanted a wide coverage so that the book would include areas of contestation and space for creative argument. If any of the previously published extracts we suggested was found to be less 'worthy' for inclusion by the part editor, or was found to lack sufficient edge to warrant inclusion in the place of some other more pressing piece, we entered into negotiation with the authors concerned until we either decided to replace the problematic piece or, alternatively, until we selected a new framework for it, so that its points could be gleaned in a more productive and challenging context. Some of the new articles were revised several times too as other contributors offered feedback and suggestions. Points of controversy and differences in approach across the book were flagged, but not removed or homogenized. So, as they say in the press, 'the views expressed in these pages are not necessarily those of the editors'. At the same time, the expression of views is very much our editorial policy.

The contents of the book became a debate, a field of subjective evaluation, and a process of performing politics in print. The work was collaborative,

but did not erase the distinctiveness of individual authors' words or ideas. This is a most rewarding form of editorship. Students and other readers, it is to be hoped, may benefit from an engaged, subjective grappling with key ideas which may spark independent thought and creative interchange with the 'subject' of 'politics and performance'.

In this, as in the sister volume, *The Routledge Reader in Gender and Performance* (1998), we found that many of the authors who wrote new pieces for inclusion in this book tended to cite, react, and refer to the same set of authors' and practitioners' work: a shared canon was recognized both implicitly and explicitly, though many sought to challenge this canon and, in so doing, further enshrined it, even if they didn't endorse it. So, on a larger scale, this book may seem to endorse a canon of sorts, but it is not intended to do so. The book is caught up in a cycle of production and reception that it can highlight and critique, but not erase. Some of the articles included set out to introduce ideas and performance traditions but end up challenging the status of the work they discuss. In Clive Barker's introduction to Part One, for instance, the author (Barker) reveals himself to be intensely, energetically aware of and tuned in to the controversial nature of his enterprise: the need to destabilize any notion of a canon or a set of 'rules' for performance shines through in his blistering attack on performance rules per se. Writing as a theatre-maker and as one of the 'gurus' whose work is most often 'canonized' in classroom teaching, Barker dares to reject the status of the canonical and urges readers, instructors, performers, and audiences to consider the value of free experiment. Barker's approach to his chapter is politicized and polemical, inspired and irascible; it is written with both conviction and with the enriching but also enervating experience of years 'in the business'. This style of writing is only one of many which make their marks in these pages. Each contribution is grounded in a political stance, however, and each in turn seeks to shed light on other politicized approaches to performance.

What, however, is meant by the highly subjective term 'politics'? Politics is one of the subjects (with money and religion) which we're not meant to discuss over dinner. Discussion near food, near the rituals of domestic performance, is seen to endanger and potentially disrupt the heterogeneity and comfortable unity of the family and the domestic setting. But in this book, we wanted to disrupt the notion of a unified subject: 'politics' (and performance). North American and British approaches to the term 'politics' – as to the preparation of the food near which politics should not be discussed – differ enormously. We do not always understand each other or indeed speak the same language, though our shared language is English. When the net of contributions is cast wider, to include European, African, Asian, Australasian, and Latin American approaches to politics and performance, the notion of a shared or 'safe' setting for debate is shattered altogether. This book brings together a raucous, rowdy bunch of authors who would not necessarily choose

to dine together, but whose ideas and voices inform and enrich one another's when taken together. The sacred and profane are mixed, and the personal subjective voice of some contributions blends uneasily but intriguingly with the more distanced tones of some of the 'academic' extracts.

Perhaps this book should be called a 'taster': it offers a nibble of this, a morsel of that; gourmet cooking and more simple gastronomy side by side, and each visitor at the feast is free to select. A number of the pieces are spicy: richly textured and flavoured. The editing of long pieces down to short extracts brings out the taste of key arguments, in distilled form. Yet the process of distillation risks oversimplification and even misrepresentation. The introductions to the respective parts tend, therefore, to acknowledge the editing process and some indicate that the attempt to make sense of connections was helpfully irritating, forcing a reconsideration of huge issues and debates which have, and have not, shifted over time. It made a difference to the energy of this book that the editing was completed during that strange period in media history that experienced the Clinton 'Monicagate' trials: a new kind of media 'theatre' played out in a period still smarting from the impact of the Thatcher/Reagan/Bush years on the financial state of the theatre sector. There is an anger and sense of frustration underlying many of the part introductions, and that is itself a statement about the context in which politics and performance are currently played out. To write about this huge subject is to make enormous leaps, with no safety nets, and in full view of a floor littered with broken bodies below. Yet to leap is to keep the theatre – and the energy which fuels us to write about, make, direct, act in, create and otherwise engage with theatre and live arts and dance and music – alive.

The subject of politics and the politics of subjectivity

Sarah Daniels's play *Masterpieces* was one of the first plays to make me sit up and listen, look, and feel. When the actors on stage discussed pornographic images but held them at an angle so that we in the audience couldn't see what they saw, I left frustrated at not being allowed to share their point of reference for the argument. The visibility and accessibility of pornography is, after all, one of the recurring arguments between characters that fuels the play and leads to the dilemma of the central female figure, who enacts a radical rejection of the values of a porn-saturated culture. The play made me feel angry on several counts, and left me thinking and talking that anger through long after I left the theatre. Both the sense of being left out of the visual frame of reference, and the sense of carrying the pornography argument and its complex resonances with me back into 'real life' left me feeling intensely affected, and frustrated. In time, of course, I came to realize that that was the point (as Sarah Daniels points out in her foreword to this book).

Such realizations don't always dawn quickly, but they usually stay with us once they do. Sarah Daniels's work is affective, radical in its content and intent, emotionally charged, and politicized in its concept of delivering political conscience through performance. This kind of work, often thought of as 'radical theatre' and most often associated with playwriting of the late 1960s through the mid-1980s, can still be found on our stages, and in our streets. Many other forms of political theatre and performance can also be found, in many other kinds of venues. This work seeks to reach across the fourth wall and to knock it down, to inspire an energetic, frustrated, annoyed or angry or hopeful or optimistic sense which leaves its audience thinking as they leave the theatre or close the covers of the printed script. So, I encouraged Sarah Daniels to write the foreword. When she asked what I meant by 'politics and performance', I explained that I tend to admire and respect theatre and performance work which attempts to reach out to inspire ideas as well as feelings, and which affects its audience in some way and urges social change.

That's what I mean by 'politics and performance'. But that's only my interpretation, and is only a starting-point for describing the origins of this book. The chapters are, therefore, each introduced by a theatre-maker and/or scholar with her or his own way of interpreting the phrase 'politics and performance'. Each of these authors was invited to invent her or his own framework, and to select a writing 'voice' or style to say what needed to be said, to make the necessary connections and to leave the necessary doors open for further debate.

In this, as in the sister volume, it would have been wonderful if images could have been included for each contribution, as it is simply impossible to capture the energy of performance work without even the visual aid of still images. However, the politics and economics of production mitigated against a visually enriched text. This book includes many articles that focus on the visual status of the word, on the performative elements of language and the voice, and many articles that create visual impressions through description and analysis of productions and performance styles. Yet the book includes only one visual image in print: the photo on the cover. As it was to be the sole image, that photo had to be chosen carefully. It was also chosen subjectively. The play depicted is *Translations*, by Irish playwright Brian Friel, for Field Day Theatre Company. The actor is Stephen Rea, playing Owen in the premiere at the Derry Guildhall in 1980. The image speaks but cannot capture the vital energy of the original production, just as the English language loses the vital energy of the Irish, Gaelic language: much is lost in translation. To recapture the political force of the play, it is important to stage and re-stage it. And to do that, of course, it is necessary to fight for the future of theatres and public spaces in which 'classic', 'political' and new plays may continue to be produced, transformed and translated.

Theatres have closed and gone dark as the articles included in this book were selected and edited. Performance companies lost their funding as the pages of this book were bound. In this same period, a young black man called Stephen Lawrence was killed and the trial of his white murderers was staged as 'theatre' and televised as 'drama'. Audiences were invited to take part, and to carry their anger with them, out of the space and place of the performance event and back into their 'real lives' where decisions might be taken to prevent such hate crimes from being staged again. As this story raged on in a number of encore performances of anger, two deaths hit the theatre community in quick succession: Jerzy Grotowski, guru of actors and directors around the world, died; and Sarah Kane, a controversial and militant young playwright, killed herself. Contributors to this book mourned both losses and attended to their wounds individually and collectively. Meanwhile, as the cover illustration for this book was selected and scanned, out in the wider world, other events overtook the news: NATO bombed Belgrade in response to the staging of this century's last major exodus; thousands of ethnic Albanians were forced to flee their homes, to become exiles from their sense of self. The world watched all this happen on TV. Politics came home to us, walking right into our living rooms.

In the so-called 'real world' in which such atrocities are daily 'staged', it often seems irrelevant, even disrespectful, to engage in the luxury of academic writing. Some of that sense of the futility of the academic gesture sparks off the pages, particularly in the introductions by Clive Barker and Christopher Murray, but also throughout the book. There may be too many printed words in too many books already out there in the world; there is certainly a sense that the textual base of performance needs to give way to non-textual performance practice wherein the bodies of performers communicate across cultures and languages. Then, of course, the issue of documentation of the live performance event emerges, and is addressed in experiments with digital modes of recording plays and of creating multimedia performance practices. That kind of experimentation is discussed in the last part of this book. In both live and mediated performance environments, though, it is equally important that theatre-makers, theorists, and students work towards some understanding of the variety of physical, embodied theatre and performance approaches which have sought – in many cultures, over many centuries – to bring the minds and bodies of performers and audiences into tune.

The metaphor of cartography has crept into academic and performative discourses with intriguing frequency in recent years. The maps of politics and performance have been retraced and redrawn, and those tracings have been much commented upon. In this book, the tracings emerge without comment. The lines lead from topic to topic and discipline to discipline, from consideration of the actor on stage to the speaking voice of the performer

to the movement language of the artist in a shared space with the audience, and out into the realm of digital performance practices. The sense of spatial occupation, however, shines through. However much each author sets out her or his own agenda in non-spatial terms, still in the reading it seems that authors occupy spatial positions: not necessarily 'left' or 'right', or even 'Orient' or 'Occident', but rather a general sense of visceral presence is created by each writer. These authors, and their ideas, take up space. They insist upon taking up space. They contest the divisions of spaces and artificial or politically motivated boundaries between disciplines, and yet they instil a sense of occupation of intellectual and performative space in their own writings. Such a complex system of communication is at once appropriate to, and antagonistic towards, the dynamic process of making effective and affective political theatre.

As Antonin Artaud wrote in *The Theatre and Its Double* (1936):

> There is no question of abolishing speech in theatre but of changing its intended purpose, especially to lessen its status, to view it as something other than a way of guiding human nature to external ends, since our theatre is solely concerned with the way emotions and feelings conflict with one another or the way man is set against man in life.
>
> Yet to change the purpose of theatre dialogue is to use it in an actual spatial sense, uniting it with everything in theatre that is spatial and significant in the tangible field. This means handling it as something concrete, something disturbing, first spatially, then in an infinitely more secret and mysterious field permitting more scope.
>
> (Artaud 1989: 123)

Artaud's words can be seen to apply across a wide range of theatre and performance practices and theories. Each of the authors included in this book demonstrates that to engage with the theatre and other live art forms today is to take a position, to occupy a space in order to show the space (and its political and performative and theoretical possibilities) to the audience. In performing the act of embodiment – translating ideas through physicalization as well as intellectualization, and then finally transferring some distilled version of those ideas into print in these pages – all of the contributors have not only taught about politics and theatre but have also sought to render performance political once again.

PART II: CONTENTS AND STRUCTURE OF THE BOOK

The book includes a wide range of articles by leading performance practitioners and scholars in the fields of theatre studies, cultural studies, women's studies, social and political studies, and media studies. The articles, taken

as a set, examine the interconnected realms of gender, politics, and performance, with each part offering a new way of seeing this relationship, and a new idea about the negotiation of relations between political performance and performed politics. The politics of production of this book mitigated against any division of the parts along either disciplinary or generic boundaries. There are not separate sections on subjects such as playwriting or political dance, for instance. Instead, the book explores eight major areas of political performance, all of which apply across the art forms and all of which encourage and develop comparative frameworks for cross-disciplinary and cross-generational contributions.

The authors of the introductions to the eight parts – Clive Barker, Stephen Regan, Christopher Murray, Nike Imoru, Katharine Cockin, Janet Adshead-Lansdale, Phillip Zarrilli, and Susan Kozel – each chose her or his own approach to the articles which were offered to them for consideration. The style of each introduction is unique. There was no format which authors were asked to adhere to, though of course suggestions were made when asked for and views were expressed where authors indicated a willingness or eagerness to enter into debate. Within the inevitable limits of space (imposed so that the book would remain short enough to make it affordable and therefore accessible to readers, and especially to students), each author contributing new material was invited to say what she or he wanted to say, so long as that piece could in some way link, discuss, or frame the pieces included in the section as a whole. There are many different voices arising from this book, and many ideas expressed and discussed across articles as well. The book aims, in that sense, to offer a dialogue (or even an argument) like that which might be encountered at a major conference or festival, except that the medium of print allows those who are no longer with us to feature in the dialogue (albeit when framed by others, and without the ability to argue back), and allows contemporary authors to take time to formulate their thoughts and correct their grammar. Readers get a tidied-up debate, as it were, but a debate nonetheless.

Part One draws together and then contrasts and problematizes some of the key ideas of five 'gurus' of performance studies. The articles have, of necessity, been extracted to fit the limited space of this book. As a result of this ruthless editing, these short pieces reveal insights into the much more complex life works of their authors: five practitioners whose work is often cited by other practitioners and critics (in these pages and in the workshops and classrooms of the world). Of course, no total picture of the work of any of these key figures can be gleaned from these brief glimpses into their work. However, by combining and contrasting sample ideas from each, it becomes possible to launch a comparative study of political theatre practices, and to provide just enough of a grounding to allow for contextualized historicizing and theorizing, as developed in subsequent parts.

Part One is introduced by Clive Barker, a veteran of Joan Littlewood's Theatre Workshop and world-renowned expert on theatre games (see his classic text of that name, Methuen, 1976). Barker did not choose any of the extracts in his section but agreed to undertake the difficult task of contextualizing them for this volume. After much debate and careful thought, he drew back and came at the subject matter running: he explodes into the chapter with a characteristic sense of playfulness and a direct address to the reader, with a warning that when these (or other) brief extracts from longer works setting out performance strategies are taken out of context and put into print, they should be approached with both scepticism and care. Part One introduces the work of: Jerzy Grotowski (1933–99), the Polish theatre director who founded the Theatre Laboratory in the 1960s and published his influential ideas on directing and theatre-making in his book *Towards a Poor Theatre* (1968), among other major accomplishments; Konstantin Stanislavski (1863–1938), one of Grotowski's great influences and indeed one of the most important contributors to the modern theatre's approach to performance, notably for his invention of and teaching about 'method acting' (see *An Actor Prepares*, 1936); Augusto Boal, renowned Brazilian theatre director and theorist whose work has inspired so many (see especially *Theatre of the Oppressed*, 1974, and *Games for Actors and Non-Actors*, 1992); Cicely Berry, Voice Director for the Royal Shakespeare Company and instructor to several generations of actors and directors (see especially *Voice and the Actor*, 1993); and Eugenio Barba, director of the Odin Teatret in Denmark and controversial experimenter in the field of 'theatre anthropology' (see his several books on the subject, including *The Floating Islands*, 1979). This part of the book is intended to open up debate: to throw a range of ideas and attitudes into circulation, before authors contributing to subsequent parts engage with these ideas in more critically informed contexts.

In Part Two, Stephen Regan (founding editor of *The Year's Work in Critical and Cultural Theory*) argues that a very distinctive and influential kind of political analysis of drama and performance can be found in the writings of Raymond Williams. Regan assesses the continuing impact of Williams's legacy on the work of contemporary critics, introducing short extracts from important texts by Marvin Carlson, Elin Diamond, Christopher Innes, and Stuart Hall. While these authors might not be expected to 'dine together' in other settings, Regan uses the setting of this book as a space to explore the range of related, though distinct, avenues which politics and performance have traversed in recent years. The last piece in this part, by cultural and media theorist – and expert on race relations – Stuart Hall, provides a point of contrast to the theatrical frameworks within and about which the other pieces in the section engage. While this last contribution is not ostensibly concerned with either 'theatre' or 'performance' as

conventionally defined, it certainly has much to do with what many of the other writers contributing to this book have referred to as 'the theatre of everyday life'.

In Part Three, Christopher Murray (who has written extensively on Irish theatrical history) engages critically with a range of extracts from the work of Peter Brook, Bertolt Brecht, Antonin Artaud, and Patrice Pavis: all 'gurus' of a class with those in Part One. Murray, like Barker, takes off the kid gloves in the handling of these figures. He writes more as a theatre scholar than as an active participant in the working practices about which he writes, with the effect that this part of the book makes use of the energy of Part One and incorporates some of the critical distancing and ground of Part Two. At the same time, Murray takes a politicized position with regard to the rich field of 'intercultural perspectives'. Here, as in other parts of the book, the field of 'post-colonial' theory is problematized and debated from particular national and geographical perspectives, rather than from any total-izing or appropriating framework, and the insights of sophisticated theory are brought to bear on performance practices and on the problems of casting too wide a net in assuming that any theory or practice may be fully 'trans-portable' or adaptable.

In Part Four, Nike Imoru (a theatre director and academic based in the north of England) provides a critical framework for comparison of four distinct essays on the theme of 'power, politics, and the theatre'. Imoru has, in other contexts, written and spoken about racial identity and sexuality in performance theory and practice. In introducing this rich mix of material – new essays by Awam Amkpa and Gordon McDougall, and extracts from previ-ously published work by Coco Fusco and Baz Kershaw – she focuses on the issue of revolution: cultural, economic, and theatrical. Imoru leads the reader through the distinctive areas of debate introduced by each of the four contrib-utors to this part: the notion of a 'trope of post-coloniality' as explored in the work of Nigerian playwright and theatre scholar Amkpa; the idea of a 'revolutionary theatre' as espoused by theatre director and teacher McDougall in his essay charting the stages of the revolution in recent theatre history; the performance-art-orientated approach taken by cultural theorist and provo-cateur Coco Fusco in her resonant exploration of 'other' states of play for intercultural performance and the practical and politically charged 'take' on 'performance, community, culture' that Baz Kershaw maps out. The posi-tions taken by these four authors differ markedly, as might be expected given their very diverse origins and relationships to their own 'performing subjects'.

Part Five takes the dynamic of power and attaches it to the subject of sexuality in performance. The contributions to this section range widely in content and style, from Joseph Bristow's and Jeffrey Weeks's contributions to debates about sexuality and identity, to Judith Butler's call to arms on Queer subjectivity and performativity extracted from her influential book

Bodies that Matter (1993), to Andrew Parker and Eve Kosofky Sedgwick's much-quoted writing on 'sexual politics, performativity, and performance'. These four short extracts from well-known texts are framed at the top by a new essay by Leslie Hill, in which she puts her energetic and persuasive argument to the effect that the 'suffragettes invented performance art', and at the end by a moving creative essay by playwright Tony Kushner in which some of the more 'academic' ideas of the book are explored in a personal voice, with a personal, though highly political, message intended. Theatre historian Katharine Cockin (expert on the Pioneer Players and biographer of Edith Craig) takes a step back from all of these contributions and gazes at each set of ideas through the lens of history; she explores each piece and sets up a framework for investigation into the impact and legacy which each author makes to the continuing evolution of 'sexuality in performance' on stage and in the classroom. In this section, we deliberately selected a wide transdisciplinary mix, from Cockin's framing of psychoanalytic and feminist approaches to the more sociological and materialist ideas developed throughout the chapter. This unusual selection reflects on an editorial strategy: a decision not to repeat or 'replay' ideas already discussed at length in the sister volume, *The Routledge Reader in Gender and Performance* (1998), but rather to show how the field of 'sexuality' resonates within the context of this particular book. Sexuality is therefore treated in these pages both in terms of its 'performative' theoretical possibilities and connotations, and also in terms of its treatment as a change-orientated political and cultural marker reaching across disciplines, art forms, and decades, though taking a new shape or set of shapes in each distinct context.

In Part Six, Janet Adshead-Lansdale (expert on dance notation and performance analysis) takes on five major threads of contemporary discourse around the intertwined areas of performance theory, live arts, and the media. She argues for evaluation of performance theory and practice in cross-disciplinary and cross-cultural contexts, but she also urges a responsible approach to 'intercultural' performance that recognizes differences as it celebrates points of commonality. This part of the book makes some broad sweeps across disciplinary boundaries, reaching out from Alan Read's sensitive study of the quotidian in his work on 'theatre and everyday life', to the more systematic approach to performance theory outlined in an extract from one of Richard Schechner's many significant contributions to the debate, and then to Colin Counsell's work on semiotics in 'Signs of Performance'. From these theoretical writings, Adshead-Lansdale draws us on to consider two contributions from the field of dance: Susan Leigh Foster's work on gender and choreography and Sally Banes's contribution on recent developments in dance theory.

Part Seven takes another step into the arena of theatre practice, with and through an introduction by Phillip Zarrilli (theatre director and specialist in non-western martial arts and acting theory). Zarrilli draws upon examples

from his own research into performance practice in India to support his arguments for a sustained, thorough, and responsible approach to 'political theatres, post-coloniality, and performance theory'. In each of the four essays in this part – previously published work by Helen Gilbert and Joanne Tompkins, Ian Watson, and Sally Ann Ness, and a new essay by South African theatre specialist Miki Flockemann – the theme of 'post-coloniality' is problematized and explored within an informed framework that recognizes the spatial, geographical, and cultural nexus of forces influencing the making and reception of any performance work. No assumptions are made about the portability of any theory or performance practice between one culture to another, but rather, a sympathetic reading is given to the overall effort to explore performance traditions through both embodied practice and performance theorizing which itself develops through practice.

In Part Eight, Susan Kozel interjects a dynamic and interrogative voice into the mix. As a young dancer and maker of digital performance (with a training in philosophy and experience of teaching performance studies at university level), Kozel weaves a framework for analysis of five very different extracts and essays. She develops the increasingly familiar idea that artists today work in 'post-linear' frameworks enabled and influenced by digital communications systems, and that this shift is changing the nature of inter-action at every level, including the performative. The work included in this part draws together a number of the broad themes of the rest of the book: the nature of the performance event, the mutability of the body and the impermanence and ever-shifting perception of, and location of the 'stage'. Rebecca Schneider writes on the work of Native American women's theatre company Spiderwoman and its early contributions to a still-developing non-linear performance tradition; Nick Kaye offers informative musings on 'telling stories: narrative against itself ' in his analysis of Karen Finley and Yvonne Rainer's 'postmodern' work; Sue-Ellen Case grabs the reader's attention with her insights into the uses of the World Wide Web for lesbian creativity and establishment of performative roles and virtual communities; Richard Loveless articulates a need to recognize the opportunities which new technologies provide as each new generation of artists works to 'summon the future'. Finally, in my own discussion of the state of play of performance studies in the age of what I call 'replay culture', I attempt to offer some links between major ideas explored in the Reader as a whole.

This book was 'replayed' many times in the process of becoming. The last chapter was revised more frequently than the others as advances in new technologies and performance strategies for new media took the concept of 'linearity' in performance round the bend. As the concept of 'linearity' was refigured and replayed by each contributing author, so the book looped back on itself, demanding a reconsideration of each chapter's, and each author's, concepts of 'politics' and of 'performance'.

The Reader opens with a foreword in which playwright Sarah Daniels jokes about the 'mixed-up' nature of the modern theatrical event, and teases out cultural assumptions about the role of the theatre in the political world of today. The book ends with an afterword by political performance poet Adeola Agbebiyi, in which she summons the image of Miranda, surviving and reinventing herself in her own image, rising up from the wreckage of one of Shakespeare's last and best-known plays. This closing invocation to *The Tempest* – and the indirect reference for those who know the play to the influences of the patriarchal figure of the Duke/Magician/Father Prospero – marks a significant aspect of the book. This performance poem is offered as an afterword to a largely academic text, and it is offered in the same spirit of dialectic that fuels Barker's warnings in Part One and many of the debates which spark and smoulder (or crest, crash, and undulate) throughout. Here, the poet invites readers to think not only of her contribution to the text but also of other texts, by 'great masters' and by recent artists: by 'magicians' and patriarchs, and by their dispossessed daughters. By extension, she invites artists, scholars, and audiences today to follow Prospero's lead and throw away magical staffs and other props, and look ahead with clear eyes focused on the future. The poem recalls Richard Loveless's reference to the dilemma of the collaborative relationship between artists and scientists: that 'artists believe in magic' and scientists claim not to have 'experience of that'. The slippage is that between the 'magic' of theatre and the realization, or spatial occupation, of the individual who stands, embodied and positioned but alone, looking to the future while contemplating the past. This is the space in which 'politics' and 'performance' are made, lived, and studied today.

London, April 1999

Practice to theory: Theatre games

Clive Barker

INTRODUCTION TO PART ONE

T HERE IS A STORY, PROBABLY APOCRYPHAL, ABOUT A TIME WHEN SIR PETER HALL WAS REHEARSING A PLAY at the Royal Shakespeare Company, and the rehearsal became bogged down. Turning to the leading actor he said: 'Let's put the books on one side and improvise.' The actor considered this and replied: 'You may, of course, exercise your director's right and insist that we improvise, but if you do, I shall exercise my actor's right and walk out.' On another occasion a director had begun rehearsals with improvising and the process went on for so long that Hall was reduced to crying out: 'For heaven's sake, when are you going to rehearse the play?' I hope I am not taking Sir Peter's name in vain but these stories raise several important points about the need to escape the domination of the text, and the problems that are revealed when a director does.

Stanislavski opens his book of instruction, *An Actor Prepares*, with the case of a young actor beginning his training and being allocated the role of Othello to study. Returning home he begins to read. 'Hardly had I read two pages when I was seized with a desire to act' (1937: 2). Seized in this way the young actor begins to improvise, carried away by the emotion his improvisation arouses. 'I had worked for almost five hours without noticing the passage of time. To me this seemed to show that my inspiration was real' (ibid.). The result of this feverish activity is that the actor oversleeps and is late for rehearsal, the atmosphere is disturbed and the rehearsal consequently cancelled. Returning home, determined on an early night, the actor, once more, is seduced into improvising: 'I didn't invent anything new. I merely repeated what I had done yesterday, and now it seemed to have lost its point'

(ibid.: 3). When the actor finally gets to rehearse, he finds to his astonishment that the words don't help him to define the limits and the usage of his improvisation. There are too many words and 'the words [interfere] with the acting, and the acting with the words' (ibid.: 4). The catastrophic rehearsals carry on as the actor struggles to escape from the seduction of illusory freedom and to avoid the entrapment of the text.

The central dilemma caused by the theatrical inversion of the normal psychophysical processes of everyday life has attracted the attention of many theorists and practitioners. In everyday life, something catches our eye or ear, some thought arises in the mind, and we react: we respond through action and finally verbalize. In the theatre we are handed the words on the first day of rehearsal, if not before. Different playwrights write in different styles and the function of the dialogue differs, quite widely at times. In some cases, the dialogue is definitive and contains almost all the audience needs to know, such as in Priestley's *An Inspector Calls*. In others, such as *Waiting for Godot*, the dialogue is allusive and even elusive. Unless the actors in the Priestley can reconstruct the process which would precede verbalization in everyday life, the play remains literary and lifeless in performance. Unless the actors in the Beckett can construct some subtextual action, not necessarily clarified, the play doesn't begin to exist. The former tempts the actor to hang on to the text and to illustrate it, rather than reconstitute it: in the words of Eugenio Barba, they will not launch themselves upon a voyage of discovery. In the latter, there is a temptation to leap bravely over the side and to lose all sense of direction, but it is not unknown for actors to cling to the text of Beckett's play as if it alone contained everything to hold an audience and convey significance and meaning through the words. The strength and resolution of actors to hold on to the words should not be underestimated.

Many and varied are the methods and systems that have been called into being to break the defining and restricting power of the text, and Stanislavski's pioneering work is pre-eminent, although there is a sense of abdication in his stress on the structuring of the inner life to create the conditions in which the life of the text arises naturally and without a great deal of attention being paid to it. Cicely Berry, in approaching the problem from the other end, seems in danger of oversimplifying the psychophysical processes of the way we live and conduct our relationships. Both have a great deal to offer the actor, provided they are not taken prescriptively. In the words of the other great theorist, Bertolt Brecht, they advance proposals for others to test out and build on. Boal, Brecht's critic and follower, and Grotowski, Stanislavski's heir and disciple, have both redefined the nature of performance, away from the traditions and forms of the Dramatic Theatre, to make the problems largely irrelevant by redefining the political and aesthetic parameters. Boal does not escape the problems. In the age of the mass spread of culture through satellite television and cinema, a South American peasant

could conceivably express his experience not directly but through imposed stereotypes of performance, such as American soap operas. Grotowski withdrew further from public performance into enclosed forms, allowing spectators only for the purpose of justifying activities which had no dramaturgical intention. Without wishing to disparage the work of these great thinkers and practitioners, Boal's methods for training actors are crude, facile, and tainted with prescription. The working process he set up cannot be exported. It has to be restricted to the people who work with him in the political situation and context which solely validates it. Grotowski's work in Pontedera, for those of us privileged to glimpse it, had both beauty and spiritual power, without ever being directly referential. However, the long tradition, which he himself researched diligently, seems never to have been accessed by those who worked with him, with the result that there are wonderfully talented and accomplished actors who have little idea how to employ their skills in the theatre outside the barns of Pontedera or how to communicate them to others with more mundane aims. Barba, and Savarese his collaborator, have similarly avoided the dramatic problems by a comparative analysis of other forms of theatre, more stylized than the dramatic conventions, in which the problems simply do not arise. Out of Barba's research and training methods, hybrid new forms of theatre have emerged and performers have experimented with them. There is much that could be said about the new work being produced in the theatre, but in this essay I want to stick to my topic.

The development of the work of the thinkers listed above took, or has taken, many years. What is written in books or imparted at workshops is the distilled result of research and experimentation. This means that the result of this process of research and experimentation is often communicated, but not always the process itself. Yat Malmgren (who I hope one day will publish his journey in which he interlocks the teaching ideas of Stanislavski and Laban) said that Laban once remarked towards the end of his life, that he had wished the Nazis had burned all his books, because so many people were teaching Laban and not movement.[1] What begins as free examination becomes reified, sometimes stultifying. Without either some access to the process of discovery or a critical attitude to it, students can acquire a vocabulary through which to describe what they are *not* doing. Beware those who teach the Stanislavski Method! Albert Filozov, who trained with Stanislavski's colleagues, begins his classes not with theory, but with the actors' own movement and builds upon that (Merlin 1999). Chkhivadze, the leading actor of the Georgian Rustavelli Theatre Company, says that although Stanislavski's ideas are the best way to train actors, no professional actor would ever use them because acting is much more complicated than that (see Parkhomenko 1990: 229). In my own work, I am influenced by all of the people included in this section and in addition by Laban. I acknowledge their ideas in my classes but I would be appalled at any idea of teaching a Laban or Stanislavski

class or of teaching Grotowski or Barba. I would be even more horrified if I thought anyone was teaching classes based on my work. My ideas (or some of them) are written down for other theatre workers to read and incorporate into their own work, if they find them useful. My instruction would be: if you think an idea is right, do not accept it but try to prove it wrong. I keep a work book in which I write down the form and content of every class I give. In my mind, I believe that I only have to look at the book to know how to run the next class I am going to give – but this is a total illusion. Every time I look at the book it is no help at all. I have no way of even guessing at why I ran the past classes in the way I did. At least one entry has an opening sentence, 'Don't try to make sense of this or you'll go mad.' Yet I still persist in believing that I never vary in the content and order of the classes. I will try to resolve this paradox one day. In the meantime, let us resolve that, if we insist on using the ideas of Stanislavski, Laban, Grotowski, and company prescriptively, we will give away any freedom we have tried to create and will have picked up one more stick with which to beat ourselves, one more concrete standard against which to measure our failure.

Note

1 Conversation with the writer.

Jerzy Grotowski

TOWARDS A POOR THEATRE

From: *Towards a Poor Theatre*, tr. T.K. Wiewiorowski, ed. Eugenio Barba, preface by Peter Brook (Holstebro: Odin Teatrets Forlag, 1968; London: Methuen, 1969).

I AM A BIT IMPATIENT WHEN ASKED, 'What is the origin of your experimental theatre productions?' The assumption seems to be that 'experimental' work is tangential (toying with some 'new' technique each time) and tributary. The result is supposed to be a contribution to modern staging – scenography using current sculptural or electronic ideas, contemporary music, actors independently projecting clownish or cabaret stereotypes. I know that scene: I used to be part of it. Our Theatre Laboratory productions are going in another direction. In the first place, we are trying to avoid eclecticism, trying to resist thinking of theatre as a composite of disciplines. We are seeking to define what is distinctively theatre, what separates this activity from other categories of performance and spectacle. Secondly, our productions are detailed investigations of the actor–audience relationship. That is, *we consider the personal and scenic technique of the actor as the core of theatre art*.

It is difficult to locate the exact sources of this approach, but I can speak of its tradition. I was brought up on Stanislavski; his persistent study, his systematic renewal of the methods of observation, and his dialectical relationship to his own earlier work make him my personal ideal. Stanislavski asked the key methodological questions. Our solutions, however, differ widely from his – sometimes we reach opposite conclusions.

I have studied all the major actor-training methods of Europe and beyond. Most important for my purposes are: Dullin's rhythm exercises, Delsarte's investigations of extroversive and introversive reactions, Stanislavski's work on 'physical actions', Meyerhold's bio-mechanical training, Vakhtanghov's

synthesis. Also particularly stimulating to me are the training techniques of oriental theatre – specifically the Peking Opera, Indian Kathakali, and Japanese Noh theatre. I could cite other theatrical systems, but the method which we are developing is not a combination of techniques borrowed from these sources (although we sometimes adapt elements for our use). We do not want to teach the actor a predetermined set of skills or give him a 'bag of tricks'. Ours is not a deductive method of collecting skills. Here everything is concentrated on the 'ripening' of the actor which is expressed by a tension towards the extreme, by a complete stripping down, by the laying bare of one's own intimacy – all this without the least trace of egotism or self-enjoyment. The actor makes a total gift of himself. This is a technique of the 'trance' and of the integration of all the actor's psychic and bodily powers which emerge from the most intimate layers of his being and his instinct, springing forth in a sort of 'translumination'.

The education of an actor in our theatre is not a matter of teaching him something; we attempt to eliminate his organism's resistance to this psychic process. The result is freedom from the time-lapse between inner impulse and outer reaction in such a way that the impulse is already an outer reaction. Impulse and action are concurrent: the body vanishes, burns, and the spectator sees only a series of visible impulses.

Ours then is a *via negativa* – not a collection of skills but an eradication of blocks.

Years of work and of specially composed exercises (which, by means of physical, plastic and vocal training, attempt to guide the actor towards the right kind of concentration) sometimes permit the discovery of the beginning of this road. Then it is possible to carefully cultivate what has been awakened. The process itself, though to some extent dependent upon concentration, confidence, exposure, and almost disappearance into the acting craft, is not voluntary. The requisite state of mind is a passive readiness to realize an active role, a state in which one does not '*want to do that*' but rather '*resigns from not doing it*'.

Most of the actors at the Theatre Laboratory are just beginning to work toward the possibility of making such a process visible. In their daily work they do not concentrate on the spiritual technique but on the composition of the role, on the construction of form, on the expression of signs – i.e., on artifice. There is no contradiction between inner technique and artifice (articulation of a role by signs). We believe that a personal process which is not supported and expressed by a formal articulation and disciplined structuring of the role is not a release and will collapse in shapelessness.

We find that artificial composition not only does not limit the spiritual but actually leads to it. (The tropistic tension between the inner process and the form strengthens both. The form is like a baited trap, to which the spiritual process responds spontaneously and against which it struggles.) The forms of common 'natural' behaviour obscure the truth; we compose a role as a system of signs which demonstrate what is behind the mask of common

vision: the dialectics of human behaviour. At a moment of psychic shock, a moment of terror, of mortal danger or tremendous joy, a man does not behave 'naturally'. A man in an elevated spiritual state uses rhythmically articulated signs, begins to dance, to sing. A *sign*, not a common gesture, is the elementary integer of expression for us.

In terms of formal technique, we do not work by proliferation of signs, or by accumulation of signs (as in the formal repetitions of oriental theatre). Rather, we subtract, seeking *distillation* of signs by eliminating those elements of 'natural' behaviour which obscure pure impulse. Another technique which illuminates the hidden structure of signs is *contradiction* (between gesture and voice, voice and word, word and thought, will and action, etc.) – here, too, we take the *via negativa*.

It is difficult to say precisely what elements in our productions result from a consciously formulated programme and what derive from the struc-ture of our imagination. I am frequently asked whether certain 'medieval' effects indicate an intentional return to 'ritual roots'. There is no single answer. At our present point of artistic awareness, the problem of mythic 'roots', of the elementary human situation, has definite meaning. However, this is not a product of a 'philosophy of art' but comes from the practical discovery and use of the rules of theatre. That is, the productions do not spring from *a priori* aesthetic postulates; rather, as Sartre has said: 'Each tech-nique leads to metaphysics.'

For several years, I vacillated between practice-born impulses and the application of *a priori* principles, without seeing the contradiction. My friend and colleague Ludwik Flaszen was the first to point out this confusion in my work: the material and techniques which came spontaneously in preparing the production, from the very nature of the work, were revealing and promising; but what I had taken to be applications of theoretical assumptions were actually more functions of my personality than of my intellect. I real-ized that the production led to awareness rather than being the product of awareness. Since 1960, my emphasis has been on methodology. Through practical experimentation I sought to answer the questions with which I had begun: What is the theatre? What is unique about it? What can it do that film and television cannot? Two concrete conceptions crystallized: the poor theatre, and performance as an act of transgression.

By gradually eliminating whatever proved superfluous, we found that theatre can exist without make-up, without autonomic costume and scenog-raphy, without a separate performance area (stage), without lighting and sound effects, etc. It cannot exist without the actor–spectator relationship of percep-tual, direct, 'live' communion. This is an ancient theoretical truth, of course, but when rigorously tested in practice it undermines most of our usual ideas about theatre. It challenges the notion of theatre as a synthesis of disparate creative disciplines – literature, sculpture, painting, architecture, lighting, acting (under the direction of a *metteur-en-scène*). This 'synthetic theatre' is the contemporary theatre, which we readily call the 'Rich Theatre' – rich in flaws.

The Rich Theatre depends on artistic kleptomania, drawing from other disciplines, constructing hybrid-spectacles, conglomerates without backbone or integrity, yet presented as an organic artwork. By multiplying assimilated elements, the Rich Theatre tries to escape the impasse presented by movies and television. Since film and TV excel in the area of mechanical functions (montage, instantaneous change of place, etc.), the Rich Theatre countered with a blatantly compensatory call for 'total theatre'. The integration of borrowed mechanisms (movie screens on stage, for example) means a sophisticated technical plant, permitting great mobility and dynamism. And if the stage and/or auditorium were mobile, constantly changing perspective would be possible. This is all nonsense.

No matter how much theatre expands and exploits its mechanical resources, it will remain technologically inferior to film and television. Consequently, I propose poverty in theatre. We have resigned from the stage-and-auditorium plant: for each production, a new space is designed for the actors and spectators. Thus, infinite variation of performer–audience relationships is possible. The actors can play among the spectators, directly contacting the audience and giving it a passive role in the drama (e.g. our production of Byron's *Cain* and Kalidasa's *Shakuntala*). Or the actors may build structures among the spectators and thus include them in the architecture of action, subjecting them to a sense of the pressure and congestion and limitation of space (Wyspianski's *Akropolis*). Or the actors may play among the spectators and ignore them, looking through them. The spectators may be separated from the actors – for example, by a high fence, over which only their [the spectators'] heads protrude (*The Constant Prince*, from Calderón); from this radically slanted perspective, they look down on the actors as if watching animals in a ring, or like medical students watching an operation (also, this detached, downward viewing gives the action a sense of moral transgression). Or the entire hall is used as a concrete place: Faustus' 'last supper' in a monastery refectory, where Faustus entertains the spectators, who are guests at a baroque feast served on huge tables, offering episodes from his life. The elimination of stage–auditorium dichotomy is not the important thing – that simply creates a bare laboratory situation, an appropriate area for investigation. The essential concern is finding the proper spectator–actor relationship for each type of performance and embodying the decision in physical arrangements.

We forsook lighting effects, and this revealed a wide range of possibilities for the actor's use of stationary light-sources by deliberate work with shadows, bright spots, etc. It is particularly significant that once a spectator is placed in an illuminated zone, or in other words becomes visible, he too begins to play a part in the performance. It also became evident that the actors, like figures in El Greco's paintings, can 'illuminate' through personal technique, becoming a source of 'spiritual light'.

We abandoned make-up, fake noses, pillow-stuffed bellies – everything that the actor puts on in the dressing room before performance. We found

that it was consummately theatrical for the actor to transform from type to type, character to character, silhouette to silhouette – while the audience watched – in a *poor* manner, using only his own body and craft. The composition of a fixed facial expression by using the actor's own muscles and inner impulses achieves the effect of a strikingly theatrical transubstantiation, while the mask prepared by a make-up artist is only a trick.

Similarly, a costume with no autonomous value, existing only in connection with a particular character and his activities, can be transformed before the audience, contrasted with the actor's functions, etc. Elimination of plastic elements which have a life of their own (i.e., represent something independent of the actor's activities) led to the creation by the actor of the most elementary and obvious objects. By his controlled use of gesture the actor transforms the floor into a sea, a table into a confessional, a piece of iron into an animate partner, etc. Elimination of music (live or recorded) not produced by the actors enables the performance itself to become music through the orchestration of voices and clashing objects. We know that the text *per se* is not theatre, that it becomes theatre only through the actors' use of it – that is to say, thanks to intonations, to the association of sounds, to the musicality of the language.

The acceptance of poverty in theatre, stripped of all that is not essential to it, revealed to us not only the backbone of the medium, but also the deep riches which lie in the very nature of the art-form.

Why are we concerned with art? To cross our frontiers, exceed our limitations, fill our emptiness – fulfil ourselves. This is not a condition but a process in which what is dark in us slowly becomes transparent. In this struggle with one's own truth, this effort to peel off the life-mask, the theatre, with its full-fleshed perceptivity, has always seemed to me a place of provocation. It is capable of challenging itself and its audience by violating accepted stereotypes of vision, feeling, and judgement – more jarring because it is imaged in the human organism's breath, body, and inner impulses. This defiance of taboo, this transgression, provides the shock which rips off the mask, enabling us to give ourselves nakedly to something which is impossible to define but which contains Eros and Caritas.

In my work as a producer, I have therefore been tempted to make use of archaic situations sanctified by tradition, situations (within the realms of religion and tradition) which are taboo. I felt a need to confront myself with these values. They fascinated me, filling me with a sense of interior restlessness, while at the same time I was obeying a temptation to blaspheme: I wanted to attack them, go beyond them, or rather confront them with my own experience which is itself determined by the collective experience of our time. This element of our productions has been variously called 'collision with the roots', 'the dialectics of mockery and apotheosis', or even 'religion expressed through blasphemy; love speaking out through hate'.

As soon as my practical awareness became conscious and when experiment led to a method, I was compelled to take a fresh look at the history

of theatre in relation to other branches of knowledge, especially psychology and cultural anthropology. A rational review of the problem of myth was called for. Then I clearly saw that myth was both a primeval situation, and a complex model with an independent existence in the psychology of social groups, inspiring group behaviour and tendencies.

The theatre, when it was still part of religion, was already theatre: it liberated the spiritual energy of the congregation or tribe by incorporating myth and profaning or rather transcending it. The spectator thus had a renewed awareness of his personal truth in the truth of the myth, and through fright and a sense of the sacred he came to catharsis. It was not by chance that the Middle Ages produced the idea of 'sacral parody'.

But today's situation is much different. As social groupings are less and less defined by religion, traditional mythic forms are in flux, disappearing and being reincarnated. The spectators are more and more individuated in their relation to the myth as corporate truth or group model, and belief is often a matter of intellectual conviction. This means that it is much more difficult to elicit the sort of shock needed to get at those psychic layers behind the life-mask. Group identification with myth – the equation of personal, individual truth with universal truth – is virtually impossible today.

What is possible? First, *confrontation* with myth rather than identification. In other words, while retaining our private experiences, we can attempt to incarnate myth, putting on its ill-fitting skin to perceive the relativity of our problems, their connection to the 'roots', and the relativity of the 'roots' in the light of today's experience. If the situation is brutal, if we strip ourselves and touch an extraordinarily intimate layer, exposing it, the life-mask cracks and falls away.

Secondly, even with the loss of a 'common sky' of belief and the loss of impregnable boundaries, the perceptivity of the human organism remains. Only myth – incarnate in the fact of the actor, in his living organism – can function as a taboo. The violation of the living organism, the exposure carried to outrageous excess, returns us to a concrete mythical situation, an experience of common human truth.

Again, the rational sources of our terminology cannot be cited precisely. I am often asked about Artaud when I speak of 'cruelty', although his formulations were based on different premises and took a different tack. Artaud was an extraordinary visionary, but his writings have little methodological meaning because they are not the product of long-term practical investigations. They are an astounding prophecy, not a programme. When I speak of 'roots' or 'mythical soul', I am asked about Nietzsche; if I call it 'group imagination', Durkheim comes up; if I call it 'archetypes', Jung. But my formulations are not derived from humanistic disciplines, though I may use them for analysis. When I speak of the actor's expression of signs, I am asked about oriental theatre, particularly classical Chinese theatre (especially when it is known that I studied there). But the hieroglyphic signs of the oriental theatre are inflexible, like an alphabet, whereas the signs we use are the

skeletal forms of human action, a crystallization of a role, an articulation of the particular psycho-physiology of the actor.

I do not claim that everything we do is entirely new. We are bound, consciously or unconsciously, to be influenced by the traditions, science, and art, even by the superstitions and presentiments peculiar to the civilization which has moulded us, just as we breathe the air of the particular continent which has given us life. All this influences our undertaking, though sometimes we may deny it. Even when we arrive at certain theoretic formulas and compare our ideas with those of our predecessors which I have already mentioned, we are forced to resort to certain retrospective corrections which themselves enable us to see more clearly the possibilities opened up before us.

When we confront the general tradition of the Great Reform of the theatre from Stanislavski to Dullin and from Meyerhold to Artaud, we realize that we have not started from scratch but are operating in a defined and special atmosphere. When our investigation reveals and confirms someone else's flash of intuition, we are filled with humility. We realize that theatre has certain objective laws and that fulfilment is possible only within them, or, as Thomas Mann said, through a kind of 'higher obedience', to which we give our 'dignified attention'.

I hold a peculiar position of leadership in the Polish Laboratory. I am not simply the director or producer or 'spiritual instructor'. In the first place, my relation to the work is certainly not one-way or didactic. If my suggestions are reflected in the spatial compositions of our architect Gurawski, it must be understood that my vision has been formed by years of collaboration with him.

There is something incomparably intimate and productive in the work with the actor entrusted to me. He must be attentive and confident and free, for our labour is to explore his possibilities to the utmost. His growth is attended by observation, astonishment, and desire to help; my growth is projected onto him, or, rather, is *found in him* – and our common growth becomes revelation. This is not instruction of a pupil but utter opening to another person, in which the phenomenon of 'shared or double birth' becomes possible. The actor is reborn – not only as an actor but as a man – and with him, I am reborn. It is a clumsy way of expressing it, but what is achieved is a total acceptance of one human being by another.

Konstantin Stanislavski

TOWARD A PHYSICAL
CHARACTERIZATION

From: *Building a Character*, tr. Elizabeth Reynolds Hapgood (London: Methuen, 1968).

A T THE BEGINNING OF OUR LESSON I told Tortsov, the Director of our school and theatre, that I could comprehend with my mind the process of planting and training within myself the elements necessary to create character, but that it was still unclear to me how to achieve the building of that character in physical terms. Because, if you do not use your body, your voice, a manner of speaking, walking, moving, if you do not find a form of characterization which corresponds to the image, you probably cannot convey to others its inner, living spirit.

'Yes,' agreed Tortsov, 'without an external form neither your inner characterization nor the spirit of your image will reach the public. The external characterization explains and illustrates and thereby conveys to your spectators the inner pattern of your part.'

'That's it!' Paul and I exclaimed.

'But how do we achieve that external, physical characterization?' I asked.

'Most frequently, especially among talented actors, the physical materialization of a character to be created emerges of its own accord once the right inner values have been established,' explained Tortsov. 'In *My Life in Art* there are many examples of this. One is the case of the part of Dr Stockman in *An Enemy of the People* by Ibsen. As soon as the right spiritual form was fixed, as the right inner characterization was woven out of all the elements germane to the image, there appeared, no one knows from where, Stockman's nervous intensity, his jerky gait, his neck thrust forward and two jutting fingers, all earmarks of a man of action.'

'But if we are not lucky enough to have such a spontaneous accident? What do you do then?' I asked Tortsov.

'What do you do? Do you remember in Ostrovski's play, *The Forest*, how Peter explains to Aksyusha the way to act so that the two will not be recognized on their flight? He says to her, "You drop one lid – and it makes a squint-eyed person!"'

'Externally it is not difficult to disguise yourself. I once had something of the sort happen to me; I had an acquaintance I knew very well. He talked with a deep bass voice, wore his hair long, had a heavy beard and bushy moustache. Suddenly he had his hair cut and shaved off his whiskers. From underneath there emerged rather small features, a receding chin and ears that stuck out. I met him in this new guise at a family dinner, at the house of some friends. We sat across the table from one another and carried on a conversation. Whom does he remind me of? I kept saying to myself, never suspecting that he was reminding me of himself. In order to disguise his bass voice my friend used only high tones in speaking. This went on for half the meal and I talked with him as though he were a stranger. [. . .]'

As Tortsov was describing [this] personal experience he squinted one eye almost imperceptibly, as though he were bothered with an incipient sty. Meantime he opened his other eye wide and raised the brow above it. All this was done so that it could be scarcely noticed even by those standing close to him. Yet even this slight change produced a strange effect. He was of course still Tortsov but he was different and you no longer had confidence in him. You sensed knavery, slyness, grossness, all qualities little related to his real self. It was only when he stopped acting with his eyes that he became once more our nice old Tortsov. But let him squint one eye – and there again was that mean little slyness, changing his whole personality.

'Are you aware,' he explained to us, 'that inwardly I remain the same and speak in my own person regardless of whether my eye is squinted or open, whether my eyebrow is raised or lowered? If I were to acquire a twitch and that were causing my eye to squint I should also have remained unchanged in personality and continued normal and natural. Why should I change inwardly because of a slight squint in my eye? I am the same whether my eye is open or shut, whether my eyebrow is raised or lowered.

'Or, let us suppose, I am stung by a bee [. . .] and my mouth is distorted.'

Here Tortsov, with extraordinary realism, pulled his mouth to the right side so that his speech was completely altered.

'Does this external distortion not only of my face but of my speech,' he went on in his radically changed method of pronunciation, 'impinge on my personality and natural reactions? Must I cease to be myself? Neither the sting of the bee nor the artificial distortion of my mouth should influence my inner life as a human being. And what about lameness (here Tortsov limped) or paralysis of the arms (instantly he lost all control over them) or a humped shoulder (his spine reacted correspondingly) or an exaggerated

way of turning your feet in or out (Tortsov walked first one way and then the other)? Or an incorrect position of the hands and arms holding them too far forward or too far back (he illustrated this)? Can all these external trifles have any bearing on my feelings, my relations to others or the physical aspect of my part?'

It was amazing with what ease, simplicity, and naturalness Tortsov instantly demonstrated all the physical shortcomings he was describing – a limp, paralysis, a hump, various postures of legs and arms.

'And what remarkable external tricks, which completely transform the person playing a part, can be accomplished with the voice, with speech and pronunciation, especially of consonants! To be sure your voice has to be well placed and trained if you are to change it, for otherwise you cannot, for any length of time, speak either with your highest or your lowest tones. As for altering your pronunciation, especially that of consonants, this is done very simply: pull your tongue back, shorten it (Tortsov did it as he was speaking) and a special manner of speech, rather reminiscent of the English way of handling consonants, will result. Or lengthen your tongue, pushing it a little in advance of your teeth (again he did what he was describing) and you will have an inane lisp, which with proper elaboration would be suitable for a role like that of the Idiot.

'Or else, try putting your mouth into unusual positions and you will get still other ways of talking. For example, take an Englishman who has a short upper lip and very long, rodent-like front teeth. Give yourself a short upper lip and show your teeth more.'

'But how can you do that?' I said, trying it out on myself without success.

'How do I do it? Very simply,' answered Tortsov, pulling a handker-chief out of his pocket and rubbing his upper teeth and the inside of his upper lip until they were quite dry. Then under cover of his handkerchief he tucked in his upper lip which remained stuck to his dry gums, so that when he took his hand from his face we were amazed at the shortness of his upper lip and sharpness of his teeth.

This external artifice hid from us his ordinary, familiar personality; in front of us there stood the Englishman he had just mentioned. We were under the impression that everything about Tortsov was changed; his pronun-ciation, his voice were different, as well as his carriage, his walk, his hands and legs. Nor was that all. His whole psychology seemed transformed. And yet Tortsov had made no inner adjustment. In another second he had aban-doned the trick with his upper lip and continued to speak in his own person, until he again put the handkerchief in his mouth, dried his lip and gums and, when he dropped his hand with the handkerchief, was at once changed again into his Englishman.

This happened intuitively. It was only when we worked it out and confirmed it that Tortsov admitted the phenomenon. It was not he who explained it to us but we who told him, how all the characteristics which intuitively came to the surface were appropriate to and filled out the portrait

of the gentleman with a short upper lip and long teeth – and all the result of a simple external artifice.

After digging down into his own thoughts and taking account of what went on inside himself Tortsov remarked that even in his own psychology in spite of himself there had been an imperceptible impulse which he found difficult immediately to analyse.

It was, however, an undoubted fact that his inner faculties responded to the external image he had created, and adjusted to it, since the words he pronounced were not his words, although the thoughts he expressed were his very own.

In this lesson then Tortsov vividly demonstrated that external characterization can be achieved intuitively and also by means of purely technical, mechanical, simple external tricks.

But how to find the right trick? Here was a fresh problem to intrigue and disturb me. Is this something to be learned, to be imagined, to be taken from life, or found accidentally, in books, by studying anatomy?

'The answer is – in all those ways,' explained Tortsov. 'Each person evolves an external characterization out of himself, from others, takes it from real or imaginary life, according to his intuition, his observation of himself and others. He draws it from his own experience of life or that of his friends, from pictures, engravings, drawings, books, stories, novels, or from some simple incident – it makes no difference. The only proviso is that while he is making this external research he must not lose his inner self. [. . .]'

Augusto Boal

THE STRUCTURE OF THE ACTOR'S WORK

From: *Games for Actors and Non-Actors*, tr. Adrian Jackson (London and New York: Routledge, 1992).

The primacy of emotion

IN 1956 I STARTED WORKING AT THE ARENA THEATRE of São Paulo, of which I was the artistic director until I had to leave Brazil in 1971. At this time, the Brazilian theatre was completely dominated by Italian directors, who used to impose pre-established forms on every play performed. To fight against this tendency, in concert with the actors we created an acting laboratory in which we set about a methodical study of the works of Stanislavski. Our first principle at that time was that emotion took precedence over all else and should be given a free rein to shape the final form of the actor's interpretation of a role.

But how can emotions 'freely' manifest themselves throughout an actor's body, if that very instrument (the body) is mechanized, automated in its muscle structures and insensible to 90 per cent of its possibilities? A newly discovered emotion runs the risk of being canalized by the mechanized patterns of the actor's behaviour; the emotion may be blocked by a body already hardened by habit into a certain set of actions and reactions.

How does this mechanization of the actor's body come about? By repetition. The senses have an enormous capacity for registering, selecting and then hierarchizing sensations. The eye, for example, can pick up an infinite variety of colours, whatever the object of its attention: a road, a room, a picture, an animal. There are thousands of greens, shades of green perfectly perceptible to the human eye. The same applies to hearing and sounds, and to the other senses and their sensations. A person driving a car sees an infinity of sensations stream

past. Riding a bicycle involves an extremely complicated structure of muscular movements and tactile sensations, but the senses select the most important stimuli for this activity. Every human activity, from the very simplest onwards – walking, for instance – is an extremely complicated operation, which is possible only *because* the senses are capable of selection; even though they pick up all sensations, they present them to the consciousness according to a definite hierarchy, and this is repeated over and over again in our lives.

This becomes even more evident when a person leaves their habitual environment and visits an unknown town or country; the people dress differently, speak with another rhythm, the noises and the colours aren't the same, the faces are differently shaped. Everything seems wonderful, unexpected, fantastic. But after a few days, the senses once again learn to select and the routine starts all over. Let us imagine what happens when a (South American) forest-dwelling Indian comes to town or when a city-dweller gets lost in the forest. For the Indian the noises of the forest are perfectly natural, his senses are used to selecting from them; he can fix his bearings by the noise of the wind in the trees, by the brightness of the sun through the leaves. By contrast, what is natural and routine to us city-dwellers can drive the Indian mad, incapable as he is of selecting from the sensations produced by a big city. The same thing would happen to us if we got lost in virgin forest.

This process of selection and structuration results in a mechanization because the senses always select in the same way.

When we began our exercises, we had not yet considered *social* masks; at that time we were considering mechanization in its purely physical form, i.e. by always carrying out the same movements, each person mechanizes [her/his] body to execute these movements as efficiently as possible, thus denying themselves the possibility of original action every time the opportunity arises.

Wrinkles appear because the repetition of particular muscle constructions eventually leaves its mark on the face.

What is a sectarian but a person – of the left or right – who has mechanized all their thoughts and responses?

Like all human beings, the actor acts and reacts according to mechanisms. For this reason, we must start with the 'de-mechanization', the re-tuning (or de-tuning) of the actor, so that he may be able to take on the mechanizations of the character he is going to play. He must relearn to perceive emotions and sensations he has lost the habit of recognizing. In the first phase of our work, we did sensory exercises, roughly following Stanislavski's indications.

A few examples follow.

Muscular exercises

The actors relax all the muscles in their bodies and focus their attention on each individual muscle. Then they take a few steps, bend down and pick up

an object (anything), doing the whole thing very slowly and trying to feel and remember all the muscular structures which intervene in the accomplishment of these movements.

They then repeat exactly the same action, but this time mentally, without the object, pretending to pick it up from the ground and trying to remember all the contractions and relaxations of muscle which occurred during the previous operation. The object can be varied (a key, a chair, a sock) or the exercise can be complicated – dress and undress, first with, and then without clothes. Or ride a bicycle *sans* bicycle, lying flat on the ground with arms and legs in the air.

The most important thing is that the actors become aware of their muscles, of the enormous variety of movements they *could* make. [. . .]

Sensory exercises

The actors swallow a spoonful of honey, followed by a pinch of salt, and then a taste of sugar. Then they enact the same thing without the original stimulus. They must try to recall the tastes, actually experience them again, and physically manifest all the reactions which accompany the absorption of honey, salt, sugar, etc. This exercise is not about mimicry (smiles for honey, grimaces for the salt), but rather about genuinely experiencing the same sensations 'from memory'. The same can be done with smells. [. . .]

Memory exercises

We did easy versions of these every day. Before going to sleep, each of us would try to remember minutely and chronologically all that had happened during the day, with the maximum detail – colours, faces, weather – revisualizing almost photographically everything we had seen and re-hearing all we had heard, etc. Often also, on their arrival at the theatre, actors would be asked what had happened in their lives since the previous day – and they then had to deliver a detailed account to the rest of the group. The exercise became more interesting when several actors had taken part in the same event – a festival, a reunion, a show, a play, a football match. The versions would be compared, and, when there were differences, we would endeavour to arrive at an objective version of the facts or try to understand the reasons for the differences in the accounts. [. . .] In memory exercises the important thing is to have lots of concrete details. Equally it is vital that this exercise is practised with absolute regularity, as a daily routine, preferably at a particular time of day. The point of this is not only to develop the memory, but also to enhance awareness; everyone knows that they have to remember everything they see, hear and feel, and thus their powers of attention, concentration, and analysis develop. [. . .]

Emotion exercises

There is a wall between what the actor feels and the final form which expresses it. This wall is formed by the actor's own mechanisms. The actor feels Hamlet's emotions and yet, involuntarily, he will express Hamlet's emotions in his own way; his own physiognomy, his own tone of voice, etc. But the actor could also be in a position to *choose*, out of a thousand ways of smiling, the one which, in his view, would be Hamlet's; out of a thousand ways of getting angry, the one which, in his view, would be Hamlet's way. To make this choice possible, one has to start by destroying the wall of mechanisms, which is the actor's 'mask'. The bourgeois theatre of São Paulo by contrast used to *reinforce* each actor's mannerisms and automatisms (the actor's 'trademarks') on to which the characters would be glued. The 'stars' would always play themselves – the 'stars'.

We wanted to converse – we wanted the actors to start by nullifying all their personal characteristics, in order to let those of the character flower. These exercises were intended to abolish the so-called 'personality' of the actor – his mould, his pattern – and assist the birth of the 'personality' of the character and its mould or pattern. But how does one arrive at this new mould?

The starting point is to feel the character's emotions, genuinely, so that these emotions may then find, in the relaxed body of the actor, the most adequate and efficient way of 'transmitting' themselves to the audience, so that the spectators may also feel them.

[. . .] People remember emotions that they have felt at a particular moment, in particular circumstances which they alone have lived through and which are *similar* to their character's own circumstances. These are absolutely unique circumstances which must be transferred and modified in order to match the character's emotions. I have never killed anyone, but I have felt the desire to do so; I try to remember the desire that I had and I transfer that desire to Hamlet when he kills his uncle. Some degree of transference is inevitable, but I do not believe it should go as far as in the case reported by Robert Lewis: a well-known actor used to make his audience cry out in horror, when, in a scene of great pathos, he used to get out his revolver and point it at his temple, finger on the trigger, ready to shoot, while he pondered aloud the futility of his existence. The actor's performance was absolutely overwhelming, even to the point that he himself was overwhelmed; the spectators cried when they saw him cry, they sobbed when they heard his sobbing.

When Lewis asked him how he had achieved such an impact, such an overflowing of emotion, such a traumatic effect both on the audience and on himself, the actor answered:

[. . .] It goes like this: when I point the revolver at myself, I have to think of something sad, threatening, terrible. Fine. That's what I do.

You remember how I always raise my eyes to the ceiling when I'm aiming? That's the key. I think back to one winter when I was poor and lived in a house with no heating or electricity, and whenever I took a bath or a shower, the water was ice-cold. When I raise the revolver to my head, I lift my eyes towards the shower-head, I think of the cold water about to gush down my body. . . . Oh my friend, how I suffer, how the tears well up in my eyes!

In spite of such excesses, emotion memory exercises can be effective and useful [. . .].

Rationalizing emotion

But an intense emotion memory exercise, or for that matter any emotion exercise, can be very dangerous unless one afterwards 'rationalizes' what has happened. Actors discover things when they take the risk of experiencing emotions. [. . .] Which doesn't mean to say that we should dismiss emotion exercises; on the contrary, they must be done, but with the aim of 'understanding' the experience, not simply feeling it. We must know why a person is moved, what is the nature of this emotion, what its causes are – not limit ourselves simply to the how. We want to experience phenomena, but above all we want to know the laws which govern these phenomena. And that is the role of art – not only to show how the world is, but also why it is thus and how it can be transformed. I hope no one can be satisfied with the world as it is; it must be transformed.

The rationalization of emotion does not take place solely after the emotion has disappeared, it is immanent in the emotion, it also takes place in the course of an emotion. There is a simultaneity of feeling and thinking.

[. . .] Thus we must be absolutely clear that emotion 'in itself', disordered and chaotic, is worth nothing. The important thing about emotion is what it signifies. We cannot talk about emotion without reason or, conversely, about reason without emotion; the former is chaos, the latter pure abstraction. [. . .]

Cicely Berry

VOICE AND THE ACTOR

From: *Voice and the Actor* (London: Virgin, 1993).

THE VOICE IS THE MEANS BY WHICH, IN EVERYDAY LIFE, YOU COMMUNICATE with other people, and though, of course, how you present yourself – your posture, movement, dress, and involuntary gesture – gives an impression of your personality, it is through the speaking voice that you convey your precise thoughts and feelings. This also involves the amount of vocabulary you have at your disposal and the particular words you choose. It follows, therefore, that the more responsive and efficient the voice is, the more accurate it will be to your intentions.

The voice is the most intricate mixture of what you hear, how you hear it, and how you unconsciously choose to use it in the light of your personality and experience. This is complex, as you will see, and is conditioned by four factors:

Environment. As children you learn to speak unconsciously, because of your needs and because you are influenced by the sounds you hear spoken around you. It is an imitative process, so that you start to talk roughly in the same way as the family, or the unit in which you grow up – that is, with a similar tune and with similar vowels and consonants. Possibly the facility with which you convey your needs, and the resistance to or compliance with them at this very early stage, influences the individual use of pitch later – how easily you get what you want, in fact.

'Ear'. By this I mean the perception of sound. Some people hear sounds more distinctly than others, and some people are more accurate in their

production of them. If you have a good 'ear' you are open to a greater number of different notes in the voice and to the differing shades of vowels and consonants. This is involved with pleasure in sound and you are aware of a larger spectrum of choice than that provided by your immediate environment. Perhaps you are quicker to see what the voice can do for you.

Physical agility. People have varying degrees of muscular awareness and freedom: this is partly due to environment, though not completely, for it is also tied up with the ease with which you feel you can express yourself in speech, and this of course is to some extent conditioned by education. An introverted and thoughtful person often finds more difficulty in speaking, and does not carry the thought through into the physical process of making speech. There is a kind of reluctance in committing oneself to speech, and this certainly affects the muscles involved in making speech, making their movement less firm and so the result less positive. The less you wish to communicate in speech, the less firmly you use the muscles, and this of course has much to do with confidence. It very rarely has anything to do with laziness. Furthermore, some people think more quickly than they speak, so they trip over words and the result is unfinished. You have to relate the mental intention to the physical action.

Personality. It is in the light of your own self that you interpret the last three conditions, by which you unconsciously form your own voice. So that, though you start by imitation, it is your emotional reaction to your family and environment, your degree of sensitivity to sound, your own individual need to communicate, and your ease or unease in doing so, which are the contributory factors that make you evolve your own completely personal voice and speech.

The voice, therefore, is incredibly sensitive to what is going on around it. In very broad terms, the speech of people who live in country districts is usually slower and more musical than the speech evolved in cities, which is nearly always sharp and glottal and quick – for example, New York, London, and Glasgow have very similar speech characteristics. The condition of life conditions the speech, so that the rhythm, pitch, and inflection vary accordingly. In the same way, but to an infinitely more subtle degree, personal relationships and the degree of ease with one's environment and situation continually affect the individual's voice.

Now the image you have of your own voice is often disturbingly different from the way it actually sounds to other people. It often does not tally with how you think of yourself. Most people are shocked, for instance, when they hear their voice recorded for the first time – it sounds affected, high-pitched, sloppy, or just dull. Hearing it recorded is not necessarily a good test, as the mechanism is selective and does not give a whole picture of the voice, just as a photograph, while true, does not give a whole picture of the person. However, you do not hear your own voice as other people hear it, partly because you hear it via the bone conduction and vibrations in your own head, so that you never hear the end product. But, more important, you hear it

subjectively – that is, tied up with your own conceptions of sound, of how you would like to sound, and also tied up with what you know you want to convey, for you are on the inside. So the impression you have of your own voice is completely subjective. The result is that you can never be quite sure of the impression you are making, or how accurate your voice is to your intentions – it quite often belies them.

Because it is such a personal statement, criticism of your voice is very close to criticism of yourself, and can easily be destructive. What you need to do is open up the possibilities of your voice and find out what it can do, and try to find a balance between being subjective and objective about it.

This you can do by exercising its physical resources, and perhaps by being bolder in the standards you set yourself. Speaking and using the voice is partly a physical action involving the use of certain muscles, and, just as an athlete goes into training to get his muscles to the required efficiency, or a pianist practises to make his fingers more agile, so if you exercise the muscles involved in using the voice, you can increase its efficiency in sound.

Let us see quite simply how sound is made. To make a sound two factors are needed, something that strikes and something that is struck and which resists the impact to a greater or lesser degree and vibrates accordingly. These vibrations disturb the surrounding air and set up sound waves which you receive through the ear and interpret accordingly. If the sound happens in a room the space will amplify the sound; the emptier the space and the less porous the walls, the more it will be amplified. For instance, a stone building such as a church amplifies sound relatively more than a room which may have materials in it which absorb sound, and where the walls are more porous. Now, a musical sound has a third factor which is a resonant, either a resonating space or resonating material, such as wood, which amplifies the initial sound and sustains it so you hear a note of resultant pitch. Take, for example, a violin: the bow strikes the strings which vibrate according to their length and tautness, these vibrations disturb the surrounding air and set up sound waves which your ear then transmits into sound, and you hear a violin note. The initial sound, however, is amplified and resonated by the wooden case of the violin, and that wooden box sets up its own vibrations which are the harmonics of the original note and which give that note the particular quality of the violin. The sound of one violin can also vary enormously from the sound of another. The quality of the bow and strings, the precise measurements of the box and the quality of its wood, how it is made, and so on, make the resonating vibrations different and so set up slightly different harmonics. Thus, the sound from two different instruments is still recognizable as a note from a violin, though the quality of the note can vary enormously. Furthermore, the way in which the player uses the instrument can make an enormous difference to the sound. The length and tautness of the strings determines the pitch.

You can make an analogy between the violin and the voice. With the voice the breath is the initial impulse, which strikes against the vocal cords

in the larynx, which have come together, and makes them vibrate. This sets up sound waves which can then be resonated in the chest, the pharynx or hollow space about the larynx, in the mouth and nose and bones of the face, and the hollow spaces in the head (the sinuses).

Physically, one person varies in size and shape from another person, so each individual voice is intrinsically different. But it is how you use the breath, how you use the resonating spaces, that matters, and it is important, therefore, that you use them as well as possible.

Eugenio Barba

THEATRE ANTHROPOLOGY

From: *A Dictionary of Theatre Anthropology: The Secret Art of the Performer*, by Eugenio Barba and Nicola Savarese, tr. Richard Fowler (London: Routledge, 1991).

WHERE CAN PERFORMERS FIND OUT HOW TO CONSTRUCT THE MATERIAL BASES of their art? This is the question which theatre anthropology attempts to answer. Consequently it neither responds to the need to analyse scientifically what the performer's language consists of, nor does it answer the question, fundamental to those who practise theatre or dance, of how one becomes a good actor or dancer.

Theatre anthropology seeks useful directions rather than universal principles. It does not have the humility of a science, but an ambition to uncover knowledge which can be useful to a performer's work. It does not seek to discover laws, but studies rules of behaviour.

Originally, anthropology was understood as the study of human beings' behaviour, not only on the socio-cultural level, but also on the physiological level. Theatre anthropology is thus the study of human beings' socio-cultural and physiological behaviour in a performance situation.

Similar principles, different performances

Different performers, at different places and times and in spite of the stylistic forms specific to their traditions, have shared common principles. The first task of theatre anthropology is to trace these recurrent principles. They are not proof of the existence of a 'science of the theatre' nor of a few universal laws. They are nothing more than particularly good 'bits of advice': information useful for scenic practice. To speak of a 'bit of good advice'

seems to indicate something of little value when compared with the expression 'theatre anthropology'. But entire fields of study – rhetoric and morals, for example, or the study of behaviour – are likewise collections of 'good advice'.

The 'bits of good advice' are particular in this respect: they can be followed or ignored. They are not inviolate laws; rather – and this is perhaps the best way to use them – one respects them so as to be able to ignore them and go further.

Contemporary Occidental performers do not have an organic repertory of 'advice' to provide support and orientation. They lack rules of action which, while not limiting artistic freedom, aid them in their different tasks. The traditional Oriental performer, on the other hand, has a base of organic and well-tested 'absolute advice', that is, rules of art which codify a closed performing style to which all the performers of a particular genre must conform.

Needless to say, performers who work within a network of codified rules have a greater freedom than those who – like Occidental performers – are prisoners of arbitrariness and an absence of rules. But Oriental performers pay for their greater liberty with a specialization which limits their possibilities of going beyond what they know. A set of precise, useful, and practical rules for the performer seems to be able to exist only by being absolute; closed to the influence of other traditions and experience. Almost all masters in Oriental theatre enjoin their students not to concern themselves with other performance genres. Sometimes they even ask them to not watch other forms of theatre or dance. They maintain that this is the way to preserve the purity of the performers' style and that their complete dedication to their own art is thereby demonstrated. This defence mechanism has at least the merit of avoiding the pathological condition which results from an awareness of the relativity of rules: a lack of any rules at all and a falling into arbitrariness.

In the same way that a Kabuki actor might ignore the best 'secrets' of Noh, it is therefore symptomatic that Etienne Decroux, perhaps the only European master to have elaborated a system of rules comparable to that of an Oriental tradition, seeks to transmit to his students a rigorous closedness to scenic forms different from his own. For Decroux, as for Oriental masters, this is not a question of narrow-mindedness or intolerance. It is awareness that the bases of a performer's work, the points of departure, must be defended as precious possessions, even at the risk of isolation. Otherwise they will be irremediably polluted and destroyed by syncretism.

The risk of isolation is that purity might have to be paid for with sterility. Those masters who isolate their students in a fortress of rules which, in order to be strong, are now allowed to be relative and are therefore excluded from the usefulness of comparison, certainly preserve the quality of their own art, but they jeopardize its future.

A theatre can, however, be open to the experiences of other theatres, not in order to mix different ways of making performances, but in order to find basic common principles and to transmit these principles through its

own experiences. In this case, opening to diversity does not necessarily mean falling into syncretism and a confusion of languages. On one hand, it avoids the risk of sterile isolation and, on the other hand, it avoids an opening-at-any-cost which disintegrates into promiscuity. Considering the possibility of a common pedagogical base, even if in an abstract and theoretical way, does not mean, in fact, considering a common way of making theatre. 'The arts,' Decroux has written, 'resemble each other because of their principles, not because of their works.' I could add: and so it is with theatres. They resemble each other because of their principles, not because of their performances.

Theatre anthropology seeks to study these principles. It is interested in their possible uses, not in the profound and hypothetical reasons which might explain why they resemble each other. Studying these principles in this way, it will render a service to both the Occidental and the Oriental performer, to those who have a codified tradition as well as to those who suffer from the lack of one.

Lokadharmi and natyadharmi

'We have two words,' the Indian dancer Sanjukta Panigrahi said to me, 'to describe man's behaviour: *lokadharmi* stands for behaviour (*dharmi*) in daily life (*loka*); *natyadharmi* stands for behaviour in dance (*natya*).'

In the course of the past several years I have visited numerous masters from different performance forms. With some I have collaborated at length. The purpose of my research has not been to study the characteristics of the various traditions, nor what rendered their arts unique, but to study what they had in common. What began as my own almost isolated research has slowly become the research of a group consisting of scientists, scholars of western and Asiatic theatre and artists from various traditions. To these latter goes my particular gratitude: their collaboration is a form of generosity which has broken through the barriers of reticence in order to reveal the 'secrets' and, one could almost say, the intimacy of their professions. It is a generosity which at times has become a form of calculated temerity as they put themselves into work situations which oblige them to search for something new and which reveal an unexpected curiosity for experimentation.

Certain Oriental and Occidental performers possess a quality of presence which immediately strikes the spectator and engages his attention. This occurs even when these performers are giving a cold, technical demonstration. For a long time I thought that this was because of a particular technique, a particular power which the performer possessed, acquired through years and years of experience and work. But what we call technique is in fact a particular use of the body.

The way we use our bodies in daily life is substantially different from the way we use them in performance. We are not conscious of our daily techniques: we move, we sit, we carry things, we kiss, we agree and disagree

with gestures which we believe to be natural but which are in fact cultur-
ally determined. Different cultures determine different body techniques
according to whether people walk with or without shoes, whether they carry
things on their heads or with their hands, whether they kiss with the lips or
with the nose. The first step in discovering what the principles governing a
performer's scenic *bios*, or life, might be, lies in understanding that the body's
daily techniques can be replaced by extra-daily techniques, that is, techniques
which do not respect the habitual conditions of the body. Performers use
these extra-daily techniques.

In the Occident, the distance which separates daily body techniques from
extra-daily techniques is often neither evident nor consciously considered. In
India, on the other hand, the difference between these two techniques is
obvious, even sanctioned by nomenclature: *lokadharmi* and *natyadharmi*. Daily
techniques generally follow the principle of less effort: that is, obtaining a
maximum result with a minimum expenditure of energy. When I was in
Japan with Odin Teatret, I wondered about the meaning of the expression
which the spectators used to thank the actors at the end of the performance:
otsukaresama. The exact meaning of this expression – used particularly for
performers – is: 'you are tired'. Performers who have interested and touched
their spectators are tired because they have not saved their energy. And for
this they are thanked.

But an excess, a waste of energy, does not sufficiently explain the power
that is perceived in the performer's life, in their scenic *bios*. The difference
between the performer's life and the vitality of an acrobat is obvious. Equally
obvious is the difference between the performer's life and certain moments
of great virtuosity in the Peking Opera and other forms of theatre or dance.
In these latter cases, the acrobats do show us 'another body', a body which
uses techniques very different from daily techniques, so different in fact that
they seem to have lost all contact with them. But here it is not a question
of extra-daily techniques but simply of 'other techniques'. There is no longer
the tension of distance, the dialectic relationship, created by extra-daily tech-
niques. There is only the inaccessibility of a virtuoso's body.

The purpose of the body's daily techniques is communication. The tech-
niques of virtuosity aim for amazement and the transformation of the body.
The purpose of extra-daily techniques, on the other hand, is information:
they literally *put the body in-form*. Herein lies the essential difference which
separates extra-daily techniques from those which merely transform the body.

[Barba makes a detailed study of energy in dance and action in different
theatres and performance cultures. He then summarizes his findings thus:]

Having followed the trail of the performer's energy, we have reached
the point where we are able to perceive its nucleus:

1 in the amplification and activation of the forces which are at work in
 balance;
2 in the oppositions which determine the dynamics of movements;

3 in an operation of reduction and substitution which reveals what is
 essential in the actions and which moves the body away from daily tech-
 niques, creating a tension, a difference in potential, through which
 energy passes.

The body's extra-daily techniques consist of physical procedures which appear
to be based on the reality with which everyone is familiar, but which follow
a logic not immediately recognizable. [. . .]

The most apt but least usable translation of the term energy emerged
from one of my conversations with Indian dancer Sanjukta Panigrahi. It was
the least usable because it translates the experience of a point of departure
as well as a great result, but does not translate the experience of the process
of achieving the result. Sanjukta Panigrahi said that energy is called *Shakti*,
creative energy which is neither masculine nor feminine but which is repre-
sented by the image of a woman. For this reason, in India, only women are
given the title *Shakti amsha*, 'part of *Shakti*'. But a performer of either sex,
said Sanjukta, is always *Shakti*, energy which creates.

After discussing the dance of oppositions on which the performer's life is
based, and after considering the contrasts which the performer consciously
amplifies, after examining the balance which he or she chooses to make
precarious and then exploits, the image of *Shakti* can perhaps become a symbol
of that of which we have not spoken here, the fundamental question: how
does one become a *good* performer?

In one of her dances, Sanjukta Panigrahi shows *Ardhanarishwara*, Shiva
half-male, half-female. This is followed by the Danish actress Iben Nagel
Rasmussen presenting *Moon and Darkness*. We are in Bonn, at the end of the
International School of Theatre Anthropology, where teachers and students
from different continents have been working together for a month on the
cold, technical, pre-expressive bases of the performer's art. [. . .] Iben Nagel
Rasmussen sings a shamen's lament for a destroyed people. She then reap-
pears as an adolescent stammering joyously on the threshold of a world at
war. The Oriental actress and the Occidental actress seem to be moving far
apart, each one deep in her own culture. Nevertheless, they meet. They
seem to transcend not only their own personalities and sex, but even their
own artistic skills, and show something which is beyond all this.

A performer's master knows how many years of work lie behind these
moments. But still it seems that something flowers spontaneously, neither
sought for nor desired. There is nothing to be said. One can only watch, as
Virginia Woolf watched Orlando: 'A million candles burned in Orlando,
without him having thought of lighting a single one.'

Critical theories and performance

Stephen Regan

INTRODUCTION TO PART TWO

Politics and performance: the legacy of Raymond Williams

RAYMOND WILLIAMS IS JUSTLY CREDITED WITH HAVING ESTABLISHED the critical method known as cultural materialism. In some places he is best known for his deeply felt articulation of the politics of literature and for his cogent analysis of specific works by Jane Austen, Emily Brontë, Charles Dickens, Thomas Hardy, and George Orwell. From 1974 until his retirement in 1983, however, Williams was Professor of Drama at Cambridge University, and he was also the author of several books on drama, film, and television. One of the fundamental arguments in this body of work is that drama can be fully appreciated only when it comes to be regarded as 'writing in performance' rather than 'literature'. Accounts of Williams's early work tend to stress the importance of *Culture and Society 1780–1950* (1958), but the first book he wrote was *Drama from Ibsen to Eliot* (1952). In its revised version, *Drama from Ibsen to Brecht* (1968), the book formed part of a trilogy with *Drama in Performance* (1954) and *Modern Tragedy* (1966). Together, these works reveal some of the most decisive shifts in Williams's thinking about drama, especially his determination to move from the verbal analysis of dramatic texts towards a history of dramatic form and a critical appreciation of performance issues. What also motivates his work on drama is a sustained attempt to understand the origins and directions of dramatic naturalism, hence his deep and abiding interest in the writings of Henrik Ibsen. Williams accepts the idea

of naturalism as a progressive and potentially liberating movement which succeeded the farce and melodrama of nineteenth-century theatre, but all three books are concerned primarily with the limitations of naturalism as a dramatic form. In Williams's estimation, naturalist methods of speech and action do not permit an adequate exploration of problems of subjectivity or of hidden levels of emotional and psychological experience. More importantly, because of its particular focus on the constraining effects of family and private life, naturalism is unable to move outwards to engage the deeper levels of social and historical action. The characteristic direction of naturalist drama in this respect is towards political deadlock. What Williams looked for as he turned to Brecht and other alternatives to naturalism was the necessary 'break to action'.

At a practical level, Williams saw in film and television the promise of new kinds of action, new angles of vision, and new relationships with modern audiences. This interest in film, evident in another early book, *Preface to Film* (written with Michael Orrom in 1954), was carried through into a growing preoccupation with communications and media studies. At a theoretical level, *Modern Tragedy* (1966) represented his most combative and sustained attempt to understand the tragic sense of failure and defeat that seemed to beset so much modern literature. *Modern Tragedy* measures received academic notions of tragedy against lived experience, the death of princes against the death of Williams's father, a railway signalman from the Welsh border village of Pandy. The book is an anguished and explicit engagement with Marxist cultural theory, and one profoundly concerned with the causes and consequences of revolution in the twentieth century.

Drama in Performance is a slim book, even in its revised and expanded edition (1968), but it occupies an important position between *Drama from Ibsen to Brecht* and *Modern Tragedy*. The book is essentially a work of performance history: it insists that there are no constant relations between text and performance in drama, and that variations have to be understood in terms of the changing methods of dramatic writing and playing, as well as in terms of the changing social composition of the audience. The methods or conventions of drama are not just technical preferences; they are, at the same time, ideas of reality or ways of seeing life that have been shaped by the interests and assumptions of a particular culture. In focusing on dramatic performance as a material process, Williams exemplifies the ideas and techniques of 'cultural materialism' which he was to develop more fully in *Marxism and Literature* (1977). At the same time, as Graham Holderness points out, Williams paves the way for much of the radical theoretical criticism on drama and performance that appeared in later decades:

> Despite the fact that *Drama in Performance* predates the impact of such theoretical movements as semiotics, indispensable to any contem-

porary method of performance analysis, its flexible and enterprising articulation of dramatic texts, theatre history, particular contexts of performance, and the performance potentialities implicit in the texts, can still point to necessary directions in the theoretical analysis of drama as cultural production.

(Williams 1991: 10)

What Williams bequeaths to performance studies is an urgent commitment to new kinds of dramatic action beyond the enclosed condition that dominates the modern stage. The final chapter of the book raises questions that have profound implications, not just for theatre students, but for writers, directors, and practitioners. Why has so much modern drama excluded direct intervention and open conflict? Why is decisive action directed at social change effectively ruled out? Why is the response to social crisis in drama a matter of careful adjustment rather than full engagement, struggle, and alteration? The voice that emerges at the end of *Drama in Performance* is the overtly political and radically reforming voice that becomes familiar in *Modern Tragedy*: 'Here, undoubtedly, is the point of growth of any drama of our century: to go where reality is being formed, at work, in the streets, in assemblies, and to engage at those points with the human needs to which the actions relate' (Williams 1991: 171). This, then, is the legacy that Williams has left us: a way of looking at drama *in* performance and of moving from drama *to* performance, but also a desire and a determination to recognize 'not only the rigidity of existing orthodox formulas, but also the openings, the possibilities' (ibid.: 174).

'Drama in a Dramatized Society' (Chapter 8) is the text of Williams's 1974 Inaugural Lecture as Professor of Drama at Cambridge University, published in *Writing in Society* in 1983. In the extract printed here, there is a clear indication of the transformation, both in drama and in Williams's critical apprehension of it, that took place between the 1960s and the 1970s. Drama, he suggests, is no longer co-extensive with theatre. Along with film and television drama, there are new kinds of text, new kinds of notation, and new conventions. At a simple level, the qualitative change that drama has undergone can be accounted for in terms of access: more people than ever before have constant access to drama through cinema, radio, and television. At a deeper level, however, what Williams observes is a persistent and pervasive dramatization of all aspects of social and political activity, to the extent that drama has permeated the rhythms of everyday life. This idea of drama as habitual experience is less to be celebrated than critically understood. There is a fundamental connection here with the idea of 'the unknowable society' which Williams explores in *The English Novel from Dickens to Lawrence* (1970). As modes of dramatization and fictionalization become active as social and cultural conventions, as ways of organizing

reality, our customary ways of seeing and knowing society are thwarted and confused. What Williams points to unmistakably in his acknowledgement of 'the new exposure . . . to a flow of images, of constant representations' (below, p. 56) is the pervasive presence of the simulacrum, the image-saturated existence that Fredric Jameson came to see as a prominent aspect of postmodern culture. Once again, however, Williams takes us back to the problems inherent in naturalist drama and calls for an active break. He acknowledges, for instance, the different ways in which Strindberg and Beckett moved beyond naturalist conventions in their efforts to register a deepening sense of alienation. For Williams, however, a dissenting consciousness is never enough.

Marvin Carlson's essay (Chapter 9) is of a piece with the Williams essay in recognizing the extent to which everyday life is dramatized, and in demonstrating a materialist concern with forms of cultural production. Carlson, however, gives prominence to the work of feminist performers and theorists, especially in the 1980s, in questioning and exposing the operations of power and oppression. In particular, he points to the ways in which feminist theory has adopted and modified the ideas of selfhood and subjectivity in the writings of Sigmund Freud and Jacques Lacan, and he contends that women have had to forge a place for themselves in a patriarchal system of signs and of representation. He claims that women's performance art directly challenges this system by establishing an actual woman as a speaking subject, while at the same time welcoming the kind of 'postmodern performance style' that undermines traditional notions of character and representation, thus avoiding charges of essentialism. The problem Carlson identifies is that of establishing a subversive performance art, a style uncontaminated by the performative aspects of everyday life and therefore by dominant codes and systems of representation. Extending Williams's notion of a dramatized society, he suggests that performance is so central in constructing and maintaining social relationships and gender roles that it has become increasingly difficult to develop a theory and practice of performance that might question and challenge those habitual constructions. The project he announces here is concerned with the search for a 'resistant performance art'.

Elin Diamond's related piece (Chapter 10) shows how performance has drifted free from theatre, especially since the 1960s, and has come to designate a whole range of cultural practices, including popular entertainment, speech acts, political demonstrations, rituals, and other aspects of everyday life. Alluding to Williams and the 'dramatized society', she points to a familiar postmodern paradigm in which 'the world, via electronics, is recreated as a seamlessly produced performance' (below, p. 67). Her essay shows how a new interest in performance has led to a valuable reassessment of the political status of theatre, and how performance and theatre have been repeatedly redefined in relation to each other. While theatre has sometimes been seen as a site of authority and discipline, with actors and audiences dutifully

conforming to the requirements of the playwright's text, performance has been credited with disrupting and dishonouring the traditional sanctities of author, text and actor, and generally undermining the illusionist techniques of realist theatre. Diamond claims, however, that feminist performance criticism has contributed to and benefited from both sides of the debate. She favours a dialectical criticism which acknowledges the political potential of radical, experimental theatre and also sees in performance art a way of promoting a heightened awareness of cultural difference, including gender and racial diversity, and an understanding of the body as a social text.

The virtue of the essay by Christopher Innes (Chapter 11) is that it draws attention amidst so much postmodern theorizing to the force and impact of avant garde theatre and in so doing refocuses our gaze on the politics of modernism. Although the origins of avant garde art are to be found in the anarchist politics of Bakunin, the idea hasn't always found favour with the political left. For Georg Lukács the term smacked of the irresponsible indulgence of decadent bourgeois culture. Despite the vague definitions that are sometimes attached to 'the avant garde', Innes is confident that 'a clearly identifiable unity of purpose and interest' can be found in the works of a particular group of practitioners. What he shares with Elin Diamond is an awareness of the formative role of Antonin Artaud in the 1930s and a conviction that, judged in the light of Artaud's influence, 'theatre' need not be opposed to 'performance'. Indeed, the defining characteristic of avant garde theatre according to Innes is its primitivism, and what this primitivism produces is the kind of questioning that performance theory finds congenial: 'What is a theatre? What is a play? What is an actor? What is a spectator? What is the relation between them all?'. While the boundaries of the avant garde are 'amorphous' (and clearly overlap with a good deal of contemporary performance art), Innes nevertheless insists that the avant garde has a distinctive ideology. His essay is a valuable corrective to those theoretical works that seem intent on drawing too sharp a distinction between theatre and performance and those that are too easily seduced by what Terry Eagleton has termed 'the illusions of postmodernism'. For Innes, the avant garde stretches from the 1890s all the way to the 1990s and it carries with it the unfinished business of modernism.

Stuart Hall's article, 'Deviance, Politics and the Media' (Chapter 12), valuably reconnects us with the work of Raymond Williams by demonstrating the extent to which the mass media have the capacity to shape and define political reality. First published in 1974, the year in which Williams wrote 'Drama in a Dramatized Society', Hall's article considers the ways in which political deviance is treated by the mass media and seeks to explain why some forms of behaviour are legitimated and others not. We might rephrase the terms of this investigation slightly and ask why some kinds of performance are deemed acceptable, while others are considered illegitimate. Just

as Williams claims that modes of fictionalization and dramatization are employed by the media to persuade us of the validity of particular social values and ways of looking at the world, so Hall gives emphasis to 'the praxis of public signification' and the role played by institutions charged with the production and amplification of knowledge. Drawing powerfully on Antonio Gramsci's theories of social hegemony and Louis Althusser's conception of Ideological State Apparatuses, Hall proposes that a dominant social class maintains its rule and legitimacy not only through the coercive agencies of the state (the army, the police, the law courts, the prisons), but also through the institutional superstructure, including the press, the schools, and (we might add) the theatres and playing spaces. Here we return to Marvin Carlson's question of how to construct an effective counter-culture when the very notion of culture is, itself, already demarcated in terms of what is legitimate and what is not. Hall's aim is not to define the terms under which oppositional cultures might be produced and sustained, but rather to point to those moments of crisis when 'new problems and new groupings emerge to threaten and challenge the ruling positions of power and their social hegemony', and when we are given a special vantage point from which to observe 'the work of persuasive definition in the course of its formation' (below, p. 80).

All the essays in this part are concerned in one way or another with problems of legitimacy: with what constitutes legitimate theatre or legitimate performance or legitimate ways of seeing and understanding the world. In each case performance becomes a way of testing and transgressing conventional boundaries, pushing simultaneously against artistic conventions and social conventions. While in some ways undermining traditional theatrical structures and procedures, the concept of performance has given a new validity and significance to the theatre of the streets and to what Michel de Certeau has called 'the practice of everyday life'. Performance in its most vital manifestation serves as a zone of contact between drama and society, calling both to account. In demystifying the conventions of dramatic production, performance also demystifies the social conventions through which behaviour is regulated and contained. In understanding one, we are better equipped to understand the other. We need, as Raymond Williams says, to look both ways.

Raymond Williams

DRAMA IN A DRAMATIZED SOCIETY

From: *Writing in Society* (London: Verso, 1983); originally delivered as Williams's Inaugural Lecture as Professor of Drama at the University of Cambridge in 1974, and published by Cambridge University Press.

THE PROBLEMS OF DRAMA, IN ANY OF ITS MANY PER-SPECTIVES, ARE now serious enough to be genuinely interesting and indeed to provoke quite new kinds of question. Real and nominal continuities can of course be traced, but my own emphasis is on a transformed situation: one that I have tried to indicate in my title. Drama is no longer, for example, coextensive with theatre; many dramatic performances are now in film and television studios. In the theatre itself – national theatre or street theatre – there is an exceptional variety of intention and method. New kinds of text, new kinds of notation, new media and new conventions press actively alongside the texts and conventions that we think we know, but that I find problematic just because these others are there. [. . .]

Again, we have never as a society acted so much or watched so many others acting. Watching, of course, carries its own problems. Watching itself has become problematic. For drama was originally occasional, in a literal sense: at the Festival of Dionysus in Athens or in medieval England on the day of Corpus Christi when the waggons were pulled through the streets. The innovating commercial theatres of Elizabethan London moved beyond occasion but still in fixed localities: a capital city, then a tour of provincial cities. There was to be both expansion and contraction. In Restoration London two patent theatres – the monopoly centres of legitimate drama – could hardly be filled. The provincial theatre-building of the eighteenth century, the development of variety theatres and music-halls, the expansion of London's West End theatres in the second half of the nineteenth century: all these qualified occasion but in the light of what was to come were merely

quantitative changes. It is in our own century, in cinema, in radio and in television, that the audience for drama has gone through a qualitative change. [. . .] It means that for the first time a majority of the population has regular and constant access to drama, beyond occasion or season. But what is really new – so new I think that it is difficult to see its significance – is that it is not just a matter of audiences for particular plays. It is that drama, in quite new ways, is built into the rhythms of everyday life. On television alone it is normal for viewers – the substantial majority of the population – to see anything up to three hours of drama, of course drama of several kinds, a day. And not just one day; almost every day. This is part of what I mean by a dramatized society. In earlier periods drama was important at a festival, in a season, or as a conscious journey to a theatre; from honouring Dionysus or Christ to taking in a show. What we now have is drama as habitual experience: more in a week, in many cases, than most human beings would previously have seen in a lifetime. [. . .]

The clear public order of much traditional drama has not, for many generations, been really available to us. It was for this reason that the great naturalist dramatists, from Ibsen, left the palaces, the forums and the streets of earlier actions. They created, above all, rooms; enclosed rooms on enclosed stages; rooms in which life was centred but inside which people waited for the knock on the door, the letter or the message, the shout from the street, to know what would happen to them; what would come to intersect and to decide their own still intense and immediate lives. There is a direct cultural continuity, it seems to me, from those enclosed rooms, enclosed and lighted framed rooms, to the rooms in which we watch the framed images of television: at home, in our own lives, but need to watch what is happening, as we say, 'out there': not out there in a particular street or a specific community but in a complex and otherwise unfocused and unfocusable national and international life, where our area of concern and apparent concern is unprecedentedly wide, and where what happens on another continent can work through to our own lives in a matter of days and weeks – in the worst image, in hours and minutes. Yet our lives are still here, still substantially here, with the people we know, in our own rooms, in the similar rooms of our friends and neighbours, and they too are watching: not only for public events, or for distraction, but from a need for images, for representations, of what living is now like, for this kind of person and that, in this situation and place and that. [. . .]

The new need, the new exposure – the need and exposure in the same movement – to a flow of images, of constant representations, as distinct from less complex and less mobile cultures in which a representation of meaning, a spectacle of order, is clearly, solidly, rigidly present, at certain fixed points, and is then more actively affirmed on a special occasion, a high day or a festival, the day of the play or the procession. But there is never only need and exposure: each is both made and used. In the simplest sense our society has been dramatized by the inclusion of constant dramatic representation as a daily habit and need. But the real process is more active than that. [. . .]

Our present society, in ways it is merely painful to reiterate, is sufficiently dramatic in one obvious sense. Actions of a kind and scale that attract dramatic comparisons are being played out in ways that leave us continually uncertain whether we are spectators or participants. The specific vocabulary of the dramatic mode – drama itself, and then tragedy, scenario, situation, actors, performances, roles, images – is continually and conventionally appropriated for these immense actions. It would moreover be easier, one can now often feel, if only actors acted, and only dramatists wrote scenarios. But we are far past that. On what is called the public stage, or in the public eye, improbable but plausible figures continually appear to represent us. Specific men are magnified to temporary universality, and so active and complex is this process that we are often invited to see them rehearsing their roles, or discussing their scenarios. [. . .] I watched this morning the televised State opening of Parliament. It is one thing to say that it was pure theatre; it is harder to see, and to say, that beyond its residual pageantry was another more naturalized process which is also in part a cousin of theatre. Monarchs, of course, have always done something like this, or had it done for them. Those who lasted were conscious of their images even if they called them their majesties. Moreover, like many actors, people find roles growing on them: they come to fit the part, as he who would play the King. What is new, really, is not in them but in us.

It is often genuinely difficult to believe in any part of this pervasive dramatization. If we see it in another period or in or from another place, it visibly struts and frets, its machinery starts audibly creaking. In moments of crisis, we sometimes leave this social theatre or, as easily, fall asleep in it. But these are not only roles and scenarios; they are conventions. When you can see a convention, become really conscious of it, it is probably already breaking down. Beyond what many people can see as the theatricality of our image-conscious public world, there is a more serious, more effective, more deeply rooted drama: the dramatization of consciousness itself. 'I speak for Britain' runs the written line of that miming public figure, though since we were let in on the auditions, and saw other actors trying for the part, we may have our reservations; we may even say 'Well I'm here and you don't speak for me.' 'Exactly,' the figure replies, with an unruffled confidence in his role, for now a different consciousness, a more profound dramatization, begins to take effect; 'you speak for yourself, but I speak for Britain.' 'Where is that?' you may think to ask, looking wonderingly around. On a good day from a high place you can see about fifty miles. But you know some places, you remember others; you have memories, definitions and a history.

Yet at some point along that continuum, usually in fact very early, you have – what? Representations; typifications; active images; active parts to play that people are playing, or sometimes refusing to play. The specific conventions of this particular dramatization – a country, a society, a period of history, a crisis of civilization; these conventions are not abstract. They are profoundly worked and reworked in our actual living relationships.

They are our ways of seeing and knowing, which every day we put into prac-
tice, and while the conventions hold, while the relationships hold, most
practice confirms them. One kind of specific autonomy – thisness, hereness
– is in part free of them; but this is usually an autonomy of privacy, and the
private figure – the character of the self – is already widely offered to be
appropriated in one or other of these dramatized forms: producer or
consumer, married or single, member or exile or vagrant. Beyond all these
there is what we call the irreducible: the still unaccommodated man. But
the process has reached in so far that there are now, in practice, conven-
tions of isolation itself. The lonely individual is now a common type: that is
an example of what I mean by a dramatic convention, extending from play
to consciousness. Within a generation of that naturalist drama which created
the closed room – the room in which people lived but had to wait for news
from outside – another movement had created another centre: the isolated
figure, the stranger, who in Strindberg's *Road to Damascus* was still actively
looking for himself and his world, testing and discarding this role and that
image, this affirming memory and that confirming situation, with each in turn
breaking down until he came back, each time, to the same place. Half a
century later two ultimately isolated figures, their world not gone but never
created, sat down on the road waiting for what? – call it Godot – to come.
Let's go, they said but they didn't move. A decade later other more radi-
cally isolated figures were seen as buried to their neck, and all that was finally
audible, within that partial and persuasive convention, was a cry, a breath.
Privacy; deprivation. A lost public world; an uncreatable public world.

These images challenge and engage us, for to begin with, at least, they
were images of dissent, of conscious dissent from fixed forms. But that other
miming, the public dramatization, is so continuous, so insistent, that dissent,
alone, has proved quite powerless against it. Dissent, that it, like the modern
tragic hero, can die but no more. And critical dissent, a public form you can
carry around to lectures or even examinations: it too comes back to the place
where it started, and may or may not know it for the first time. A man I
knew from France, a man who had learned, none better, the modes of percep-
tion that are critical dissent, said to me once, rather happily: 'France, you
know, is a bad bourgeois novel.' I could see how far he was right: the modes
of dramatization, of fictionalization, which are active as social and cultural
conventions, as ways not only of seeing but of organizing reality, are as he
said: a bourgeois novel, its human types still fixed but losing some of their
conviction; its human actions, its struggles for property and position, for
careers and careering relationships, still as limited as ever but still bitterly
holding the field, in an interactive public reality and public consciousness.
'Well, yes,' I said politely, 'England's a bad bourgeois novel too. And New
York is a bad metropolitan novel. But there's one difficulty, at least I find
it a difficulty. You can't send them back to the library. You're stuck with
them. You have to read them over and over.' 'But critically,' he said, with
an engaging alertness. 'Still reading them,' I said.

I think that is where we now are. People have often asked me why, trained in literature and expressly in drama, making an ordinary career in writing and teaching dramatic history and analysis, I turned – *turned* – to what they would call sociology if they were quite sure I wouldn't be offended (some were sure the other way and I'm obliquely grateful to them). [. . .] I learned something from analysing drama which seemed to me effective not only as a way of seeing certain aspects of society but as a way of getting through to some of the fundamental conventions which we group as society itself. These, in their turn, make some of the problems of drama quite newly active. It was by looking both ways, at a stage and a text, and at a society active, enacted, in them, that I thought I saw the significance of the enclosed room – the room on the stage, with its new metaphor of the fourth wall lifted – as at once a dramatic and a social fact. [. . .]

Marvin Carlson

RESISTANT PERFORMANCE

From: *Performance: A Critical Introduction* (London: Routledge, 1996).

BY THE END OF THE 1980S THERE WAS WIDE-SPREAD INTEREST among feminist performers and theorists internationally in the questioning, the exposing, and perhaps even the dismantling of those cultural and social constructions and assumptions that governed traditional gender roles, stagings of the body, and gender performance, both on the stage and in everyday life. [. . .]

This growing interest in the cultural dynamics embedded in performance and theatrical representation itself was primarily stimulated by a materialist concern for exposing the operations of power and oppression in society; but theoretical writing on the subject was at least as much influenced by recent psychoanalytical theories as by political, social, or economic ones. The model of the psychological self developed by Freud and extended by his French follower, Jacques Lacan, has exerted a particularly strong influence in modern cultural studies, and feminist theorists in particular have found in Freud and Lacan the most fully developed model for the establishment of the dominant male subject in the patriarchal cultural system.

Lacan, following Freud and indeed the traditional Western system of representation, places the male in the subject position. This subject enters self-consciousness and language with a sense of separation and incompleteness, an ongoing 'desire' for an objectified 'other' that both threatens and promises a lost unity. Traditional theatre and visual art are based on this system, assuming a male spectator and offering the female as 'other', the object of the male's desiring gaze. As Sue-Ellen Case has observed, within the patriarchal system of signs and of representation, 'women do not have

the cultural mechanisms of meaning to construct themselves as the subject rather than as the object of performance'. The traditional audience is assumed to be the male subject, and the woman on stage 'a kind of cultural courtesan', an objectified site for the fulfilment of desire. A wedge is thus driven between this courtesan sign, 'woman', and real women that 'insinuates alienation into the very participation of women in the system of theatrical representation' (Case 1988: 120).

Women's performance art directly challenges this system by the establishment of an actual woman as a speaking subject, a phenomenon that the system denies. Hélène Cixous has suggested that women's writing should occupy the same fluid and liminal world associated by many theorists with performance. She has described such writing as

> precisely working in the in-between, examining the process of the same and the other without which nothing lives ... not frozen in sequences of struggle and expulsion or other forms of killing, but made infinitely dynamic by a ceaseless exchanging between one and the other different subjects, getting acquainted and beginning only from the living border of the other: a many-sided and inexhaustible course with thousands of meetings and transformations of the same in the other and in the in-between.
>
> (Cixous n.d.: 46)

Other feminist theorists and performers, especially those interested in seeking a more essentially feminist mode of expressivity, have followed the lead of such French theorists as Luce Irigaray and Julia Kristeva in regarding traditional language as itself a male construction, dominated by the operation of logic and abstraction and reflecting the interests of the patriarchy. Physical performance has been seen as offering a possibility for women to escape what Kristeva has called the 'symbolic' logical and discursive language of the father for the 'semiotic' poetic and physical language of the mother (Savona 1984: 540). The utilization of the body in performance may thus provide an alternative to the symbolic order of language itself, which many feminist theorists have claimed provides no opening for the representation of women within it. [. . .]

Yet even some theorists who have supported this strategy have also expressed some misgivings about it. Rachel Bowlby, for example, has warned against too ready an acceptance of bodily 'discourse' as the most effective way for women to 'speak'. 'It remains to be shown', cautions Bowlby, 'that the female body is itself productive of a distinctive mode of subjectivity' (1983: 62). It also remains to be shown whether a 'distinctive mode of subjectivity' is a desirable goal for feminism, since it runs the risk of any essentialist strategy of reinforcing traditional structural relationships between dominant and subordinate positions, thus giving new support to the power relationships they involve.

The rise of poststructuralist theory demanded just this sort of questioning of essentialist strategies. Materialist feminism has generally sought to utilize

the postmodern decentring of the subject, not to reverse Lacan and to create a new 'subject' position for women, but to encourage both performers and spectators to think critically about the whole traditional apparatus of representation, including in particular the subject/object relationship. The 'postmodern performance style', according to Jill Dolan, 'breaks with realist narrative strategies, heralds the death of unified characters, decentres the subject, and foregrounds conventions of perception', its goal being to encourage critical thinking about 'representation as a site for the production of cultural meanings that perpetuate conservative gender roles' (1989: 59–60). [. . .]

Yet a major problem still remains – precisely how to utilize representation or performance to carry out this project, given that both have been heavily involved in the cultural assumptions that performers and theorists want to challenge. At the centre of the work of one of the most influential recent writers on gender, Judith Butler, is a view of gender not as a given social or cultural attribute but as a category constructed through performance. In *Gender Trouble* Butler called gender 'performative', a 'doing'. Equally important and equally revolutionary, she characterized it also as 'not a doing by a subject who might be said to preexist the deed'. On the contrary, the 'subject' is itself 'performatively constituted' by acts, including acts that signify a particular gender (Butler 1990: 25). These acts in turn are not singular events, but 'ritualized production, a ritual reiterated under and through constraint, under and through the force of prohibition and taboo, with the threat of ostracism and even death controlling and compelling the shape of the production' (Butler 1993: 95). Such a formulation would seem to leave little room for altering performed categories, since agency itself arises not from some choosing subject existing before the performance of identity, but rather from the 'self' constituted by performance. Yet here and even more centrally Butler argues that the possibility of, indeed even a tendency toward, alteration and modification exist within the process of repeating the performance. Recalling that Derrida challenged Austin and Searle's concept of performative utterances by stressing their citationality and thus their involvement in repetition, Butler stresses that gender performance, too, is citational and, like all citation, never precisely repeats the absent original. [. . .]

Although Butler's theories are focused not on performance art but on the performative dimension of everyday life, her approach has proven richly suggestive for the former as well. Ironically, the more aware theorists have become of the centrality of performance in the construction and maintenance of social relationships in general and gender roles in particular, the more difficult it has become to develop a theory and practice of performance that could question or challenge these constructions. Little current critical performance follows the strategy so common in the late 1960s guerrilla performance of direct opposition, but an extremely wide variety of socially and politically engaged performance of a different sort has evolved, reflecting the concerns,

tensions, and assumptions of a postmodern consciousness. When the very structure of the performative situation is recognized as already involved in the operations of the dominant social systems, directly oppositional perfor-mance becomes highly suspect, since there is no 'outside' from which it can operate. Unable to move outside the operations of performance (or repre-sentation), and thus inevitably involved in its codes and reception assumptions, the contemporary performer seeking to resist, challenge, or even subvert these codes and assumptions must find some way of doing this 'from within'. They must seek some strategy suggested by de Certeau's 'tactics', which he sees as activities that 'belong to the other', outside the institutionalized space of 'proper' activity (de Certeau 1984: xix). [. . .]

Without providing specific strategies for such operations, Butler and others have nevertheless contributed significantly to grounding such strate-gies by providing a theoretical orientation that accepts the postmodern suspicion of an empowered subject existing outside and prior to social forma-tions without renouncing the possibility of a position of agency to oppose the oppressions of these formations. The key to this orientation is in the operative concept of performance itself, which like all 'restored behaviour' simultaneously reinscribes and resists pre-existing models. As Wlad Godzich notes in summarizing de Certeau's contributions to discourse theory, de Certeau 'recovers an agential dimension for us in as much as it recognizes that discursive activity is a form of social activity, an activity in which we attempt to apply the roles of the discourses that we assume', thus placing us 'squarely in front of our responsibility as historical actors' (Godzich 1988: viii). A typically postmodern double operation is involved in such perfor-mance; the constitution of the self through social performance is viewed as a dynamic simultaneously coercive and enabling.

The sort of double operations that Butler sees involved in social perfor-mance are closely related to the strategies of recent theorists and performers concerned with developing a resistant performance art in the cultural context of postmodern thought. The possibility, even the necessity, of critique if not subversion from within performative activity has become widely accepted, but the most effective performance strategies for such subversion remain much debated. The central concern of resistant performance arises from the dangerous game it plays as a double-agent, recognizing that in the postmodern world complicity and subversion are inextricably intertwined. Resistant theo-rists and performers have been very much aware of Derrida's warning that 'by repeating what is implicit in the founding concepts . . . by using against the edifice the instruments or stones available in the house . . . one risks ceaselessly confirming, consolidating . . . that which one allegedly decon-structs' (1982: 135), or more likely of Audre Lorde's more succinct and striking 'the master's tools will never dismantle the master's house' (1984: 223).

Much more in line with current attitudes, however, is de Certeau's posi-tion: 'The weak must continually turn to their own ends forces alien to them'

(1984: xix). This position is congruent with Butler's ambivalent and post-modern view: 'There is no self that is prior to the convergence or who maintains "integrity" prior to its entrance into this conflicted cultural field. There is only a taking up of the tools where they lie, where the very "taking up" is enabled by the tool lying there' (Butler 1990: 145). Much modern resistant performance takes up whatever tools the culture offers and employs them in the manner parallel to the operations Auslander has noted in his postmodern political work in general: 'an elusive and fragile discourse that is always forced to walk a tightrope between complicity and critique' (1994: 31).

From this more recent attitude, the subversive possibilities of live performance in itself became less clear. The idea that in such performance 'real women, real presence, and real time' could be separated from their 'representations' could not easily be reconciled with the growing feeling that so-called 'reality' was itself experienced only through representations. Materialist or postmodern feminists could no longer accept the modernist privileging of presence or such essentialist performance ideals as that of offering the nude female body as uninscribed, free from socially constructed roles. The performance space itself is already genderized, critics like Dolan pointed out, and in this space women's bodies 'become accountable to male-defined standards for acceptable display' (1987: 159). In the enactment of representations, one also assumes all their cultural associations – the display of gender, the frame of reference, the spectators' narrative expectations – which form part of the controlling mechanisms preventing a challenge to convention. The power of established male-oriented reception strategies over women's performance would seem to provide little opportunity for performers to gain any agency in this process, whether they attempt to exert their presence, as Potter (1985) suggests, in such highly codified performance roles as the graceful ballerina or the witty burlesque queen, or whether they seek literally to divest themselves of all such roles through nudity.

This does not mean that recent critical feminist performance has avoided nudity or highly coded traditional representations of women. On the contrary, it has frequently sought out precisely such material in order to subject it to various types of ironic quotation, a kind of political double-coding. Performers working in this direction introduce into the playing of a role a subversive and parodic self-consciousness, which is very wide-spread in contemporary engaged performance, by feminists and others, both in Europe and the United States.

Elin Diamond has suggested the use of the term 'mimicry' to characterize these various forms of 'ironic disturbance' (1989: 59–60). The modern concept of mimicry, itself a mimic distortion of Plato's conventional doctrine of 'mimesis', is derived from French theorist Luce Irigaray, who saw in Plato's condemnation of mimesis an attempt to control the proliferation of alternatives to a stable and monolithic patriarchal Truth. Instead of the shadowy 'mere copy' of mimesis, Irigaray proposes a multiple and excessive 'mimicry' that undermines rather than reinforces the unique claim of

patriarchal Truth. Women, she suggests, must 'play with mimesis', must 'assume the feminine role deliberately. Which means already to convert a form of subordination into an affirmation, and thus to begin to thwart it' (Irigaray 1985: 76). [. . .]

Chapter 10

Elin Diamond

PERFORMANCE AND CULTURAL POLITICS

From: the introduction to *Performance and Cultural Politics*, ed. Elin Diamond (London: Routledge, 1996).

IN OUR SIMPLEST REFERENCES, AND IN THE BLINK OF AN EYE, performance is always a doing and a thing done. On the one hand, performance describes certain embodied acts, in specific sites, witnessed by others (and/or the watching self). On the other hand, it is the thing done, the completed event framed in time and space and remembered, misremembered, interpreted, and passionately revisited across a pre-existing discursive field. Common sense insists on a temporal separation between a doing and a thing done, but in usage and in theory, performance, even its dazzling physical immediacy, drifts between present and past, presence and absence, consciousness and memory. Every performance, if it is intelligible as such, embeds features of previous performances: gender conventions, racial histories, aesthetic traditions – political and cultural pressures that are consciously and unconsciously acknowledged.[1] [. . .] Which is to say [. . .] it is impossible to write the pleasurable embodiments we call performance without tangling with the cultural stories, traditions, and political contestations that comprise our sense of history.

Yet to invoke history, and to propose a 'drift' between presence and absence, is not to hitch performance to an old metaphysics of presence – the notion that an absent referent or an anterior authority precedes and grounds our representations. [. . .] The postmodern assumption is that there [is] no unmediated real and no presence that is not also traced and retraced by what it seems to exclude (see Sayre 1989: 9ff.; Phelan 1993: 146–66). Indeed, postmodern notions of performance embrace what Plato condemned in theatrical representation – its non-originality – and gesture toward an epistemology grounded not on the distinction between truthful models and

fictional representations but on different ways of knowing and doing that are constitutively heterogeneous, contingent, and risky. Thus while a performance embeds traces of other performances, it also produces experiences whose interpretation only partially depends on previous experience. This creates the terminology of 're' in discussions of performance, as in *re*embody, *re*inscribe, *re*configure, *re*signify. 'Re' acknowledges the pre-existing discursive field, the repetition – and the desire to repeat – within the performative present, while 'embody', 'configure', 'inscribe', 'signify', assert the possibility of materializing something that exceeds our knowledge, that alters the shape of sites and imagines other as yet unsuspected modes of being.

Of course, what alters the shape of sites and imagines into existence other modes of being is anathema to those who would police social borders and identities. Performance has been at the core of cultural politics since Plato sought to cleanse his republic of the contamination of histrionic display, from both performers and spectators. But the contestations over censorship are just one manifestation of cultural politics. Performances [may be seen] as cultural practices that conservatively reinscribe or passionately reinvent the ideas, symbols, and gestures that shape social life. Such reinscriptions or reinventions are, inevitably, negotiations with regimes of power, be they proscriptive conventions of gender and bodily display (see Apter 1996; Foster 1996a; Cohen 1996; Schneider 1996) or racist conventions sanctioned by state power (see Robinson 1996; Dicker/sun 1996; Roach 1996; McCauley 1996; Patraka 1996). Viewing performance within a complex matrix of power, serving diverse cultural desires, encourages a permeable understanding of history and change. [. . .] Critique of performance (and the performance of critique) can remind us of the unstable improvisations within our deep cultural performances; it can expose the fissures, ruptures, and revisions that have settled into continuous re-enactment.

Performance/theatre

Because performance discourse, and its new theoretical partner, 'performativity', are dominating critical discussion almost to the point of stupefaction, it might be helpful to historicize the term in relation to debates with clearly defined ideological investments. Since the 1960s performance has floated free of theatre precincts to describe an enormous range of cultural activity. 'Performance' can refer to popular entertainments, speech acts, folklore, political demonstrations, conference behaviour, rituals, medical and religious healing, and aspects of everyday life. [...] Because it appears to cut across and renegotiate institutional boundaries, as well as those of race, gender, class, and national identity, performance has become a convenient concept for postmodernism. It has also become a way for sceptics of postmodernism to excoriate what Raymond Williams has called our 'dramatized' society, in which the world, via electronics, is recreated as a seamlessly produced performance.

This focus on performance has produced provocative debates among theatre theorists about the political status of theatre in relation to performance.[2] Among early experimental groups like Beck and Malina's Living Theater, Joseph Chaikin's The Open Theater, Ed Bullins's and Robert Macbeth's New Lafayette Theater, Richard Schechner's The Performing Garage, Richard Foreman's Ontological-Hysteric Theater, Barbara Ann Teer's National Black Theater; in journals like *TDR (The Drama Review,* formerly *Tulane Drama Review*) and *Performing Arts Journal;* and in mid-1960s poststructuralist theorizing (Barthes on Brecht, Derrida on Artaud), performance came to be defined in opposition to theatre structures and conventions. In brief, theatre was charged with obeisance to the playwright's authority, with actors disciplined to the referential task of representing fictional entities. In this narrative, spectators are similarly disciplined, duped into identifying with the psychological problems of individual egos and ensnared in a unique temporal–spatial world whose suspense, reversals, and deferrals they can more or less comfortably decode. Performance, on the other hand, has been honoured with dismantling textual authority, illusionism, and the canonical actor in favour of the polymorphous body of the performer. Refusing the conventions of role-playing, the performer presents herself/himself as a sexual, permeable, tactile body, scourging audience narrativity along with the barrier between stage and spectator. Theatre collectives of the 1960s were greatly influenced by Artaud and by experimentation across the arts. They and their enthusiastic theorists believed that in freeing the actor's body and eliminating aesthetic distance, they could raise political consciousness among spectators and even produce new communal structures. In performance theory of the late 1970s, the group affirmation of 'being there' tends to celebrate the self-sufficient performing instant. In performance theory of the 1980s, consciousness-raising drops away (totalizing definitions of consciousness are, after all, suspect) (see Marranca 1977: xii). In line with poststructuralist claims of the death of the author, the focus in performance today has shifted from authority to effect, from text to body, to the spectator's freedom to make and transform meanings.

Feminist performance criticism has been vitally sensitive to both sides of this debate. Feminists have wondered whether performance can forget its links to theatre traditions, any more than, say, deconstruction can forget logocentrism. [...] But feminists also know that highly personal, theory-sensitive performance art, with its focus on embodiment (the body's social text), promotes a heightened awareness of cultural difference, of historical specificity, of sexual preference, of racial and gender boundaries and transgressions. This dialectic has been a focusing element for performers and theorists who want both political consciousness-raising and 'erotic agency', the pleasure of transgressive desire (Forte 1992: 248–62). Without resolving this dialectic, we might observe that if contemporary versions of performance make it the repressed of conventional theatre, theatre is also the repressed of performance. Certainly powerful questions posed by theatre representation – questions of subjectivity (who is speaking/acting?), location (in what sites/spaces?), audience (who is

watching?), commodification (who is in control?), conventionality (how are meanings produced?), politics (what ideological or social positions are being reinforced or contested?) – are embedded in the bodies and acts of performers. To study performance is not to focus on completed forms, but to become aware of performance as itself a contested space, where meanings and desires are generated, occluded, and of course multiply interpreted.

Performativity / performance

Poststructuralist conceptions of the human subject as decentred by language and unconscious desire, and postmodern rejections of foundational discourses (especially totalizing conceptions of gender, race, or national identity) have all made performance and performativity crucial critical tropes, whose relatedness I want briefly to explore. [. . .]

In a runner-up article to her ground-breaking *Gender Trouble*, Judith Butler uses performance to underscore the fictionality of an ontologically stable and coherent gender identity (Case 1990: 270–71).[. . .] [In *Bodies That Matter*] she deconstructively elaborates a temporality of reiteration as that which instantiates gender, sex, and even the body's material presence. 'There is no power that acts, but only a reiterated acting that is power in its persistence and instability' (Butler 1993: 9), and again, 'performativity is thus not a singular "act"', for it is always a reiteration of a norm or set of norms, and to the extent that it acquires an act-like status in the present, it conceals or dissimulates the conventions of which it is a repetition' (ibid.: 12). Performance, as I have tried to suggest, is precisely the site in which concealed or dissimulated conventions might be investigated. When performativity materializes as performance in that risky and dangerous negotiation between a doing (a reiteration of norms) and a thing done (discursive conventions that frame our interpretations), between someone's body and the conventions of embodiment, we have access to cultural meanings and critique. Performativity, I would suggest, must be rooted in the materiality and historical density of performance.

Notes

1 The notion that historical memory is embedded in the performative present is a constant theme in Herbert Blau's work. See, Blau 1987: 'So long . . . as there is performance to be referred to *as such* it occurs within a circumference of representation with its tangential, ecliptic, and encyclical lines of power. What blurs in the immanence of seeing are the features of that power. . . . '

2 The performance/theatre inquiry has been a thematic in Blau's writing since *Blooded Thought: Occasions of Theater* (Performing Arts Journal Publications, 1982). For a recent look at these issues in the academy, see Dolan, 1993: 417–41. For an earlier brief discussion of theatre as a discipline in the postmodern academy, see Case, 1990: 1–13.

Christopher Innes

AVANT GARDE THEATRE:
Themes and definitions

From: *Avant Garde Theatre 1892–1992* (London: Routledge, 1993).

A'VANT GARDE' HAS BECOME A UBIQUITOUS LABEL, eclectically applied to any type of art that is anti-traditional in form. At its simplest, the term is sometimes taken to describe what is new at any given time: the leading edge of artistic experiment, which is continually outdated by the next step forward. But 'avant garde' is by no means value-neutral, as such usage implies. For Marxist critics like Georg Lukács it became synonymous with decadence, a cultural symptom of the malaise engendered by bourgeois society; for apologists it is the defining imperative in all art of our time, and 'the modern genius is essentially avant-gardistic' (Poggioli 1968: 224).

Borrowed from military terminology by Bakunin, who titled the short-lived anarchist journal he published in Switzerland in 1878 *L'Avant-Garde*, the label was first applied to art by his followers. Their aim in revolutionizing aesthetics was to prefigure social revolution; and avant garde art is still characterized by a radical political posture. Envisioning a revolutionary future, it has been equally hostile to artistic tradition, sometimes including its immediate predecessors, as to contemporary civilization. Indeed, on the surface the avant garde as a whole seems united primarily in terms of what they are against: the rejection of social institutions and established artistic conventions, or antagonism towards the public (as representative of the existing order). By contrast any positive programme tends to be claimed as exclusive property by isolated and even mutually antagonistic sub-groups. So modern art appears fragmented and sectarian, defined as much as manifestos as imaginative work and representing the amorphous complexity of

post-industrial society in a multiplicity of dynamic but unstable movements focused on philosophical abstractions. Hence the use of 'isms' to describe them: symbolism, futurism, expressionism, formalism, surrealism.

However, beneath this diversity there is a clearly identifiable unity of purpose and interest (at least in the theatre) which has all the characteristics of a coherent trend, since its principles can be shown to be shared quite independent of direct influence. For example, there are striking similarities between the work of Antonin Artaud in the 1930s and of Jerzy Grotowski in the 1960s, even though Grotowski knew nothing of the 'theatre of cruelty' when he developed his concept of 'poor theatre'. At the same time one can trace all the network of cross-fertilization that normally defines a single artistic movement, signalled equally by the continuing influence of a precursor (Alfred Jarry, August Strindberg) or shared vocabulary (for instance 'theatre laboratory'), as by co-operation and imitation.

Thus Artaud and Roger Vitrac named their theatre after Jarry, and Eugène Ionesco was a member of the Collège de Pataphysique, an anti-establishment group devoted to Jarry's ideas. He included the figure of Jarry in one of his plays, while Jean-Louis Barrault based one of his last major productions on Jarry's life. Jarry's *Ubu* plays have been performed by Peter Brook, [Joseph] Chaikin and the Becks' Living Theatre, while a 'Savage God' theatre company (named after W.B. Yeats' disapproving response to the first performance of *Ubu roi*) was founded in Canada by John Juliani. Similarly the whole German expressionist movement derived from Strindberg, and one of Artaud's earliest productions was Strindberg's *Dream Play*, which also influenced Fernando Arrabal. Artaud worked both with Roger Blin, who directed all Genet's major plays, and with Barrault, who was responsible for establishing Brook's International Centre of Theatre Research in Paris, one of the many 'theatre laboratories' that – following Grotowski's lead – were established in Belgium, Denmark, and the United States in the 1960s. It was specifically Artaud's influence that led Brook to branch out from the traditional theatre, and Artaud's *The Theatre and its Double* had an almost immediate impact on the American counter-culture theatre groups when finally translated into English. Ariane Mnouchkine is consciously paralleling both Artaud and Brook. Eugenio Barba was trained by Grotowski, and Chaikin by the Becks, while Grotowski, Brook, and Chaikin have co-operated on joint projects. Brook worked with Charles Marowitz, whose Open Space theatre produced Sam Shepard's first major play; and Shepard later collaborated with Chaikin. Heiner Müller, whose early work has links with Artaud as well as the expressionists, joined forces with the neo-surrealist Robert Wilson in the 1980s. These interconnections chart the mainline avant garde movement, although there are many other names that could be mentioned.[1]

For contemporary observers in the 1920s, or even in the 1960s, what is central was often obscured by the rhetoric of manifestos claiming uniqueness for different aspects of the general movement. But from today's perspective shared concerns stand out clearly because they recur. And this

recurrence is even more significant since, although it is obviously a response to the ethics of the age, it by no means reflects popularly accepted ideas or the dominant ideological assumptions.

Perhaps paradoxically, what defines this avant garde movement is not overtly modern qualities, such as the 1920s romance of technology – Georges Antheil's 'aeroplane sonata', Corrado Govoni's 'poésie elettriche' or Enrico Prampolini's 'theatre of mechanics' – but primitivism. This has two complementary facets: the exploration of dream states or the instinctive and subconscious levels of the psyche; and the quasi-religious focus on myth and magic, which in the theatre leads to experiments with ritual and ritualistic patterning of performance. These are integrated not only by the Jungian concept that all figures of myth are contained in the unconscious as expressions of psychological archetypes, but also by the idea that symbolic or mythopoeic thinking precedes language and discursive reason, revealing fundamental aspects of reality that are unknowable by any other means (see Eliade 1968: I, 88). Both are variations of the same aim: to return to man's 'roots', whether in the psyche or prehistory. In theatrical terms this is reflected by a reversion to 'original' forms: the Dionysian rituals of ancient Greece, shamanistic performances, the Balinese dance-drama. Along with anti-materialism and revolutionary politics, the hallmark of avant garde drama is an aspiration to transcendence, to the spiritual in its widest sense. Antonin Artaud's pretentious claim to a 'Holy Theatre' – picked up by various avant garde artists, most recently Murray Shafer – is revealing.

Even for anthropologists or ethnographers, the primitive is almost always seen through a western, contemporary prism; and creative artists freely re-interpret primitive models to serve aims that would be alien to the original culture. However, this is far more than a cult of the superficially exotic and barbaric. In avant garde drama, as the widespread use of a term like 'theatre laboratory' in the 1960s and 1970s indicates, primitivism goes hand in hand with aesthetic experimentation designed to advance the technical progress of the art itself by exploring fundamental questions: 'The questions are: What is a theatre? What is a play? What is an actor? What is a spectator? What is the relation between them all? What conditions serve this best?'[2] On this level, the scientific ethos of the modern age parallels the return to 'primal' forms, equally signalling an attempt to replace the dominant modes of drama – and by extension the society of which these are the expression – by rebuilding from first principles.

The idealization of the primitive and elemental in theatre, together with the rediscovery and adapting of remote or archaic models, could be seen as an extension of the medievalism and orientalism of the nineteenth-century romantics. It parallels the borrowings from African sculpture or pre-Columbian Indian artifacts in the visual arts from Post-Impressionism on, and can be found in many other aspects of modern culture. It is echoed in Freud's 'primal' therapy and his 'attempt in *Totem and Taboo* to exploit the newly won analytic insights for an investigation of the origins of religion and

morality' (1948–74: XX, 72), or in the anthropological value placed on the primitive state by Lévi-Strauss. It is expressed in Conrad's fascination with 'the heart of darkness', or in D.H. Lawrence's primitivism, as in the popular escapism of Edgar Rice Burroughs' *Tarzan* series that were as much in vogue during the 1960s and 1970s, as they had been when first published between 1912 and 1936. It also conditions critical theories such as Mikhail Bakhtin's ideal of 'carnivalesque' literature, which proposes artistic forms that embody the anarchic and grotesque, inherently revolutionary energies of the Roman Saturnalia and medieval popular carnivals as an alternative to the 'limited and reduced aesthetic stereotypes of modern times' (Bakhtin 1968: 224).

Indeed aspects of primitivism – ranging from ritualistic techniques, or borrowing from archaic and oriental traditions, to the presentation of dream states and surrealistic images, or an attempt to tap the spectators' subconscious – have been so widespread in twentieth-century theatre that the boundaries of the avant garde are amorphous. In part the movement is hard to distinguish because its influence has been so pervasive. It can be traced in an official institution like Vilar's Théâtre National Populaire, which also searched for 'ceremonial subjects' to establish a communion between actors and spectators comparable with the mass enthusiasm evoked by medieval mysteries. It surfaces in the Nazi *'Thingspiel'*, and in rock festivals, where the rhythms and psychedelic lights urge a similar surrender to the instinctive id that in the right conditions resembles a Dionysiac revel.

Avant garde elements also appear in other types of experimental theatre. Some of W.B. Yeats' comments seem to echo exactly the same concerns: 'I have always felt that my work is not drama but the ritual of a lost faith' – 'drama which would give direct expression to reverie, to the speech of the soul with itself'. And his borrowing from Japanese Noh theatre, or his use of incantation and ritualized movement, is typical. Even his Rosicrucian mysticism has its counterparts. Yet his poetic aims are traditional, appealing 'to the eye of the mind' – the conscious imagination – and relying on 'the ancient sovereignty of words', while the avant garde moved in exactly the opposite direction (Yeats and Moore 1953: 156; Yeats 1961a: 333, 224ff; Ellmann 1964: 166). Similarly, Samuel Beckett's work is related in its use of symbolism and psychodrama, as in its stripping away of worn-out theatrical idioms to create minimalist images – but despite early interest in the surrealists, his existential vision is quite distinct from the avant garde stress on liberating the primitive side of the psyche.

The mainstream of the avant garde is not simply defined by shared stylistic qualities, although these may be what is most immediately obvious. Rather, the avant garde is essentially a philosophical grouping. Its members are linked by a specific attitude to western society, a particular aesthetic approach, and the aim of transforming the nature of theatrical performance: all of which add up to a distinctive ideology. Although there may be stylistic similarities in the work of a symbolist like Yeats, or an existentialist like Beckett – as in surrealists like Cocteau and Breton, an absurdist such as

Adamov, or a religious dramatist like T.S. Eliot – the essential basis of their art is antithetical to the anarchic primitivism and radical politics of the avant garde.

Notes

1 For example, Mary Wigman, Meredith Monk, Anna Halprin.
2 Peter Brook (following Grotowski), programme note to *The Tempest*, Centre for International Theatre Research, 1968.

Stuart Hall

DEVIANCE, POLITICS, AND THE MEDIA

From: *The Lesbian and Gay Studies Reader*, ed. Henry Abelove, Michèle Aina Barale, and David M. Halperin (London: Routledge, 1993); originally published in *Deviance and Social Control*, ed. Paul Rock and Mary McIntosh (London: Tavistock, 1974).

[*From Part III*]

WE ARGUE THAT MILITANT POLITICAL DEVIANCE is engendered – in its location incidence and form – as a counter-praxis to institutionalized consensual politics. But consensus, in either its political or its ideological form, does not spontaneously evolve: it must be actively constructed. That is the praxis to which deviant politics is a counter. The rise of conflict politics in its deviant form is, therefore, problematic for the society, and requires its own 'interpretative work'. Problematic situations are those in which the available public meanings and definitions fail to account for, and cannot easily be extended to cover, new developments. New political developments, which are both dramatic and 'meaningless' within the consensually validated norms, pose a challenge to the normative world. They render problematic not only how the political world is defined, but how it ought to be. They 'breach our expectancies'. They interrupt the 'seen but unnoticed, expected background features' of everyday political scenes which we use as schemes of interpretation for comprehending political life (Garfinkel 1967). When such practical reasons and accounts are breached, and we are 'deprived' of consensual support for alternative definitions of social reality, the active work of constructing new meanings and 'definitions of the situation' begins. This social construction of meanings is not to be confused with the elaboration of theories and explanatory models (though it often comprises the *ad hoc* element in them): the latter are systematic accounts, governed by a more formal logic of propositions, which attempt to be internally coherent

and consistent. Political structures engender their own characteristic ideologies and theorizing or, better, political structures, ideological and theoretical forms are interpenetrating elements or 'practices' in any specific social formation which is 'structured in dominance' (Althusser 1971); but the work of public and pragmatic management of political reality cannot be accomplished at this level.[1] We are dealing, rather, with the construction of *ad hoc* 'explanations', accounts 'for all practical purposes', working definitions of political reality, with their own situational logic (or 'logic-in-use') which serve to 'make sense of' problematic situations, and which then become the 'socially sanctioned grounds of inference and action that people use in their everyday affairs and which we assume others use in the same way' (Garfinkel 1967). [. . .]

The social construction and the 'interpretative work' involved in explanations at this level, which resolve problematic, troubling, or deviant events, is, nevertheless, a complex process. The work of establishing new kinds of 'knowledge' about problematic features of social or political life is accomplished through the mediation of language: the transactions of public language are the specific *praxis* – the praxis of public signification – through which such new 'knowledge' is objectivated.[2] The relationship between this 'knowledge' and its social base 'is a dialectical one':

> that is, knowledge is a social product *and* knowledge is a factor in social change. This principle of the dialectic between social production and the objectivated world that is its product has already been explicated.
>
> (Berger and Luckmann 1967: 104)

The social production of new definitions in problematic areas produces both 'explanations' and 'justifications'. 'Legitimation' is this process of 'explaining' and 'justifying'.

> Legitimation 'explains' the institutional order by ascribing cognitive validity to its objectivated meanings. Legitimation justifies the institutional order by giving a normative dignity to its practical imperatives. It is important to understand that legitimation has a cognitive as well as a normative element . . . Legitimation not only tells the individual why he *should* perform one action and not another; it also tells him why things are what they are.
>
> (Berger and Luckmann 1967: 111)

In complexly structured, socially differentiated societies like Britain or the United States, based on an advanced division of labour, groups lead highly segregated lives, and maintain apparently discrete, often contradictory, 'maps of problematic social reality'. In such societies, Durkheim observed, '*representations collectives* become increasingly indeterminate'. This is especially true of the political domain, which progressively becomes a segregated area,

requiring a special expertise, familiarity or commitment: a finite province of the social world. [. . .]

This does not mean that there are no prevailing and dominant symbolic universes which 'integrate different provinces of meaning and encompass the institutional order in a symbolic totality' (Berger and Luckmann 1967). But it does mean that such symbolic universes operate at a high degree of typification, and are experienced by the majority as, at best, sedimented and stereotypical constructs.[3] It also means that those who are not directly concerned with enforcing norms and definitions in a problematic or contested area of political life are heavily dependent for their 'working definitions' on those agents, institutions, and channels which have access to power and have appropriated the means of signification. This accords with our knowledge about the situations in which typically the mass media exert innovatory power.

The mass media cannot imprint their meanings and messages on us as if we were mentally *tabula rasa*. But they do have an integrative, clarifying, and legitimating power to shape and define political reality, especially in those situations which are unfamiliar, problematic, or threatening: where no 'traditional wisdom', no firm networks of personal influence, no cohesive culture, no precedents for relevant action or response, and no first-hand way of testing or validating the propositions are at our disposal with which to confront or modify their innovatory power. The sort of 'effectiveness' we have in mind here is not reflected at the primitive behavioural level normally pursued in traditional mass media studies. It is best expressed, as it has been by Halloran (1970), in the following terms:

> The sort of situation I have in mind is where television puts across an attitude or mode of behaviour by presenting it as an essential component of required behaviour in a valued group. It is stated or implied that certain forms of behaviour, attitudes, possessions, etc. are necessary if the individual is to remain a member in a group . . . Those who do not have what it takes or refuse to make the effort may be presented as deviants or non-conformists. The appropriate social sanctions for deviance and the modes of approval for acceptance are sometimes explained and illustrated. Adoption of the behaviour or attitudes may also be presented as conducive to the integration and general welfare of the group. . . . What is involved in this type of influence is the provision of social realities where they did not exist before, or the giving of new directions to tendencies already present, in such a way that the adoption of the new attitude or form of behaviour is made a socially acceptable mode of conduct, whilst failure to adopt is represented as socially disapproved deviance.

In the area of political deviance, the prevailing, emergent 'commonsense' definitions have largely been the product of *three* main agencies: professional politicians (or trade union leaderships) – the legitimate 'gate-keepers' of the

political domain; agents or representatives of face-to-face control; and the mass media.[4] Each of these agencies for the definition of political reality has a different perspective on the phenomenon of political deviance: but, like all the elements in a social formation 'structured in dominance', these perspectives show a strong disposition, in the fact of overt challenge, to 'hang together'. By political gate-keepers we mean, of course, both the organized mass parties, since each has a vested interest in the 'sacred' nature of the consensus. By mass media we mean, essentially, television, the press (regional, national, and local), and radio. By 'agencies of face-to-face control' we mean vice-chancellors and university administrators with respect to student militancy; public spokesmen and the army with respect to Ulster; official trade union functionaries with respect to 'unofficial strikes'; the police and the social welfare agencies with respect to squatting, rent strikes, militant demonstrations, 'Black Power' militants, etc. [. . .]

[From Part V]

[In this part, the author outlines the problems posed by the model he presents. The last of these is specifically concerned with issues of representation:]

This brings us to the third cluster of problems: the relationship between what we have called the different 'agents of signification', or the role which the institutions charged with the production and amplification of 'knowledge' play within a social formation which is complexly structured in dominance. The starting-point for such a discussion must be Gramsci's (1971) notion of the production and maintenance of social hegemony.

> What we can do . . . is to fix two major superstructural 'levels': the one that can be called 'civil society', that is the ensemble of organisms commonly called 'private', and that of 'political society' or the State. These two levels correspond on the one hand to the function of 'hegemony' which the dominant group exercises throughout society and on the other hand to that of 'direct domination' or command exercised through the State and 'juridical' government. The functions in question are precisely organizational and connective. The intellectuals are the dominant group's 'deputies' exercising the subaltern functions of social hegemony and political government.

The functions for this double structure which Gramsci anticipated included the organization of 'spontaneous' consent, 'given by the great masses of the population to the general direction imposed on social life by the dominant fundamental group', and the exercise of coercive power, which '"legally" enforces discipline on those groups who do not "consent" either actively or passively'. Gramsci's formulations are based on the notion of the distinctive role and position within the State of 'the coercive apparatus', which brings 'the mass of the people into conformity with the specific type of production and the specific

economy at a given moment', and the apparatus for the maintenance of social hegemony, 'exercised through the so-called private organizations, like the Church, the trade unions, the schools, etc.'. He adds that 'it is precisely in civil society that intellectuals operate especially'. This distinction has recently been expanded by such theorists as Althusser and Poulantzas who, while differing precisely in the way they conceive the relations between what Althusser (1971) has called 'the State Apparatus' and the 'Ideological State Apparatuses', nevertheless share, with Gramsci, a fundamental determination to 'think' the specificity of the ideological or superstructural level within a complex social formation. In essence, both insist that a dominant social class maintains its rule and legitimacy, not only through the coercive agencies of the state, but also via 'the whole institutional superstructure of bourgeois class power: parties, reformist trade unions, newspapers, schools, churches, families . . .' (Stedman Jones 1972): both insist, therefore, on the specificity, the 'relative autonomy' – until the 'last instance' – of the various levels of the superstructure. Poulantzas (1968) argues that though state power imposes limits on the ideological institutions, 'power relations in the State ideological apparatuses do not depend directly on the class nature of the State power and are not exhaustively determined by it'. Thus, 'in a social formation several contradictory and antagonistic ideologies exist'. Althusser (1971) argues that 'ideologies are realized in institutions, their rituals and practices' – 'it is by the installation of the Ideological State Apparatuses in which the ideology is realized itself that it becomes the ruling ideology'.

> But this installation is not achieved all by itself; on the contrary, it is the stake in a bitter and continuous class struggle: first against the former ruling classes and their positions in the old and new ISAs, then against the exploited class. . . . In fact, the struggle in the ISAs is indeed an aspect of the class struggle, sometimes an important and symptomatic one. . . . But the class struggles in the ISAs is only one aspect of a class struggle which goes beyond the ISAs.
>
> (Althusser 1971: 172)

Despite the important differences of emphasis between these theorists, the important questions to which they are addressed concern the relations of unity and difference within the ideological or signifying agencies, between the ideological institutions of 'indirect hegemony' and the State institutions of 'direct domination'. Only by concrete analysis can we determine the degree to which the signifying agencies may undertake their work of amplifying and elaborating a specific form of ideological consciousness within limits set by the prevailing structures of power and interest, *and yet* not be 'exhaustively determined by it' – becoming, that is, the locus of contending and conflictful definitions of the situation, the focus of struggle at the level of authority and consent (as Althusser puts it), 'the seat and the stake' of ideological class struggle.

> Ideologies are not 'born in the ISAs but from the social classes at grips
> in the class struggle: from their conditions of existence, their practices,
> their experiences of the struggle, etc.
>
> (Althusser 1971: 173)

In any specific historical conjuncture, therefore, we are required to examine
the specificity of the role and the work which such agencies of signification
undertake; to acknowledge that contradictory definitions contend for hege-
mony within their orbit: at the same time recognizing that their form,
content, and direction cannot be deduced from some abstract 'dominant
ideology' which is taken, in a process of conflict-free realization, to saturate
all the complex levels of a social formation from one end to another in an
unproblematic manner. As Gramsci observed:

> The dominant group is co-ordinated concretely with the general inter-
> ests of the subordinate groups, and the life of the State is conceived of
> as a continuous process of formation and superseding of unstable equi-
> libria . . . between the interests of the fundamental group and those of
> the subordinate groups – equilibria in which the interests of the domi-
> nant group prevail, but only up to a certain point, i.e. stopping short
> of narrowly corporate economic interests.

In our case, we are required to offer an analysis which would clarify where
the dominant paradigms of an ideological consensus originate: what the role
of the media, the political apparatus, and the judicial and other agencies of
face-to-face control play in elaborating those definitions: the existence of
disjunctures between the different levels of civil and state institutions in the
amplifying of such 'maps of problematic social reality'; the differences
between the different institutions, and yet their complex unity-in-dominance;
the locale of struggle and conflict in the elaboration of consensual perspec-
tives; and the forms of class struggle expressed by these similarities and
differences. [. . .]

In crisis moments, when the *ad hoc* formulas which serve, 'for all prac-
tical purposes', to classify the political world meaningfully and within the
limits of legitimacy are rendered problematic, and new problems and new
groupings emerge to threaten and challenge the ruling positions of power
and their social hegemony, we are in a special position to observe the work
of persuasive definition in the course of its formation. This is a privileged
moment for the student of ideologies. In this process the mass media play
an extremely important role: but they remain only *one* of the several insti-
tutions in which this process of signification is realized. The relation at any
specific moment between the *ad hoc* definitions arrived at within their domain
and the structure of a prevailing or dominant ideology; the relation between
the work of managing the definition of social reality and reproducing the
relations of production and power; the relation between the ideological and

the coercive apparatuses of the state; the outcome of the groups which contend on its terrain over the means and modes of signification; the relation, above all, of the operative definitions of power and control which are employed by the state apparatus, to the structure of definitions 'determined by the whole field of struggle between contending classes' – the area of consensus, to which the media seem too powerfully attached: these and other related issues can only be clarified by the study of a specific conjuncture between the different levels of practice and institution in a historical moment.

We said [earlier in the article that] such a study was only possible on the basis of a theoretical detour. But the route by which such insight is gained into the specificity of ideological discourse cannot be the final resting place of theory. Phenomenology teaches us to attend, once again, to the level of *meaning*: symbolic interaction presses on us the decisive level of 'definitions of the situation' as critical intervening variables: ethnomethodology refers us to the interactive work by which normative features of interpreted social situations are sustained, and the indexable character of expressions. Yet, in the end, these different aspects of the process by which abnormal political events are signified must be returned to the level of the social formation, via the critical concepts of power, ideology, and conflict.

Notes

1 Althusser's formulations on the specificity of practices and contradictions within 'the ever-pre-givenness of a structured complex unity' seem to us crucial and definitive. See, especially, 'Contradiction and Over-Determination' and 'On the Marxist Dialectic' in *For Marx* (Althusser 1969).

2 Work is only just beginning on the specificity of 'signification' as a form of praxis. Apart from the work of Marxist structuralists, such as the *Tel Quel* group, see some suggestive remarks on *poiesis* as a praxis in Lefebvre (1968).

3 On degrees of 'typification', see Berger and Luckmann (1967).

4 The media both serve as primary agents of signification, generating descriptions and explanations of their own account, and as secondary agents, relaying and amplifying accounts given by other agencies. Where its secondary function is concerned, the link must be made via the notion of the media's 'accredited witnesses' – its sensitivity to other power-signifying agencies in society set against the problems of access by alternative minority groups. It is by way of some structure composed of accredited witnesses/limited access/notions of news values that the media reproduces the structure of dominance and subordination within the public discourse.

Theorizing and playing: Intercultural perspectives

Christopher Murray

INTRODUCTION TO PART THREE

THE CONCEPT OF THE WORLD AS CAN-OPENER WAS ADVANCED BY PETER BROOK (b. 1925) and developed in the first of the excerpts below. Brook's whole approach is universal rather than national: he wants his performers and audiences to expand to include all races, all classes, and varieties of human experience. When he says, 'we all have an Africa inside us' he means a whole continent of varied history, ethnography, and language which each of us can and should tap into. Brook has always wanted to get away from a narrow, insular idea of theatre, of culture, and of style. To broaden is undeniably a laudable aim; 'little-Englandism' is a recipe for low-brow, reactionary art. Moreover, we cannot be complacent: we must involve ourselves in lives, cultures, and politics outside our immediate community if we are not to be the slaves of parochialism. And yet, surely, all art is rooted in the local. To tell a story truly onstage it is necessary to be entirely faithful to the specific environmental details. Can this be done if performance is by a multicultural cast? Can Shakespeare's language be best or even well served if its pronunciation, its rhythms, and its puns are subordinated (because not universally appreciated) to stage images derived by association of ideas from the pooling of diverse imaginations? These are questions legitimately provoked by Brook's world-famous theatrical practice. His work is devised work; the text is there to serve the ensemble. There is no question about the purity of Brook's intentions; he is a romantic in search of a Holy Grail of theatre in its essence. Increasingly, following his early preoccupation with Theatre of Cruelty, Brook has confined himself to what in *The Empty Space* (1968) he calls 'Holy Theatre', which for all its purity seems a narrow objective.

Moreover, by prioritizing the making of theatre over the serving of a text, however this is to be defined, Brook's project, for all the beauty and the spiritual glow it emanates, is at bottom a kind of Coca-Cola ad for world unity. The can that's opened may contain the genie of self-deception, after all.

Bertolt Brecht (1898–1956) derived his concept of alienation mainly from Russian formalism, a purely aesthetic body of theory which he politicized. In formalism, as in romantic theories of poetry, the purpose was to 'make strange', to present the familar in a strange light. Brecht's political version of this purpose might be described as 'making strange with an attitude'. Brecht's doctrine of 'alienation', ironically reminding audiences they are in a theatre, has proved to be one of the most fruitful ideas in modern theatre and has now been assimilated into productions from Broadway to Stratford-upon-Avon and even to the West End. In short, a radical idea has been adapted to commercial theatre not because it is radical but because it makes for good, lively, and as we say nowadays, in-your-face theatre.

The phrase 'making strange' is used repeatedly throughout the extract on 'Alienation Effects in Chinese Acting'. The basic idea here is to shock the audience into a fresh perception of what had become too familiar. Making the strange familiar is the flipside of making the familar seem strange. Elsewhere, Brecht refers to 'complex seeing' as the objective: to bring an audience to see and therefore understand the nature of social reality. Although the root of this idea lay in romantic poetics, part of Brecht's design was to uproot the romantic response to art. Hence his placing of placards within the theatre warning the audience, 'don't goggle so romantically'. In order to get his audiences to see reality properly Brecht had to break their habit of empathizing with heroes or heroines, as they had been conditioned to do by traditional, Aristotelian drama. Brecht abolished heroes and heroines and replaced these with figures *illustrating* certain tendencies in society. Once the audience was impeded from empathizing with such figures it could begin to think rather than feel. Undoubtedly, the techniques of satiric German cabaret showed Brecht how to make audiences simultaneously recoil and enjoy, while Erwin Piscator's use of film within stage performances showed him the advantages of montage and of breaking up the effect of illusion. Chinese acting reinforced Brecht's idea on alienation, just as Japanese acting encouraged Yeats in London in 1916 to develop performance as entering 'the deeps of the mind' (1961a: 224).

'It is not all that simple to break with the habit of assimilating a work of art as a whole. But this has to be done if just one of a large number of effects is to be singled out and studied' (see p. 94 below). Thus Brecht justifies the use of just a single aspect of Chinese acting, one which happened to confirm his own ideas. He saw a troupe of Chinese actors during his trip to Moscow in May 1935. As Brecht's biographer comments: 'The leading actor, Mei Lan-Fang, made almost as strong an impression on him as the

Balinese dancers had made on Antonin Artaud four years earlier, just before he formulated his ideas for a Theatre of Cruelty' (Hayman 1983: 188). The famous Mei Lan-Fang (1894–1961) performed women's roles. Clearly, he performed in the naive, undisguised way Brecht admired. As he says in this extract: 'Above all, the Chinese artist never acts as if there were a fourth wall besides the three surrounding him. He expresses his awareness of being watched.' The Chinese actor did not immerse himself in a role or induce a trance-like state in the spectator; instead, he drew attention to the illusion being created.

Brecht was trying to negotiate a position between the naturalistic style developed by Stanislavski ((1863–1938); see Part One of this volume), which he disliked, and the popular playing style he had observed at German fairgrounds. Brecht's use of the word *Verfremdung* (alienation) dates from this observation of the Chinese actors in Moscow in 1935. Previously, he had used the word *Entfremdung* (distancing), meaning more or less the same thing. Essentially, Brecht wanted 'defamiliarization' so that the audience would criticize what they saw. He then developed this concept of acting, with the V-effekt, for his own 'epic' theatre in Germany. It is acting, as Brecht succinctly put it, in quotation marks. The actor distances herself from the role by restricting herself to describing what happened (as in Brecht's example of the street scene). And yet, even in his own lifetime, there was always a conflict between Brecht's theory and practice, forcing him to modify his views. It is important to note that Brecht was flexible rather than autocratic in his ideas.

While Antonin Artaud (1896–1948) might be thought to share a certain amount of Brecht's opposition to bourgeois theatre he was not as politically minded as Brecht. Indeed, because of his utter commitment to the avant-garde, Artaud would probably have been anathema to Brecht. In contrast to Brecht, Artaud's dramatic interest lay in the psychology of characterization, what he calls 'the mysterious depths of ourselves'. Yet if a distinction is made in representation between 'identity' and 'difference', between naturalistic imitation and some kind of symbolism, it is clear that Artaud would after all join Brecht in opposition to Stanislavski. 'In the contemporary performance theory both Brecht and Artaud display variations of the side of difference through systems of "alienation" and the uncanny "cruelty" of the double: the incessant sliding of signified from under the signifier, the schizophrenic duality of any attempt to identify with difference' (McDonald 1992: 130).

Artaud's idea of culture was, as he said, first of all a protest 'against the idea of culture as distinct from life'. The theatre having become remote from 'the secret forces of the universe' it was necessary to 'break through language in order to touch life [and] to create or recreate the theater'.

Life can thus be renewed in the theatre. Artaud's concept of theatre was bound up with his somewhat unscientific ideas on 'plague', which he saw as a mysterious visitation acting without direct physical contact. The theatre is

born when looters exploit the plague to steal riches which are useless to them: 'an immediate gratuitousness providing acts without use or profit'. In this last phrase Artaud parts company with Brecht for good. In Brecht's aesthetic, theatre was socially and scientifically useful or it was decadent. Though for Artaud the theatre as plague was cleansing, this is a concept of therapy closer to Aristotle (and closer still to Freud) than to Brecht (or, of course, to Marx).

In the extract below, Artaud calls for a new form of language, a 'concrete' language which would subordinate dialogue to all the physical resources of the stage (lighting, sound effects, etc.). He calls this 'spatial poetry'. By this means Artaud wished to bypass naturalistic drama and rediscover religious ritual. This basic idea was to provide Peter Brook with the starting point for *his* great spiritual odyssey, assisted for a time by Ted Hughes, whose ideas on language (visceral, anti-rational, druidic) corresponded to some degree with Artaud's.

In the second of his two manifestos on Theatre of Cruelty, Artaud said that its purpose was 'to restore to the theater a passionate and convulsive conception of life, and it is in this sense of violent rigor and extreme condemnation of scenic elements that the cruelty on which it is based must be understood' (1958: 122). Thus we must not think of it as primarily sadistic or senationalist but as a revolt against purely literary drama and an attempt to return to something more raw, visual, and 'metaphysical' (a favourite word in Artaud's vocabulary and one which challenges the whole thrust of naturalism).

Artaud is more noteworthy for his influence than for his actual ideas, which might be called hysterical. Rock music can probably achieve a greater degree of 'plague' than any theatre performance along the lines Artaud actually describes. The drug culture of the 1960s showed the dangers of Artaud's ennobling of 'frenzy'. But once he found his major disciple in Peter Brook, whose production of Weiss's *Marat/Sade* in 1962 was to prove a landmark in the modern theatre, Artaud was reborn. Theatre of Cruelty revolutionized Shakespearean production with Brook's *King Lear* in 1963. Artaud's ideas also fructified the Living Theatre of the Becks, after which his place in theatre history was firmly established.

As it is now a commonplace that we inhabit a global village, it is not surprising that continuing efforts are being made to create a theatre as portable and meaningful worldwide as the shows of travelling players were within the much narrower confines of Renaissance England or Europe. Intercultural performance, however, is something rather more complex than touring to or from exotic places. Patrice Pavis calls interculturalism 'a search for a new professional identity', but worries whether it is 'a dead end, or a pocket of resistance' (see below, p. 103).

With the dissolution of borders between nations and barriers between ethnic and class divisions there has grown up a consensus that access to and

participation in art should be as diverse as democratically possible. Cultural studies have gradually developed an intercultural approach to performance on the basis that boundaries and their negotiation are what (in this context) performance is about. Another way to put this is to say performance confronts what anthropologists call *liminality*. If, as Victor Turner argues, cultures express themselves most fluently by means of performance, the central problem at the heart of intercultural performance must be to retain artistic fluency. The question, in short, becomes 'the feasibility of theater as a mediator across boundaries of historical and cultural difference' (Roach 1992: 13). This gives theatre an active socio-political role quite distinct from its broadly aesthetic one.

Kazimierz Braun emphasizes that the audience is a crucial factor in performance, and to that end he will not allow the audience to be taken for granted: normal seating arrangements are suspended. The possibility of a genuine intercultural performance is raised here, a meeting between diverse cultures. Pavis is, however, thinking more of intercultural performance *as such*, the adaptation and transmission of foreign cultures. He sees this process as in some respects open to severe criticism as either exploitative or naive. He is rightly suspicious of 'Orientalism' in Edward Said's sense (i.e. cultural imperialism), but Pavis does not appear to leave sufficient room in his theory for the sort of dynamic intercultural exchange rendered possible by Kazimierz Braun's ideas.

In the end, it may be said that there is a major distinction to be made between cultural assimilation (for example, Yeats's use of the Japanese Noh for his plays for dancers or Brecht's use of Chinese acting for his epic theatre) and what one may call the 'foreign mission' performance of indigenous, ethnic drama. It would appear that Brook's ideas for an *international* intercultural project have no real base in theatre history. It may be argued that theatre is rooted in community and nationalistic interests. Where the community is multicultural, the arts will likewise be multicultural. But *inter*culturalism is another matter. It is programmatic and devised; it may or may not find its audience. It is probably too international for its own good. In which case, although Pavis is very much in favour of raising what he calls the horizon of expectations in an audience, multiracial productions may be a hybrid too far. There is a challenging frontier here, and one must not be against experimentation, but behind the concept of interculturalism lurks the spectre of the (Trojan?) horse designed by a committee.

Peter Brook

THE WORLD AS A CAN OPENER

From: *The Shifting Point: Forty Years of Theatrical Exploration, 1946–87* (London: Methuen, 1988).

IN THE MIDDLE OF AFRICA, I SCANDALIZED AN ANTHRO-POLOGIST by suggesting that we all have an Africa inside us. I explained that this was based on my conviction that we are each only parts of a complete man: that the fully developed human being would contain what today is labelled African, Persian, or English.

Everyone can respond to the music and dances of many races other than his own. Equally one can discover in oneself the impulses behind these unfamiliar movements and sounds and so make them one's own. Man is more than what his culture defines; cultural habits go far deeper than the clothes he wears, but they are still only garments to which an unknown life gives body. Each culture expresses a different portion of the inner atlas: the complete human truth is global, and the theatre is the place in which the jigsaw can be pieced together.

In the last few years, I have tried to use the world as a can opener. I have tried to let the sounds, shapes, and attitudes of different parts of the world play on the actor's organism, in the way that a great role enables him to go beyond his apparent possibilities.

In the fragmented theatre that we know, theatre companies tend to be composed of people who share the same class, the same views, the same aspirations. The International Centre of Theatre Research was formed on the opposite principle: we brought together actors with nothing in common – no shared language, no shared signs, no common jokes.

We worked from a series of stimuli, all coming from without, which provided challenges. The first challenge came from the very nature of

language. We found that the sound fabric of a language is a code, an emotional code that bears witness to the passions that forged it. [. . .]

With Avesta, the two-thousand-year-old language of Zoroaster, we encountered sound patterns that are hieroglyphs of spiritual experience. Zoroaster's poems, which on the printed page in English seem vague and pious platitudes, turn into tremendous statements when certain movements of larynx and breath become an inseparable part of their sense. Ted Hughes's study of this led to *Orghast* – a text which we played in collaboration with a Persian group. Though the actors had no common language they found the possibility of a common expression.

The second challenge, which also came to the actors from the outside, was the power of myths. In playing out existing myths, from myths of fire to myths of birds, the group was stretched beyond its everyday perceptions and enabled to discover the reality behind the fairytale trappings of mythology. Then it could approach the simplest everyday action, the gesture, the relation with familiar objects in the knowledge that if a myth is true it cannot belong to the past. [. . .]

The third challenge came from allowing the outside world – people, places, seasons, times of day or night – to act directly on the performers. From the start, we studied what an audience means, and deliberately opened ourselves to receive its influence. Reversing the principle on which theatre tours are based, where finished work remains constant although circumstances change, we tried in our travels, to make our work fit the moment of playing. Sometimes this came from pure improvisation, such as arriving in an African village with no fixed plans at all and letting circumstances create a chain reaction out of which a theme would arise as naturally as in a conversation. Sometimes we let the audience dominate the actors completely – as in Lamont, California, where, one Sunday morning under a tree, a crowd of strikers who had been listening to César Chávez stimulated our actors into creating the images and characters that they needed passionately to cheer or hiss, so that the performance became a direct projection of what the audience had uppermost on its mind.

In Persia, we took *Orghast* away from its serious-minded audience and its setting of royal tombs and did a performance in a village, to see whether we could bring it down to earth. But the task was too difficult – we had not acquired the necessary experience. Two years later, in California, however, together with the Teatro Campesino, we played *The Conference of the Birds* to an audience of farmworkers in a park and it all fell into place: a Sufi poem translated from Persian to French, from French to English, from English to Spanish, played by actors of seven nationalities, had made its way across the centuries and across the world. Here it was no alien classic; it found a new and urgent meaning in the context of the Chicano struggle.

[. . .] The constant lesson taught and retaught was respecting audiences and learning from them. Whether throbbing with excitement (I think of three hundred black teenagers in Brooklyn); or menacing, stoned on glue in the

Bronx; or grave, immobile, and attentive (in a Saharan oasis), the audience is always 'the other person': as vital as the other person in speech or love.

And it is clear that just pleasing the other is not enough. The relationship implies an extraordinary responsibility: something has to take place. What? Here we touched the basic questions: What do we need from the event? What do we bring to the event? What in the theatre process needs to be prepared, what needs to be left free? What is narrative, what is character? Does the theatre event tell something, or does it work through a sort of intoxication? What belongs to physical energy, what belongs to emotion, what belongs to thought? What can be taken from an audience, what must be given? What responsibilities must we take for what we leave behind? What change can a performance bring about? What can be transformed?

The answers are difficult and ever-changing, but the conclusion is simple. To learn about theatre one needs more than schools or rehearsal rooms: it is in attempting to live up to the expectations of other human beings that everything can be found. Provided, of course, one trusts these expectations. This is why the search for audiences was so vital.

Another aspect of the process we were following was that of interchange between working groups. Groups of many nationalities had passed through our Centre in Paris, and this prepared the way for the eight-week experience of living together with the Teatro Campesino in San Juan Bautista. [. . .]

The work with the Campesino was a major experiment, and it established that it is possible for different groups to help each other to search for the same goal. Once again, it was differences between the groups that made the strongest experiences occur.

In Paris, in 1972, we worked with deaf children, touched by the vividness, eloquence, and speed of their body languages. The American National Theatre of the Deaf spent a very rich period with us, experimenting both in movement and in sound, and extending the possibilities of both companies.

Then there was the summer we worked intensively on a reservation in Minnesota with the American Indian group from La Mama. The remarkable sensitivity of these actors toward sign language convinced us that something important would take place if we could bring the Indian and the deaf groups together. So one day, in the quiet of our space in the Brooklyn Academy of Music, we all met. And as theatre is a far more powerful means of communication than any social form, we did theatrical work together. We began with direct communication through signs, which spread rapidly from conversational signs to poetic ones, and soon penetrated into the strange area where what to a hearing person is a vibrating sound, to a deaf person is a vibrating movement. These became one and the same channel of expression.

That same night we decided to perform together, and we rapidly prepared a special version of *The Conference of the Birds* in which all three groups took part. Performing in front of an audience produces the heat which makes every experience touch its peak; this performance technically was very rough, but slickness and professionalism were of little consequence. There was a

direct power produced by the combustion of the three different elements. The audience that evening had no knowledge of what gave the performance its particular electricity but both the audience and the groups took away a very precious human experience. For over twelve hours the theatre had been a meeting place, and the evening had become an expression of the essence of that meeting. [. . .]

I am constantly asked if I will 'go back' to the legitimate theatre. But research is not a pot that one opens and then puts back in a cupboard, and all theatre has the possibility of being legitimate. For years, all the large-scale productions I have been involved with have been the result of extended periods of closed research. The two aspects of the process have to stay together like the swing of a pendulum. So there can be no renouncing of the principle of playing for large audiences. In the theatre, the small experiment and the big show both can have quality and meaning. All that matters is that they should aim at capturing truth and life. Captivity kills fast. For this reason, there are no conclusions. The methods must always change.

feeling on the audience's part is induced by the artist's attitude; it is this that makes the journey famous. The scene reminded us of the march to Budejovice in Piscator's production of *The Good Soldier Schweik*. Schweik's three-day-and-night march to a front which he oddly enough never gets to was seen, from a completely historic point of view, as no less noteworthy a phenomenon than, for instance, Napoleon's Russian expedition of 1912. The performer's self-observation, an artful and artistic act of self-alienation, stopped the spectator from losing himself in the character completely, i.e. to the point of giving up his own identity, and lent a splendid remoteness to the events. Yet the spectator's empathy was not entirely rejected. The audience identifies itself with the actor as being an observer, and accordingly develops his attitude of observing or looking on.

The Chinese artist's performance often strikes the Western actor as cold. That does not mean that the Chinese theatre rejects all representation of feelings. The performer portrays incidents of utmost passion, but without his delivery becoming heated. At those points where the character portrayed is deeply excited the performer takes a lock of hair between his lips and chews it. But this is like a ritual, there is nothing eruptive about it. It is quite clearly somebody else's repetition of the incident: a representation, even though an artistic one. The performer shows that this man is not in control of himself, and he points to the outward signs. And so lack of control is decorously expressed, or if not decorously at any rate decorously for the stage. Among all the possible signs certain particular ones are picked out, with careful and visible consideration. Anger is naturally different from sulkiness, hatred from distaste, love from liking; but the corresponding fluctuations of feeling are portrayed economically. The coldness comes from the actor's holding himself remote from the character portrayed, along the lines described. He is careful not to make its sensations into those of the spectator. Nobody gets raped by the individual he portrays; this individual is not the spectator himself but his neighbour.

The Western actor does all he can to bring his spectator into the closest proximity to the events and the character he has to portray. To this end he persuades him to identify himself with him (the actor) and uses every energy to convert himself as completely as possible into a different type, that of the character in question. If this complete conversion succeeds then his art has been more or less expended. Once he has become the bank-clerk, doctor or general concerned he will need no more art than any of these people need 'in real life'. This complete conversion operation is extremely exhausting. Stanislavski puts forward a series of means – a complete system – by which what he calls 'creative mood' can repeatedly be manufactured afresh at every performance. For the actor cannot usually manage to feel for very long on end that he really is the other person; he soon gets exhausted and begins just to copy various superficialities of the other person's speech and hearing, whereupon the effect on the public drops off alarmingly. This is certainly due to the fact that the other person has been created by an 'intuitive' and

direct power produced by the combustion of the three different elements. The audience that evening had no knowledge of what gave the performance its particular electricity but both the audience and the groups took away a very precious human experience. For over twelve hours the theatre had been a meeting place, and the evening had become an expression of the essence of that meeting. [. . .]

I am constantly asked if I will 'go back' to the legitimate theatre. But research is not a pot that one opens and then puts back in a cupboard, and all theatre has the possibility of being legitimate. For years, all the large-scale productions I have been involved with have been the result of extended periods of closed research. The two aspects of the process have to stay together like the swing of a pendulum. So there can be no renouncing of the principle of playing for large audiences. In the theatre, the small experiment and the big show both can have quality and meaning. All that matters is that they should aim at capturing truth and life. Captivity kills fast. For this reason, there are no conclusions. The methods must always change.

Bertolt Brecht

ALIENATION EFFECTS IN CHINESE ACTING[1]

From: *Brecht on Theatre: The Development of an Aesthetic*, ed. and tr. John Willett (New York: Hill and Wang, 1964); originally published as 'Verfremdungseffekt in der chinesischen Schauspielkunst', in *Schriften zum Theater* (Berlin: Suhrkamp, 1957).

THE FOLLOWING IS INTENDED TO REFER BRIEFLY TO THE USE OF THE ALIENATION EFFECT in traditional Chinese acting. This method was most recently used in Germany for plays of a non-aristotelian (not dependent on empathy) type as part of the attempts[2] being made to evolve an epic theatre. The efforts in question were directed to playing in such a way that the audience was hindered from simply identifying itself with the characters in the play. Acceptance or rejection of their actions and utterances was meant to take place on a conscious plane, instead of, as hitherto, in the audience's subconscious.

This effort to make the incidents represented appear strange to the public can be seen in a primitive form in the theatrical and pictorial displays at the old popular fairs. The way the clowns speak and the way the panoramas are painted both embody an act of alienation. The method of painting used to reproduce the picture of 'Charles the Bold's flight after the Battle of Murten', as shown at many German fairs, is certainly mediocre; yet the act of alienation which is achieved here (not by the original) is in no wise due to the mediocrity of the copyist. The fleeing commander, his horse, his retinue, and the landscape are all quite consciously painted in such a way as to create the impression of an abnormal event, an astonishing disaster. In spite of his inadequacy the painter succeeds brilliantly in bringing out the unexpected. Amazement guides his brush.

Traditional Chinese acting also knows the alienation effect, and applies it most subtly. It is well known that the Chinese theatre uses a lot of symbols. Thus a general will carry little pennants on his shoulder, corresponding to

the number of regiments under his command. Poverty is shown by patching the silken costumes with irregular shapes of different colours, likewise silken, to indicate that they have been mended. Characters are distinguished by particular masks, i.e. simply by painting. Certain gestures of the two hands signify the forcible opening of a door, etc. The stage itself remains the same, but articles of furniture are carried in during the action. All this has long been known, and cannot very well be exported.

It is not all that simple to break with the habit of assimilating a work of art as a whole. But this has to be done if just one of a large number of effects is to be singled out and studied. The alienation effect is achieved in the Chinese theatre in the following way.

Above all, the Chinese artist never acts as if there were a fourth wall besides the three surrounding him. He expresses his awareness of being watched. This immediately removes one of the European stage's characteristic illusions. The audience can no longer have the illusion of being the unseen spectator at an event which is really taking place. A whole elaborate European stage technique, which helps to conceal the fact that the scenes are so arranged that the audience can view them in the easiest way, is thereby made unnecessary. The actors openly choose those positions which will best show them off to the audience, just as if they were *acrobats*. A further means is that the artist observes himself. Thus if he is representing a cloud, perhaps, showing its unexpected appearance, its soft and strong growth, its rapid yet gradual transformation, he will occasionally look at the audience as if to say: isn't it just like that? At the same time he also observes his own arms and legs, adducing them, testing them, and perhaps finally approving them. An obvious glance at the floor, so as to judge the space available to him for his act, does not strike him as liable to break the illusion. In this way the artist separates mime (showing observation) from gesture (showing a cloud), but without detracting from the latter, since the body's attitude is reflected in the face and is wholly responsible for its expression. At one moment the expression is of well-managed restraint; at another, of utter triumph. The artist has been using his countenance as a blank sheet, to be inscribed by the gest of the body.

The artist's object is to appear strange and even surprising to the audience. He achieves this by looking strangely at himself and his work. As a result everything put forward by him has a touch of the amazing. Everyday things are thereby raised above the level of the obvious and automatic. A young woman, a fisherman's wife, is shown paddling a boat. She stands steering a non-existent boat with a paddle that barely reaches to her knees. Now the current is swifter, and she is finding it harder to keep her balance; now she is in a pool and paddling more easily. Right: that is how one manages a boat. But this journey in the boat is apparently historic, celebrated in many songs, an exceptional journey about which everybody knows. Each of this famous girl's movements has probably been recorded in pictures; each bend in the river was a well-known adventure story, it is even known which particular bend it was. This

feeling on the audience's part is induced by the artist's attitude; it is this that makes the journey famous. The scene reminded us of the march to Budejovice in Piscator's production of *The Good Soldier Schweik*. Schweik's three-day-and-night march to a front which he oddly enough never gets to was seen, from a completely historic point of view, as no less noteworthy a phenomenon than, for instance, Napoleon's Russian expedition of 1912. The performer's self-observation, an artful and artistic act of self-alienation, stopped the spectator from losing himself in the character completely, i.e. to the point of giving up his own identity, and lent a splendid remoteness to the events. Yet the spectator's empathy was not entirely rejected. The audience identifies itself with the actor as being an observer, and accordingly develops his attitude of observing or looking on.

The Chinese artist's performance often strikes the Western actor as cold. That does not mean that the Chinese theatre rejects all representation of feelings. The performer portrays incidents of utmost passion, but without his delivery becoming heated. At those points where the character portrayed is deeply excited the performer takes a lock of hair between his lips and chews it. But this is like a ritual, there is nothing eruptive about it. It is quite clearly somebody else's repetition of the incident: a representation, even though an artistic one. The performer shows that this man is not in control of himself, and he points to the outward signs. And so lack of control is decorously expressed, or if not decorously at any rate decorously for the stage. Among all the possible signs certain particular ones are picked out, with careful and visible consideration. Anger is naturally different from sulkiness, hatred from distaste, love from liking; but the corresponding fluctuations of feeling are portrayed economically. The coldness comes from the actor's holding himself remote from the character portrayed, along the lines described. He is careful not to make its sensations into those of the spectator. Nobody gets raped by the individual he portrays; this individual is not the spectator himself but his neighbour.

The Western actor does all he can to bring his spectator into the closest proximity to the events and the character he has to portray. To this end he persuades him to identify himself with him (the actor) and uses every energy to convert himself as completely as possible into a different type, that of the character in question. If this complete conversion succeeds then his art has been more or less expended. Once he has become the bank-clerk, doctor or general concerned he will need no more art than any of these people need 'in real life'. This complete conversion operation is extremely exhausting. Stanislavski puts forward a series of means – a complete system – by which what he calls 'creative mood' can repeatedly be manufactured afresh at every performance. For the actor cannot usually manage to feel for very long on end that he really is the other person; he soon gets exhausted and begins just to copy various superficialities of the other person's speech and hearing, whereupon the effect on the public drops off alarmingly. This is certainly due to the fact that the other person has been created by an 'intuitive' and

accordingly murky process which takes place in the subconscious. The subconscious is not at all responsive to guidance; it has, as it were, a bad memory.

These problems are unknown to the Chinese performer, for he rejects complete conversion. He limits himself from the start to simply quoting the character played. But with what art he does this! He only needs a minimum of illusion. What he has to show is worth seeing even for a man in his right mind. What Western actor of the old sort (apart from one or two comedians) could demonstrate the elements of his art like the Chinese actor Mei Lan-fang, without the special lighting and wearing a dinner jacket in an ordinary room full of specialists? It would be like the magician at a fair giving away his tricks, so that nobody ever wanted to see the act again. He would just be showing how to disguise oneself; the hypnotism would vanish and all that would be left would be a few pounds of ill-blended imitation, a quickly-mixed product for selling in the dark to hurried customers. Of course no Western actor would stage such a demonstration. What about the sanctity of Art? The mysteries of metamorphosis? To the Westerner what matters is that his actions should be unconscious; otherwise they would be degraded. By comparison with Asiatic acting our own art still seems hopelessly parsonical. [. . .]

Notes

1 John Willett, editor of *Brecht on Theatre,* notes that 'this essay, though unpublished in German until 1949, appeared (in Mr Eric White's translation) in *Life and Letters,* London, in the winter of 1936 . . . Almost certainly this . . . is the first mention in his writings of the term "Verfremdungseffekt" (i.e. 'alienation effect'). – Eds.

2 Brecht uses the word 'Versuche'. – J.W.

Antonin Artaud

'MISE EN SCÈNE'[1] AND METAPHYSICS

From: 'La mise en scène et la métaphysique', an extract from 'The Theatre and its Double', in Complete Works, tr. Victor Corti (London: Calder and Boyars, 1968–74), repr. in Artaud on Theatre, ed. Claude Schumacher (London: Methuen, 1989). This essay was originally delivered as a lecture to the Sorbonne, 10 December 1931, and published in Nouvelle Revue Française 221, 1 February 1932.

[. . .]

HOW CAN IT BE THAT IN THE THEATRE, AT LEAST THEATRE SUCH AS WE KNOW it in Europe, or rather in the West, everything specifically theatrical, that is to say, everything which cannot be expressed in words or, if you prefer, everything that is not contained in dialogue [. . .] has been left in the background?

Besides, how can it be that Western theatre (I say Western theatre as luckily there are others such as Oriental theatre, which have known how to keep theatre concepts intact, whereas in the West this idea – just like all others – has been debased), how is it that Western theatre cannot conceive of theatre under any other aspect than dialogue form?

Dialogue – something written and spoken – does not specifically belong to the stage but to books. The proof is that there is a special section in literary history textbooks on drama as a subordinate branch in the history of spoken language.

I maintain the stage is a tangible, physical place that needs to be filled and it ought to be allowed to speak its own concrete language.

I maintain that this physical language, aimed at the senses and independent of speech, must first satisfy the senses. There must be poetry for the senses just as there is for speech, but this physical, tangible language I am referring to is really only theatrical insofar as the thoughts it expresses are beyond spoken language. [. . .]

The most urgent thing seems to me to decide what this physical language is composed of, this solid, material language by which theatre can be distinguished from words.

It is composed of everything filling the stage, everything that can be shown and materially expressed on stage, intended first of all to appeal to the senses, instead of being addressed primarily to the mind, like spoken language. [. . .]

This language created for the senses must first take care to satisfy the senses. This would not prevent it later amplifying its full mental effect on all possible levels and along all lines. It would also permit spatial poetry to take the place of language poetry and to be resolved in the exact field of whatever does not properly apply to words. [. . .]

This difficult, complex poetry assumes many guises; first of all it assumes those expressive means usable on stage[2] such as music, dance, plastic art, mimicry, mime, gesture, voice inflection, architecture, lighting, and décor.

Each of these means has it own specific poetry as well as a kind of ironic poetry arising from the way it combines with other expressive means. It is easy to see the result of these combinations, their interaction and mutual subversion.

I will return below to the subject of this poetry which can only be fully effective if it is tangible, that is to say if it objectively produces something owing to its *active* presence on stage – if, as in the Balinese theatre, a sound corresponds to a certain gesture and instead of acting as décor accompanying thought, makes it develop, guiding it, destroying it, or decisively changing it, etc.

One form of this spatial poetry – beyond any brought about by an arrangement of lines, forms, colours, and objects in their natural state, such as are found in all the arts – belongs to sign language. And I hope I may mention that other aspect of pure theatre language which escapes words, that sign, gesture, and posture language with its own ideographic values such as they exist in some undebased mime plays.

By 'undebased mime plays' I mean straightforward mime where gestures, instead of standing for words or sentences as in European mime (barely fifty years old) where they are merely a distortion of the silent parts in Italian comedy, stand for ideas, attitudes of mind, aspects of nature in a tangible, potent way, that is to say by always evoking natural things or details, like that Oriental language which portrays night by a tree on which a bird that has already closed one eye is beginning the close the other. And another abstract idea or attitude of mind could be portrayed by some of the innumerable symbols in the Scriptures, such as the eye of the needle through which the camel cannot pass.

We can see these signs form true hieroglyphics where man, insofar as he contributes to making them is only one form like any other, to which he nevertheless adds particular prestige because of his duality.

This language conjures up intense images of nature or mental poetry in the mind and gives us a good idea of what spatial poetry, if free from spoken language, could become in the theatre.

Whatever the position of this language and poetry may be, I have noticed that in our theatre, which exists under the exclusive dictatorship of words, this language of symbols and mimicry, this silent mime-play, these attitudes

and spatial gestures, this objective inflection, in short everything I look on as specifically theatrical in the theatre, all these elements when they exist outside the script, are generally considered the lowest part of theatre, are casually called 'craft' and are associated with what is known as staging or *mise en scène*. We are lucky when the word staging is not just tagged on to the idea of external artistic lavishness solely connected with costume, lighting, and décor.

Against this viewpoint, which seems to me completely Western or rather Latin, that is, pigheaded, I might even say that in as much as this language starts on stage, drawing its effectiveness from its spontaneous creation on stage, in as much as it exerts itself directly on stage without passing through words (and why could we not envisage a play composed right on stage, produced on stage) – staging is theatre far more than a written, spoken play. No doubt I will be asked what is specifically Latin about this view which is opposed to mime. What is Latin is the need to use words to express obvious ideas. For me obvious ideas, in theatre as in all else, are dead and finished.

The idea of a play built right on stage, encountering production and performance obstacles, demands the discovery of active language, both active and anarchic, where the usual limits of feelings and words are transcended.

In any event, and I hasten to say so at once, theatre which submits staging and *mise en scène*, that is to say everything about it that is specifically theatrical, to the lines, is made, crazy, perverted, rhetorical, philistine, antipoetic, and Positivist – that is to say, Western theatre.

Furthermore, I am well aware that a language of gestures and postures, dance and music is less able to define a character, to narrate man's thoughts, to explain conscious states clearly and exactly, than spoken language. But whoever said theatre was made to define a character, to resolve conflicts of a human, emotional order, of a present-day, psychological nature such as those which monopolize current theatre? [. . .]

Now to my mind the present state of society is iniquitous and ought to be destroyed. If it is theatre's role to be concerned with it, it is even more a matter for machine-guns. Our theatre is not even able to ask this question in as effective and incendiary a manner as is needed, and even if it did ask it, it would still be far from its intended purpose which is higher and even more mysterious.

All the topics detailed above stink of mankind, of materialistic, tempo-rary mankind, I might even say *carrion-man*. These personal worries digust me, utterly digust me as does just about all current theatre, which is as human as it is antipoetic and, except for three for four plays, seems to me to stink of decadence and pus.

Current theatre is in decline because on the one hand it has lost any feeling for seriousness, and on the other for laughter. Because it has broken away from solemnity, from direct, harmful effectiveness – in a word, from Danger. [. . .]

To my mind theatre merges with production potential when the most extreme poetic results are derived from it, and theatre's production potential is wholly related to staging viewed as a language of movement in space.

Now to derive the furthest poetic consequences from means of production is to make metaphysics out of them and I do not believe anyone could argue with that way of looking at the problem.

It seems to me that to make metaphysics out of language, gestures, postures, décor, and music is, from a theatrical point of view, to regard it in relation to all the ways it can have of agreeing with time and movement. [. . .]

This whole active, poetic way of visualizing stage expression leads us to turn away from present-day theatre's human, psychological meaning and to rediscover a religious, mystical meaning our theatre has forgotten.

Besides, if one has only to say words like *religious* and *mystic* to be taken for a sexton or a profoundly illiterate bonze barely fit for rattling prayer wheels outside a Buddhist temple, this is a simple judgement on our incapacity to draw all the inferences from words and our profound ignorance of the spirit of synthesis and analogy.

It may also mean that we have reached the point where we have lost all contact with true theatre, since we restrict it to the field of whatever everyday thought can achieve, to the known or unknown field of consciousness – and if theatrically we turn to the subconscious it is merely to steal what it may have been able to collect (or hide) in the way of accessible mundane experiences.

Notes

1 There is no proper English equivalent for *mise en scène*. It means 'directing' and encompasses all the activities associated with staging a play (casting, designing, stage management . . .) but it refers also to the aesthetic conception of the production and the individual reading of the director. – C.S.

2 Insofar as they show themselves able to profit by the direct physical potential offered by the stage, to replace the set forms of the art with living, threatening forms, through which the meaning of ancient ceremonial magic can find fresh reality on a theatrical level. Insofar as they accede to what one might call the *physical temptation* of the stage.

Patrice Pavis

INTERCULTURAL PERFORMANCE IN THEORY AND PRACTICE

From: the introduction to *The Intercultural Performance Reader*, ed. Patrice Pavis (London: Routledge, 1996).

[THE DEBATE ABOUT] INTERCULTURAL THEATRE HAS LED TO SOME very trenchant judgements on its moral and political value. Bharucha proposes a number of arguments to reproach Brook for his condescending neo-colonist attitudes towards India, apparent in 'his' *Mahabharata* (Bharucha in Williams, 1992). Jeyifo also questions the reinforcement in Brook's work of naturalized categories such as 'Western', 'foreign' and, from another angle, 'African', 'indigenous' (1990: 241).

On the other hand, any moral or moralizing attempt to preserve a minimum of form in the usage of the foreign culture – out of respect, or indeed restraint – is often received in Western theatre circles, amongst German dramaturgs for example, as an intolerable auto-censorship and a sign of conservatism. Nowadays whoever fails to declare [herself or himself] 'postmodern' in their use of forms and materials foreign to their own culture is considered *ipso facto* lagging behind the times, i.e. reactionary!

Consider the extreme reticence of theatre institutions (e.g. the *Théâtre Nationaux* in France, or the *Stadttheater* in Germany) to promote a politicized intercultural theatre. Where is Franco-Algerian or Germano-Turk theatre? Why are they never promoted? It seems that the institutions, sensitive in spite of everything to the ill-feeling caused by this situation, prefer to individualize every exchange with another culture. [. . .]

Intercultural theatre is at its most transportable and experimental when it focuses on the actor and performance, on training of whatever duration conducted on the 'others'' homeground, or on an experiment with new body techniques. Microscopic work of this kind concerns the body, then by

extension the personality and culture of the participates. It is only ever effective when it is accepted as *inter-corporeal* work, in which an actor confronts his/her technique and professional identity with those of the others. Here is the paradox and strength of such inter-corporeal and inter-cultural theatre: the greater its concern with the exchange of corporeal techniques, the more political and historical it becomes. Here paradox is also aporia: it is inconceivable outside of political and economic structures, *but* it is realized in an individual exchange of bodies and organic reference points. [. . .]

As a result, an intercultural practice such as this can become, and even more so in the future, form a resistance against standardization, against the Europeanization of super-productions. As was the case with Grotowski, Barba and, initially, Brook, it can generate a search for a new professional identity. However the impact of this development will remain rather modest if it only involves those few actors and directors who accept this corporeal-cultural *check-up*. Its forms are limited: the barters of Barba's actors with those groups encountered; ISTA workshops, in which a closed network of artists open to other influences patiently assembles; and private residences by Western actors with Japanese or Indian masters. So each individual, and sometimes each micro-group, has at its disposal a series of (de)formative experiences, patiently acquired from the relevant masters; the sum of these, often mannered and exotic, becomes their calling card. Moreover such acquisition sometimes degenerates into an exchange of cultural stereotypes, for metatheatrical amusement. [. . .]

A dead end, or a pocket of resistance? Evidently it all depends on what kind of culture the theatre produces in its wake. And it is only too apparent that one must exercise caution in the theory and panegyric of intercultural theatre. Nevertheless, one may attempt to sketch out such a theory by suggesting, with moderated conviction, that the appearance of Western intercultural theatre, and more generally the concern with cultural transfers in contemporary staging, does not always imply a flattening out of the imported culture. The theory describing such phenomena is not necessarily that of a universal mill pulverizing foreign cultures in order to pour them into the moulds used by the target culture, a mill operated mechanically by a few grim and depressing intellectuals. It should rather be that, less violent, of 'progressive slippages' – not of 'pleasure', unhappily, but of grains of sand in an intercultural hourglass: the mass of the source culture, metaphorically situated in the upper chamber, must pass through the narrow neck controlled by the target culture of the bottom chamber with, in this neck, a whole series of filters that keep only a few elements of the source culture selected according to very precise norms (Pavis 1992: 4–20). We will indicate only a few strategic points of the passage, a few of the operations necessary for the transfer of cultures within the movement of translation.

Identification of foreign thematic and formal elements

Even before speaking of cultural transfer, one must locate the foreign elements present and determine from what context these particles in suspension have been extracted. The identification is not automatic, given our incomplete knowledge of these forms and the considerable distortions that they may have undergone. Whatever our distance from the culture to be reconstituted may be, a few traces of it can always be recovered, often metonymic and elliptic: a narrative mode, a dramatic structure, the presence of themes or metaphors, indexes on the reality of stereotypes, a 'structure of feeling' (Raymond Williams).

Goals of the adapters

Every relationship with a foreign culture is determined by the purpose of the artists and cultural mediators who undertake its adaptation and its transmission. This purpose is as much aesthetic as ideological and, in both cases, often remains implicit or unconscious. Most often, the adapter is not someone specifically charged with transposing the contents and forms from one cultural shore to another. It is rather a group of enunciators intervening at all levels and at every stage of the production. They are subject to the institutional imperatives of the target culture, which tends to preserve from the foreign culture whatever suits its expectations, reinforces its convictions, and renews it in adapting to the restraints of actual production. In this sense, every intercultural project obeys the constraints and the needs tied specifically to the target culture that produces it. It seems idealistic to look for a universal, transcultural, and transpolitical function for intercultural theatre. The generalizing on a global scale of economic and cultural exchanges sometimes leads us to think that a 'one-world culture' is in the process of emerging. But it is, rather, a standardization of social practices dominated by the capitalist West. Its so-called universality, which subsumes all individual cultures, is in fact only a construction of the dominant West.

[Pavis goes on to discuss the preparatory work undertaken by western adapters. He argues that their training process presupposes the choice of a form, and that the 'elaboration of a form developed from existing forms, but yet *altered*, characterizes all intercultural theatre'. However, he points out that, while Western adapters may seek 'exotic' forms as ways of 'renewing the realistic tendency of their own tradition', they may find that working with a highly codified form of theatre may become a hindrance, and that the process may result in 'an aesthetic act that is devoid of any authentic theatrical experience.' (Pavis 1996: 17–18) – Eds]

Theatrical representation of a culture

Depending on whether the conception of a culture is more formalist (Mnouchkine) or authentic (Brook), two different modes of representation

may occur: either as imitation – more or less codified – of reality by the action and the stage, or as the carrying out of a stage action, in short, as the substitute for a ritual or a ceremony. In the first case, therefore, to represent is to display conventions, to grasp the codification of a culture, charting its rhetorical and stylistic figures, its narrative strategies, everything that gives a semiotic model to reality by means of a cultural or artistic artefact. But to represent also means to perform an action, to place aside all these cultural codifications, to achieve a ritualized action, to persuade both actors and spectators that they are participating in a sacred ceremony. Culture is thus transmitted as much by showing as by imitation, and functions by means of an indissoluble bond uniting people. It is a question of a way of 'performing a culture' (cf. Schechner 1982: 4; Schechner 1985), of 'acquiring a kinesthetic understanding of other socio-cultural groups' (Turner and Turner 1982: 34).

Lacking both space and examples, we cannot give details here of the other processes at work in cultural transfers, such as the levels of readability from one context to another, the confrontation between the cultural universes and their formations and the way in which the foreign culture and whatever of it is formally presented for recognition is transformed in the memory of spectators. At the end of the process, when spectators feel themselves being buried alive under the sand of signs and symbols, they have no other salvation than to give up and turn the hourglass upside down. Then the perspective inverts, and one must reverse and relativize the sediments accumulated in the receiving culture and judge them from the point of view of alterity and relativity.

In all that has been said so far, it is easy to perceive the richness and novelty of these intercultural experiences. [. . .] This richness makes any theoretical unification extremely difficult, at least in the sense of a unified, formal, and easily manageable theory. It is, moreover, clear that theorists, and in particular semioticians, have as yet hardly ventured on to the shifting sands of cultural exchange. Semioticians seem helpless when faced with the difficulty of considering their culture and that of others, their methodology and epistemology (Western, for the most part) and those of foreign cultures. Erika Fischer-Lichte, for example, warns against co-opting the concepts and vocabulary of translation theory for a concept and vocabulary of cultural exchange in theatre work. This is certainly a danger, but she proposes no other model than that of 'productive reception', borrowed from literary theory (Fischer-Lichte *et al.* 1990: 284). It is remarkable that the theoretical essays primarily come from intellectuals and artists of the Third World, or those belonging to post-colonial contexts, who seek with the energy of despair to analyse the processes of acculturation in their traditional societies (Jeyifo 1990; Rotimi 1990; Navarro 1987; Jain 1990; Darlrymple 1987).

The theoretical relativism of the West finds its self-justification in the fact that postmodern practice no longer claims any totalization nor any radicalization; it combines elements of varied geographical, historical, and ideological origin, refusing to consider exchange in terms of relationships of power, exploitation, or even simply of conflict.

Faced with this difficulty in articulating the theory and the functioning of the work, it is tempting to postulate a confluence of intercultural theatre and postmodernism (Fischer-Lichte *et al.* 1990: 278). It is certainly arguable that the two phenomena coincide in time, and in the practice of artists like Wilson, Suzuki, and Béjart. But these represent only one type of cultural exchange amongst many and one, moreover, which levels cultures and decrees the passing of those radical avant-gardes of which Brook, Artaud, and Mnouchkine are the last dinosaurs. Certainly this kind of interculturalism, that of Wilson and his epigones, holds the ideological and aesthetic high road – being much more adapted to the spirit of the times – cultural relativism has come to terms with all valorization, and no longer feels any need to relate either to one culture or cultures: 'The saraband of innumerable and equivalent cultures, each justified within its own context, has created a world that is certainly de-Westernized, but it is also a world that is disoriented' (Lévinas 1972: 60). This *dis-orient-ation* marks most of the theatrical experiments claiming to be intercultural: the 'Orient' is neither cited as a reference nor used as a touchstone to orient the West. Thus it is almost absurd to speak of *exchange* between East and West, between modernism and tradition, between individualism and a collective spirit.

Instead a third term is taking shape, and it is precisely that intercultural theatre which still aspires, for the most part, to exist at all, but which nevertheless already possesses its own laws and specific identity. It is in the search for extra-European inspiration – Asian, African, South American – that the genre of intercultural theatre has every chance of prospering, much more so than in the co-operations between European countries, which so often restrict themselves to accumulating capital, multiplying selling points, and confirming national stereotypes and the standing of actors. If there is one attitude that we must move beyond, it is that pan-European self-protective huddling which is only interested in Europe in so far as it forms a barrage against the rest of the world: even more reason for placing one's hope in an extra-European interculturalism which may lend a strong hand to the theatre of today.

Power, politics, and the theatre

Nike Imoru

INTRODUCTION TO PART FOUR:
Political theatres in cross-cultural contexts

THE FOUR ESSAYS IN PART FOUR offer a range of perspectives on political theatres at the *fin-de-siècle*. Alongside their different themes they share a common focus: they seek to examine the role and efficacy of performance and performance contexts for the late twentieth-century spectator, and they do so by attempting to fuse the practice of theatre with theoretical discourses.

With the fall of the Berlin Wall in 1987, followed by the dissolution of the Soviet Union, a number of communist states, and the Cold War over the last fifteen years, the nature of politics and political discourse has changed radically. In his essay 'Revolution and Re-creation', Gordon McDougall explores how we use and understand the terms 'revolution' and 'evolution' within the arts. He might well view the last fifteen years as an evolution in world politics, which in turn has given rise to a revolution in cultural production, including theatre. What is certain is that there has been a marked change in the ways that theatre in general is discussed. Theatre practitioners, theoreticians, and historians alike must now acknowledge the proliferation of theory in the arts and sciences that inform how we see and interpret the world.

The 'revolution' in world politics has in part given rise to the notion of a global economy. Whilst a global economy in tandem with the information superhighway is a reality, one must beware of the dangers of homogenizing experience intra- and inter-culturally. The notion of a global economy in which each culture is standardized by such technological 'advances' as digital and satellite television, cell-phones, and McDonald's remains questionable at

an economical and social level. As Coco Fusco points out in her essay, live art is perhaps the most efficacious way of demonstrating that cultures, in fundamental ways, are still tied to psycho-historical realities, such as colonial ideals, that are yet to be resolved.

The essays in this part complement each other in so far as they represent and analyse political theatres within varying cultural contexts and seek to examine them anew, in the light of current theories of culture. This is vital in terms of understanding ways forward for theatre that deems itself 'political'. The rallying cry of the avant-garde artists during the Russian Revolution was 'new forms for the new age', and it would seem that as we enter a new age, not only chronologically in terms of the new millennium, but politically in terms of global politics and ever-changing geographical boundaries, it is important to be able to articulate what has gone, what might emerge, and crucially how this might be represented in the arts, more specifically in theatre. It is also important to note that the boundaries of theatre have also evolved so that increasingly one refers to 'performance', a term which is becoming synonymous with theatre per se. In their essays, Baz Kershaw and Coco Fusco both acknowledge, from different perspectives, that the performance event is not necessarily confined to the theatre building.

Whilst all the essays offer some related themes, they also exhibit differences at the level of discourse and debate. Gordon McDougall is concerned with the nature of the arts in general and with the question of where in history one can locate a revolution in the arts at the level of form and at the level of content. It is worth pointing out that McDougall's original essay was written several decades ago and is presented here in only a slightly updated form. This allows the reader to see how the idea of revolution is dynamic and contingent upon other socio-political and socio-economic factors within a given culture; that is to say, even a revolution is not an immutable given created by elements which constitute a 'touchstone for successful revolution'. Thus McDougall asks: what does make for a 'successful revolution in art and life?' (below, p. 125). He suggests it is the form (that is, the structure and means that uphold the content) that must first be revolutionized. This was an important acknowledgement of the Russian avant-garde artist at the turn of the century who felt that radical content alone would not suffice to create a revolutionized state, a state in keeping with Leninist-Marxist politics (a communist state), if the form of presentation were itself bourgeois. They sought then to revolutionize both form and the mode of production. It was Bertolt Brecht who would make popular this idea with his now famous alienation effect in which he laid bare the devices of theatre production and sought to challenge the spectator's right to be emotionally catharted during the performance. One could argue for the ways in which the process of catharsis, a controlled release of emotions, is itself a way of curtailing or subsuming the revolutionary ire of the spectator. Thus Brecht

sought, in theory at least, to challenge conventions of reception as well as production.

McDougall's essay attempts to reassess the ways in which we have come to understand what makes revolutionary art or theatre. He sees the medium of theatre as something which already has a revolutionary or 'anarchic' potential but is aware of the ways in which it can be 'made safe' by a lack of imagination and commercial exigencies. In the last twenty years, we have witnessed radical changes to theatre in Great Britain. Small-scale touring theatre has all but 'disappeared'; funding for theatre in general is at a premium; repertory theatres are closing down; and crucially, with the advent of digital television in Great Britain, along with cable and satellite television not to speak of film (both cinema and video), more accessible forms of entertainment have emerged both economically and socially. Twenty years on, the evolution and process of creating 'political' theatre seems to have reached a standstill.

Perhaps it is for this reason that performance artists like Coco Fusco and Guillermo Gómez-Peña are finding a greater import and efficacy in performance art (though it should be noted that Fusco does not term her work so in her essay). Where McDougall lays stress on theatre history, Fusco offers a documentation and analysis of an interdisciplinary work of art in which she and Gómez-Peña re-presented themselves as ethnographic exhibits in alternative arts venues, namely art galleries, museums, national parks. Fusco's interest in the Other within Western culture, allied with a desire to interrogate the colonial psyche and its adjunct, racism, leads her to create a work of art in which she and her collaborator offer themselves to be seen as indigenous peoples from an undiscovered island. This type of performance, or re-presentation of political oppression, is not new. It is a political spectacle in which the spectators' role is blurred. They are not concealed within a dark auditorium but encouraged to engage, on whatever level, with the exhibits before them, just as they would do in a museum or an art gallery. There are parallels between Fusco's work and Augusto Boal's work in South America. Boal's work is now popular in Great Britain but originally his theatre was conceived to give voice to an oppressed majority living under a military junta in the South Americas. Fusco's re-presentation of the Other is a political act or performance. It is a display of her 'self' and her collaborator: one in which she aims to provoke an immediate response in the spectator without the usual demarcation lines which are established by the theatre auditorium whereby the spectator sits at some distance from the action on stage in darkness.

This type of performance also has an historical dimension. Fusco seeks to offer a representation and re-presentation of a so-called 'primitive' male and female in a cage in order to gauge public response at the *fin-de-siècle* to racial stereotypes. It is at this intersection between art and politics – that is, between cultural production and political action – that much theorization

has occurred in Britain and the USA, particularly in the last fifteen years. Here, then, is a process within performance of articulating experiences and of interrogating ideals that might otherwise go unconsidered. Such performances are not only political, they are also examples of how the non-dominant groups in a given culture give voice to the experiences of past and current generations. Here Fusco is drawing attention to the ways in which natives of Asia, Africa, and the Americas were frequently exhibited for the aesthetic, scientific, and cultural needs of the Europeans who bore them from native lands during the eighteenth and nineteenth centuries. The cross-cultural link is vital here because whilst the USA and UK acknowledge the colonial past (to an extent) and seek to embrace the differing cultures that have come to make up its myriad cultures, Fusco's point is that there remains an underlying sense – in some instances an overt sense – of racism which is not dissimilar to that articulated by the white forebears. To this end she is seeking to fuse politics and performance in order to interrogate both a colonial past and a post-colonial present. One might also argue for the way in which she is holding up the ideals of Western democracy, at the *fin-de-siècle*, for interrogation.

Fusco's essay, then, might also be seen as a documentation of post-coloniality in a cross-cultural context. Performance, process, and documentation form complex matrices which themselves can be read and interpreted. All this gives rise to cross-cultural contexts and interdisciplinary projects which find their locus in the spectator. Thus on an interdisciplinary level she draws on the fields of anthropology, science, history, performance (art), theatre, and gender. Each discipline, either singularly or in combination, is then read or received within specific cultures which are themselves complex matrices. Thus in Australia the performance took place in the Australian Museum of Natural History in Sydney. Given the history of the Aborigine in Australia, the performance in Sydney would have resonated differently for the Antipodean spectator from the performance in London for the British spectator. This because all the disicplines that Fusco draws on create a dynamic interplay that includes the history of the Aboriginal culture, the dominant white liberal culture, the impact and history of other indigenous cultures in the South Pacific and indeed the venue itself which professes to be: Australian, a Museum, specializing in Natural History. Even the context or setting acquires greater meanings (significance) when Fusco's performance comes literally 'into play'.

Fusco's essay gives rise to another debate within performance which is touched on by Baz Kershaw in his investigation of 'Performance, Community, and Culture'. He inquires into the nature of reading or receiving a performance within a contemporary society which has become increasingly pluralistic. One in which cultures (rather than a single culture per se) are seen to influence and impinge on each other to create and instil values, ideologies, and beliefs

which work, if not in tandem with each other, then at least in tension with each other. But more interesting is his acknowledgement that the field of performance is equally open to more contemporary theoretical analyses such as poststructuralism – a continuing bone of contention for some theatre academics and practitioners. However, rather than surrender to the simplistic notion that pluralism can only give rise to further pluralism and therefore every subject and cultural position holds equal meaning and sway under the aegis of the postmodern condition, he examines the ways in which differences and collective endeavours might be read together so that one can make explicable such phenomena as counter-cultures. In the first instance counter-cultures might simply be analysed as a class response to particular forms of socio-economic inequalities; but this does not adequately explain why, for example, an entire generation, irrespective of class, takes on similar ideals and values, given that class difference should give rise to a binarist rather than a pluralist debate.

On this point these three essays themselves find a meeting-point where they at first seemed diverse, for each of them explores another type of 'actor'. (Perhaps one can speak of a relationship between the actors that the three essayists write about and Boal's 'spectactor'.) In his essay, McDougall's 'actors' are the revolutionary activists in culture, be they writers, film-makers, or political activists. McDougall attempts to understand what makes cultural moments in history revolutionary as distinct from evolutionary. He relies on the activity of the individual. Fusco and Gómez-Peña, as artists, establish a satirical ethnographic performance in order to discern how the spectators will respond or act towards their spectacle, and Kershaw's inquiry seeks to understand, in the wake of alternative and experimental theatre of the 1960s to the 1980s, what makes a culture, or a generation, active in the creation of counter-cultural ideals. And Kershaw goes even further, asking not only how a revolution is constituted by or within cultures, but how it is that the spectator within a pluralistic culture can almost harmonize cultural differences to the extent that a collective response and potentially a revolution might occur; thereby shifting so-called alternative theatre from the 'margins' or the 'fringes' to a central position within society. In short, given class, race, and ethnic differences it is possible to discern collective intentions which galvanize a group or sets of groups to achieve what Kershaw describes as an 'extensive socially disruptive potential'. According to Kershaw, this was one of the ways in which the British alternative and community theatre movement of the 1960s–1970s gained entry into mainstream culture so that the fringes, which is where alternative theatre was seen to be situated, might actually be reconsidered as more mainstream than was perhaps appreciated at the time.

Whilst there is often considerable scepticism amongst theatre academics about the role of theory within the practice of theatre, it seems that we have

reached a time when it is no longer feasible to reject theoretical endeavours and their relationship to practice. Just as McDougall points out that in much revolutionary art the form dictated the content, so too theory has come to change, colour, and inform not only how we view performance practice and history but how we make it and relate to it. Were this not the case, then Fusco's work might simply be read as art for art's sake, or at best an attempt by an 'Other' to inform an 'Other'. Instead, meaning is proliferated along many cultural axes: not least historical, scientific, as well as political, and so on.

The subtitle of this chapter, 'Political theatres in cross-cultural contexts', itself suggests a fusing of practising and theory. We tend to view political theatre as relating to the performance text, for example the theatre of Brecht (or in companies, such as, for example, the Berliner Ensemble), while cross-cultural suggests a complexity and diversity of contexts, positions, values, and ideologies which in their similarities as well as their differences constitute a moment in history. It is inevitable that our shift in reading must take account of these proliferating differences and diversities in order to address the practice and politics of theatre within a range of cultural contexts.

This is something that Awam Amkpa addresses in 'Colonial Anxieties and Post-colonial Desires'. Amkpa offers an incisive and rigorously critical debate which develops the three aforementioned essays. In many ways the essay can be seen as a challenge to McDougall's essay and a development of those of Fusco and Kershaw.

Amkpa presents post-colonial and cultural readings in uncompromising ways. Some might argue for the 'disruptive' or destabilizing nature of his own complex and challenging discourse on colonialism and neo-colonialism within a mainstream discourse on theatre or dramatic practice. He offers an invigorating way of reading theatre written within a post- and neo-colonial context. His essay is a prime example of the political and dynamic ways in which theatre practice is being created and embraced not just within Europe and by European practitioners but beyond Europe to continents which continue to live with the legacy of colonialism.

Amkpa's essay sees the impossiblity of removing or ignoring the legacy of colonialism, arguing that to consider this as a possibility is both politically naive and artistically improbable. Instead he emphasizes the way in which the production of drama is contingent upon a post-colonial and neo-colonial culture's acknowledgement of its socio-political and psycho-social histories. What is interesting is that, like Kershaw, he does away with the idea that oppressed subjects (in this instance, colonized peoples) should reside in the margins or the 'fringes' of theatre practice, and argues that the only viable means of challenging the dominant discourse – and he cites language as a dominant discourse through which ideology and authority is transmitted – is by the subject residing at the 'centre' (literally and perhaps metaphorically) in order to disrupt the apparently stable norms of (neo-)colonialism.

One could argue, as did Audre Lorde, that ultimately 'the master's tools will never dismantle the master's house' (1984: 223); that ultimately, residing at the centre, engaging with the (metaphorical) master on any level must result, inadvertently or otherwise, in upholding the 'master's' ideals, if only superficially. Amkpa has observed this position. Note that he quotes Spivak who sees the same process as an 'impossible no to a structure, which we critique yet inhabit intimately' (Spivak 1990: 28). However, he insists that one of the ways in which assimilation such as this can be overcome is through an endless process of translation: linguistically, culturally, and politically. Amkpa sees translation as a profoundly 'proactive gesture', one which cannot be readily encapsulated and simplistically theorized within Western European modes of thought. Rather, this restless process of translating is itself about crisis. For Amkpa, crisis is both the form and the content that will begin to dismantle a reified Eurocentric logic. Ultimately for Amkpa, theatre/dramatic practice is perhaps the one arena in which narratives can be endlessly challenged, can give rise to crises as norm and to translation of narratives: be they colonial or neo-colonial; narratives that do not necessarily end with the sense of Eurocentric finality or conclusion – with closure – but with the sense of 'critical rebirth'.

Awam Amkpa

COLONIAL ANXIETIES AND POST-COLONIAL DESIRES:
Theatre as a *space of translations*

> The quest for self identity is, therefore, inseparably also a radical revision of colonially inspired historiography and the re-orientation of historical consciousness towards asserting the interests of dominated people.
>
> (Constantino 1978: 4)

> The claim of the dominant to seamlessly account for all experience is embarrassed by a force and passion that is not only disconcerting, but also negative. And this force is guaranteed, paradoxically, by an 'internal necessity' that defines dominant discourses.
>
> (Olaniyan 1995: 19)

IT MAY PERHAPS SOUND A BIT GRAND OR SELF-OBSESSIVE TO ASSERT that drama and its various modes of production have political, cultural, and economic implications in the development of cultural and social discourses (anywhere) in the world. Apart from offering symbolic interpretations and negotiations of social reality, the functions of drama in the production of cultures have imposed certain responsibilities on its producers, who sometimes find their works bigger and more serious than they thought. In this short essay, I want to draw attention to contexts of post-coloniality with particular reference to Africa, and to their manifestations in theatrical theory and practice, especially as such contexts make theatre a site for translating and enunciating anticolonial subjectivity.

Due to European colonial histories in most African countries, the dominant languages of political authority are usually English, French, Portuguese, etc.

Similarly, the dominant culture's aesthetic conventions are mediated by the epistemic demands of such languages. Artists, theorists, intellectuals, and others continue to be preoccupied with the cultural and epistemological frames such histories offer conditions of defining subjectivity, especially within cultural practices such as drama and theatre.

In most of the colonized world, to be formally educated means a simultaneous subordinate existence in two overlapping worlds – one a global space and system of knowledge derived entirely from Europe, and the other a local space fragmented by internal re-arrangements brought about by external encounters. Such cultural topographies typify colonized spaces and they discursively perform themselves as 'modern' and 'traditional', 'indigenous' and 'foreign', 'eurocentric' and its 'other'.

For playwrights who have to use European languages, and to those for whom they write, a counter-identifying discourse organizes cultural production and reception. Such counter-identifying discourse is neither unitary nor stable in approach. I want to draw attention to this trope of counter-identity amidst theories of theatre as cultural production. Writers including Ngũgĩ wa Thiong'o, Wole Soyinka, and a host of others have in their different ways drawn our attention to the existential anomaly of colonially inspired contexts, which present and represent cultural production and thought.[1] In their works, such authors map out and textualize European colonial discourse and the neo-colonial structures they have invented. They do so wilfully in order to subvert and limit the epistemologies and existential anguishes of such discourses. Their actions, in my opinion, are a means of symbolically textualizing subjectivity through discourses that counter-identify with colonial legacies by expressing desires for radically enabling post-coloniality.

Within colonial organizing strategies, the careful selection of some 'natives' engineered into a quasi-national structure, meant education had to play an overt ideological role in seeking modes of identification with the dominating discourse. The outcomes of such strategies were, however, fraught with contradictions. The social group 'invented' for perpetuating colonial and imperial projects became the dominant social formation in the margins of the imperial borders, as well as within which anticolonial battles are 'staged'. In other words, such colonially invented groups, negotiated different forms of discourses contesting the colonized spaces of their countries, as well as leading missions of retrieving their indigenous identities. As Gyan Prakash puts it: 'The project of retrieval begins at the point of the subaltern's erasure' (1992: 12). What we find presented in culture, as a result of this strategy, is a spectrum of attitudes about the 'natives' colluding with and simultaneously counteracting the dominant force in their cultures. Whereas 'natives' were politically positioned to perpetuate colonial hegemony, their development as a counteractive force coupled with their sense of alienation led to contradictions in their cultural politics and practices. The traces left in cultural representation demonstrate a set of discursively negotiated nationalistic identities and counter-hegemonic tendencies. As Parry observed: 'for purposes of

administration and exploitation of resources, the native was constructed as a programmed, "nearly selfed" other of the European and not as its binary opposite' (1987: 27). Hence, the sites for contesting social reality and identities of the elite became physical and psychological and much more complicated through the process of self-aware representation than they would have done if they remained identifiable in cultural assumption and representation as the 'other' of the colonizing cultures.

Dramatists such as Wole Soyinka, Femi Osofisan, Ngũgĩ wa Thiong'o, Ama Ata Aidoo, Micere Mugo, and Rose Mbowa, work with and within a conscious development of subjective selfhood. Such energies enable a sense of 'otherness' and citizenship within a global culture whose vocabulary of being and cognition offer possibilities to their creativity.[2] Within such actions, they engage in what Homi Bhabha (1994) calls 'projective disincorporation' as they seek an in-betweenness between colonially determined axes of 'native' and 'foreign', barbaric and civilized, in order to develop metaphors of subjectivity. They accomplish their theatrical and cultural aims by engaging strategically with, and 'doing things to' European languages, epistemologies, and cultural practices. Rather than allowing themselves or their work to be overpowered in existential despair over the predominance of European languages and discourses, these playwrights and their audiences have channelled their energies into subverting the colonizing discourses of such languages by fragmenting, compacting, and inscribing them with decolonizing energies.

Abiola Irele in his brilliant essay 'In Praise of Alienation' describes the situation thus:

> We are wedged uncomfortably between the values of our traditional culture and those of the West. The process of change which we are going through has created a dualism of forms of life, which we experience at the moment, less as a mode of challenging complexity than as one of confused disparateness.
>
> (Cited in Appiah 1992: 54)

Contrary to Irele's suggestion, my contention is that such dualism and social activism in the cultures of post-colonial society challenges 'complexity' rather than reflecting 'a confused disparateness'. This is done through questioning the terms of relationships to European cultures and practices as well as through negotiations with internal disparateness of diverse people brought together by colonial premises. It is such proactive use of the disparate historicity that various dramatists including Wole Soyinka, Femi Osofisan, Ama Ata Aidoo, Ngũgĩ wa Thiong'o, use theatre as arenas of translation and contesting subjectivity.

For within their practices lies the notion of theatre as a forum of engagement within which external and internal dimensions of culture and society are articulated. Ngugi wa Mirii and Ngũgĩ wa Thiong'o's *I'll Marry When I Want*, Wole Soyinka's *Death and the King's Horseman* and *Beatification of Area*

Boy, Femi Osofisan's *Once Upon Four Robbers*, or Ama Ata Aidoo's earlier *Anowa* exemplify theatres wherein identities are fragmented and re-invented to underscore the agency of cultural and social activism in post-colonial societies.

As cultural activists with audiences seeking anti-colonial activism, the experiences of colonially determined dualism is not unique to the educated or elite of most African societies. Indeed, I insist that the European-educated members of their societies are not necessarily the only ones to feel the impact of colonialism and its attendant alienation. As Anthony Appiah warns: 'we must not fall for the sentimental notion that the "people" have held on to an indigenous national tradition, that only the educated bourgeoisie are "children of two worlds"' (Appiah 1992: 58). For colonial and imperialist history reorganized and reinvented even what we term 'traditional' or 'indigenous' people and structures, by stabilizing, reframing, and depoliticizing them. Just as those taken into classrooms and educated in European etiquette were undergoing assimilation, colonial regimes were organizing what was 'traditional' or 'indigenous', or perhaps depoliticizing cultures to fit into the dualism of its epistemology and language. It is the ways in which theatre and drama in post-colonial societies rename what is colonially named, reframe what is colonially framed, that set the contexts of quests for cultural subjectivity.

As a cultural process in most of colonized Africa, cultural revivalism by the Western educated elite led to moderations and adaptations of languages in which they were constituted. In such contexts, ambivalence and liminality in terms of thematic preoccupation and style characterize their works and act as enunciative actions. Wole Soyinka's thesis of 'The Fourth Stage' (in Soyinka 1988) is perhaps one of the most sophisticated schematizations of such a discourse. The notion that identity is socially and culturally invented and sometimes when left unchecked breeds tyranny, or the persistent stubbornness of the will to reproduce oneself as the myth of Ogun does in his thesis, underscore the use of theatre as a metaphor of subjectivity.[3] Soyinka's philosophical attitude and art stress such cultural and linguistic ambivalence by denying external and internal colonial discourses any comfortable authority.

The language issue continues to be bothersome to some intellectuals and their pedagogies. Colonized subjects are historically coerced into a cosmopolitanism and globalism within which their subjectivity is limited to at most mimicry and at worst subject-less-ness. Thus in cultural practices, colonial epistemes are identifiable sites for writing defiance and opposition. Actions of becoming and belonging are performable through cultural practices that self-consciously pidginize and creolize the content and structure of European languages. Ngũgĩ wa Thiong'o's much-touted farewell to writing in English in the early eighties was too simplistic in understanding the deep and violent cleavages colonialism had created across the continent. Colonialism and European languages were not simply imposed on people, but also reorganized social relations, reinvented ethnicities, and sparked off varying cultural practices that

identified and disidentified with its hegemonies. Within the search for enunciative voice and subjectivity lies cultural practices consciously descriptive and dialogic in fragmenting, reinscribing, relocating, and projecting post-colonial desires and designs for more fulfilling conditions of agency. This is what *translation* implies in the practices of the playwrights discussed here. Such a cultural attitude is akin to what Homi Bhabha calls a *third space,* that 'space of translation: a place of hybridity, figuratively speaking, where the constructions of a political object that is new, neither the one nor the other, properly alienates our political expectations, and changes, as it must, the very forms of our recognition of the moment of politics' (1994: 25).

Translation implies a proactive gesture. In the cases of European languages and cultural practices within colonially mediated societies, modes of domination produce their own means of resistance. Difference is acknowledged, celebrated, and used to challenge the basis of relationships between identities within and outside the countries of such politically aware dramatists. Anthony Appiah underlines this when he asserts:

> The terms of resistance are already given us, and our contestation is entrapped within the Western cultural conjuncture we affect to dispute. The pose of repudiation actually presupposes the cultural institutions of the West and the ideological matrix in which they, in turn, are imbricated.
>
> (1992: 59)

Within such processes, alienation is, in Fanon's opinion, used in a way that 'the colonized adorn themselves with psychic wounds' (1964), like open sores that are eyesores to the squeamishness of the colonizers and those who benefit from its institutional decorum. The deliberate inscriptions or reinscriptions on colonial language are meant to perform 'the psychic wounds of colonization' and its alienating conditions where body and mind reside in oppositional locations. It is precisely this alienating factor that Spivak describes as shouting an 'impossible no to a structure, which we critique yet inhabit intimately' (1990: 28), thus stressing the ambivalence and productive contradictoriness of sites of translation and subjectivity. For African dramatists politically conscious about post-colonial struggles, retreat into nihilism and abandonment is out of the question; rather the creative use of such situations becomes ideologically invigorating. Their creative drive is itself stimulated by the historical limits of language and colonizing epistemologies, in other words, their energies echo what Fanon insists happens when the state of emergency imposed by the dominant colonizing culture becomes the state of emergence of new identities whose project and mission is interrogative of being, place, and time.

The analysis here examines processes of using drama in archaeological inscriptions of subjective identities that complicate and contest the colonial ones, as well as espousing quests for anti-imperialist and critical national iden-

tities. Such energies are encapsulated in the dramas of most of the political dramatists mentioned. The wide discursive sweep of their practices describes the heterogeneous scope of their post-coloniality. As a term, post-coloniality continues to elude those eager to offer simplistic 'catch-all' definitions for active and lived phenomena where colonial and neo-colonial marginalization dictates the structures of living, and contexts where being and belonging are historically and daily negotiated. These negotiations generate anti-colonial practices as well as neo-colonial contradictions. Indeed, the changing faces of colonization sustain the very neo-colonial contests political dramatists seek to expose and contradict. As a desire for subjective speaking, the works of these dramatists offer metaphors of decolonization as a perpetual foundation for subjectivity. Within such metaphors reside specific issues of class, gender, ethnicity, and sexuality.

Framed by colonial histories, the works of these authors reflect an insurbodination in relation to history. The energies of their works and activism are not about 'a theory' but the act of theorizing, whereby histories, cultural practices, representations, their contexts of signification, ideologies, and discourses of identities and democratic participation, are reframed with analytical and metaphorical rigour. What they set out to do is not to present theses but to explore questions that can engender activism. The spaces they try to represent through their varied practices are spaces of negotiation, translation, and embattlement with an enemy that must be stabilized, framed, ambushed, betrayed, and persistently critiqued. They are also sites for critical rebirth through languages and cultural practices like theatre. More importantly, the language of post-colonial critique of imperialism and Eurocentrism is not only a product of crisis but itself produces a crisis within stable meanings and interpretations of social and cultural reality.[4]

Of course, the complexity of social and cultural contexts of 'reality' in most African societies will inevitably affect and mediate the theatre and its varied practices. The energies described in this short essay make what is foreign local and what is local foreign, thus asserting the creativity of artists while working within what is ultimately a language of political subjectivity. For audiences, plays can be local or 'foreign', yet in either case, the theatre offers a forum for translating social and cultural realities. For the dramatist, the act of translation of those realities into the form of a play engages with the same interpretative energies and forms of creative cultural moderation, whether in original or adapted work.

Notes

1 See Thiong'o 1983, 1986, and 1993; and Soyinka 1976 and 1988.
2 Wole Soyinka, Nigerian playwright, Nobel laureate in literature and author of *Death and the King's Horseman*; Femi Osofisan, Nigerian playwright author of *Morountodun* and other plays; Ngũgĩ wa Thiong'o, Kenyan novelist and

co-author of *Trials of Dedan Kimathi* and *I'll Marry When I Want*; Ama Ata Aidoo, Ghanaian poet and dramatist, author of *Anowa*; Micere Mugo, Tanzanian critic and co-author of *Trials of Dedan Kimathi;* Rose Mbowa, Ugandan dramatist famous for work with grassroots community groups.

3 Ogun is a Yoruba god with similar characteristics to the Greek Dionysus. Soyinka uses the legend and mythology of the god as an aesthetic structure.

4 For more detailed illustration of this phenomenon, see Wole Soyinka's 'The Fourth Stage' (in Soyinka 1988) and *Death and the King's Horseman*.

Gordon McDougall

REVOLUTION AND RE-CREATION

A new essay, based on a chapter from 'The Theatrical Metaphor', unpublished thesis, 1972.

W E TALKED A LOT ABOUT REVOLUTION IN THE 1960s (when this essay was born). There seemed a lot to put right. The times they were a-changing only in our imaginations. Democrats and socialists were in power but they pursued mad policies and were led by the aged. The phrase 'generation gap' was coined. In Edinburgh Malcolm Muggeridge was appointed student Rector and opposed putting contraceptive machines in the toilets. Two students, Anna Coote and Lindsay Mackie (now distinguished journalists), led a campaign, backed by us at the Traverse Theatre, to oust him. Eventually he resigned. Five centuries of Scottish Presbyterianism began to be pushed back. The Traverse was the hotbed of sexual and social revolution. For over a week, after another student show, we ousted the Vietnam War from the national tabloid headlines. We pre-figured Watergate and anticipated *les événements*.

In the 1970s we wondered where all that energy had gone. A student came up to me in Oxford and complained that if I continued to do plays like David Hare's *Teeth and Smiles*, 'before we know where we are we'll have a Permissive Society'. It felt as if all the old battles had to be refought: no, the Universe *didn't* begin in 4004 BC . . . In the 1980s the counter-revolution struck and stayed, and playwrights fought the war by asserting what was wrong instead of celebrating what was right. The 1990s have left us gasping on the shore.

In *Touch and Go*, D.H. Lawrence explored the relation between social and sexual politics, and the possibilities for revolution in both. His conclusion was that in England we always back away from confrontation with ultimate power, whether male or capitalist. The play poses the question: what is a

revolutionary situation, and how can revolution be said to differ from evolution? The importance of the debate can be judged from the irony that, written in 1919, the play was first performed in 1979.[1]

We tend to think of revolution as being induced and led, and therefore as something apart from the 'natural' law of evolution. Certainly we think of it as acting faster, more violently than evolution. St Just, in his great speech at the end of Act II of Büchner's *Danton's Death*, says that it will take four years to translate the adage that all men are created equal into physical terms, but in normal times it would have taken a century and would have been punctuated with generations.

Büchner's skill, however, is to suggest, through St Just's references to the bodies floating down the river of revolution, that no change in the culture of violence and rule by force has taken place. Human consciousness has not been reformed. Indeed, St Just is arguing to send yet more bodies to the guillotine. True revolution, Büchner's subtext tells us, can only happen in the mind of man: how fast can that be achieved?

In 1972, during their investigation to discover whether the indigenous population of what is now Zimbabwe would accept the settlement proposed by London, the Pearce Commission came upon a village which was not even aware that there had ever been a split between Britain and Rhodesia. In our time of mass communication it is hard to imagine ourselves into the state of a people who are able to remain six years 'behind the times'. (We have to go back 350 years to the time when a group of New Model Army soldiers four years into the Civil War came upon a village in Gloucestershire which was unaware that a war had broken out.) The *Guardian* inferred from the insouciance of the African village that African self-rule would not come quickly. There is an African proverb: 'For a man awakened from a deep sleep does not see clearly.' But although the fact that he does not see clearly may mean that he develops slowly, it may also mean that he is susceptible to influence and that he may take sudden uncharacteristic actions as a result of sudden realizations.

Physics has no way of explaining how time can flow, or move at all. Yet we experience the flow, and the changes that come with it. Either physics, through some combination of quantum mechanics and relativity, needs to explain consciousness, or in scientific terms we have to acknowledge it to be an illusion. How can we do this when our consciousness is what makes us understand our humanity? – at the same time as it sullies the impartiality of every scientific observation we make.

'To be conscious,' says T.S. Eliot in *Burnt Norton*, 'is not to be in time'. Through the theatre experience time can be made to change its pressures. In the theatre, Tennessee Williams suggests in his introduction to *The Rose Tattoo*, we enter a world outside of time. Communication is the essence of speed in revolution, as the New Model Army found. The coup against Gorbachev was the first revolution to be destroyed purely by the speed of mass communication. And communication is the essence of what the arts are about.

But in the arts we tend to speak in terms of innovation rather than revolution. It seems safer in view of the fact that new styles which appear revolutionary do not preserve their provocative gloss for long and are replaced by further new styles. We tend to dismiss an interest in form for form's sake as decadent: Art Nouveau and Mannerism are seen as fading forms of an earlier strength of expression.[2] In this view we could be encouraged by the Soviet application of the term 'formalist' to any but the most imitative of styles. Yet when we recognize an interest in form as producing a new vision, new ways of seeing, we do hail it, as with the Impressionist painters, as a revolutionary movement.

In the arts, then, as in social politics, we are left with the question: what distinguishes revolution from evolution? Is it merely the blood on the pavement that tells us? What if we end up with the same violence, the same rulers, the same system writ small – as Büchner depicts in *Danton's Death*? Or is revolution (as St Just believes) merely another *form* of evolution – a natural law, led and directed by whomever history throws up according to history's laws?

We need to recognize that it is as impossible in a historic context as it is in an artistic context to separate the form from the content. It is the form of Büchner's play which gives the lie to its characters' spurious dedication to ongoing violence, just as Cassius's recognition of future audiences watching his actions depicted in a play reflects adversely on the heroic garb in which he wants to dress the murder he has inspired:

> Stoop, then, and wash. How many ages hence
> Shall this our lofty scene be acted over
> In states unborn and accents yet unknown!
>
> (Shakespeare, *Julius Caesar*, III.1. 111–13)

In both of these theatrical transactions, as in all true theatre, the audience does the work. We are not told something; we discover it through our experience, our relation to the event. Each revolution in our personal or social lives to some extent increases our insights, makes it impossible for us to return to our previous imprisonment, not through physical means but through emotional and spiritual. The extent of revolution can surely only be measured not by blood but by the extent to which it increases vision.

Meyerhold (Russian theatre director, 1874–?1940), who was accused of formalism by the Stalinist regime, continually insisted that the function of art in a revolutionary context is to inspire. He criticizes his pupil Eisenstein for making the mistake of failing to show 'the starlit sky ... the dream which helps mankind shoulder formidable and exhausting tasks . . . and carry them through to their conclusion' (1969: 272).

Lenin, Meyerhold goes on to say, was a living exponent of this principle. But even increasing the level of aspiration is not a touchstone for successful revolution in art and life. The work of Samuel Beckett cannot be

said to increase aspiration; but he increases vision. His plays make it more likely that his audience may behave with compassion and humanity. If the effect of a revolution is ultimately to brutalize, it is surely not true, or at least successful, revolution. Beckett's work is concerned, through a minimalist exploration of form, to arrive at the essential in human-ness. So the form of revolution is inextricably linked with its content, just as the form in which theatre is expressed is always a guide to its content.

When we speak about revolution, then, whether in art or life, we must consider form as well as content, and often the relation of form to content in life runs parallel to similar examinations in art. At the same time as Einstein was demonstrating in Germany that matter and energy are different aspects of the same thing, the expressionists were examining new forms of perception and developing new attitudes to perceiving. Many of our most important revolutions, in art as well as in life, occur without our being aware of them and without our being able to name their leaders because new perceptions are created simultaneously by real and artistic experience.

The change in perception which now makes Fellini's techniques in 8½ seem commonplace, whereas when it first appeared they were virtually incomprehensible, has partly been effected by cinematic developments and partly by changes in interpretation brought about by the whole post-modern movement of self-reference.[3] So we understand, without conscious effort, that a revolution has occurred in film-making by the fact that reflexivity and formal experiment need not incur a loss of emotional tension, 'involvement' or enjoyment. One can do two things at the same time: one can appreciate what one is distanced from.

The form in which a work of art is expressed is an integral part of its message: therefore it is not only acceptable but often necessary to use the form to comment, to make of the form *itself* an image of life's means of communication. All great dramatists have used the dialogue between form and content to create the theatre experience, emphasizing continually that the event is happening *now*, that the theatrical action is real, takes place in the audience's imagination, in the moment of performance, in what I have called 'the theatrical metaphor'.[4]

Once we have allowed real life to intrude on the theatre spectacle – even to the extent of accepting that the theatre event is a part of our *real lives* – we are forced to create a new form for the art, in order to embrace it. In this process we are entitled to use the form itself as a frame which not only encloses but comments on the action, determines not only its scope but also its quality. The essential condition of this process, however, if it is to be successful, is that we should not be aware of the form as form during the theatre experience.

The appreciation of art never implies the spectator's being merely a passive observer; indeed art could never function on this level. Some involvement on the part of the audience is obligatory: what post-war playwrights, sculptors, painters, film-makers have been trying to do is to make the

audience's involvement not merely emotional but self-critical, through an awareness of their role in the artistic experience as audience-participators.

Of the more than fifty playwrights with whom I have worked, while each relationship has been different in practical terms, each has involved to some degree the exploration of the formal possibilities of the theatrical environment. Partly this has been made possible by more flexible theatre spaces. But it is true of even more conventional playwrights that their most important contributions have been those of form rather than content. John Osborne's most important innovation was not the new subject-matter of *Look Back in Anger*, which almost single-handedly caused talk of a 'revolution' in British theatre; it was the creation, eight years later in *Inadmissible Evidence* of a new play form – a form without form – held together solely by the white heat of Osborne's writing and the 'double-vision' he gave us of the characters.

If *Look Back in Anger* was – as Kenneth Tynan described it in the review that is as famous as the play – 'the best young play of its generation', then *Inadmissible Evidence* was the best play about the death of youth in that generation – a generation between philosophies, who neither fought a war nor were able to cash in on the new freedoms of the sixties. It needed a form which took theatre beyond the well-made, three-act play (which *Look Back* still was); it was searching for a new kind of theatrical poetry. In more recent years, Pinter, Arden, Howard Barker, and Théâtre de Complicité have contributed to the formal advance of the British theatre by creating new languages for the stories they are concerned to tell.

We had thought *Look Back* was revolutionary largely because it had taken the theatre so long to catch up. The mood that had brought in Clement Attlee with a landslide majority in 1945, that survived the Age of Austerity (Sissons and French 1963) in the late forties, that started in the early fifties to democratize art through new galleries, concert halls and theatres – that ethos was not at all reflected in the West End of Enid Bagnold, N.C. Hunter and the later Terence Rattigan, and Noël Coward. Osborne seemed to capture that frustrated youthful artistic aspiration (expressed offstage in Jimmy Porter's trumpet as it had been in the New Orleans jazz of *The Glass Menagerie*). He wrote a play that set out a youthful agenda which anticipated the sixties, but the play's 'well-made' form was still embedded in the pre-war culture of second-act cliff-hangers and tightly-knit duologues.

So, in spite of our reticence in thinking about art in terms of revolution, there is a tendency to speak of post-war theatre revolutions: in England in the mid-fifties, in the States in the sixties, in the musical in the eighties. Rather than speaking in terms of revolution, it would be more accurate to see these movements as part of a continuous liberation of occupied territory. The movement has been in process since the early twenties and the resistance fighters include O'Neill, Pirandello, and Tennessee Williams, as well as Artaud, Brecht, and Beckett – and Stephen Sondheim.

It has been a movement towards the re-creation of the true theatrical experience, a process of liberation from the theatrical boundaries which made

this experience hard to capture after the early seventeenth century. It has involved a change in attitudes as to what plays should be about, to what it is permissible to say, to how ideas may be presented, and to the form of audience which is desirable. It has brought about a partial but significant democratization of performance and has, in world terms, been a movement of steady discovery rather than revolution. Yet perhaps, taking a standpoint at the end of a century, this whole and gradual process, forged by many different minds and skills, has effected a revolution in consciousness.

Poetry, like revolution, is anarchic in character because it encourages imaginative and compassionate forces which are continually in opposition to the forces of social order. Plato thought theatre anti-social because the audience sympathized with Oedipus when social order demanded his expulsion. Aristotle argued that pity and terror could be brought into play and regulated. I think Plato got closer to the truth. Theatre is guided by a motive and a form which it shapes for itself, for its own purpose, which it does not adapt from previous modes or genres. Theatre, like revolution, must continually find new forms for its anarchic purpose. Its function is to re-form: through play, to re-create.

Freud believed that human nature was essentially anti-social, that the human drives militate against an ordered society. But Melanie Klein saw in play a means by which the child could, through symbol formation, sublimate destructive instincts. In *Life Against Death*, Norman O. Brown argues that childhood is man's eternal goal and in 1970 Richard Neville published a book[5] in which he claimed that 'play power' was the strongest force available to man: sex, creativity, artistic experience had all been contaminated because they had become *hard work*. He could have enlisted serious philosophical support:

> Man only plays when in the full meaning of the word he is a man, and he is only completely a man when he plays.
>
> (Schiller, *Letters on the Aesthetic Education of Man*)[5]

> As soon as he apprehends himself as free and wishes to use his freedom . . . then his activity is play.
>
> (Sartre, *Being and Nothingness*)[6]

In this development theatre has a major role to play . . . one cannot get away from the word, or the image. For theatre is by its very nature play, for the audience as well as its creators: in fact, the audience are creators, players in the game. And another word for play is recreation. Through playing we create ourselves anew.

This form of re-creation, I have suggested, is the only true form of revolution because it affects our consciousness as opposed to our physical state. The problem with evolution is that it has focused the consciousness on the intellect, just as playwrights and critics have recently focused on what 'can

be said' through the theatre. Once we understand that we create our own past and our own present then the theatre moment, the moment of play, allows us to re-create the present – and through this the past and future.

Theatre is in its process a vicarious medium. Its tendency is to show rather than do, to talk rather than act. Yet the very fact that an actor 'acts' while he 'plays' a role, suggests a linguistic basis for the dual role of the theatre: to release by play, to lead one to act.

And, although the theatre is based on vicarious representations of experience, the theatre experience is not itself vicarious. By releasing elements of the consciousness which are not realized in everyday waking life, by freeing from linear time, by suggesting possibilities of a fuller, fairer, richer life, but above all by engaging its actors and audience in a communal activity in which social barriers may be broken down, it aims to create a new level of awareness, a compassion which may later and perhaps indirectly allow the spectator to 'act' in a different role.

Notes

1 At the Oxford Playhouse in a production by the writer.

2 The term Art Nouveau came into fashion after the opening in 1895 of L'Art Nouveau, a shop specializing in modern design at 22 Rue de Provence in Paris by Samuel Bing. For an introduction, see Battersby 1969. The term Mannerism was invented by the art historian Luigi Lanzi in 1792 to describe a tendency in sixteenth-century art. For an introduction, see Shearman 1967.

3 *Otto e Mezzo* (1963), director Federico Fellini, is perhaps the first truly postmodern film. Alberto Moravia (*L'espresso*, 17 February 1963) says that it represents the central theme in contemporary culture: that the artist, even when he has nothing to say, 'can still say how and why he has nothing to say'.

4 This is a term for something which, in the years since this essay was first written, has often been described as 'meta-theatre' and linked with the postmodern. This argument anticipated such theories, drawing from the theatre practitioner's daily encounter with the reinterpretation of form in relation to content. The 'theatrical metaphor' is a description of the experience undergone by the spectator in intense moments of tragedy or comedy. It is an experience of being involved and detached, of being conscious of illusion and reality, of recognition, of the awareness of being both inside and outside of one's life within the same moment.

5 *Play Power* (1970), Richard Neville, published by Jonathan Cape.

6 J. C. Friedrich von Schiller (1759–1805), German dramatist, historian and philosopher, creator, with Goethe, of the *Sturm und Drang* movement.

7 Jean-Paul Sartre (1905–80), French existential philosopher, writer, and playwright.

Coco Fusco

THE OTHER HISTORY OF INTERCULTURAL PERFORMANCE

From: *English Is Broken Here: Notes on Cultural Fusion in the Americas* (New York: New Press, 1997).

IN THE EARLY 1900S, FRANZ KAFKA WROTE A STORY that began 'Honored members of the Academy! You have done me the honor of inviting me to give your Academy an account of the life I formerly led as an ape' (1979: 245). Entitled 'A Report to the Academy', it was presented as the testimony of a man from the Gold Coast of Africa who had lived for several years on display in Germany as a primate. That account was fictitious and created by a European writer who stressed the irony of having to demonstrate one's humanity; yet it is one of many literary allusions to the real history of ethnographic exhibition of human beings that has taken place in the West over the past five centuries. While the experiences of many of those who were exhibited is the stuff of legend, it is the accounts by observers and impresarios that constitute the historical and literary record of this practice in the West. My collaborator, Guillermo Gómez-Peña, and I were intrigued by this legacy of performing the identity of an Other for a white audience, sensing its implications for us as performance artists dealing with cultural identity in the present. Had things changed, we wondered? How would we know, if not by unleashing those ghosts from a history that could be said to be ours? Imagine that I stand before you then, as did Kafka's character, to speak about an experience that falls somewhere between truth and fiction. What follows are my reflections on performing the role of a noble savage behind the bars of a golden cage.

Our original intent was to create a satirical commentary on Western concepts of the exotic, primitive Other; yet, we had to confront two unexpected realities in the course of developing this piece: (1) a substantial portion

of the public believed that our fictional identities were real ones; and (2) a substantial number of intellectuals, artists, and cultural bureaucrats sought to deflect attention from the substance of our experiment to the 'moral implications' of our dissimulation, or in their words, our 'misinforming the public' about who we were. The literalism implicit in the interpretation of our work by individuals representing the 'public interest' bespoke their investment in positivist notions of 'truth' and depoliticized, ahistorical notions of 'civilization'. This 'reverse ethnography' of our interactions with the public will, I hope, suggest the culturally specific nature of their tendency toward a literal and moral interpretation. [. . .]

[We decided] to take a symbolic vow of silence with the cage performance, a radical departure from Guillermo's previous monologue work and my activities as a writer and public speaker. We sought a strategically effective way to examine the limits of the 'happy multiculturalism' that reigned in cultural institutions, as well as to respond to the formalists and cultural relativists who reject the proposition that racial difference is absolutely fundamental to aesthetic interpretation. We looked to Latin America, where consciousness of the repressive limits on public expression is far more acute than it is here, and found many examples of how popular opposition has for centuries been expressed through the use of satiric spectacle. Our cage became the metaphor for our condition, linking the racism implicit in ethnographic paradigms of discovery with the exoticizing rhetoric of 'world beat' multiculturalism. Then came a perfect opportunity: in 1991, Guillermo and I were invited to perform as part of the Edge '92 Biennial, which was to take place in London and also in Madrid as part of the quincentennial celebration of Madrid as the capital of European culture. We took advantage of Edge's interest in locating art in public spaces to create a site-specific performance for Columbus Plaza in Madrid, in commemoration of the so-called Discovery.

Our plan was to live in a golden cage for three days, presenting ourselves as undiscovered Amerindians from an island in the Gulf of Mexico that had somehow been overlooked by Europeans for five centuries. We called our homeland Guatinau, and ourselves Guatinauis. We performed our 'traditional tasks', which ranged from sewing voodoo dolls and lifting weights to watching television and working on a laptop computer. A donation box in front of the cage indicated that, for a small fee, I would dance (to rap music), Guillermo would tell authentic Amerindian stories (in a nonsensical language), and we would pose for Polaroids with visitors. Two 'zoo guards' would be on hand to speak to visitors (since we could not understand them), take us to the bathroom on leashes, and feed us sandwiches and fruit. At the Whitney Museum in New York we added sex to our spectacle, offering a peek at authentic Guatinaui male genitals for $5. A chronology with highlights from the history of exhibiting non-Western peoples was on one didactic panel and a simulated Encyclopaedia Britannica entry with a fake map of the Gulf of Mexico showing our island was on another. After our three days in May

1992, we took our performance to Covent Garden in London. In September, we presented it in Minneapolis, and in October, at the Smithsonian's National Museum of Natural History. In December, we were on display in the Australian Museum of Natural History in Sydney, and in January 1993, at the Field Museum of Chicago. In early March, we were at the Whitney for the opening of the biennial, the only site where we were recognizably contextualized as artwork. Prior to our trip to Madrid, we did a test run under relatively controlled conditions in the Art Gallery of the University of California, Irvine.

Our project concentrated on the 'zero degree' of intercultural relations in an attempt to define a point of origin for the debates that link 'discovery' and 'Otherness'. We worked within disciplines that blur distinctions between the art object and the body (performance), between fantasy and reality (live spectacle), and between history and dramatic re-enactment (the diorama). The performance was interactive, focusing less on what we did than on how people interacted with us and interpreted our actions. Entitled *Two Undiscovered Amerindians Visit . . .* , we chose not to announce the event through prior publicity or any other means, when it was possible to exert such control; we intended to create a surprise or 'uncanny' encounter, one in which audiences had to undergo their own process of reflection as to what they were seeing, aided only by written information and parodically didactic zoo guards. In such encounters with the unexpected, people's defence mechanisms are less likely to operate with their normal efficiency; caught off guard, their beliefs are more likely to rise to the surface.

Our performance was based on the once popular European and North American practice of exhibiting indigenous people from Africa, Asia, and the Americas in zoos, parks, taverns, museums, freak shows, and circuses. While this tradition reached the height of its popularity in the nineteenth century, it was actually begun by Christopher Columbus, who returned from his first voyage in 1493 with several Arawaks, one of whom was left on display at the Spanish Court for two years. Designed to provide opportunities for aesthetic contemplation, scientific analysis, and entertainment for Europeans and North Americans, these exhibits were a critical component of a burgeoning mass culture whose development coincided with the growth of urban centres and populations, European colonialism, and American expansionism. [. . .]

For Gómez-Peña and myself, the human exhibitions dramatize the colonial unconsciousness of American society. In order to justify genocide, enslavement, and the seizure of lands, a 'naturalized' splitting of humanity along racial lines had to be established. When rampant miscegenation proved that those differences were not biologically based, social and legal systems were set up to enforce those hierarchies. Meanwhile, ethnographic spectacles circulated and reinforced stereotypes, stressing that 'difference' was apparent in the bodies on display. Thus they naturalized fetishized representations of Otherness, mitigating anxieties generated by the encounter with difference.

In his essay, 'The Other Question' Homi Bhabha explains how racial classification through stereotyping is a necessary component of colonialist discourse, as it justifies domination and masks the colonizer's fear of the inability to always already know the other (1990: 71–88). Our experiences in the cage suggested that even though the idea that America is a colonial system is met with resistance – since it contradicts the dominant ideology's presentation of our system as a democracy – the audience reactions indicated that colonialist roles have been internalized quite effectively. [. . .]

[Racial] stereotypes have been analysed endlessly in recent decades, but our experiences in the cage suggest that the psychic investment in them does not simply wither away through rationalization. The constant concern about our 'realness' revealed a need for reassurance that a 'true primitive' *did* exist, whether we fit the bill or not, and that she or he is visually identifiable. Anthropologist Roger Bartra sees this desire as being part of a characteristically European dependence on an 'uncivilized other' in order to define the Western self. In his book *El Salvaje en el Espejo/The Savage in the Mirror* (1992), he traced the evolution of the 'savage' from mythological inhabitants of forests to 'wild' and usually hairy men and women who even in the modern age appeared in freak shows and horror films. These archetypes eventually were incorporated into Christian iconography and were then projected onto peoples of the New World, who were perceived as either heathen savages capable of reform or incorrigible devils who had to be eradicated. [. . .]

Not surprisingly, the popularity of these human exhibitions began to decline with the emergence of another commercialized form of voyeurism – the cinema – and the assumption by ethnographic film of their didactic role. Founding fathers of the ethnographic film-making practice, such as Robert Flaherty and John Grierson, continued to compel people to stage their supposedly 'traditional' rituals, but the tasks were now to be performed for the camera. [. . .] The representation of the 'reality' of the Other's life, on which ethnographic documentary was based and still is grounded, is this fictional narrative of Western culture 'discovering' the negation of itself in something *authentically* and *radically* distinct. Carried over from documentary, these paradigms also became the basis of Hollywood film-making in the 1950s and 1960s that dealt with other parts of the world in which the United States had strategic military and economic interests, especially Latin America and the South Pacific.

The practice of exhibiting humans may have waned in the twentieth century, but it has not entirely disappeared. The dissected genitals of the Hottentot Venus are still preserved at the Museum of Man in Paris. Thousands of Native Americans' remains, including decapitated heads, scalps, and other body parts taken as war booty or bounties, remain in storage at the Smithsonian. [. . .] And at the Minnesota State Fair last summer, we saw 'Tiny Teesha, the Island Princess', who was in actuality a black woman midget from Haiti making her living going from one state fair to another.

While the human exhibition exists in more benign forms today – that is, the people in them are not displayed against their will – the desire to look upon predictable forms of Otherness from a safe distance persists. I suspect after my experience in the cage that this desire is powerful enough to allow audiences to dismiss the possibility of self-conscious irony in the Other's self-presentation; even those who saw our performance as art rather than artifact appeared to take great pleasure in engaging in the fiction, by paying money to see us enact completely nonsensical or humiliating tasks. A middle-aged man who attended the Whitney Biennial opening with his elegantly dressed wife insisting on feeding me a banana. The zoo guard told him he would have to pay $10 to do so, which he quickly paid, insisting that he be photographed in the act. After the initial surprise of encountering caged beings, audiences invariably revealed their familiarity with the scenario to which we alluded.

We did not anticipate that our self-conscious commentary on this practice could be believable. We underestimated public faith in museums as bastions of truth, and institutional investment in that role. Furthermore, we did not anticipate that literalism would dominate the interpretation of our work. Consistently from city to city, more than half of our visitors believed our fiction and thought we were 'real'; at the Whitney, however, we experienced the art world equivalent of such misperceptions: some visitors assumed that we were not the artists, but rather actors who had been hired by another artist. As we moved our performance from public site to natural history museum, pressure mounted from institutional representatives obliging us to didactically correct audience misinterpretation. We found this particularly ironic, since museum staffs are perhaps the most aware of the rampant distortion of reality that can occur in the labelling of artifacts from other cultures. In other words, we were not the only ones who were lying; our lies simply told a different story. For making this manifest, we were perceived as either noble savages or evil tricksters, dissimulators who discredit museums and betray public trust. When a few uneasy staff members in Australia and Chicago realized that large groups of Japanese tourists appeared to believe the fiction, they became deeply disturbed, fearing that the tourists would go home with a negative impression of the museum. In Chicago, just next to a review of the cage performance, the daily *Sun-Times* ran a phone-in questionnaire asking readers if they thought the Field Museum *should* have exhibited us, to which 47 percent answered no, and 53 percent yes (7 January 1993). We seriously wonder if such weighty moral responsibilities are levelled against white artists who present fictions in non-art contexts.

[Fusco gives details of the differing reactions of audiences in the different countries she toured.]

I may have been more prepared, but during the performances, we both were faced with sexual challenges that transgressed our physical and emotional boundaries. In the cage we were both objectified, in a sense, feminized, inviting both male and female spectators to take on a voyeuristic relation-

ship to us. This might explain why women as well as men acted upon what appears to be the erotic attraction of a caged primitive male. [. . .] Interestingly, women were consistently more physical in their reactions, while men were more verbally abusive. In Irvine, a white woman asked for plastic gloves to be able to touch the male specimen, began to stroke his legs, and soon moved towards his crotch. He stepped back, and the woman stopped – but she returned that evening, eager to discuss our feelings about her gesture. [. . .] While men taunted me, talked dirty, asked me out, and even blew kisses, not one attempted physical contact in any of our performances.

As I presented this 'reverse ethnography' around the country, people invariably asked me how I felt inside the cage. I experienced a range of feelings from panic to boredom. I felt exhilarated, and even playful at times. I've also fallen asleep from the hot sun and been irritable because of hunger or cold. I've been ill, and once had to be removed from the cage to avoid vomiting in front of the crowd. The presence of supportive friends was reassuring, but the more aggressive reactions became less and less surprising. The night before we began in Madrid, I lay awake in bed, overcome with fear that some demented Phalangist might pull a gun on us and shoot us before we could escape. When nothing of that sort happened, I calmed down and never worried about our safety again. I have to admit that I liked watching people on the other side of the bars. The more we performed, the more I concentrated on the audience, while trying to feign the complete bewilderment of an outsider. Although I loved the intentional nontheatricality of this work, I became increasingly aware of how engaging in certain activities can trigger audience reactions, and acted on that realization to test our spectators. Over the course of the year, I grew fond of the extremists who verbalized their feelings and interacted with us physically, regardless of whether they were hostile or friendly. It seems to me that they had a certain braveness, even courage, that I don't know I would have in their place. When we came upon Tiny Teesha in Minnesota, I was dumbstruck at first. Not even my own performance had prepared me for the sadness I saw in her eyes, or my own ensuing sense of shame.

Baz Kershaw

PERFORMANCE, COMMUNITY, CULTURE

From: *The Politics of Performance: Radical Theatre as Cultural Intervention* (London: Routledge, 1992).

The roots of a theory

WHATEVER JUDGEMENT IS PASSED ON THE SOCIAL AND POLITICAL EFFECTS of British alternative and community theatre, it must be informed by the fact that the movement was integral to a massive cultural experiment. From this perspective the leading edge of the movement was not stylistic or organizational innovation (though both these were fundamental to its growth); rather, its impact resulted from a cultural ambition which was both extensive and profound. It was extensive because it aimed to alter radically the whole structure of British theatre. It was profound because it planned to effect a fundamental modification in the cultural life of the nation. Hence, the nature of its success or failure is not a parochial issue of interest only to students of theatre. In attempting to forge new tools for cultural production, alternative theatre ultimately hoped, in concert with other oppositional institutions and formations, to re-fashion society.

[In order to] construct a theory which will facilitate our investigations into alternative theatre's potential for efficacy, both at the micro-level of individual performance events and at the macro-level of the movement as a whole [we need to] address a number of basic questions about the relationships between performers and audiences, between performance and its immediate context, and between performances and their location in cultural formations. The answers will show how the nature of performance enables the members of an audience to arrive at collective 'readings' of performance 'texts', and how such reception by different audiences may impact upon the

structure of the wider socio-political order. The focus will be on opposi-tional performances because the issue of efficacy is highlighted by such practices, but the argument should be relevant to all kinds of theatre.

My central assumption is that performance can be most usefully described as an *ideological transaction* between a company of performers and the commu-nity of their audience. Ideology is the source of the collective ability of performers and audience to make more or less common sense of the signs used in performance, the means by which the aims and intentions of theatre companies connect with the responses and interpretations of their audiences. Thus, ideology provides the framework within which companies encode and audiences decode the signifiers of performance. I view performance as a transaction because, evidently, communication in performance is not simply uni-directional, from actors to audience. The totally passive audience is a figment of the imagination, a practical impossibility; and, as any actor will tell you, the reactions of audiences influence the nature of a performance. It is not simply that the audience affects emotional tone or stylistic nuance: the spectator is engaged fundamentally in the active construction of meaning as a performance event proceeds. In this sense performance is 'about' the transaction of meaning, a continuous negotiation between stage and audi-torium to establish the significance of the signs and conventions through which they interact.

In order to stress the function of theatre as a public arena for the collec-tive exploration of ideological meaning, I will investigate it from three perspectives, drawn in relation to the concepts of *performance, community*, and *culture*. I will argue that every aspect of a theatrical event may need to be scrutinized in order to determine the full range of potential ideological readings that it makes available to audiences in different contexts. The notion of 'performance' encompasses all elements of theatre, thus providing an essential starting point for theorizing about theatre's ideological functions. Similarly, the concept of 'community' is indispensable in understanding how the constitutions of different audiences might affect the ideological impact of particular performances, and how that impact might transfer (or not) from one audience to another. Lastly, theatre is a form of cultural production, and so the idea of 'culture' is a crucial component in any account of how performance might contribute to the wider social and political history.

Viewed from these perspectives, British alternative and community theatre between 1960 and 1990 provided an exceptionally rich field of inves-tigation, for three main reasons. Alternative theatre was created (initially, at least) outside established theatre buildings. Hence, every aspect of perfor-mance had to be constructed in contexts which were largely foreign to theatre, thus making it easier to perceive the ideological nature of particular projects. Next, the audiences for alternative theatre did not come ready-made. They, too, had to be constructed, to become part of the different constituencies which alternative theatre chose to address, thus providing another way of highlighting the ideological nature of the movement's overall

project. Finally, alternative theatre grew out of and augmented the major oppositional cultural formations of the period. Particular performances were aligned with widespread subversive cultural, social, and political activity, with the result that they were part of the most fundamental ideological dialectics of the past three decades.

This is particularly the case because, besides being generally oppositional, many individual companies and, to a large extent, the movement as a whole, sought to be popular. As well as celebrating subversive values, alternative theatre aimed to promulgate them to a widening span of social groupings. Hence, the movement continually searched out new contexts for performance in a dilating spectrum of communities. And often – particularly in the practices of community theatre – alternative groups aimed to promote radical socio-political ideologies in relatively conservative contexts. Thus, complex theatrical methods had to be devised in order to circumvent outright rejection. Inevitably, the whole panoply of performance came into play as part of the ideological negotiation, and all aspects of theatre were subject to cardinal experiment so that its appeal to the 'community' might effect cultural – and socio-political – change. In an important sense, then, we are dealing with a rare attempt to evolve an *oppositional popular culture*. [...] Whilst it is obvious that alternative theatre did not bring about a political revolution, it is by no means certain that it failed to achieve other types of general effect. As Robert Hewison (1986: 225) argues, the possibility that it did contribute significantly to the promotion of egalitarian, libertarian, and emancipatory ideologies, and thus to some of the more progressive socio-political developments of the last three decades, cannot be justifiably dismissed. [. . .]

Performance and efficacy

In all forms of Western theatre the gathering phase is designed to produce a special attitude of reception, to encourage the audience to participate in the making of the performance in a particular frame of mind. In other words, the conventions of gathering for a performance are intended to effect a transition from one social role into another, namely, the role of audience member or spectator. A crucial element in the formation of the role is the 'horizon of expectation' which performative conventions create for the audience; that is to say, the framework within which a piece of theatre will be understood as one type of performance event rather than another (a pageant, a pantomime, a classical tragedy) (Bennett 1990). So the precise nature of the audience's role will vary. However, the anthropologist Victor Turner has pointed out that in some respects the role is always similar to that experienced by participants in ritual. It is a *liminal* role, in that it places the participant 'betwixt and between' more permanent social roles and modes of awareness. Its chief characteristic is that it allows the spectator to accept

that the events of the production *are both real and not real*. Hence it is a *ludic* role (or frame of mind) in the sense that it enables the spectator to participate in playing around with the norms, customs, regulations, laws, which govern her life in society (Turner 1982: 11). Thus, the ludic role of spectator turns performance into a kind of ideological experiment in which the outcome has no *necessary* consequence for the audience. Paradoxically, this is the first condition needed for performance efficacy. [. . .]

Theatrical performance [is linked] to carnival and other forms of public celebration which are designed to produce what Victor Turner has called *communitas:* primarily 'a direct, immediate and total confrontation of human identities' (Turner 1982: 47). As, according to Turner, *communitas* is the foundation of community cohesiveness, then the paradox of rule-breaking-within-rule-keeping is crucial to the efficacy of performance in its contribution to the formation of (ideological) communities. It is when this paradox is operating at its most acute – when a riot of anger or ecstasy could break out, but does not – that performance achieves its greatest potential for long-term efficacy. For the 'possible worlds' encountered in the performance are carried back by the audience into the 'real' socio-political world in ways which may influence subsequent action. Thus, if a modification of the audience's ideology (or ideologies) is induced by crisis, whether as a confirmation or a radical alteration, then the function of the rhetorical conventions of dispersal is to effect a re-entry into society, usually in ways which do not lead to immediate efforts to influence the existing socio-political order, in whatever direction. In this respect, theatre which mounts a radical attack on the status quo may prove deceptive. The slow burning fuse of efficacy may be invisible.

It should also be noted that audience members always have a *choice* as to whether or not the performance may be efficacious for them. For the ludic role of spectator permits the participant to treat the performance as of no consequence to her or his life: it's only a fiction, only a 'possible world', with no bearing on the real one. It also follows that if the spectator decides that the performance is of central significance to her or his ideology then such choice implies a commitment. It is this commitment that is the source of the efficacy of performance for the future, because a decision that affects a system of belief, an ideology, is more likely to result in changes to future action. It is in this respect that the collective impact of a performance is so important. For if a whole audience, or even a whole community, responds in this way to the symbolism of a 'possible world', then the potential of performance efficacy is multiplied by more than the audience number. To the extent that the audience is part of a community, then the networks of the community will change, however infinitesimally, in response to changes in the audience members. Thus the ideology of communities, and so their place in culture, may begin to have a bearing on the wider socio-political make-up of a nation or even a continent. [. . .]

Culture and performance

The idea of community as a process of ideological meaning-making helps to explain how individual performances might achieve efficacy for their audiences. However, we need also to determine how different communities might be similarly changed by a single show, or a series of shows, even given the complex variability of readings resulting from contextuality[1] and inter-textuality[2]. We must acknowledge, too, that this problem – which encompasses the issue of how a theatrical movement may influence society – is bound to be exacerbated in contemporary societies which are subject to post-modernist pluralism. To express this, for the moment, in terms of a post-structuralist analysis: if signs are indeed in arbitrary relationship to what they signify, then (pace Esslin 1987: 21) all we can anticipate is a riot of individual readings whose disparate nature can only reinforce the pluralistic and fragmented society which produced them in the first place.

My purpose now is to defend the possibility of common collective readings of performance on an inter-community basis, to suggest how different performances for different communities might successfully produce consonant effects in relation to society as a whole. [. . .] I will adopt [Raymond Williams's] notion of culture as a 'signifying system', by which he means the system of signs via which groups, organizations, institutions, and, of course, communities recognize and communicate with each other in the process of becoming a more or less influential formation within society. In other words, 'culture' is the medium which can unite a range of different groups and communities in a common project in order to make them into an ideological force operating for or against the status quo.

The British alternative and community theatre movement was a cultural formation in the sense adopted above. However, to establish the potential significance of the movement to British society as a whole we need to investigate its place in the cultural organization of post-war Britain. That significance is partly a question of scale, and [. . .] it was by no means negligible in this respect; but even more important were the ways in which the movement was part of the great cultural shifts of the 1960s, 1970s, and 1980s. For its cultural alliances clearly have a bearing on the possible extent of its ideological influence; its potential efficacy cannot be accurately assessed if it is isolated from the very forces that brought it about in the first place. Thus, it is crucial to my argument that British alternative theatre was, at least initially, part and parcel of the most extensive, and effective, oppositional cultural movement to emerge in Western countries in the post-war period: the international counter-culture of the late 1960s and early 1970s.

Much of the debate about the nature of the counter-culture (and later similar formations) has focused on its relationship to the class structure of society [. . .] but 'class' is an inadequate concept for explaining exactly *how* the counter-culture might have achieved such extensive socially disruptive potential.

A number of cultural critics have argued that generational membership may provide a better explanation for the extensive influence of counter-cultures. That is to say, a full-blown counter-culture is ultimately the product of a whole generation, in that all members of a particular generation may be decisively affected by their historical positioning. [. . .] This perspective has profound implications for our assessment of the socio-political status of the institutions of the counter-culture, including the alternative theatre movement. For a start, it moves those institutions from the margins of historical change to somewhere closer to the centre, for those institutions then represent a changed generational awareness both to the generation and to the rest of society. In addition, the institutions are a concrete embodiment and a widespread medium for the promulgation of alternative, and usually oppositional, ideologies. In addition, the generational locus provides a basis for the popularity of the institutions and their forms of production. Hence, the idea of the counter-culture thus conceived enables us to understand how the 'alternative' may become 'popular', how the socially marginal impulse of middle-class youth may become ideologically central to a whole society.

We can gain a measure of what this may mean historically by considering the nature of the cultural movements that in large part issued from the late 1960s counter-culture in the 1970s. [. . .]

The late 1960s counter-culture was a major stimulus to, and a partial source for, the ideological orientations of the great emancipatory and libertarian movements of the 1970s and 1980s. These included the gay rights and black consciousness movements, the women's and feminist movements, the community activist movement and the various movements that fought for the rights of people with disabilities, the elderly, the hospitalized, and other types of socially disadvantaged group, and it may include even the campaign for a popular, grass-roots-based culture that was fought in the mid-1980s.

I am not suggesting, of course, that the late 1960s counter-culture *caused* these movements, for they have their sources in a widespread and continuing dissatisfaction with the inadequacies of late-capitalism in providing for the needs of minorities and marginalized groups. However, that initial counter-culture did provide a 'model' for oppositional action against hegemony, on a grand scale. [. . .] But how could a phenomenon that was so socially diffuse and historically distended possess anything like an identifiable ideology?

Theodore Roszak [. . .] identifies the ideological foundation of the counter-culture as an opposition to hegemony by a utopianist idealism which promoted an egalitarian ethic through the advocacy of participative democracy on a localized level (Roszak 1969: 200).

Now the profound simplicity of Roszak's interpretation indicates how this ideological root for the counter-culture provided the formation with three major advantages for its oppositional promulgation. Firstly, the ideology was amenable to adaptation and elaboration in a phenomenally wide variety of different cultural practices. [. . .] Secondly, it provided the counter-culture

with the principle of non-bureaucratic institutional organization. [. . .] Thirdly, the formulation was adaptable and was adopted by the subsequent cultural formations as a central element of their ideologies. Despite their sometimes profound differences, and the contradictions between them, they can be related to a singular ideological tendency which was in deep opposition to the status quo. So, at the very least, these movements were united by resistance to the dominant order; but also they maintained at least a modicum of ideological coherence through their commitment to egalitarianism and participatory democracy.

Thus, the idea of the counter-culture provides us with a key theoretical component for understanding how particular performances connected with general social change from the 1960s to the 1980s. For the British alternative theatre movement was only one, relatively small, part of the counter-cultural and emancipatory movements of the 1960s, 1970s, and 1980s. As such it played, I think, a key role in promoting and popularizing oppositional ideologies. [. . .] Its chief tactic was allied to the emergence of the aesthetics of anti-nuclear, anti-war, and civil rights demonstrations in Britain and the USA. This is best described as a carnivalesque resistance to the oppressions of affluence, as promoted by the capitalist, technocratic, and meritocratic status quo. [. . .] A new mode of *celebratory protest* [. . .] challenged dominant ideologies through the production of alternative pleasures that were particularly attractive to the generations born in the 1940s and 1950s. And, inevitably, its audacity was greeted with an ambiguous embrace by the dominant socio-political order.

Notes

1 Contextuality: the propensity of a performance text to achieve different meanings according to the context in which it occurs. The 'ideological relativity' of a text results from contextuality.

2 Inter-textuality: the ways in which the codes (conventions/signs) of a performance text gain meaning for an audience through its relationships with other texts.

Sexuality in performance

Katharine Cockin

INTRODUCTION TO PART FIVE

THE ESSAYS IN THIS PART DEMONSTRATE THAT DEBATES ABOUT SEXUALITY have held a prominent position in Europe and the Western world in the late twentieth century which has witnessed sex wars, sexual revolution, sexual liberation, a sex industry, and cyber sex. Sexuality is, as Joseph Bristow explains, a relatively recent term. The concern to define sexuality which has been developing from the mid-nineteenth century has been driven by regulatory and normative motives and by liberatory demands for civil rights. Arguments about identity (including sexual identity) have begun to deploy a specialized notion of performance to articulate the way in which a sense of self is constructed through a dynamic and precarious process within language. The poststructuralist concept of discourse (a system of language practised within a social context of power relations operating by determining and structuring what can be said and what is unspeakable) is used to argue for the construction of the self or 'subject' within language, so that language speaks me as much as I believe that I speak it. Subject formation within language involves subjection rather than self-determination. The humanist term 'individual' is therefore frequently rejected because of its association with a coherent unified self operating through an unproblematic rationality and agency. Theories of language, such as structuralism and poststructuralism, and theories of the unconscious, proposed by Sigmund Freud (1859–1939) and Jacques Lacan (1901–81), have made a significant impact on the debates about identity and sexuality.

Bristow's historical survey of the term 'sexuality', in a series of books on 'today's critical terminology', explores the relationships between sexuality,

sex, the body, and desire. The term 'sex' is used in a number of ways: as a category to distinguish between female and male; and to signify a sexual encounter, as in 'having sex', which invariably represents only (hetero) sexual intercourse (penile–vaginal penetration). Indeed, the precise legal interpretation of such vocabulary has played a significant part in contemporary US presidential politics. Ways in which the body is sexed and how this relates to sexual desire have been problematized by a number of cultural practices, including performance art and film. The film *Sick: The Life and Death of Bob Flanagan, Masochist* includes scenes which could be described either in terms of genital mutilation or of sexual gratification. The indeterminacy arises from the acknowledgement of a diversity of sexual desires and demonstrates the ways in which available meanings are constrained by different discourses. Bristow traces the significant shift in thinking about sexuality from the mid-nineteenth-century sexologists, whose prescriptive and normative approach tended to classify and pathologize, to the psychoanalysts' dissociation of sexuality from reproduction, posed by Sigmund Freud and latterly Jacques Lacan. Sexologists theorized homosexuality in terms of 'inversion' or a 'third sex', acknowledging its existence while constructing it as abnormal. Feminist critique of Freud and Lacan has demonstrated that their theories are phallocentric (centring on the phallus), often eliding phallus with the anatomical penis itself. Melanie Klein (1882–1960) and Nancy Chodorow (b. 1944) are amongst those who have recast the frame in order to foreground mother–daughter relationships and female sexual desire. Nevertheless the revolution posed by Freudian thinking resides primarily in locating the formation of sexual desire in childhood and in arguing that it is acquired rather than innate. The turbulent and dynamic drives associated with sexual desire have provoked debates about pornography and violence. Michel Foucault (1926–84) has been influential in exploring the relationships between power and desire, while later theorists have attempted to dislodge the presumed connections between sex, gender, and sexuality. Bristow identifies the diversity of contemporary debates about sexuality, particularly regarding 'bisexuality, transgender issues and sexual communities of colour' (below, p. 161).

Further problems arise from the prescriptive and normative approaches of Freudian psychoanalytic accounts of sexuality. Two such problems present themselves: a heterosexual ideal is presumed, designating homosexuality as an effect of faulty development; and the emphasis on early formation of sexuality which, while significantly challenging the notion of innate sexuality, risks fixing an origin for sexuality at some point. Weeks accounts for such difficulties in his taxonomy of four key paradoxes concerning identities. This format in some senses parodies, or cites, the classificatory approach of the sexologists. Weeks notes that the attachment of sexual identities to class, race, national, and gender identities has recently been challenged. Paradox

1, the assumption that sexual identities are fixed and unified, is also central to heteropatriarchy (the system of values and institutions which structure the oppression of women, reproducing a normative heterosexuality). The revelation of the unstable and diverse nature of sexual identities appears at moments of crisis when norms are threatened or when categories simply do not fit. Such crises have occurred when political activists have challenged – with a view to achieving civil rights for gays and lesbians – the exclusivity of certain categories otherwise presumed to be all-inclusive, such as marriage, access to adoption, and military service. Paradox 2, that identity is both 'deeply personal' and social, is revealed through the reinvention of the self in a social and cultural context.

Paradox 3 notes that sexual identities appear to be 'simultaneously historical and contingent' rather than natural, necessary truths to be expressed. Instead sexual identities are historically changing, making any narrative vulnerable to contestation. For example, genetic arguments about homosexuality generally have sought the 'origins' of homosexuality, locating it in the body. Both biological essentialist and poststructuralist arguments about sexuality have been concerned to identify 'origins', most particularly as regards homosexuality. Heterosexuality, presumed to be the norm, has not been considered worthy of investigation until very recently. A concern for the historian writing about same-sex desire in the past is whether it is possible to claim lesbians and gays prior to the nineteenth century, the point when a homosexual identity was constructed. Furthermore, there is no necessary connection between desire and social identity. Thus one may not recognize oneself in a particular sexual identity, as occurs, for example, when same-sex encounters are practised by self-identified heterosexuals. History and the formation of new identities are linked when narratives use the past to make sense of the present positioning, to differentiate, to assert, to unify a group. Paradox 4, the notion that sexual identity is a fiction, or a narrative, serves the purpose of denaturalizing sexual identity. In this way, heterosexual identity would also acquire a fictional status. The power of dominant identities resides in their naturalization such that it is a rare occasion when, for instance, a heterosexual makes an announcement to that effect. In producing workable alternative fictions of identity, identity itself is denaturalized, revealing the power structures which maintain the insidious fiction that identity is natural, is inevitably thus and not otherwise. The remaking of identities is a sign of agency and potential for change. Thus 'identities can be remade', emphatically moment by moment produced, or indeed performed.

Theorists such as Sedgwick and Butler have revived and developed the work in the philosophy of language by J.L. Austin (1911–60) to explore the relationship between speech and act. The concept of performance, more specifically the performative, has been used subsequently more widely, beyond the linguistic domain of pragmatics, to consider the context of language moment

by moment in producing the subject provisionally or partially as an inevitably incomplete process. Butler remarks on the risks which this focus on the momentary nature of the process, 'the presentist view of the subject', poses for historical accounts of subjectivity. For example, the term 'queer' has been appropriated and reworked, transforming it from a term of abuse to a celebratory affirmation. This demonstrates the dynamics of interpellation (hailing or invocation) of the subject whereby an identity or subject position is constructed through the performative (defined by Butler as 'forms of authoritative speech') which functions through the power of repetition and citation. The citational and iterative aspect of performativity is dependent on prior conventions and practices rather than bound within the present moment. Thus the subversive effect of the term 'queer' requires the citation of the abusive meaning of the term. This reversal risks reinforcing the existing power structure which is actually being challenged. This exemplifies the instability of subjectivity. There is a risk in identity categories of reinscribing and reanimating other meanings. It is therefore a dynamic process, the effects of which are unpredictable. Sedgwick and Parker examine the terms of Austin's exclusion of 'anomalous, exceptional, nonserious' performatives which, indeed, associate the theatrical with the abnormal. The contemporary circumstances of homophobic persecution in the US army appears to demonstrate aspects of Austin's argument: saying as doing, the relationship between speech to act, and act to identity. The context of speech and the relationship between speech and auditors prove to be significant.

The umbrella term 'queer' has signified a problematic grouping when it has effaced otherwise significant differences in the name of a political coalition. Some critiques of queer have argued that the term excludes lesbians and that queer theory is irrelevant to queer political activism. 'Queer' identity has provided a new position from which to challenge norms yet the instability of identity produces vulnerabilities. While it frees up the binary opposition of hetero/homo-sexual, which inevitably privileges the former term, its diverse meanings include those who politically affiliate to anti-homophobic discourse.

Such boundaries and distinctions are to some extent challenged by the exuberance of Kushner's essay which presents an optimistic political critique within an autobiographical narrative, making references to contemporary local politics and to their broader implications. The opposition between theory and practice reserves some space for a discourse which is beyond theorizing: this is exposed as a false opposition in Kushner's work as a theatre practitioner. Kushner's dream of guilt and self-hatred about his first sexual experience is used to narrate the process whereby identity is formed through the transformation from victimhood to agency. Yet Kushner links the subjective reorganization of dream material to the community within which change is possible.

Hill's essay argues, as its title asserts, that 'suffragettes invented performance art'. Hill is self-consciously provocative in an enthusiastic sweep across history, connecting the controversial contemporary performance artists who explore the explicit or medicalized body with the activities of women who campaigned for the vote in Britain in the first two decades of the twentieth century. Performance art is discussed in relation to the theatre on the basis of approaches to form and content, to 'life,' art, and propaganda, to the personal and the political. Hill challenges the opposition between performance art and 'life' yet risks reinstating others (theory/practice; form/content) while emphasizing agency and the momentary performative act, risks privileging an image of empowerment above the histories of a political struggle.

The spectacle of suffrage activists exemplifies a challenge to femininity in which power was circulating in a volatile way. The self-conscious visibility of women in the public sphere as political agents was often represented in the press in a voyeuristic manner, transforming 'terrorists' into dissident female bodies, curious freaks who either refused to conform to conventional feminine appearance or achieved it in spite of unconventional behaviour. As Butler pointed out, the 'conceit of autonomy' fails to attend to the instability of subjectivity. Although suffrage activists constructed a political position for themselves in other contexts they were forcibly placed, in spite of the lack of fit, into the impossible and rejected subject position of femininity. To some extent the performances of civic disobedience were given from available scripts. The arguments for women's enfranchisement thus cited the Enlightenment tradition and constructed the enfranchisable woman in imperial, anglocentric terms: the white English mother. The suffrage marches explicitly cited earlier political revolts. The 'suffragette' was, like 'queer,' a 'reverse discourse' whereby a term of abuse was appropriated and used in defiant celebration. If the 'suffragettes' can be understood in terms of performativity their power derives not from their uniqueness – as origin of performance art – but from their citation of earlier phenomena and contexts.

Queer is mobilized against identity by means of parody and mimicry to act out, or perform to excess, roles which otherwise are widely uninvestigated or held to be self-evidently natural. Thus drag, camp, and role-play are aspects of the theatrical which is, as Jill Davis has remarked, 'the trope of queer' (Davis 1997: 80). Butler has emphasized in her later work that performativity does not imply free choice for the performing subject but rather a subjection to act out available scripts. Clearly the concept of performativity has brought fresh attention to performance and theatre, possibly challenging the boundaries of the everyday and the theatrical.

Leslie Hill

SUFFRAGETTES INVENTED PERFORMANCE ART

LONG BEFORE KAREN FINLEY SMEARED CHOCOLATE ON HER BOTTOM, Annie Sprinkle showed us her cervix, or Orlan began her course of reconstructive cosmetic surgery performances, comely Edwardian ladies were pioneering a new hybrid art form in which the personal was political, the political was performative, and the performance was public.

In the late twentieth century taboos have become a rare delicacy, making iconoclasm ever more difficult and subsequently dramatic, so it may seem a stretch at first to compare Orlan's surgically implanted horns with Mrs Pankhurst's slender wrist handcuffed to the Prime Minister's carriage, but on closer inspection they are practically joined at the hip. To say that the suffragettes invented performance art is a rash, though intriguing, claim, and in order to substantiate it I would seem to unwisely volunteer myself for a headlong rush into the thick of the cultural, critical, and post-postist frenzied foray by attempting a definition of 'performance art'. If we've learned anything from critical theory it is simply that everything is up for grabs, so I offer my quick exegesis of performance art not as definitive, but rather as another contribution to an ongoing dialogue from the perspective of a performance practitioner.

The most fundamental element of performance art/live art is live presence, the presence of the performer and the live reception by an audience. Defining this type of work generally involves stating what it is not, in particular differentiating it from two things: on the one hand, from the world of theatre, of artifice, of acting; and, on the other hand, apparently contradictory to this, from 'real life'. Both theatre audiences and performance art

audiences make no bones about the fact that these two art forms are totally distinct, normally avoiding either one or the other. Mirage-like, the boundaries between theatre and performance art appear to be very clear until they are approached too closely, at which point the distinct impression seems to vanish. Distinctions between the two forms are based primarily on association and stereotype, things that characterize rather than define. Ten top performance art associations/stereotypes in my experience, for example, are: (1) that performance artists are perpetually naked; (2) that performance pieces are necessarily filled with effluvia; (3) that performance artists are either gay men, straight women, lesbians, women of colour, men of colour, unemployed Northern Irish single-parent coal miners or some otherwise oppressed minority; (4) that performance artists are either smart or smart asses; (5) that performance artists are self-indulgent; (6) that performance art is probably political, even if no one can understand it; (7) that solo performance work is usually autobiographical (a logical progression of 3 and 5) and is frequently self-written, directed, and performed; (8) that performance art events will be advertised using one or more of the following adjectives: 'cutting-edge', 'ground-breaking', 'iconoclastic', 'uncompromising', 'hard hitting', 'contemporary', and/or 'in your face'; (9) that a wig on the head of a performance artist is a prop, not a costume; (10) that within any given performance piece, meaning will be deconstructed faster than it is constructed, thereby leaving the audience in deficit by the end of the piece.

These are all associations which characterize performance art as distinct from theatre though none of them actually precludes theatre, nor do these associations serve to untangle the conceptual roots of the two forms. The real difference and the most significant differentiating factor between the two, to my mind, is the respective relationship between content and form. In theatre, form is more or less a given structure within which an infinite array of content/subject matter can be represented and explored in a variety of styles; in performance art, the content generally proceeds and determines the form of a piece so that both the content and the form are sources of infinite possibility. Most theatre can be described starting with the three-word preface 'A play about —,' whereas in performance art there is no such precedent of form and a piece may be described as an event, a performance, a happening, a time-based or durational piece, an installation, a video, a web site, etc., signifying that while theatre by definition assumes a form, albeit flexible, performance art is defined by nothing so much as its proclivity to shape-shift. While some of this experimentation with form no doubt comes from the inevitable pressure on the artist to present works which are 'cutting edge', 'ground-breaking', and 'iconoclastic', I believe most of it originates from a desire to better suit the formal expression of art works to their content. In a nutshell, I would make the distinction that theatre is led by form and performance art is led by content.

At the other end of the spectrum, we encounter that hoary old chestnut: 'What is "art" and what is "life"? . . . and what is "live art"? . . . and which

came first the chicken or the egg?'. If watering plants in a greenhouse, stalking random strangers in the street, photographing oneself every hour on the hour for a year all count as acts of performance art, where do we draw the line between an art event and life itself? Again, this perhaps mythical boundary seems to manifest itself as a series of mirages: most of us perceive a distinction between the two, and yet if we come too close the images dissipate only to reappear further towards the horizon. Many have hinged the issue, and I would tend to follow suit, on the absence or presence of intentionality on the part of the would-be artist. If an action is consciously conceived and executed as a performance by the artist, then who's to say them nay? In addition to deliberate intent, I would also cite the existence of a 'performance presence awareness', the artist's awareness, to some degree, of the effect they create as a performer, as an important element when distinguishing between what is and what isn't performance art. Similarly, I would cite a degree of 'performance presence control', the artist's ability to control the effect they create as a performer as significant. In naming these points I hope to have made the best of a bad job in establishing a performance art definition loose enough to allow for the fluidity of the art form and yet not so vague as to be meaningless.

In my understanding and usage of the term, then, any of number works presented in gallery and theatre spaces could be dubbed performance art, but so would certain political demonstrations. For example, in December 1997 British news featured a story in which disabled citizens demonstrated against proposed government funding cuts to their benefits. An image which seared the public consciousness was that of an armless, legless man on the ground in front of Parliament, painting the pavement blood-red with his stumps. In this instance, disabled protesters quite accurately surmised that the live presence of even a handful of them in front of Westminster would make an impression much stronger and more powerful than petitions with thousands of signatures. As for the thalidomide man, I believe he demonstrated an absolute awareness of his performance presence and absolute control over that presence within the context of the demonstration. He wasn't 'acting' a part, and yet he was most certainly 'performing' to the public, with a very keen understanding of the dramatic and emotive effects of his performance. The performance was absolutely content-led, the form adopted having been deemed the most effective within the context of the political struggle. Some would distinguish, in this case, between art and propaganda, and categorize the event I have just described as the latter. To insist, however, on a generic categorization of 'art' and 'propaganda' as mutually exclusive would be simplistic and elitist, or as Lisa Tickner has pointed out, 'a kind of propaganda for art: . . . secur[ing] the category of art as something complex, humane and ideologically pure, through the operation of an alternative category of propaganda as that which is crude, institutional and partisan' (1987: xi). From my perspective, the event witnessed by the British public was performance art, not theatre, not simply 'life', but powerful, political performance art.

Necessity, so they say, is the mother of invention. Likewise, social prejudice, political oppression, and negative stereotypes seem to be the surrogates of performance art. Plants flower more prolifically in borderline conditions. Performance, likewise, grows thicker and faster in the margins and cracks of society than it does in the centre. For example, I don't know of a single performance put on by a white American nuclear middle-class family with 2.5 children and a Jeep Cherokee. Most of the performers I can think of off the top of my head are either women, gay, and/or racial minorities. Probably this isn't a coincidence. The emergence of performance art has, quite correctly, been linked historically to visual and conceptual art in the 1960s and 1970s, but it has its deepest roots, I would argue, in the feminist movement. After all, suffragettes invented performance art. Of course artists have always promoted, questioned, or opposed the various cultural hegemonies within which they work, whether consciously or unconsciously, but the suffrage movement was the first in British history systematically to organize the arts on a massive scale into a political sword and shield. The work produced within the suffrage movement was undeniably propagandist in that it was created within the context of a political campaign with particular beliefs and arguments and with the aim of bringing about direct political reform as well as ideological change. It was also so powerfully performative that the images have stayed with us quite clearly even through an entire century of remarkable feminist reform and 'outrageous-up-front-in-your-face' art.

Among the vanguard of the most active, most visible, and most influential women in the suffrage movement were the actresses. The Victorian ideal of middle- and upper-class domestic bliss revolved around the notion of 'separate spheres' for the sexes; the man's world was the public world of business and commerce, a worldly world necessarily tainted and tarnished (and plagued by sexually transmitted diseases), while the woman's was the domestic sphere, the world of tranquil beauty and uplifting spirituality wherein the overall moral health of the family could be kept flowering in germ-free hothouse conditions. Actresses led lives clearly outside the prescribed pattern and were therefore less inclined to worry about shocking the neighbours or jeopardizing their financial security than the traditional 'womanly woman', who was more often than not strictly socially confined and financially dependent on her nearest male relative. Despite the hitherto lowly rank of actresses, who were classed for centuries with prostitutes, theatre critics of the late nineteenth century had made Ellen Terry a household name, bestowing a new air of dignity and respectability on the profession. The rise of the popular press and its increasing coverage of the theatre and its leading personalities also set a precedent for star-gazing in which entertainers would be more frequently solicited for personal details, including their political opinions. When the militant suffrage campaign began, actresses were already unconventional, financially self-sufficient, accustomed to performing in public and learning how to work with the press: they were the natural choice as field marshals to the generalship of the Pankhursts.

Initially, actresses and female playwrights did what they knew best: they put on plays. With the exception of Elizabeth Robins's successful three-act play, *Votes for Women!*, suffrage plays were generally short, low-budget affairs, put together in snatched moments of free time and generally presented to highly informed audiences of 'the converted'. Writing for audiences versed in the arguments of 'pro' and 'anti' platforms, it is perhaps not surprising that the suffrage theatre normally confined itself to short, concise sketches rather than full-length plays, and that most of these sketches concentrate their energies on undermining the opposition, rather than repeating pro-suffrage arguments. Just as cartoon caricature had been an effective weapon against suffragists, portraying them in various unflattering guises such as the 'old maid' or 'the shrieking sisterhood', suffrage theatre provided a quick, impressionistic means to strike back at their opponents with the very weapon which had proved so difficult for feminists to wield: humour. Despite the suffrage theatre's success as a locus for community solidarity and a breeding-ground for the development of well-honed pro-suffrage arguments, these events were simply too small to create much of an impact beyond their immediate audiences. The suffrage issue was one that had been introduced into Parliament by John Stuart Mill in 1867 and had been more or less successfully swept under the carpet for fifty years. What the women needed, first and foremost, was to capture the attention of the public at large and under the circumstances, low-budget theatre wasn't the ideal medium. Suffragist artists held fast to their content and adapted their form: plays, paintings, and private concerts metamorphosed into marches, banners, and cavalry trumpets.

In addition to inventing performance art, the early feminist movement also coined the phrase 'the personal is political' and demonstrated that 'the medium is the message' long before McLuhan. The message was that women's rights and women's influence should no longer be confined to the home, but should extend into the public sphere; the medium was thousands of women marching together through the streets of the capital city. A pro-suffrage play might reach an audience of one or two hundred people per performance, most or all of whom were already supporters. The suffrage artists and the suffrage political leaders realized the need to stage a performance the entire nation could attend. The first of these marches was the 'Mud March' of 9 February 1907 in which 3,000 women marched through the horrible weather from Hyde Park Corner to an assembly in the Exeter Hall. Humble though it may have been, this march and the mass-media coverage it excited gave the movement more publicity in one week than it had enjoyed in the previous fifty years, catapulting the fight for women's suffrage into the public consciousness. Partly in response to a reported remark by the Prime Minister that he simply didn't believe the majority of women actually wanted the vote, the WSPU (The Women's Social and Political Union) organized 'Women's Sunday' on 21 June 1908, in which women from all over the country were urged to turn out in public to show the Prime Minister, the

MPs, and the nation at large that the suffrage campaign comprised not simply a few dour spinsters but women from all ages and all walks of life. Mrs Pankhurst declared it the largest political meeting in English history and even *The Times* estimated the attendance at half a million people, conceding, 'it is impossible to recall anything at all comparable in mere magnitude.' On 17 June 1911, forty thousand women marched again in their most spectacular and theatrically executed procession, a seven-mile-long stream of women with music, floats, hand-embroidered banners, and historical costumes worn by women representing great women of history, such as Joan of Arc. The parade was called the Women's Coronation Procession because in scale and grandeur it fully rivalled the great national tradition of the coronation procession.

Through the spectacle of the marches and the power of the live presence of the women themselves claiming centre stage in the national press, the public was largely converted to their cause. The government, however, turned down their reform bill in 1912, giving rise to a new wave of performances. Whereas the processions had shown the public a peaceful, 'feminine' front of women (and perhaps the grandest millinery display in history), continued government opposition spawned a new hybrid of politics and performance, a more visceral, uncompromising, iconoclastic, hard-hitting, in-your-face style of performance. This time the women specifically targeted the privileged white male where it would really hurt: they burned feminist slogans into golf courses with acid; burned cricket pavilions and tea rooms, smashed the windows of London clubs, and bombed or burned unoccupied country houses, including Lloyd George's half-completed home in Surrey. Pillar boxes were set alight, telegraph wires were cut, and railway stations were burned. One might argue that these were acts of terrorism rather than performance, but no one can dissuade me from thinking that the scores of fashionable ladies who synchronized their wristwatches, made their way to the select shopping districts of Oxford Street, Knightsbridge, and Kensington and demurely produced hammers from dainty handbags with which they decorously smashed exclusive windows, were not exquisite performers with absolute performance awareness and control, perfectly marrying the content and the form of their work. There are countless examples of political 'performance' to be found in the suffrage movement, from Mrs Drummond's megaphone address from the cabin roof of a river launch to members of the Commons on their terrace tea-break, to Mary Richardson's slashing of the Velázquez *Rokeby Venus* in the National Gallery as a protest against the imprisonment of Mrs Pankhurst, to hunger striking in prisons. My purpose here isn't to catalogue them all, but rather to note the cross-fertilization of politics, theatre, and philosophy which gave rise to so many of the ideologies which drive contemporary performance art, such as 'the personal is political', the focus on the body as a site of oppression and resistance, the potential effectiveness of guerrilla tactics in alternative representations of the 'status quo', the power of the live presence and of performing personal truths rather than

'acting'. I suppose this is really all by way of saying that I'm sick of 'post-feminism' and I'm tired of young women who can't be bothered to have political opinions and I'm irritated by visual artists who think they invented performance in the 1960s and 1970s, and I'm uninspired by deconstructionist and postmodern critics who pour scorn on sincerity and I'm bored by art that doesn't say anything about anything, so I thought maybe somebody ought to state for the record that suffragettes invented performance art. And by the way, they got the vote too.

Joseph Bristow

S E X U A L I T Y

From: *Sexuality* (London: Routledge, 1997).

WHAT IS SEXUALITY? To this blunt question, the answer would seem clear enough. Sexuality is surely connected with sex. But if we find ourselves pressed to define what is meant by sex, then the situation becomes somewhat more complicated. In the English language, the word sex is certainly ambiguous. A sign with various connotations, sex refers not only to sexual activity (*to have sex*), it also marks the distinction between male and female anatomy (*to have a sex*). So it would perhaps be wise to think twice about the ways in which sexuality might be implicated in these distinct frameworks of understanding. Is sexuality supposed to designate sexual desire? Or does it refer instead to one's sexed being? If we find ourselves answering yes to both enquiries, then sexuality would appear to embrace ideas about pleasure *and* physiology, fantasy *and* anatomy. On reflection, then, sexuality emerges as a term that points to both internal and external phenomena, to both the realm of the psyche and the material world. Given the equivocal meaning of sex, one might suggest that sexuality occupies a place where sexed bodies (in all their shapes and sizes) and sexual desires (in all their multifariousness) intersect only to separate. Looked at from this dual perspective, there are many different kinds of sexed body and sexual desire inhabiting sexuality. Small wonder this immensely significant term has for decades generated a huge amount of discussion from conflicting critical viewpoints. [. . .]

Sexuality is a comparatively new term. The word became common currency in late-nineteenth-century Europe and America when anthropological, scientific, and sociological studies of sex were flourishing as never before. In its earliest scientific usage, sexuality defined the meanings of human

eroticism, and when marked by a prefix – such as 'bi', 'hetero', or 'homo'– the word came to describe types of person who embodied particular desires. In previous decades, however, the label sexuality was used somewhat differently, and it is worth pondering briefly the rather unexpected contexts in which sexuality appears at these earlier times.

Dip into the *Oxford English Dictionary* and you will see that the first recorded use of sexuality appears in 1836. The word turns up in an edition of the collected works of eighteenth-century English poet, William Cowper (1731–1800). Cowper's editor notes that this eminent writer 'built his poem' titled 'The Lives of Plants' upon 'their sexuality'. The *OED* suggests that in this editorial commentary sexuality means 'the quality of being sexual or having sex'. Yet 'having sex' in this particular instance refers primarily to botany. This example alone plainly shows that sexuality has not always belonged to an exclusively human domain.

A slightly later usage of sexuality may also strike us as a little surprising. The *OED* lists its third definition of the word in a quite familiar manner, as 'recognition of or preoccupation with what is sexual'. Yet here, too, the example employed to support this definition presents 'what is sexual' in an uncommon way. The example in question comes from the authorial Preface to *Yeast: A Problem* (1851), a polemical Condition-of-England novel by English writer Charles Kingsley (1819–75): 'Paradise and hell . . . as grossly material as Mahomet's, without the honest thorough-going sexuality, which you thought made his notion logical and consistent'. This sentence may well encourage us to ask why Kingsley should associate sexuality with argumentative rationality. Rarely, if ever, in the twentieth century has sex been thought to underpin the cognitive powers of the mind. To the contrary, some theorists are convinced that sexuality opposes reason because it exerts a hydraulic force which threatens to rise up and subvert the logical intellect.

If these two examples from the *OED* have any value, then it is to confirm that the contemporary perspectives from which we view sexuality have for the most part arisen in the past century. [. . .] Only by the 1890s has sexuality and its variant prefixed forms become associated with types of sexual person and kinds of erotic attraction. [. . .]

Having devoted much of his research to examining the recent emergence of the word sexuality in its current sense, Jeffrey Weeks remarks that it is vital not to forget that 'what we define as "sexuality" is an historical construction' (Weeks 1986: 15). Warning against the belief that sexuality refers to an essentially human quality known through all time, Weeks claims that sexuality is a ' "fictional unity", that once did not exist, and at some time in the future may not exist again'. In other words, the term sexuality is historically contingent, coming to prominence at a time when detailed attention was increasingly turned to classifying, determining, and even producing assorted sexual desires. Consequently, he questions whether sexuality is an entirely suitable expression for discussing the erotic lives of cultures that preceded the late-Victorian moment when sexuality earned its current name. [. . .]

The rise of sexuality as a peculiarly modern phenomenon [is illustrated by] the development of sexology, in particular from the 1860s through to the early twentieth century. Sexology was the science that sought to know the name and nature of diverse desires and sexual types, and the comprehensive vocabulary it created retains its influence to this day. Not only did sexology bring the figures of the bisexual, homosexual, and heterosexual to public attention, it also investigated perverse behaviours, including sadism and masochism. Sexological writings often went to inordinate lengths to classify sexual perversions, compiling case histories that featured men and women making frank and startling disclosures about their erotic desires. Countless volumes of this kind provided an imposing, if at times inflexible, system of terms for describing a broad range of sexual types and practices. But such works did not always celebrate the phenomena they investigated. Since early sexology often leant heavily on medical science, it had a marked tendency to codify certain sexual behaviours as categories of disease. It would take many decades before sexology decisively shifted its emphasis away from pathologizing styles of sexual conduct. By comparison, modern scientific inquiries in the sexological tradition often try to refrain from presenting dissident desires as illnesses. Yet despite their liberal-minded gestures, books of this kind still [. . .] often take pains to identify norms against which sexual performance can be measured. The same is largely true of popular works that offer sexual advice. Authors of contemporary guides on sex often focus on developing tried and tested techniques that will lead to orgasm: an event that sexologists almost always concur is the ultimate aim of sexuality. [. . .] Despite its taxonomic zeal to expand our knowledge of eroticism, sexology unfortunately has limited explanatory power when investigating all the different sexual identities and behaviours it seeks to evaluate.

If, since the turn of the twentieth century, one field of knowledge has more than any other taken our understanding of sexuality well beyond sexology, then it is surely psychoanalysis. In his researches into the unconscious Sigmund Freud (1859–1939) strived (and sometimes failed) to divorce his analytic methods from those of nineteenth-century hereditarian science, the field of inquiry that fascinated the earlier generation of sexologists. [. . .] His successor, Jacques Lacan (1901–81), by locating desire within the field of signification at last disengaged psychoanalysis from its scientific heritage. In many respects, Lacan's work completes one of the main tasks begun by Freud: to dissociate eroticism from biological mechanisms. Psychoanalysis was the first body of theory to produce a detailed account of why sexuality must be understood separately from reproduction. [. . .]

Freud identified the two interdependent structures he called the Oedipus and castration complexes. Similarly, Lacan argued that sexuality was structured around the primary symbol of cultural authority he named the phallus. Both writers have gained notoriety for developing what undeniably are paradigms that take the centrality of the anatomical penis, the psychology of penis-envy, the symbolic power of the phallus entirely for granted.

Psychoanalytic phallocentrism would become the subject of intense debate among feminists, both in the late 1920s and early 1930s and again from the late 1960s onwards. [. . .] Whereas some feminists claim that this complex body of research is largely a symptom of patriarchal dominance, others argue that psychoanalysis provides significant clues about both the cultural and psychic mechanisms that assist in perpetuating sexual inequality in the West.

One of the main lessons of psychoanalysis is that sexuality comprises turbulent, if not destructive, drives whose early formation can at times prove impossible to eradicate in adult life. Freud's belief that the conflicted libido was caught in a life-and-death struggle would shape much subsequent discussion about the volatile condition of eroticism. Two notable debates focus on sexuality as a seemingly boundless source of impulsive energy caught within a dynamic of creation and destruction. The first is found in the work of several avant-garde theorists – including Georges Bataille (1897–1962), Gilles Deleuze (1930–95), and Félix Guattari (1930–92) – who have tried to unravel why sexuality violently oscillates between life and death. The second appears most vividly in modern feminist debates about pornography. Undoubtedly, pornography continues to divide feminist opinion about the injurious or emancipatory effects of erotic desire. On the one hand, many radical feminist campaigners against pornography claim that it leads time and again to violent sexual crimes, and should therefore be legally called to account for the serious damage it causes. On the other, libertarian feminists eager to combat punitive state censorship argue that [. . .] some types of graphic sexual representation can allow women to explore and emancipate desires otherwise suppressed in a patriarchal society.

Yet this widespread emphasis on how sexuality either represses or frees sexual desire strikes French social theorist Michel Foucault (1926–84) as nothing more than a means through which power has been organized in Western society. In *The History of Sexuality* (1976–84), Foucault prompts us to contemplate the historical circumstances that shape some of the leading claims made by psychoanalysts and philosophers about the explosive condition of eroticism. [. . .] By concentrating on how power-laden discourses construct desire, he scrutinizes the conceptual regimes that have led many thinkers, from Freud to contemporary feminists, to much the same conclusion: that tempestuous sexual desires are inevitably trapped within a system of suppression and liberation. Repeatedly, Foucault explores the cultural dynamics that have persuaded the modern epoch to believe that sex 'has become more important than our soul, more important almost than our life' (Foucault 1978: 156). [. . .]

Acutely conscious of how powerful concepts such as sexuality come to dominate our lives, Foucault examines the political fabrication of influential beliefs which profess that erotic behaviours, identities, and styles are fundamental to human existence. In the process, Foucault constantly looks at how sexuality emerged as an intelligible category whose widespread acceptance has played a crucial role in regulating the social order. Although on

occasions strongly criticized for treating eroticism as if it were separate from gender, Foucault has none the less inspired a later generation of feminist and queer theorists to confront the cultural interests served by the meanings ascribed to sexual desire. In this regard, critics such as Judith Butler, Gayle Rubin, and Eve Kosofsky Sedgwick have paid close attention to the troublesome ways in which modern society has been remarkably willing to accept essentialist definitions of what it means to be male or female, masculine or feminine, heterosexual or homosexual. Their work stands at the forefront of a vibrant series of critical explorations that reveal why we need to denaturalize the essentialist presumptions about desire that have governed modern approaches to erotic identities and practices.

As we head towards the next century, few would doubt that the established categories through which the West has long understood sexuality are now under considerable strain. In a late-capitalist world influenced by fragmentary postmodern styles of thought, sexual identities are undergoing such rapid transformation that the sexological and psychoanalytic classifications that were once readily accepted are starting to look redundant. Sexual identities are currently diversifying: debates are flourishing about bisexuality, transgender issues, and sexual communities of colour – all of which contest the antiquated vocabulary that persists in misrepresenting their desires. [. . .]

Chapter 26

Jeffrey Weeks

THE PARADOXES OF IDENTITY

From: *Invented Moralities: Sexual Values in an Age of Uncertainty* (Cambridge: Polity, 1995).

IDENTITIES ARE TROUBLING BECAUSE THEY EMBODY SO MANY PARADOXES: about what we have in common and what separates us; about our sense of self and our recognition of others; about conflicting belongings in a changing history and a complex modern world; and about the possibility of social action in and through our collective identities. And few identities are so paradoxical as sexual identities.

Sexual identities have a special place in the discourse of identity. They are like relay points for a number of interconnected differences, conflicts, and opportunities. For the past few centuries, at least, sex may have been central to the fixing of the individual's place in the culture, but it has not been simply a categorization and placing for a *sexualized* identity (as male or female, normal or pervert, heterosexual or homosexual), rather for a whole set of social positionings. Concepts of national identity have been intricately bound up with the notions of appropriate gendered or sexualized behaviour (Parker *et al.* 1992). The injunctions of nineteenth-century imperial propagandists to the young innocent – to 'be a man' and eschew masturbation, homosexuality, or nameless other secret sins, or to embody motherhood and purity for the sake of the race – brought together class, race, gender, and sexuality into a potent brew which locked normality and sexuality into a fixed hierarchy that few could escape from even if not so many lived up to it.

The settling of class identities in the first wave of industrialization in the nineteenth century also froze the fluidity of gender differences and sexual behaviour. 'Respectability' betokened more than a middle-class modesty and discretion; it became a way of life where sexual desire and gendered activity

were regulated by approved and approvable behaviour (Weeks 1981/1989). Alfred Kinsey was neither the first nor the last to notice the distinct class accents to human sexual behaviour (Kinsey *et al.* 1948). Similarly, the generation of a racialized 'Western identity', with its distinct sexual classifications and typologies, in turn depended upon the identification of the colonized of the world as distinctly 'other', more primitive, more priapic or blatant, and certainly less 'civilized', which in turn served to confirm 'our' superiority, and the truth of 'our' sexualities. [. . .] Sexuality is woven into the web of all the social belongings we embrace, and that is why the emergence over the past two hundred years, and in a rush since the 1960s, of alternative or oppositional sexualized identities – lesbian and gay, 'queer', bisexual, transvestite and transsexual, sadomasochistic, an exotic parade dancing into history with a potentially infinite series of scripts and choreographies – is seen as subversive by sexual conservatives. They breach boundaries, disrupt order, and call into question the fixity of inherited identities of all kinds, not just sexual, which is also the reason, no doubt, for identities being so problematic to those committed to sexual change. If they are asserted too firmly there are dangers of fixing identifications and values that are really necessarily always in flux; yet if their validity is denied, there is an even greater danger of disempowering individuals and groups from the best means of mobilizing for radical change (Weeks 1991).

Identities are paradoxical, and they raise paradoxes. I want to illustrate this by exploring four key paradoxes.

Paradox 1: sexual identity assumes fixity and uniformity while confirming the reality of unfixity, diversity, and difference

Many of us in the west like to say who we are by telling of our sex: 'I am gay/straight'; 'I am male/female'. It places us securely in recognized discourses, embodying assumptions, beliefs, practices, and codes of behaviour. Yet the truth is rather more complex. [. . .]

Since the nineteenth century the placing of individuals into clearly demarcated sexual categories, and hence identities, has gone hand in hand with the presentation of plentiful evidence detailing the fluidity and uncertainty of desire and cultural loyalties (Weeks 1985). It is difficult to fit neatly into the social categories which define and limit possible identifications. The binary divisions that many of us in Western countries take for granted, between men and women, heterosexual and homosexual, normal and perverse, provide barriers against, in the words of Epstein and Straub, 'the uncontrollable elasticity and terrifying lack of boundaries within or between bodies' (1991: 14). They simplify the complexity of desires, they order the potential multiplicity of our identifications. But those barriers are often fragile, inadequate blocks to the flux of contemporary life, and the range of possible ways of being.

The repressed usually returns, sometimes in distorted and damaging ways (such as the homophobia of the 'repressed homosexual'), sometimes in liberating and creative ways, in the elective communities where dissident or oppositional sexual identities, at least, are forged and confirmed. Then identities can become enabling. Yet, I would argue, they are still only ever provisional. We can put on a good performance with them. But we should never believe they are final, or embody some unique truth about ourselves. 'Unfixity', write Laclau and Mouffe, 'has become the condition of every social identity' (1984: 85) – and especially, I would add, of every sexual identity.

Paradox 2: identities are deeply personal but tell us about the multiple social belongings

All cultures seem to depend on their members having a secure sense of self, and a placing in the order of things. But there is no reason to think that the modern individual is a reflex product of his or her 'instincts'. Self-identity, at the heart of which is sexual identity, is not something that is given as a result of the continuities of an individual's life or the fixity and force of his or her desires. It is something that has to be worked on, invented and reinvented in accord with the changing rhythms, demands, opportunities, and closures of a complex world; it depends on the effectiveness of the biographical narratives we construct for ourselves in a turbulent world, on our ability to keep a particular narrative going (Plummer 1995).

We apparently need a sense of the essential self to provide a grounding for our actions, to ward off existential fear and anxiety and to provide a springboard for action (Giddens 1991; Cohen 1994). So we write into our personal narratives the elements which confirm what we say we are. [. . .]

The sexual persona, like the whole personality, is, in Connell's formulation (1987: 220), a social practice seen from 'the perspective of the life history', and the sources of that personal history are inevitably cultural. The socio-sexual identities we adopt, inhabit, and adapt, work in so far as they order and give meaning to individual needs and desires, but they are not emanations of those needs and desires. Indeed they have no necessary connection at all to the contingencies of the body. The sources of the narratives that keep us going, that make sense of our individual peculiarities, are deeply historical, dependent on social bonds that provide the map for personal meaning and cultural identification. And those bonds are multiple: we come from different nations, classes, statuses, religions, racial and ethnic groupings, different genders and generations and geographical areas, each of which provides a sliver of experience, a residue of a personal history, which we try to integrate into our personal biographies, to shape our individual identity. Sexual identity involves a perpetual invention and reinvention, but on ground fought over by many histories.

Paradox 3: sexual identities are simultaneously historical and contingent

[. . .] We are increasingly accustomed to seeing sexuality as a spectrum along which lie many potential sexual desires and many different identities. But that easy pluralism obscures the fact that historically sexual identities have been organized into violent hierarchies, where some positions are marked as superior (more natural, healthier, more true to the body than others). The shaping of a distinctive categorization of 'the homosexual' over the past century or so in the leading Western countries (but not, until recently, others) has been an act of power, whose effect, intended or not, has been to reinforce the normality of heterosexuality. As Eve Sedgwick has put it:

> The importance – an importance – of the category 'homosexual' . . . comes not necessarily from its regulatory relation to a nascent or already constituted minority of homosexual people or desires, but from its potential for giving whoever wields it a structuring definitional leverage.
>
> (1985: 86)

[. . .] Yet if histories (rather than History) and various forms of power relations (rather than a single Power) provide the context for sexual identities, our assumption of them is not determined by the past but by the contingencies, chances, and opportunities of the historic present. As I have already suggested, there is no necessary relationship between a particular organization of desire and a social identity. Many people who practise various forms of homosexual activity fail to recognize themselves in labels such as 'homosexual', lesbian and gay, queer, or whatever the available identity is at any particular time, even in the West, where such descriptions and self-descriptions are hegemonic. In other parts of the world, homosexual practices, where they are not banned totally, are integrated into various patterns of relations, without giving rise to Western-style identities, though other forms of identity do of course exist (Herdt 1994).

[. . .] Available identities are taken up for a variety of reasons: because they make sense of individual experiences, because they give access to communities of meaning and support, because they are politically chosen (Weeks 1985). These identities can, however, equally be refused, precisely because they do not make sense to an individual, or because they have no cultural purchase. [. . .]

The creation of an identity involves finding a delicate balance between the hazards and opportunities of contemporary life and an identification with some sort of history, an 'imaginary reunification', in Stuart Hall's phrase, of past and present: 'identities are the names we give to the different ways we are positioned, and position ourselves, in the narratives of the past' (quoted in Gates 1993: 231).

The challenge is always one of shaping usable narratives that can make sense of the present through appropriating a particular history. Not surprisingly,

one of the first signs of the public emergence of new identities is the appearance of works that detail the 'roots' of those hitherto obscured from recorded or respectable history: history as a way of legitimizing contingency.

Paradox 4: sexual identities are fictions – but necessary fictions

Sexual identities are historical inventions, which change in complex histories. They are imagined in contingent circumstances. They can be taken up and abandoned. To put it polemically, they are fictions. This is not of course how they are seen or experienced, or what we wish to believe. Worse, in the age of uncertainty through which we are currently struggling, to say this often seems a betrayal of what we need most desperately to hold on to, an arid intellectualism which leaves minorities without hope, and the vulnerable defenceless. [. . .]

But to say that something is a historical fiction is not to denigrate it. On the contrary, it is simply to recognize that we cannot escape our histories, and that we need means to challenge their apparently iron laws and inexorabilities by constructing narratives of the past in order to imagine the present and future. Oppositional sexual identities, in particular, provide such means and alternatives, fictions that provide sources of comfort and support, a sense of belonging, a focus for opposition, a strategy for survival and cultural and political challenge. Such a view of identity does two things. First of all it offers a critical view of all identities, demonstrating their historicity and arbitrariness. It denaturalizes them, revealing the coils of power that entangle them. It returns identities to the world of human beings, revealing their openness and contingency.

Second, because of this, it makes human agency not only possible, but also essential. For if sexual identities are made in history, and in relations of power, they can also be remade. Identities then can be seen as sites of contestation. They multiply points of resistance and challenge, and expand the potentialities for change. Identities, particularly those identities which challenge the imposing edifice of Nature, History, Truth, are a resource for realizing human diversity. They provide means of realizing a progressive individualism, our 'potential for individualization' (Melucci 1989: 48) and a respect for difference.

Judith Butler

CRITICALLY QUEER

From: *Bodies That Matter: On the Discursive Limits of 'Sex'* (New York: Routledge, 1993)

> Discourse is not life; its time is not yours.
>> (Michel Foucault, 'Politics and the Study of Discourse')

[. . .]

THE TEMPORALITY OF THE TERM [QUEER] IS WHAT CONCERNS ME HERE: how is it that a term that signalled degradation has been turned – 'refunctioned' in the Brechtian sense – to signify a new and affirmative set of meanings? [. . .]

erformative power

Eve Sedgwick's recent reflections on queer performativity ask us not only to consider how a certain theory of speech acts applies to queer practices, but how it is that 'queering' persists as a defining moment of performativity (Sedgwick 1993). The centrality of the marriage ceremony in J.L. Austin's examples of performativity suggests that the heterosexualization of the social bond is the paradigmatic form for those speech acts which bring about what they name. 'I pronounce you . . . ' puts into effect the relation that it names. But from where and when does such a performative draw its force, and what happens to the performative when its purpose is precisely to undo the presumptive force of the heterosexual ceremonial?

Performative acts are forms of authoritative speech: most performatives, for instance, are statements that, in the uttering, also perform a certain action

and exercise a binding power. [. . .] Implicated in a network of authorization and punishment, performatives tend to include legal sentences, baptisms, inaugurations, declarations of ownership, statements which not only perform an action, but confer a binding power on the action performed. If the power of discourse to produce that which it names is linked with the question of performativity, then the performative is one domain in which power acts *as* discourse.

Importantly, however, there is no power, construed as a subject, that acts, but only, to repeat an earlier phrase, a reiterated acting that *is* power in its persistence and instability. This is less an 'act', singular and deliberate, than a nexus of power and discourse that repeats or mimes the discursive gestures of power. Hence, the judge who authorizes and installs the situation he names invariably *cites* the law that he applies, and it is the power of this citation that gives the performative its binding or conferring power. And though it may appear that the binding power of his words is derived from the force of his will or from a prior authority, the opposite is more true: it is *through* the citation of the law that the figure of the judge's 'will' is produced and that the 'priority' of textual authority is established. Indeed, it is through the invocation of convention that the speech act of the judge derives its binding power; that binding power is to be found neither in the subject of the judge nor in his will, but in the citational legacy by which a contemporary 'act' emerges in the context of a chain of binding conventions.

Where there is an 'I' who utters or speaks and thereby produces an effect in discourse, there is first a discourse which precedes and enables that 'I' and forms in language the constraining trajectory of its will. Thus there is no 'I' who stands *behind* discourse and executes its volition or will *through* discourse. On the contrary, the 'I' only comes into being through being called, named, interpellated, to use the Althusserian term, and this discursive constitution takes place prior to the 'I'; it is the transitive invocation of the 'I'. Indeed, I can only say 'I' to the extent that I have first been addressed, and that address has mobilized my place in speech, paradoxically, the discursive condition of social recognition *precedes and conditions* the formation of the subject: recognition is not conferred on a subject, but forms that subject. Further, the impossibility of a full recognition, that is, of ever fully inhabiting the name by which one's social identity is inaugurated and mobilized, implies the instability and incompleteness of subject-formation. The 'I' is thus a citation of the place of the 'I' in speech, where that place has a certain priority and anonymity with respect to the life it animates: it is the historically revisable possibility of a name that precedes and exceeds me, but without which I cannot speak.

Queer trouble

The term 'queer' emerges as an interpellation that raises the question of the status of force and opposition, of stability and variability, *within* performativity.

The term 'queer' has operated as one linguistic practice whose purpose has been the shaming of the subject it names, or rather, the producing of a subject *through* that shaming interpellation. 'Queer' derives its force precisely through the repeated invocation by which it has become linked to accusation, patholo- gization, insult. This is an invocation by which a social bond among homopho- bic communities is formed through time. The interpellation echoes past interpellations, and binds the speakers, as if they spoke in unison across time. In this sense, it is always an imaginary chorus that taunts 'queer'. To what extent, then, has the performative 'queer' operated alongside, as a deformation of, the 'I pronounce you . . .' of the marriage ceremony? If the performative operates as the sanction that performs the heterosexualization of the social bond, perhaps it also comes into play precisely as the shaming taboo which 'queers' those who resist or oppose that social form as well as those who occupy it without hegemonic social sanction.

On that note, let us remember that reiterations are never simply replicas of the same. And the 'act' by which a name authorizes or deauthorizes a set of social or sexual relations is, of necessity, *a repetition*. 'Could a performa- tive succeed,' asks Derrida, 'if its formulation did not repeat a "coded" or iterable utterance . . . if it were not identifiable in some way as a "citation"?' (1988: 18). If a performative provisionally succeeds (and I will suggest that 'success' is always and only provisional), then it is not because an intention successfully governs the action of speech, but only because that action echoes prior actions, and *accumulates the force of authority through the repetition or cita- tion of a prior, authoritative set of practices*. What this means, then, is that a performative 'works' to the extent that it *draws on and covers over* the consti- tutive conventions by which it is mobilized. In this sense, no term or statement can function performatively without the accumulating and dissim- ulating historicity of force.

This view of performativity implies that discourse has a history [. . .] that not only precedes but conditions its contemporary usages, and that this history effectively decentres the presentist view of the subject as the exclu- sive origin or owner of what is said. [. . .] What it also means is that the terms to which we do, nevertheless, lay claim, the terms through which we insist on politicizing identity and desire, often demand a turn *against* this constitutive historicity. [. . .]

As much as it is necessary to assert political demands through recourse to identity categories, and to lay claim to the power to name oneself and determine the conditions under which that name is used, it is also impos- sible to sustain that kind of mastery over the trajectory of those categories within discourse. This is not an argument *against* using identity categories, but it is a reminder of the risk that attends every such use. The expectation of self-determination that self-naming arouses is paradoxically contested by the historicity of the name itself: by the history of the usages that one never controlled, but that constrain the very usage that now emblematizes autonomy; by the future efforts to deploy the term against the grain of the

current ones, and that will exceed the control of those who seek to set the course of the terms in the present.

If the term 'queer' is to be a site of collective contestation, the point of departure for a set of historical reflections and futural imaginings, it will have to remain that which is, in the present, never fully owned, but always and only redeployed, twisted, queered from a prior usage and in the direction of urgent and expanding political purposes. This also means that it will doubtless have to be yielded in favour of terms that do that political work more effectively. Such a yielding may well become necessary in order to accommodate – without domesticating – democratizing contestations that have and will redraw the contours of the movement in ways that can never be fully anticipated in advance.

It may be that the conceit of autonomy implied by self-naming is the paradigmatically presentist conceit, that is, the belief that there is a one who arrives in the world, in discourse, without a history, that this one makes oneself in and through the magic of the name, that language expresses a 'will' or a 'choice' rather than a complex and constitutive history of discourse and power which compose the invariably ambivalent resources through which a queer and queering agency is forged and reworked. To recast queer agency in this chain of historicity is thus to avow a set of constraints on the past and the future that mark at once the *limits* of agency and its most *enabling conditions*. As expansive as the term 'queer' is meant to be, it is used in ways that enforce a set of overlapping divisions: in some contexts, the germ appeals to a younger generation who want to resist the more institutionalized and reformist politics sometimes signified by 'lesbian and gay'; in some contexts, sometimes the same, it has marked a predominantly white movement that has not fully addressed the way in which 'queer' plays – or fails to play – within non-white communities; and whereas in some instances it has mobilized a lesbian activism (see Smyth 1992), in others the term represents a false unity of women and men. Indeed, it may be that the critique of the term will initiate a resurgence of both feminist and anti-racist mobilization within lesbian and gay politics or open up new possibilities for coalitional alliances that do not presume that these constituencies are radically distinct from one another. The term will be revised, dispelled, rendered obsolete to the extent that it yields to the demands which resist the term precisely because of the exclusions by which it is mobilized.

We no more create from nothing the political terms that come to represent our 'freedom' than we are responsible for the terms that carry the pain of social injury. And yet, neither of those terms are as a result any less necessary to work and rework within political discourse.

In this sense, it remains politically necessary to lay claim to 'women', 'queer', 'gay', and 'lesbian', precisely because of the way these terms, as it were, lay their claim on us prior to our full knowing. Laying claim to such terms in reverse will be necessary to refute homophobic deployments of the terms in law, public policy, on the street, in 'private' life. But the necessity

to mobilize the necessary error of identity (Spivak's term) will always be in tension with the democratic contestation of the term which works against its deployments in racist and misogynist discursive regimes. If 'queer' politics postures independently of these other modalities of power, it will lose its democratizing force. The political deconstruction of 'queer' ought not to paralyse the use of such terms, but, ideally, to extend its range, to make us consider at what expense and for what purposes the terms are used, and through what relations of power such categories have been wrought. [. . .] 'Queering' might signal an inquiry into (a) the *formation* of homosexualities (a historical inquiry which cannot take the stability of the term for granted, despite the political pressure to do so) and (b) the *deformative* and *misappropriative* power that the term currently enjoys. [. . .]

The temporary totalization performed by identity categories is a necessary error. And if identity is a necessary error, then the assertion of 'queer' will be necessary as a term of affiliation, but it will not fully describe those it purports to represent. As a result, it will be necessary to affirm the contingency of the term: to let it be vanquished by those who are excluded by the term but who justifiably expect representation by it, to let it take on meanings that cannot now be anticipated by a younger generation whose political vocabulary may well carry a very different set of investments. Indeed, the term 'queer' itself has been precisely the discursive rallying point for younger lesbians and gay men and, in yet other contexts, for lesbian interventions and, in yet other contexts, for bisexuals and straights for whom the term expresses an affiliation with anti-homophobic politics. That it can become such a discursive site whose uses are not fully constrained in advance ought to be safeguarded not only for the purposes of continuing to democratize queer politics, but also to expose, affirm, and rework the specific historicity of the term.[1]

Notes

1 This essay was originally published in *GLQ* 1, 1 (1993). I thank David Halperin and Carolyn Dinshaw for their useful editorial suggestions. This chapter is an altered version of that essay.

Andrew Parker and Eve Kosofsky Sedgwick

SEXUAL POLITICS, PERFORMATIVITY, AND PERFORMANCE

From: the introduction to *Performativity and Performance*, ed. Andrew Parker and Eve Kosofsky Sedgwick (New York: Routledge, 1995).

WHEN IS SAYING SOMETHING DOING SOMETHING? And how is saying something doing something? If they aren't coeval with language itself, these questions certainly go as far back, even in European thought, as – take your pick – Genesis, Plato, Aristotle. Proximally, posed explicitly by the 1962 publication of the British philosopher J.L. Austin's *How to Do Things with Words*, they have resonated through the theoretical writings of the past three decades in a carnivalesque echolalia of what might be described as extraordinarily productive cross-purposes. One of the most fecund, as well as the most under-articulated, of such crossings has been the oblique intersection between performativity and the loose cluster of theatrical practices, relations, and traditions known as performance.

A term whose specifically Austinian valences have been renewed in the work of Jacques Derrida (1982) and Judith Butler (1990, 1993), performativity has enabled a powerful appreciation of the ways that identities are constructed iteratively through complex citational processes. If one consequence of this appreciation has been a heightened willingness to credit a performative dimension in all ritual, ceremonial, scripted behaviours, another would be the acknowledgement that philosophical essays themselves surely count as one such performative instance.[1] The irony is that, while philosophy has begun to shed some of its anti-theatrical prejudices, theatre studies have been attempting, meanwhile, to take themselves out of (the) theatre. Reimagining itself over the course of the past decade as the wider field of performance studies, the discipline has moved well beyond the classical ontology of the black box model to embrace a myriad of performance

practices, ranging from stage to festival and everything in between: film, photography, television, computer simulation, music, 'performance art', political demonstrations, health care, cooking, fashion, shamanistic ritual . . .

Given these divergent developments, it makes abundant sense that performativity's recent history has been marked by cross-purposes. For while philosophy and theatre now share 'performative' as a common lexical item, the term has hardly come to mean 'the same thing' for each. Indeed, the stretch between theatrical and deconstructive meanings of 'performative' seems to span the polarities of, at either extreme, the *extroversion* of the actor, the *introversion* of the signifier. [. . .] A text like Lyotard's *The Postmodern Condition* (1984) uses 'performativity' to mean an extreme of something like *efficiency* – postmodern representation as a form of capitalist efficiency – while, again, the deconstructive 'performativity' of Paul de Man (1979) or J. Hillis Miller (1991) seems to be characterized by the *dis*linkage precisely of the cause and effect between the signifier and the world. At the same time, it's worth keeping in mind that even in deconstruction, more can be said of performative speech-acts than that they are ontologically dislinked or introversively non-referential. Following on de Man's demonstration of 'a radical estrangement between the meaning and the performance of any text' (1979: 298), one might want to dwell not so much on the non-reference of the performative, but rather on (what de Man calls) its necessarily 'aberrant' relation to its own reference – the torsion, the mutual perversion, as one might say, of reference and performativity.

Significantly, perversion had already made a cameo appearance in *How to Do Things with Words* (1975) in a passage where the philosophical and theatrical meanings of performative actually do establish contact with each other. After provisionally distinguishing in his first lecture constatives from performatives – statements that merely describe some state of affairs from utterances that accomplish, in their very enunciation, an action that generates effects – Austin proceeded to isolate a special property of the latter: that if something goes wrong in the performance of a performative, 'the utterance is then, we may say, not indeed false but in general *unhappy*' (1975: 14). Such 'infelicity', Austin extrapolated, 'is an ill to which *all* acts are heir which have the general character of ritual or ceremonial, all *conventional* acts' (ibid.: 18–19). But if illness was understood here as intrinsic to and thus constitutive of the structure of performatives – a performative utterance is one, as it were, that always may get sick – elsewhere Austin imposed a kind of quarantine in his decision to focus exclusively, in his 'more general account' of speech acts, on those that are 'issued in ordinary circumstances':

[A] performative utterance will, for example, be *in a peculiar way* hollow or void if said by an actor on the stage, or if introduced in a poem, or spoken in soliloquy. This applies in a similar manner to any and every utterance – a sea-change in special circumstances. Language in

such circumstances is in special ways – intelligibly – used not seriously, but in ways *parasitic* upon its normal use – ways which fall under the doctrine of the *etiolations* of language. All this we are *excluding* from consideration.

(Ibid.: 22)

This passage, of course, forms the heart of Derrida's reading of Austin in 'Signature Event Context': where Austin sought to purge from his analysis of 'ordinary circumstances' a range of predicates he associated narrowly with theatre, Derrida argued that these very predicates condition from the start the possibility of any and all performatives. 'For, finally', asked Derrida, 'is not what Austin excludes as anomalous, exceptional, "nonserious", that is, *citation* (on the stage, in a poem, or in a soliloquy), the determined modification of a general citationality – or rather, a general iterability – without which there would not even be a "successful" performative?' (1982: 325). Where Austin, then, seemed intent on separating the actor's citational practices from ordinary speech-act performances, Derrida regarded both as structured by a generalized iterability, a pervasive theatricality common to stage and world alike.

Much, of course, has long since been made of Austin's parasite, which has gone on to enjoy a distinguished career in literary theory and criticism. And Derrida's notion of a generalized iterability has played a significant role in the emergence of the newly expanded performance studies. Yet what, to our knowledge, has been under-appreciated (even, apparently, by Derrida) is the nature of the perversion which, for Austin, needs to be expelled as it threatens to blur the difference between theatre and world. After all these years, in other words, we finally looked up 'etiolation' and its cognates in our handy Merriam-Webster, and were surprised to discover the following range of definitions:

etiolate (vt) (1) to bleach and alter or weaken the natural development of (a green plant) by excluding sunlight; (2) to make pale and sickly [. . .]; (3) to rob of natural vigor, to prevent or inhibit the full physical, emotional, or mental growth of (as by sheltering or pampering) [. . .]

etiolated (adj): (1) grown in absence of sunlight, blanched; lacking in vigor or natural exuberance, lacking in strength of feeling or appetites, effete . . .

etiolation (n): (1) the act, process or result of growing a plant in darkness; (2) the loss or lessening of natural vigor, overrefinement of thought or emotional sensibilities: decadence

etiology (n): a science or doctrine of causation or of the demonstration of causes; (2) all the factors that contribute to the occurrence of a disease or abnormal condition

What's so surprising, in a thinker otherwise strongly resistant to moralism, is to discover the pervasiveness with which the excluded theatrical is hereby linked with the perverted, the artificial, the unnatural, the abnormal, the decadent, the effete, the diseased. We seem, with Austinian 'etiolation', to be transported not just to the horticultural laboratory, but back to a very different scene: the Gay 1890s of Oscar Wilde. Striking that, even for the dandyish Austin, theatricality would be inseparable from a normatively homophobic thematics of the 'peculiar', 'anomalous, exceptional, "nonserious"'.

If the performative has thus been from its inception already infected with queerness, the situation has hardly changed substantially today. The question of when and how is saying something doing something echoed, to take one frighteningly apt example, throughout C-SPAN's coverage of the debates surrounding the Pentagon's 1993 'don't ask, don't tell, don't pursue' policy on lesbians and gay men in the US military. The premise of the new policy is:

> *Sexual orientation* will not be a bar to service unless manifested by homosexual *conduct*. The military will discharge members who engage in homosexual conduct, defined as a homosexual act, a *statement* that the member is homosexual or bisexual, or a marriage or attempted marriage to someone of the same gender.[2]

'Act', 'conduct', and 'statement' pursue their coercively incoherent dance on the ground of identity, of 'orientation'. Since the unveiling of the policy, all branches of government have been constrained to philosophize endlessly about what kind of *statement* can constitute 'homosexual *conduct*', as opposed to orientation, and hence trigger an investigation aimed at punishment or separation. Performativity – as any reader of Austin will recognize – lives in the examples. Here is an example of a US Congressman imitating J.L. Austin:

> Representative Ike Skelton, a Missouri Democrat who heads the House [Armed Services Military Forces and Personnel] subcommittee, asked [the Joint Chiefs of Staff] for reactions to four situations: a private says he is gay; a private says he thinks he is gay; an entire unit announces at 6.30 a.m. muster that they are all gay; a private frequents a gay [bar] every Friday night, reads gay magazines and marches in gay parades. He asked what would happen in each situation under the new policy.[3]

Such highly detailed interrogations of the relation of *speech* to *act* are occurring in the space of a relatively recent interrogation of the relation of *act* to *identity*. 'Sexual orientation will not be a bar to service unless manifested by homosexual conduct' – contrast these fine discriminations with the flat formulation that alone defined the issue until 1993: 'Homosexuality is incompatible with military service'. In response to many different interests, the monolith

of 'homosexuality' has diffracted into several different elements that evoke competing claims for legitimation or censure. Unlikely as the influence may seem, the new policy is clearly founded in a debased popularization of Foucauldian and post-Foucauldian work in the history of sexuality. Probably through the work of legal scholars involved in gay/lesbian advocacy, the queer theorists' central distinction between same-sex sexual *acts* and historically contingent gay/lesbian *identities* has suddenly become a staple of public discourse from Presidential announcements to the call-in shows (assuming it's possible at this point to distinguish between the two). Yet the popularization of this analytic tool has occurred through an assimilation of it to such highly phobic formulations as the Christian one, 'Hate the sin but love the sinner'. (Was it for this that the careful scholarship of the past decade has traced out the living and dialectical linkages and gaps between same-sex acts and queer and queer-loving identities? – all of which need to be nurtured and affirmed if any are to flourish.)

A variety of critiques of agency, as well, have begun to put interpretive pressure on the relations between the individual and the group as those are embodied, negotiated, or even ruptured by potent acts of speech or silence. Viewed through the lenses of a postmodern deconstruction of agency, Austin can be seen to have tacitly performed two radical condensations: of the complex producing and underwriting relations on the 'hither' side of the utterance, and of the no-less-constitutive negotiations that comprise its uptake. Bringing these sites under the scrutiny of the performative hypothesis, Austin makes it possible to see how much more unpacking is necessary than he himself has performed. To begin with, Austin tends to treat the speaker as if s/he were all but co-extensive – at least, continuous – with the power by which the individual speech act is initiated and authorized and may be enforced. (In the most extreme example, he seems to suggest that war is what happens when individual citizens declare war! [1975: 40, 156].) 'Actions can only be performed by persons,' he writes, 'and obviously in our cases [of explicit performatives] the utterer must be the performer' (ibid.: 60). Foucauldian, Marxist, deconstructive, psychoanalytic, and other recent theoretical projects have battered at the self-evidence of that 'obviously' – though in post-Foucauldian theory, in particular, it seems clear that the leverage for such a critique is available precisely in the space opened up by the Austinian interest in provisionally distinguishing what is being said from the fact of the saying of it.

If Austin's work finds new ways to make a deconstruction of *the performer* both necessary and possible, it is even more suggestive about the 'thither' side of the speech-act, the complex process (or, with a more postmodernist inflection, the complex space) of uptake. Austin's rather bland invocation of 'the proper context' (in which a person's saying something is to count as doing something) has opened, under pressure of recent theory, onto a populous and contested scene in which the role of silent or implied witnesses, for example, or the quality and structuration of the bonds that unite auditors

or link them to speakers, bears as much explanatory weight as do the particular speech acts of supposed individual speech agents. Differing crucially (as, say, theatre differs from film?) from a more familiar, psychoanalytically founded interrogation of *the gaze,* this interrogation of the space of reception involves more contradictions and discontinuities than any available account of interpellation can so far do justice to; but interpellation may be among the most useful terms for beginning such an analysis. (In the Congressional hearings on 'don't ask, don't tell', a lively question was this: if a drill sergeant motivates a bunch of recruits by yelling 'Faggots!' at them, is it permissible for a recruit to raise his hand and respond 'Yes, sir'?) It is in this theoretical surround that the link between performativity and performance in the theatrical sense has become, at last, something more than a pun or an unexamined axiom.

Notes

1 An exemplary instance of this acknowledgement would be Felman (1983), which undertakes both a speech-act reading of *Don Juan* and a theatrical reading of Austin.
2 'Text of Pentagon's New Policy Guidelines on Homosexuals in the Military', *New York Times* (July 20, 1993), p. A16 (national edition), emphasis added.
3 Eric Schmitt, 'New Gay Policy Emerges as a Cousin of Status Quo', *New York Times* (July 22, 1993), p. A14 (national edition). [Square brackets added to quotation by Parker and Sedgwick. – Eds.]

Tony Kushner

COPIOUS, GIGANTIC, AND SANE

From: *Thinking About the Longstanding Problems of Virtue and Happiness: Essays, a Play, Two Poems, and a Prayer* (London: Nick Hern, 1995). Presented on the occasion of the March on Washington for Gay and Lesbian Rights, 25 April 1993; first published in the *Los Angeles Times*, 25 April 1993.

THE FIRST TIME I HAD SEX WITH A MAN, I was twenty-one years old and afterwards I had a nightmare. I was lying with my lover in a strange bed, and he was asleep. I was visited by the ghost of the African-American man who for decades had worked as the foreman at my family's lumber company in Louisiana. His name was Rufus Berard, and I'd adored him when I was a child; he had died when I was still very young. [. . .] Rufus was staring not unkindly but with unsettling intensity, refusing to speak and weeping silently.

Then my paternal grandfather arrived. He looked ill (which at the time of the dream he was) and angry (which he seldom was), a cancer-ridden Jeremiah. He had come to pronounce anathema: 'You're going to die,' he said with immense loathing and satisfaction, this man who had always been a loving grandparent. 'There's something wrong in your bones.' And having handed down my death sentence, he walked away, back into the Cave of the Psyche, home to goblins.

Rufus, continuing to cry, watched my grandfather go. Before vanishing into deep-indigo shadows, my grandfather turned back to me. As if in answer to a question I'd asked about Rufus's silent, mournful presence in the dream, my grandfather said, 'He's the Black Other,' and disappeared. Rufus smiled at me and I woke up.

I've forgotten certain details about the first man I slept with, whom I did not see again, but the bleak and dire vision our happy sex conjured up remains with me, as vivid as any recollected actual experience. When AIDS first became an inescapable feature on the landscape, the dream

came back to me often in broad daylight: learning that a friend was sick or seropositive, waiting for my own test results, my dream-grandfather's words would frighten me with what seemed an awful premonitory power.

But in this nocturnal drama of guilt and patriarchal damnation, my unconscious also saw fit to write a character bearing not only compassion but kinship, and a way out of death into life and life's political, social concomitant: liberation.

I grew up in a small southern city in the sixties, in the culture of 'genteel' post-integration bayou-country racism. The African-American population of Lake Charles, Louisiana was ghettoized and impoverished; black women, referred to by their employers as 'girls' even though many were middle-aged or older, entered the homes of white people through years, lifetimes of domestic servitude, and black men performed the poorly remunerated labour white men wouldn't do. There were countless incidents of discrimination and occasionally bias crimes, but southern Louisiana wasn't at that time Klan country. [. . .]

Part of me understood the phantasm of the grieving black man who visited me that night as a figure of my own demise. But his presence had a doubleness that is important to consider. Toni Morrison, in *Playing in the Dark*, writes: 'Images of blackness can be evil *and* protective, rebellious *and* forgiving, fearful *and* desirable – all the self-contradictory features of the self.'

One of my most vivid memories from childhood is from the day of Martin Luther King's funeral. I watched it on TV with Maudi Lee Davis, the woman who worked as my family's maid. Maudi cried throughout the broadcast, and I was both frightened and impressed – I felt her powerful grief connected us, her and me and my quiet hometown, with the struggle I knew was being waged in the world, in history. It was an instant in which one feels that one is being changed as the world is changed, and I believe I was.

I don't know what power it is in human beings that keeps us going against indescribable forces of destruction. I don't know how any African-American, any person of colour in this country stays sane, given that the whole machinery of American racism seems designed to drive them crazy or kill them. I don't know why it is every woman isn't completely consumed all the time by deliberating rage. I don't know why lesbians and gay men aren't all [. . .] twisted and wrecked inside [. . .]. By means of what magic do people transform bitter centuries of enslavement and murder into Beauty and Grace? One mustn't take these miracles of perseverance for granted, nor rejoice in them too much, forgetting the oceans of spilled blood of all the millions who didn't make it, who succumbed. But something, some joy in us, refuses death, makes us stand against the overt and insidious violence practised upon us by death's minions.

Something in me, smarter than me, pointed the way towards identification with the Black Other, towards an embrace of my status as a pariah, as rejected, as a marginal man. I learned, we learn, to transform the gestures,

postures, and etiquette of oppression into an identity; we learn to take what history has made of us and claim it proudly as what we are, and choose to be. We refuse victim status, we constitute ourselves as history's agents rather than as its accidents, and even if that's only partly true, such a claim empowers us, and makes us grow too big for shackles, for kitchens, for closets, for ghettos of all kinds. Wayne Koestenbaum, in his brilliant book, *The Queen's Throat* writes: 'one is fixed in a class, a race, a gender. But against such absolutes there arises a fervent belief in *retaliatory self invention* . . . to help the stigmatized self imagine it is received, believed, and adored' (1993: 133; emphasis added). We find love, in other words, that Great Ineffable that breaks through our hermetically sealed worlds of private pain and disgrace and self-hatred, that unites us with others, that makes us willing to give up even life itself for more connection, more strength, more love.

I grew up hating being gay, hating not only myself but those like me, so much so that in college I evinced such a deep disdain for homosexuality that I repulsed the boy with whom I first fell in love. I feel only part of the way out of that miasma, and I am at times awestruck by the staying power and persuasiveness and pervasiveness of shame. I can almost rival Woody Allen for years in therapy, and I am convinced that as necessary as it is, therapy alone cannot heal the soul. Only community can. [. . .]

There aren't words, or I can't find the words, to describe this moment: when the grey forbidding wall of Oppression starts to crack, when a space opens up between the sky and the horizon, when change becomes possible. For all the manifold horrors of the present day – ethnic cleansing, nationalism and fascism recrudescing, the calamity in Waco, and the ongoing decimation of AIDS – I am going to Washington full of hope. The whole city will be as queer as the Castro on a Saturday night – queerer, because there will be gay women there and gays of colour and old people and fat people and disabled people and even heterosexuals who are Gay for the Day. We will be a community in the process of transforming itself and the world, the offspring Walt [Whitman] described once in a vision: 'Copious, gigantic, and sane.'

Performance theory, live arts, and the media

Janet Adshead-Lansdale

INTRODUCTION TO PART SIX

I N THIS CHAPTER, A DISCUSSION OF THEORETICAL
APPROACHES TO POLITICS AND PERFORMANCE frames
the issues which 'live art' and 'performance' give rise to. These issues are
then related to the selections from essays which follow, namely those by Sally
Banes, Colin Counsell, Susan Leigh Foster, Alan Read, and Richard
Schechner. Their shared concerns can be seen to lie in their commitment to
theorize performance as politically significant. This is important since it might
be argued that transient performances, such as live art, dance, and perfor-
mance art, which traditionally neither use words nor have an obvious
narrative, have little to do with politics. Debate about the capacity of these
practices to make explicit, or even implicit, social or political comment, has
often led to the conclusion they are relatively simple evocations of personal
states – or abstract play with the media they employ – harmless and fun,
rather than a serious challenge to the cultures of which they are part. In
consequence, while they often escape censorship, where a play or a novel
might not, they also escape serious debate. It is possible, however, to argue,
as these theorists do, that performance constitutes a discourse which, by its
very structuring of the movement of the human body, 'speaks' to, and of,
everyday experiences, as well as to larger ideologies.

Colin Counsell's text is part of a longer analysis of the way meaning is
constructed in theatre, focusing on the major characters of the twentieth
century: Stanislavski, Strasberg, Brecht, Brook, and Wilson. Counsell uses
their work to show how the long-accepted criteria of theatre, such as the
perceived need for a plot or narrative, have been challenged in recent years

and discusses how we can still see it as theatre. The importance of the conventions of everyday communication in theatre which create a new 'gestural universe' appropriate to our own time are the subject of his text. This is, broadly speaking, a semiotics of theatre, which is based on Elam's writings, combined with an analysis of intercultural performance, based on Pavis, two major theorists in this field.

Like Alan Read, he refers largely to an 'underground' and 'environmental' theatre. Using the London subway as a performance space, requiring spectators to move, and sometimes by involving them in the action, are all devices which were also common to dance practitioners of the New York Judson dance scene in the late 1960s though the 1970s, and which were also evident later in England. They serve to emphasize the role of the spectator in constructing, interpretively, a new political sense of artist/audience relationships.

Alan Read proposes an 'ethics' of performance whose values relate directly to everyday life. This kind of theatre is essentially oppositional, essentially political, standing in dialectical relation to mainstream practices. The forms that arise are often termed 'fringe' or 'experimental', stretching the limits of the arts and challenging their boundaries. He also sees theatre as enabling us to live this life better – clearly a moral motive – but a complex one to argue for.

It is hard to debate the values of a resistant politics when we have available to us only the 'language' of the dominant politics (by 'language' I mean to include all forms of non-verbal communication as well as verbal). Alan Read addresses the problem of recognizing the cultural construction of performance while also acknowledging the distinctive character of theatre and the many different manifestations of it at any one time. He is sensitive to the difficulties as well as the strengths of using other disciplines, and this he shares with Susan Foster.

Susan Foster's method of addressing other disciplines through choreography rather than addressing choreography through other disciplines (e.g. psychoanalysis, ethnography, etc.) thus delves deeper into these issues and makes a major contribution to the wider debate across the many activities of performance.[1] It also helps to 'politicize' the body.

Politicizing the body

An example of the current 'politicization' of the body and its everyday movement in the UK can be found in the work of such performers as Wayne MacGregor. Quite deliberate manipulation of sexuality and the politics of gender are evident in the 1990s Western vogue for androgynous, but male, performance. The male dancer, with bald head and long skirt, moving with

great fluidity and in a highly sensuous manner, has become a familiar sight on the British stage, challenging stereotypes of masculinity and femininity. Meanwhile the female has become increasingly flattened (physically barely recognizable as female), negated, and desexualized. Solo performances by men, and male-led groups presented in the mid-1990s Dance Umbrella festivals held each year in London, have increased dramatically, reversing the position of ten years ago (see, for example, the programme for 1998 compared with 1988). If we ask why this is the case some of the answers might lie in the shifting territory of sexuality, and in the emergence of 'queer theory' as men take over the ground formerly occupied by feminists.

Thus the discourse of performance can take its place as part of a larger political and personal strategy of representation. It remains poorly understood, however, since body language and its developed forms in theatrical gesture, in dance, and in live art, have received less scholarly and political attention than the visual arts, music, plays, poetry, and novels and are often complicated to interpret.

The political potential of performance rests on dichotomies deriving from the branch of Western philosophy attributed to Descartes (1596–1650) in the early seventeenth century, although its fundamental tenets hark back to Ancient Greece. Arguments about knowledge, freedom, and immortality rely on a distinction between mind and body, where the physical body is seen as an encumbrance to spirituality and life after death. Thus a complex web of concepts emerges in which one idea is placed against its opposite, typically as 'mind' is therefore valued more highly than 'body', and intellectual activity more highly than physical activity; high arts more than popular arts, and, crucially, the right over the left. The term 'right' has more than one connotation of course – not simply reflecting one side of a symmetrical body, but carrying value, associations of the 'correct' or 'proper' side, associations with right and wrong.

Since dance and performance arts have been thought to embody, quite literally, the values of the terms linked to the 'left', they have been contrasted with 'intellectual' pursuits, and sometimes seen as a dangerous indulgence in sensuality at the expense of spirituality. Underlying these binarisms are the most basic and obvious ones of sexual difference of male and female and of gendered identity in terms of masculine and feminine. It is no accident then that, in the West, dance and performance arts, both academically and practically, have been unusually dominated by the presence of women (quite unlike music or playwriting), and it is particularly fascinating that this has changed in recent years.

Susan Foster's work offers a 'political' analysis in the sense that it challenges these traditional and still often-prevailing notions of 'knowledge', and of how disciplines work. She illustrates this by easing away the distinctions between performance and writing practice. In *Corporealities* she makes the

reader reconsider what it is to write in an academic style: she changes voice and style of writing, using different typsetting styles and elaborate footnotes which are at the side of the page not at its foot (Foster 1996b: xii). She demonstrates in her own writing how ideas of the body can be used metaphorically to create a different discourse, as for example when she says that bodies 'develop choreographies of signs through which they discourse: they run (or lurch, or bound, or feint, or meander . . .) from premise to conclusion' (ibid.: xi). This is to articulate movement as meaningful within a culturally understood sign system, and therefore capable of political intervention, just as the choreographer 'elaborates a theory not only of gendered corporeal identity but also of relations among gendered bodies' (below p. 210).

Performance and cultural identity

Ballet International/Tanz Aktuell is a useful journal for its analysis of contemporary practice and for its consideration of dance and politics at the nation-state level in a series of issues published in 1998.[2] Issues on Portugal (no. 2, February), Israel (no. 5, May), and Sweden (no. 6, June) could be expected in a journal which claims European-wide coverage, but extended volumes on China (no. 1, January) and Korea (no. 4, April), and Aboriginal dance in Australia (no. 7, July) are more surprising. Instead of regarding the dance of 'others' as weird and 'exotic' practices (as the early anthropologists did) or appropriating it within Western ballet (as the early dance historians did) what is apparent in the late 1990s is an analysis which attempts to unpack the complex interaction of cultures within globalization.

It is highly appropriate that such an analysis should emerge from Australia, given its Pacific frontiers, but Western cultural heritage. In an issue of the Australian journal *Writings on Dance* titled 'Performance across Cultures' the American scholar, Barbara Kirschenblatt-Gimblett undertakes 'a critical examination of the varieties of multi-culturalism and the way they structure difference' (1995: 55–61). In opposition to the eclecticism of difference, it has been argued that such a cultural smorgasbord is largely meaningless, hiding the existence of virtually incompatible conceptions of art, and associated traditions of scholarship (Brock 1995). A detailed postcolonial analysis of power relations can also be found in Savigliano's study which examines the colonization of emotion, 'passion' in this case, and its commodification in Tango, which 'seems to attempt an assimilation while fuming an ironic, underground, culturally specific resentment' (1995: 4). Philosophers such as David Best argue that the capacity of the arts to make 'powerful and incisive moral and social comments' is deeply embedded in a culture (1992: 169). The arts are part of what constitutes 'the form of life of a society' (ibid.: 171) and thus to understand them is to understand the

culture, in quite precise ways. It is also to understand the concepts and conventions of each very specific form of the art.

The politics of gender

Gender emerges as one key thread in a politics of the body, visible at the present time in a preoccupation with the possibility of escaping rigid sexual and gender categories to create new fluid bodies and sexualities. It is also evident in cultural anxiety about eating, health, and illness. Although eating problems are often seen as female, inward-looking (possibly hysterical) failures to adjust to the 'real' world, and seen to be somehow separate from the broader interests of society, they can be thought of differently. This difference might be explained within current debates (medical and legal as well as social) on the freedom of the individual to choose both physical sexuality and gender construction. Plastic surgery on stage is not unknown (Orlan) and violence against the self is increasingly common as the live arts explore these issues too.

Combining gender and cultural identity issues, Sally Banes describes the politics of identity at work between 1970 and the late 1990s in American postmodern dance. Early works often dealt with pregnancy and parenting, drawing on the feminist movement, and creating all-female worlds, as direct political commentary. Later, however, the work moved on to reveal the 'issue of difference within gender – the diversity of women in terms of class, race, and ethnicity' (below, p. 217). Performance art which suggested a more complex layering of identity and of bodily representations followed. She completes her account with the rise of parody, bad manners, and the exposure of extreme sado-masochistic and erotic values.

Performance theory and practice

A parallel set of arguments exists in relation to the concept of 'performance' itself. Richard Schechner suggests that there are basic qualities shared by play, games, sports, theatre, and ritual, which are found in a characteristic use of time, in the value they attach to certain objects, their non-productivity in terms of economic gain, and the special rules they develop which detach them from everyday life. He is sensitive to the criticism that a Wittgensteinian philosopher might make, that there can be no single set of conditions which all activities would have to share to count as 'performance' and recognizes overlaps between them. A more useful notion is of a network of characteristics which are related in various ways in different manifestations of performance. However, it requires a particular interpretative stance even to

group these activities as 'performance' and one which might need to be elaborated by further consideration of their distinctiveness as well as their similarities.

Notes

1 Foster's 'political performance' in writing gives a quite new dimension to this subject in focusing it towards what constitutes knowledge in a field. To pursue this further see Liz Stanley's writing on how feminisms provide a source both of counter-knowledge and of (political) action (Stanley 1997). Her identification of liminal spaces, of borderlands and of 'territory in between' opens up the possibility of reconfiguring performance practice.
2 Other dance journals worth following up include *Live Art*, the British journal *Performance Research*, and the American *The Drama Review (TDR)*.

Alan Read

THEATRE AND EVERYDAY LIFE

From: *Theatre and Everyday Life: An Ethics of Performance* (London: Routledge, 1993).

IS THE THEATRE GOOD? A reply is likely to come back: 'That is not the point, the question is what does it mean?' But here I want to reassert the value of theatre in order not to leave it to those who least care for it. Anyone who has made theatre will point to a difficult truism that appears to diffuse the possibility of criticism: that theatre is always as good as it can be, given what is available to it at any one time or place. But though theatre might be said to be beyond good and evil, theoretical relativism is an inadequate response to its practices. Irrespective of the postponement of value judgements by those who make theatre, responsibility for its future is assumed by those who least often make it, have least competence in it and most authority over it. The question I begin with is therefore an ethical one. Can theatre have value divorced from everyday life? Everyday life is the meeting ground for all activities associated with being human – work, play, friendship, and the need to communicate, which includes the expressions of theatre. Everyday life is thus full of potential – it is the 'everyday' which habitually dulls sense of life's possibilities. Theatre, when it is good, enables us to know the everyday in order better to live everyday life.

Theatre is worthwhile because it is antagonistic to official views of reality. It derives equal sustenance from theory and practice, common sense and judgement, everyday life and the specialisms and techniques of expression. In the absence of an aesthetics and ethics which take account of these peculiarities from within theatre, political demands are imposed from outside. These impositions become the common focus of debate in and around theatre and often reflect back on the theatre in cyclical hyperbole: 'Theatre in Crisis'

is a common call to arms. But the terms of the debate are set from without by a complex of assumptions concerning theatre's relations to other cultural practices, let alone everyday life. If theatre is critical of life, everyday life is critical of theatre. Critical disciplines removed from the everyday to establish their authority over this problematic domain cannot accept this simple dialectic. Outmoded forms of reference such as 'political theatre' and 'community arts' limit thought to partitioned realms which have very little to do with the complexity of real contexts. These partitions not only patronize practitioners who well understand the ambivalent nature of their work, but worse, dictate boundaries to users of theatre – audiences – which are quite puerile in their simplifications. The reason for placing theatre and everyday life in a single title lies here. While the two might appear to suggest a binary opposition, examining both more closely reasserts the need to think not of an inside or outside of theatre but the way theatre is in dialectical relation to the quotidian. It is not sufficient to address the 'politics of theatre' alone, the structures of funding, arts policies, and jurisdictions, but in a remedial act, a practice which combines poetics and ethics, rethink what the theatre and its politics might be. Regarding theatre then means to look at its practice and history to ascertain what warrants criticism before that responsibility is assumed elsewhere. There are sufficient purveyors of official views of reality to make this a worthwhile act. Criticism is critical because good theatre has an invaluable role to play in disarming the tyrannies of the everyday.

An evaluation of performance and the quotidian takes as its object the neglected and the undocumented, reviewing the unwritten theatre in a local network of work and recreation. There seems little need of more writing about already well documented theatres and exhaustively profiled personnel. Between the neighbourhood and its daily life the practices to be articulated are ones which have escaped the professional and the prominent. This is a profane theatre, a discreet and little documented domain of operations which circulate between the most habitual daily activity and the most overt theatrical manifestations distanced but never fatally removed from that everyday world. [. . .]

If theatre does not happen in an empty space, what does? Everyday life – the demands of which pose ethical, poetic, and political questions to theatre on its arrival. Ethics is relevant because I have to ask the question how people can live and work together, while valuing the difference between people and accounting for justice in society. A poetics is necessary to ascertain the internal mechanics of theatre, what I mean by theatre and how it produces its effects. Politics are already imbued in these positions because theatre and its thought are possible only within a *polis*, different cultures have different politics that give rise to different theatres with more or less freedom, and theatre's relevance and innovation are contingent upon such variable political perspectives. A philosophy of theatre worth its salt starts from these premises. [. . .]

But why write about theatre in this way, now? [. . .] Confidence in progress has dissolved and the industrial has given way to the ephemeral: to

services, tourism, communications proliferation and invisible earnings and finance. If 'All that is solid melts into air' what is left for a theatre that trades on the transience of images, the passing of actors from the presence of an audience? Is not the impermanence of theatre destined to dematerialize along with other information codes on the air, be subsumed within communications in general and television in particular? [. . .]

While the architectural solidity of certain theatre buildings steadfastly refuses the impermanence of their trade, in the shadow of these theatres there continues to be innovation and experiment. [. . .] I am reluctant to name this theatre mistrusting the connotations preordained categories bring and the innovative possibilities they exclude. It is not fringe theatre, community theatre or educational theatre. It can incorporate the characteristics of all, or none, of these generic forms at any one time. Because it is a theatre resistant to official views of reality it is not possible to describe it with the language of that officialdom. This theatre is peopled, in its performers and audiences, by those with a deep resistance to theatre traditions as academic, who reinterpret and return these traditions to the theatre where they belonged, to the frontiers of everyday life. This theatre has drawn voraciously on the urban experience, the televisual and filmic, the fine art tradition and cabaret, the novel and pedestrian experience, the quotidian. The place this theatre has traded its wares is the street, the factory, the school, the prison, the farm: in fact almost anywhere including the most solid of theatre buildings I have described. As though it was never genetically suited to the architecture on offer this theatre has spawned a rash of 'new' theatre architecture to house its aspirations. In this act it follows the theatre in the round, the community centre, the black box, the experimental space, all of which had been thrown up by previous 'revolutions' in reaction both to the architecture of the past and the theatre contained therein. The 'fringe' was not named as such at the beginning of these developments in Britain but soon became both a home for the alternative and a margin to the centre, confirming the geographical and economic status of the mainstream which commanded the central pedestrian axes of the city. Currently there is renewed experiment internationally with 'non-theatre' spaces, significantly the architecture of the industrial period, reconditioned for a 'new theatre to meet a new public'. New theatre there may well be, but the identity of the audience continues to confirm the suspicion that the 'old public' is simply willing to travel further to see what it has always wanted – good theatre. Nevertheless the Old Museum of Transport in Glasgow, the Gaswerk in Copenhagen, the Cartoucherie in Paris, the Mercat de les Flors in Barcelona mark a shift from the attempt to purpose-build for the future, rather, in the spirit of bricolage, resiting from the past. Ironically theatre comes home to roost in places where the transport, technology, munitions, and decoration of the everyday, trams, power, arms, and flowers, were once fashioned. Where something was once made, serviced, detonated, and sold, the simulacrum has taken hold.

So, theatre may be many things but it is not for my purposes a building. [. . .] I consider theatre to be a process of building between performers and their constituencies which employs the medium of images to convey feeling and meaning. While traditional theatre buildings might provide heat and light for this exchange, they also serve to solidify this process as institution and representation. Institution because of the stratified and organized nature of the process of witness that entering buildings inevitably entails, particularly where such buildings are recognized as conventional theatre spaces. Representation because of the expectation that entry to such buildings brings with it: one of Classical mimesis, truth to life, the fourth and invisible wall and the myriad conventions of the theatre that permeate its identity. This serves to remind us that theatre is a public act and one which is unlikely to relieve itself of the institutional conditioning that fashions all such societal formations. These are also precisely the features which attract many to the theatre as a 'good night out'. And why not?

It would be churlish to deny these features, yet irresponsible to accept them uncritically as determinants of theatre in general, or somehow essential to theatre or its future. [. . .] From the proliferation of dance forms to physical theatres, environmental work drawing on the site-specific tradition of sculpture, to carnival forms derived from localized calendar events, the inadequacy of the categories describing the work underestimates the imperative they share to move beyond the 'mimetic', to the 'cathartic'. And this continuing provocation to tradition occurs at the end of a century which has already seen a succession of transformations in theatre forms and contents. There is a veritable explosion of expressive forms developing in and around the rubric of theatre in direct reciprocation to their apparent loss from the everyday. This proliferation of performance stretches theatre's limits of definition and does nothing to deny the possibility that theatre continues to be 'a good night out'.

It is the dialectic between these traditions and conventions and the challenges of contemporary work that characterize theatre's dynamic. Each of these traditions and conventions has given rise to the radical experiments that depart from them. [. . .]

An ethics of performance is an essential feature of any philosophy and practice of theatre. Without it a set of cultural practices which derive from a very specific arrangement of power relations between people are unhinged from responsibility to those people. That might be a fashionable view but one which [has to be contested] if only to ask [. . .] what is good about theatre? Theatre after all contributes to an idea of social or public good the best organization of which should be the central debate of a public politics. Theatre's narratives, however disjunct through aesthetic experiment, always offer alternative realities and insights to the everyday, and those who make theatre are for better or worse paid a certain respect and sometimes achieve the status of exemplary figures. Good theatre stands face to face with its audience. Where theatre has been able to do this it has changed lives and

histories. Where it hasn't it has imaginatively impoverished itself and its audience. [. . .] Given the confusions which surround the status of the 'social' in that theory, it is important that the question of ethics should be reassessed. Ethical concerns after all have important things to say about the relations between people that bear more than a passing resemblance to theatre. Yet I am also aware of the ideological problems that such a proposal brings in its wake. An ethics of performance does not validate any arguments for censorship. An ethical theatre cannot be produced in the purpose-build design of another time. It can only be built as a response, and with a responsibility, to its traditions with constant attention to a vocabulary drawn from the frontier disciplines that press upon its borders, new ways of describing the problematics of place, aesthetic value, and audience that are central to its continued existence. [. . .]

Richard Schechner

APPROACHES TO PERFORMANCE THEORY

From: *Performance Theory*, revised and expanded edition (New York: Routledge, 1988).

Play, games, sports, theatre, and ritual

SEVERAL BASIC QUALITIES ARE SHARED BY THESE ACTIVI-
TIES: (1) a special ordering of time; (2) a special value attached to objects; (3) non-productivity in terms of goods; (4) rules. Often special places – non-ordinary places – are set aside or constructed to perform these activities in.

Time

Clock time is a mono-directional, linear-yet-cyclical uniform measurement adapted from day–night and seasonal rhythms. In the performance activities, however, *time is adapted to the event,* and is therefore susceptible to numerous variations and creative distortions. The major varieties of performance time are:

1 *Event time,* when the activity itself has a set sequence and all the steps of that sequence must be completed no matter how long (or short) the elapsed clock time. *Examples*: baseball, racing, hopscotch; rituals where a 'response' or a 'state' is sought, such as rain dances, shamanic cures, revival meetings; scripted theatrical performances taken as a whole.
2 *Set time,* where an arbitrary time pattern is imposed on events – they begin and end at certain moments whether or not they have been 'completed'. Here there is an agonistic contest between the activity and the clock. *Examples*: football, basketball, games structured on 'how many' or 'how much' can you do in *x* time.

3 *Symbolic time*, when the span of the activity represents another (longer or shorter) span of clock time. Or where time is considered differently, as in Christian notions of 'the end of time', the Aborigine 'dreamtime', or Zen's goal of the 'ever present'. *Examples*: theatre, rituals that reactualize events or abolish time, make-believe play and games. [. . .]

In football the clock is very active in the game itself. Both teams, while playing against each other, are also playing with/against the clock. Time is there to be extended or used up. [. . .] Suspense drama takes a similar attitude toward time; frequently the hero is trying to get something done before time runs out.

Most orthodox theatre uses symbolic time, but experimental performances often use event or set time. Allan Kaprow's happenings – both those he did in the late 1950s and 1960s and the more private conceptual work of the 1980s – use event time. Take, for example, *Fluids* (1967). As Kaprow describes the piece.

> *Fluids* is a single event done in many places over a three-day period. It consists simply in building huge, blank, rectangular ice structures. . . . The structures are to be built in about 20 places throughout Los Angeles. If you were crossing the city you might suddenly be confronted by these mute and meaningless blank structures which have been left to melt.
>
> (Kaprow 1968: 154)

Fluids is over when the monoblocks melt, however long that takes. Kaprow is aware of what this piece is about.

> Obviously, what's taking place is a mystery of sorts; using common material (at considerable expense) to make quasi-architectural structures which seem out of place amid a semi-tropical city setting. . . . *Fluids* is in a state of continuous fluidity and there's literally nothing left but a puddle of water – and that evaporates.
>
> (Kaprow 1968: 154–5)

Similarly, Anna Halprin's *Espozione* (1963) consisted of 40 minutes of performers' carrying heavy burdens while climbing up a huge cargo net. They moved as rapidly as they could and carried as much as they were able. When the time was up, the piece was over.

Ionesco's *Victims of Duty* – like so many other dramas from Sophocles' *Oedipus* onward – presents an action controlled by event time within a world defined by symbolic time. Choubert must look for Mallot, that's his 'duty'. The steps of that search, though unknown to Choubert, are known to the Detective who forces Choubert to re-experience his past. What is important

is that Choubert does what he is asked, not how long it takes. The 'chew-swallow' sequence that ends the play locks Choubert, Madeleine, Nicolas, and the Lady into a routine from which there is no escape – the activity is endless because it is looped. [. . .]

Symbolic time, seemingly absent from happenings and the like, is actually most difficult to banish. Once action is framed 'as theatre' spectators read meanings into whatever they witness. Orthodox acting and scenic arrangements stress mimesis with its symbolic time; happenings stress the breaks between persons and tasks, thus the thing done may be mimetic without being a 'characterization'.

In everyday life objects are valued for their practical use (tools), scarcity and beauty (jewels, precious metals, art), bartering power (paper, wooden, and metal money), or age. In the performance activities all objects – except certain ritual implements and relics – have a market value much less than the value assigned to the objects within the context of the activity. Balls, pucks, hoops, batons, bats – even theatrical props – are mostly common objects of not much material value and cheaply replaced if lost or worn out. Often theatrical props and costumes are designed to look more costly than they actually are. But during the performance these objects are of extreme importance, often the focus of the whole activity. Sometimes, as in theatre and children's play, they are decisive in creating the symbolic reality. The 'other-worldliness' of play, sports, games, theatre, and ritual is enhanced by the extreme disparity between the value of the objects outside the activity when compared to their value as foci of the activity. From the standpoint of productive work it is silly to put so much energy into the 'control of the ball' or the 'defence of 10 yards of territory.' It is equally silly to think that a costume can make a king out of an actor, or even help Lee J. Cobb become Willy Loman. And of what material value is a saint's bones – or the Veil of Turin?

Non-productivity

The separation of performance activities from productive work is a most interesting, and unifying, factor of play, games, sports, theatre, and ritual. What J. Huizinga and Roger Caillois say about play applies to all performative genres.

> Summing up the formal characteristics of play, we might call it a free activity standing quite consciously outside 'ordinary' life as being 'not serious,' but at the same time absorbing the player intensely and utterly.
>
> (Huizinga 1955: 13)

> A characteristic of play, in fact, is that it creates no wealth or goods.
>
> (Caillois 1961: 21)

But how can this be? On every side we see professional sports and theatre (not to mention the churches and synagogues) enmeshed in big-time economics. Individual athletes earn millions, and leagues sign TV contracts worth billions. Money is exchanged for admissions, salaries, media contracts, concessions, endorsements, and so forth. Billions more exchange hands through betting. Large-scale enterprises are entirely dependent on these activities. And, as more leisure time becomes available, we may expect a steady increase in these expenditures. Are we then to believe, as Huizinga does, that modern play is 'decadent' because it participates so completely in the economic arrangements of society?

The issue is complex. It can be unravelled only by appreciating the structural elements of the performative activities. In productive work the economic arrangements determine the form of the operation. Thus a man with little money may run a small automotive shop employing a few workers. A large corporation with millions to spend may operate an assembly line. [. . .] It is not simply a case of 'increased efficiency' or the production of more objects. The entire operation changes its shape, *what it is*, according to various modes of production.

Rules

But the difference between sandlot and major league baseball is one of quality, not form. The same rules apply to both games. The San Francisco Giants may have *better* players than the Sixth Street Eagles, but the Giants can't have *more* players on the field and still call their game baseball. When the rules are changed – and sometimes they are changed in response to economic pressures, TV has had an effect on sports – they are usually changed all the way down the line. And when adjustments are made at the sandlot level – because not enough players show up, or whatever – these adjustments are recognized as necessary compromises with what the game *should* be. What I've been saying about sports could be said, with some variations, about rituals, games, and theatre too. No matter how much is spent, paid, bet, or in other ways implicated in these performative activities, their respective forms remain constant. When money does 'corrupt' a form – a game is fixed, a star hired not for her ability to play a given role but simply because of her 'name' – people are able to recognize the misalignment. Some activities, like professional wrestling, fall between sports and theatre: the matches are known to be fixed but a certain willing suspension of disbelief is practised.

Economic arrangements thus affect the players, their bosses, spectators, audiences, fans, and bettors – everyone involved in the activity – while the activity itself remains largely unaffected. The money, services, and products (clothing, sports equipment, etc.) generated *by* these activities are not part *of* them. In games, sports, theatre, and ritual – play, again, is a separate case – the rules are designed not only to tell the players how to play but to *defend the activity against encroachment from the outside*. What rules are to games and

sports, traditions are to ritual and conventions are to theatre, dance, and music. If one is to find a 'better way' to perform, this better way must conform to the rules. The avant-garde is apparently a rule-breaking activity. But actually, experimentation in the arts has its own set of rules. Think about it: the ordinary technological environments most of today's Americans live in and with – cars and planes, appliances, TV and stereo, etc. – have changed much more radically over the past seventy years than have the concerns or techniques of the avant-garde. Performance activities all along the continuum – from play through to ritual – are traditional in the most basic sense.

Special rules exist, are formulated, and persist because these activities are something *apart from everyday life*. A special world is created where people can make the rules, rearrange time, assign value to things, and work for pleasure. This 'special world' is not gratuitous but a vital part of human life. No society, no individual, can do without it. It is special only when compared to the 'ordinary' activities of productive work. In psychoanalytic terms, the world of these performance activities is the pleasure principle institutional-ized. Freud believed that art was the sublimation of the conflict between the pleasure and reality principles; and he felt that artistic creation was an exten-sion of fantasy life – he identified art with play. Indeed, the art of the individual may be as Freud described it. But these performance activities are something different. Only theatre (music, dance) is art in the strict sense. Individuals engaged in ritual, games, or sports must conform to the rules which separate these activities from 'real life'. Although I do not wish to elaborate here, I think these activities are the social counterparts to indi-vidual fantasy. Thus their social function is to stand apart from ordinary life, both idealizing it (in these activities people play by the rules) and criticizing it (why can't *all* life be a game?).

Performance spaces

Perhaps this will be clearer if we consider for a moment where sports, theatre, and ritual are performed. Great arenas, stadiums, churches, and theatres are structures often economically non-self-supporting. Situated in population centres where real estate comes high, these large spaces lie fallow during great hunks of time. Unlike office, industrial, or home spaces, they are used on an occasional rather than steady basis. During large parts of the day, and often for days on end, they are relatively unused. Then, when the games start, when services are scheduled, when the show opens, the spaces are used intensely, attracting large crowds who come for the scheduled events. The spaces are uniquely organized so that a large group can watch a small group – and become aware of itself at the same time. These arrange-ments foster celebratory and ceremonial feelings. In Goffman's words, there is 'an expressive rejuvenation and reaffirmation of the moral values of the community' in those spaces where 'reality is being performed' (Goffman 1959: 35–6).[1] Certainly, more than elsewhere, these places promote social

	Play	Games	Sports	Theatre	Ritual
Special ordering of time	Usually	Yes	Yes	Yes	Yes
Special value for objects	Yes	Yes	Yes	Yes	Yes
Non-productive	Yes	Yes	Yes	Yes	Yes
Rules	Inner	Frame	Frame	Frame	Outer
Special place	No	Often	Yes	Yes	Usually
Appeal to other	No	Often	Yes	Yes	Yes
Audience	Not necessarily	Not necessarily	Usually	Yes	Usually
Self-assertive	Yes	Not totally	Not totally	Not totally	No
Self-transcendent	No	Not totally	Not totally	Not totally	Yes
Completed	Not necessarily	Yes	Yes	Yes	Yes
Performed by group	Not necessarily	Usually	Usually	Yes	Usually
Symbolic reality	Often	No	No	Yes	Often
Scripted	Sometimes/ No	No	No	Yes	Usually

Figure 1 Performance chart

Note: happenings and related activities are *not* included as theatre in this chart. Happenings would not necessarily have an audience, they would not necessarily be scripted, there would be no necessary symbolic reality. Formally, they would be very close to play.

solidarity: one 'has' a religion, 'roots for' a team, and 'goes to' the theatre for essentially the same reasons. What consequences flow from TV's ability to conflate all these spaces into one box multiplied millions of times, we are just beginning to discover.

It will facilitate matters if I summarize the formal relations among play, games, sports, theatre, and ritual in a 'performative chart' (Figure 1).[2] Referring to it, we see that theatre has more in common with games and sports than with play or ritual. However, certain key characteristics of happenings relate more to play than anything else; this is one strong indication of the real break between orthodox and 'new' theatre. Furthermore, play is obviously the ontogenic source of the other activities: what children do, adults organize. The definitive break between games, sports, and theatre on the one hand, and play and ritual on the other, is indicated by the different quality and use of the rules that govern the activities. These distinctions in the rules are the keys to more general distinctions. The five activities can be rather neatly subdivided into three groups (Figure 2). Play is 'free activity' where one makes one's own rules. In Freudian terms play expresses the pleasure principle, the *private* fantasy world. Ritual is strictly programmed, expressing the individual's submission to forces 'larger' or at least 'other' than oneself. Ritual epitomizes the reality principle, the agreement to obey rules that are *given*. Games, sports, and theatre (dance, music) mediate

Self-assertive 'I': +	Social 'We': ±	Self-transcendent 'Other': –
Play	Games Sports Theatre	Ritual
Rules established by Player	Rules establish frames: 'Do' (freedom), 'Don't Do'	Rules given by Authority
Pleasure principle, Eros, id, private world, assimilation	Balance between pleasure and reality principles ego, accommodation	Reality principle, Thanatos, superego

Figure 2

between these extremes. It is in these activities that people express their *social* behaviour. These three groupings constitute a continuum, a sliding scale with many overlaps and interplays. However, differences in degree become differences in kind. Ritual and play are alike in many ways – periods of playful licence are often followed by or interdigitated with periods of ritual control, as in Mardis Gras–Lent or in the activities of ritual clowns. The performance chart, to be read accurately, might be folded into a cylinder so that play and ritual are close together, the 'opposites' of games, sports, and theatre.

In Figure 2 games, sports, and theatre are 'middle terms', balancing and in some sense mediating and combining, play (+) and ritual (–). In the middle terms rules exist as frames. Some rules say what must be done and others what must not be done. Between the frames there is freedom. In fact, the better the player, the more able s/he will be to exploit this freedom. This is clear for sports and games, but what about theatre? For the actress playing Hedda Gabler, to give an example, the situation is complex (Figure 3). The first frame concerns the physical stage or space, the second the conventions of her epoch; the third the drama itself; and the fourth are the instructions given to the actress by her director. She need not worry about any except this last, for each inner frame contains within it the rules established by frames further out.

There is an 'axiom of frames' which generally applies in the theatre: the looser an outer frame, the tighter the inner, and conversely, the looser the inner, the more important the outer. Thus the improvisational actor is freed from both director and drama, but s/he will therefore have to make fuller use of conventions (stock situations and characters, audience's expectations, etc.) and the physical space. The actor will also find himself directly confronting his own limitations: there will be little mediating between him and his audience. Even the wildest avant-garde work will be framed by space, sometimes literally interstellar space. I know of no production where conven-

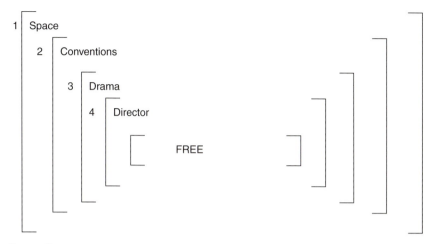

Figure 3

tions are completely disregarded. However, the frames are not static, even within a single production. Kaprow's *Calling* (1965) took place in several locations, some of them outdoors. Because there were so few spatial or conventional limitations, Kaprow gave his performers very specific tasks: the inner frame was tight, the outer ones very loose.

This kind of analysis doesn't say much about the particular role of the actor, director, playwright, or architect-designer. But it does outline their relationships to each other and suggest that each function is meaningful only in terms of the whole set. One cannot discuss a single frame without referring to the others, because it is only within a pattern or relationships that a specific phenomenon takes place.

The indication that theatre has more in common with sports and games than with ritual or play should be the cue to explore work in (mathematical and transactional) game analysis as methodologies for the study of theatre. [. . .]

Notes

1 I know I'm quoting Goffman out of context. He meant that any place where something is done that 'highlights the official values of the society' – such as a 'party,' or 'where the practitioner attends his client' – is a celebratory place. I have specified what Goffman intended to keep general.
2 I am indebted to Arthur Koestler (1961) for the way in which I use the terms 'self-assertive' and 'self-transcedent' in Figures 1 and 2.

Colin Counsell

SIGNS OF PERFORMANCE

From: *Signs of Performance: An Introduction to Twentieth-Century Theatre* (London: Routledge, 1996).

The theatrical space

HOW CAN WE DESCRIBE THEATRE AS AN ARTFORM, what are its characteristic components? Perhaps the first thing we expect of it is a plot or, more accurately, a *narrative*, a series of events and actions which succeed each other according to a causal or developmental logic. In contrast to, say, film this narrative will be enacted live, by performers who occupy the same physical time/space as the audience. Each performer will use their everyday expressive resources – voice, gesture, movement, and so on – to construct a fictional participant in the narrative, a character, which will function as the notional author of the actor's words and actions. Visual and spatial arts – painting, architecture, clothes design – will be employed in sets, props, and costume not solely to complement narrative and character but also to establish a fictional time and space conceptually removed from the real site of performance, a hypothetical other-place in which the action will be deemed to have occurred. The whole performance will take place in an agreed venue for representation, in which the spaces and functions of spectators and actors are strictly separated.

This list might accord with most people's conception of theatre. Yet during the course of the twentieth century, with its wealth of formal experiment in all the arts, the indispensability of each of these components has been challenged. It is debatable whether even the first and most conventional of Samuel Beckett's plays, *Waiting for Godot,* has a narrative in the accepted sense, whereas some of his later, more experimental pieces lack plot and development entirely.

Beckett's works are built of a predetermined sequence of events and actions, of course, but this cannot be said of Improvisational Theatre. The obvious riposte is that Improvisational Theatre is not real theatre, but it is precisely the parameters of 'real theatre' that are at issue. [. . .]

Theatre has been performed in bare spaces and with minimal props since Aeschylus, and directors such as Ingmar Bergman have made this practice commonplace on the modern stage. It is questionable whether picket lines and market places, both familiar theatre spaces, constitute 'agreed venues for representation', but even if they do we must still account for the Underground Theatre. There the audience meets the actors at a pre-arranged place and time, and accompanies them as they travel the London subway system and perform eccentric actions. The show itself consists of those actions and the reactions of unsuspecting commuters. The commuters are not aware that it is theatre and as a consequence the necessity for both an *agreed* venue and a hypothetical other-place disappears into a maze of qualifications.

The very separation of audience's and performers' spaces was questioned by experiments with so-called 'Environmental Theatre' in the United States. By staging action in the audience's space, and moving among spectators to get from one site to the next, the Performance Group under director Richard Schechner violated traditional spatial boundaries. Of course, it could be argued that the Performance Group's actors carried the borders of their special space around with them, by virtue of the fact that they were to be 'read' in a different way from members of the audience. Thus with the very distinction between actor and spectator a *perceptual* division of space was effected. However, the later work of Polish director Jerzy Grotowski problematized even this. In his 'paratheatre', participants collaborated to create the event, each effectively acting both as onlooker and actor, and so rejecting the distinction entirely.

It might appear that one distinctive characteristic of theatre, the physical presence of its actors, remains inviolable, but this is not so. Once again Beckett acts as a kind of one-man assault against theatrical norms. The curtain rises on his play *Breath* to reveal a stage filled only with 'miscellaneous rubbish', and the action consists of a light rising and falling, co-ordinated with the taped sound of breathing and of a child's birth cry. There is no story, set, hypothetical other-place, character, nor even a live performer. It is therefore perplexing that there are still clear grounds for viewing the piece as theatre.

How is it that, while a play such as *Breath* lacks so many of the features we deem characteristic of theatre, we still view it *as* theatre? The answer is that the event presents us with indications, signs, that it is to be addressed as such. If *Breath* were to be staged on a roadside, and without any further explanation, we would have difficulty knowing how to view it. But performed in a recognized theatrical venue, the circumstances themselves (the stage, curtains and so on, the arrangement of playing and viewing spaces, our foreknowledge of the building's purpose) would signal the identity appropriate to the piece. Indeed, the process of identification, of granting the event

a given status, usually begins much earlier. We are likely to have read reviews, seen publicity material, or at least have heard of Samuel Beckett before buying our ticket. If we inadvertently come upon a performance in a park or on a picket line, a host of other familiar indicators – the arrangement of actors/ spectators, the way performers move and speak, the audience's passivity and so on – would tell us what species of event it was, and consequently how to view it.

Therefore theatre cannot adequately be defined with a checklist of its component parts. In 'recognizing' theatre we perform what is essentially an *interpretative* act. We read its elements as 'signs', taking them to first signify the event's general cultural identity. [. . .]

The audience's interpretative role, however, goes beyond recognizing theatre as a category. The audience is also active in manufacturing the meanings a theatrical event offers, for this too requires the spectator to use their cultural experience. In order to understand how theatre works, the meanings it constructs and the means by which it does so, we must now examine it and the audience's place within culture. [. . .]

The abstract and the concrete

The Law of the Text enables a theatrical event to function as a symbolic unity. This symbolic register was the focus of work undertaken in the 1930s by the Prague Formalists, who were arguably the first to turn an informed semiotic eye upon the stage. Terming their work 'the semiotization of the object', Keir Elam gives an account of their conclusions:

> The very fact of [the object's] appearance onstage suppresses the practical function of phenomena in favour of a symbolic or signifying role. . . . A table deployed in dramatic representation will not usually differ in any material or structural fashion from the item of furniture that the members of the audience eat at, and yet it is in some sense transformed: it acquires, as it were, a set of quotation marks. It is tempting to see the stage table as bearing a direct relationship to its dramatic equivalent – the fictional table that it represents – but this is not strictly the case; the material object becomes, rather, a semiotic unit standing not directly for another (imaginary) table but for the intermediary signified 'table', i.e. for the *class of objects* of which it is a member.
>
> (Elam 1980: 8 [Counsell's brackets])

This accurately restates the Prague Formalists' view; in Jindrich Honzl's words, 'Everything that makes up reality on the stage . . . stands for other things' (see Matejka and Titunik 1976: 74). Nevertheless the explanation is incomplete because it describes only one of the theatre's registers.

Pavis points out that mime implicates two kinds of movement, the gestural universe of the mime itself and the world of ordinary gestures that is drawn into the spectator's interpretative consideration as a comparison. In this he describes a situation unique to live performance. No artform truly constructs an 'illusion', for when reading a novel or watching a film we remain aware that we are experiencing fiction. But this is relative. In reading a novel we engage solely with language, while with a mainstream film our attention, or interpretative activity, is always bounded by the edge of the screen. When we are confronted with the real physical presence of the actor, however, we are reminded of the outside of the fiction. We are reminded of *artifice*; the 'author' is present and the event we see is a product of his or her authorial contrivances. Theatre is an 'uncomfortable' artform because its symbolic register is continually threatened by another, one in which theatre's fictionality, its meaning-*making*, remains overt. [. . .]

Theatre, then, operates in two registers. The first we shall call the *Abstract* register. In Elam's words, this 'suppresses the practical function of phenomena in favour of a symbolic or signifying role' and it is therefore bound up with the other-place of the locus. Being conceptually distanced from the audience, it functions on a symbolic level. It deals with abstractions – not the tangible and equivocal social world we experience, but a world already quantified, categorized, by the discourse the locus encodes. Thus it construes reality in terms of that discourse's symbolic entities: the stage table represents a general class of objects, 'Tables', the character of theatrical realism becomes a 'fully rounded individual', and the world of Expressionism is seen through the distorting eye of the repressed, subjective self. It is this very quality of symbolic transposition that enables it to be illusionistic. The stage becomes an other-place and its objects become things of the playworld – the person is not an actor but King Lear – and this applies not only to realistic theatre but to all forms that foster an illusion, operating primarily in the Abstract register. But to support this illusion the Abstract must efface its own mechanics [it] must elide or reinterpret all signs that it is a product of artifice, a fiction.

The second we shall call the *Concrete* register. Here the person onstage is recognized as an actor and the table as *that* table. This register does not function symbolically, as its stage is not differentiated from the real, social space/time of the audience. Consequently its utterances have the same status of *provisionality* as any ordinary utterance, a result of our recognition that its meanings have been *made*. Thus it deals not in systematized symbolic categories but in the real material stage and the multiplicity of discourses found there. Its views are not abstract but partisan, told by a discernible teller. Manufacturing no illusion, its mechanics and fictionality can be admitted within the performance. That is, artifice must be accounted for in our interpretation of the text; we must make-sense not merely of the told but also the telling.

In most theatrical forms these two registers function side by side. They are antithetical, however, for the Abstract's illusion is threatened by the

Concrete's overt artifice, just as illusion can potentially redefine signs of contrivance, give them other significance. [. . .]

The dialogic space

All that we have examined makes it apparent that we cannot speak unguardedly of a production's meaning. Meaning in the theatre is always *made*, and one of its makers is the audience. [. . .]

The meanings offered by a particular theatrical event [. . .] are produced in the interaction between auditorium and stage. Theatre governs its own reading by establishing relationships, ways of viewing that enable the audience to make-sense of the theatrical text, and in doing so determine the kinds of sense that can be made. We can now use this and the other analytical instruments we have examined to understand theatre's distinctive signifying regime in total.

The theatrical experience is sometimes conceived as a kind of hallucination, with the audience actually believing that what takes place onstage is real. As we have seen, this in inaccurate. The audience of course remains aware that it is in a theatre, and so is able to appreciate technique, recognize the respected actor, and demonstrate group unity with laughter and applause. Theatre does not deal in 'belief' but in signification, creates not delusions but responses and interpretations. It achieves this by manufacturing relationships between the audience and the stage. The precise terms of any such relationship depend on the form of theatre involved, for each form requires the spectator to respond with its own juxtaposition of Abstract and Concrete registers, and its own Law of the Text.

The relationship between the stage and the auditorium is one we may term *dialogic*. By this we mean that the roles of both partners in the exchange are defined relative to each other. The nature of the utterance from one dictates its mode of reception, dictates the range of responses appropriate to the other. Despite overstated claims for 'feedback', however, the power to dictate this relationship lies largely in the hands of the stage. In practice, a particular form of theatre signals to its audience how it must be interpreted, the kinds of interpretative strategies that must be used in its own reading, and so 'creates' its audience as interpreter. Different theatrical forms will therefore manufacture different audiences. Each form can be regarded as a distinct *interlocutor*, one partner in an exchange, whose 'identity' automatically offers a complementary role to its audience. The audience's role consists of adopting an interpretative strategy appropriate to that kind of theatre, a logic written into the form itself.

This indicates the *active* role played by the audience in decoding the text. Theatre does not *impose* a reading, any more than discourse imposes its view of the world. Rather, each form 'hails' the spectator, offers a position from which the text is readable. The identity of the stage as discursive partner

determines the dialogic relations, and these relations include the appropriate interpretative strategies – collectively comprising the *interpretative posture*. The audience is willing and able to adopt that posture; making-sense of the production is, after all, what we go to the theatre for. It is not that highly illusionistic forms, for example, banish awareness of the actor's presence or of theatre's contrivances. Rather, these questions are outside the posited relations, beyond those reading strategies that have been signalled as appropriate. The audience, then, has to recognize, accept, and put into practice the interpretative codes, and in doing so operates within semic parameters encoded in the event itself. Every form of theatre predicts a limited range of audiences as 'answer' to its proposal. To enter into these dialogic relations is to accept those parameters, to act in unison with other spectators, and so to become a member of an audience.

Susan Leigh Foster

CHOREOGRAPHIES OF GENDER

From: *Signs* 24, 1 (Winter 1999).

Theoretical moves

IN ORDER TO ILLUMINATE WHAT IS ENTAILED BY THE CHOREOGRAPHIC PROCESS, I begin with the example of the lone female choreographer at work in the dance studio. This example traces its origin to the modern dance tradition in the United States, a tradition whose feminist underpinnings have been well documented.[1] This initiative, undertaken by white, bourgeois women at the turn of the century, constructed a new expressive practice focused at the site of the individual dancing body. These artists sought to overhaul body and soul in order to liberate individual creative impulses from the stranglehold of societal norms and aesthetic values. Their choreographic accomplishments, congruent with experimental philosophies of education during that period, provided the rationale for the entrance of dance into higher education.[2] Construed as a way of knowing other than and outside of verbal knowledge, the professional world of modern dance and the university dance programme continue to privilege the individual creative process and its realization in dancing and in the making of new dances.

In making a new dance, the choreographer often stands motionless, staring into space, perhaps a mirror's space, for an indeterminant period of time. Then she tries out a move: one arm flings on the diagonal from low front to high back; the body flows after it, motion-filled by its momentum. The leg, initially trailing behind as the last trace of the body's twisted turning, swings suddenly to the front, causing enough impetus to carry the body

through a second turn. Exiting from the turn's wildness, the body folds at hip and knee joints, back gently curved, arms arching forward over the head. The choreographer stands back up and resumes her stare. Does the turn need an additional bend of the torso or gesture from the back foot? Should the contrast between first and second turns be heightened? Is the body's final shape too symmetrical? too soft? too familiar? This series of questions promulgates other levels of interrogation: Is the phrase delirious enough? Does it look like half-baked Trisha Brown? Will everyone see that it is a variation on the earlier theme? Can the dancer do it without wrenching her back? Should the arms scoop under (in which case it looks too much like supplication) or should they scoop over (in which case it looks like a five-year-old's rendition of waves crashing on the shore)? The choreographer wrestles with these and related questions in no prescribed order and, quite probably, without ever articulating the questions or their answers verbally. She is sorting through, rejecting, and constructing physical images. Her choices make manifest her theorizing of corporeality.

The choreographer constructs relationships of body to momentum, stasis, impulse, and flow and articulates relationships of the body's parts one to another. She engages the body's semiotic field – the connotations that head, hands, pelvis, or heels carry with them, the meanings evoked by tension, undulation, or collapse – and situates the body within the symbolic features of the performance space – the centre, side, high, and low that the architectural context designates. In so doing, she fashions a repertoire of bodily actions that may confirm and elaborate on conventional expectations for gendered behaviour, or she may contrive a repertoire that dramatically contravenes such expectations. In either case, dancing dramatizes the separation between the anatomical identity of the dancer and its possible ways of moving. Part of dance's compelling interest derives from the kinds of links the choreography makes between sex and gender. This is not to say that the anatomical body of the dancer is a natural body. That body exists along a continuum of attributes that define male or female sexual identity. Its shoulders may be unusually broad for a woman, its feet unusually flexible for a man. And this anatomy is not destiny. The dancer cultivates the body through training regimens that develop its strength, flexibility, endurance, and co-ordination.[3] It may acquire a massive muscularity uncharacteristic of the female body or a willowy flexibility uncharacteristic of the male body. This body, already codified in terms of its sex but appearing as one of two sexes, then presents itself to the viewer. Its movement will be seen as gendered, as putting into play various codes of gendered behaviour.

Thus the choreographer considers kinds of bodily stances (open or closed), bodily shapes (erect or curved), engagements with the surrounding space (direct or diffuse), timing of movements (slow or quick, continuous or abrupt), qualities of motion (restrained, sustained, undulating, bursting), and sequencing of body parts (random or sequential) characteristic of each gender's motion.[4] She stipulates a quality of focus for the dancer, projecting

attentiveness to the connections between internal sensation and external motion, projecting awareness of external space and making contact with other dancers, or calling attention to the body's enunciations in space. She likewise designates a kind of motivation for the movement in which dancers can appear to be propelled by an imaginary force located out in space or to initiate movement from within their own bodies. She reckons with established codes of contact between female and male bodies: where the body of one sex can touch the body of the other sex, what kinds of shapes bodies of the two sexes can make together, who can give weight and who bear it, who initiates movement and who follows, who is passive and who active, who is to be looked at and who is doing the looking. She forges phrases of movement that construct groupings of dancers with gendered connotations – chaotic, convoluted, pristine, or geometric. When she does this for multiple bodies, she elaborates a theory not only of gendered corporeal identity but also of relations among gendered bodies.

Male and female bodies, bodies of different colour and racial attributes may or may not evidence vocabularies or styles of movement associated with their sexual or racial identities. These bodies gesture toward, touch, or support one another. They follow in one another's pathways, reiterate or vary one another's moves. They evidence a range of emotional responses toward one another, all the while oblivious to or interactive with the audience. They may distribute themselves so as to frame a soloist or to present multiple competing events. They may cite other dances or dance traditions as part of their danced argument. In the sustained development of their activities, they will appear to narrate events, to tell a kind of story, perhaps with characters, motivations, and responses to one another, or perhaps to speak of the weight, momentum, and agility of which bodies are capable. They may enunciate values and relationships characteristic of a particular ethnic identification, or they may present a series of affective states. Accumulating these choices concerning the behaviour of bodies, the choreography builds up an image of community, one that articulates both individual and collective identities.

Throughout the creative process of articulating these identities, the choreographer engages a tradition of representational conventions, knowledge of which is shared to a greater or lesser extent by both dance makers and dance viewers. In order to achieve the meaning she envisions, the choreographer selects from among these conventions, implementing, innovating, and even challenging aspects of the tradition. Viewers will, in turn, analyse the choreographic implementation of conventions in order to derive their own interpretation of the dance. However intuitive or inspired the creative process may seem, the choreographer is nonetheless labouring at the craft of dancemaking. However distinctive or gifted her dances may seem, she is working as one of a group of practitioners sharing a body of knowledge about how dances mean what they do. However immediate the dance's message may appear to viewers, their understanding of the dance will be based on their ability to decode

the choreographic coding of meaning. Thus, the choreography may contribute innovations that will subtly alter the contents of its representational tradition, but these innovations can acquire their full meaning only through their situatedness within that tradition.

Dancers who enter the studio to translate choreography into performance begin by learning the movement, its timing, and its disposition for the body in space, as meticulously as is required by the aesthetic demands of the situation. Yet they also modify the movement so as to develop a personal relationship with it. In order to 'make it their own', they may alter movement to adapt to their bodily capacities so that they, and by extension the movement itself, achieve greater clarity in performance. They may imbue the movement with personal meanings in addition to those described by the choreographer so as to attain a greater fervency. They may elaborate a persona – an integrative conception of the body-subject who would move in the way specified in the choreography – and then use this concept to further refine stylistic features of their performance. They may also calculate the effect of their performance on viewers and calibrate effort, intensity, and focus so as to 'reach' the audience in a manner consonant with the choreography's theoretical goals. They may even connect to a history of performers or a traditional style of performance that informs their current project. Throughout the process of learning and presenting a dance, performers manifest these and other competencies, the product of years of arduous training.

Occasionally, dancers are asked to move beyond the bounds of their training as performers and to assume roles as co-choreographers of the dance. They may be asked to generate movement based on specific strictures or guidelines, to solve problems of sequencing, or even to engage critically, comment on, or select from among the representational strategies that the choreography deploys and that they embody in performance. The fact that dancers may assist in these choreographic projects, however, does not alter the distinctiveness of the two roles. Insofar as they are performers, they will be concerned primarily with these kinds of questions: How shall I phrase this section? Should I hold back here in order to provide more contrast with the intensity of that moment? Does my timing appear mannered? Can I be more focused? How can I look occupied with one action while actually waiting for the arrival of another body with whom I must appear to have a spontaneous interaction? What additional strength, flexibility, or endurance do I need to enhance the execution of the movement?

How the performer answers these questions will affect the overall impact of the choreography and may subtly alter its intent. Certainly, there is a sense in which the performance of any given dance stands as the most accurate presentation of its choreography, stands as the choreography insofar as any given viewer has access to it. Still, throughout the viewing of a dance, one can perceive the guiding score for the action as distinct from the execution of that score. One can see the residue of strategic choices concerning representation as distinct from the bringing to liveness of those

choices. And in this distinctiveness, the contrasting functions of choreography and performance are apparent: dance-making theorizes physicality, whereas dancing presents that theory of physicality.

Notes

1 See Kendall 1984; Ruyter 1979; Daly 1996; Tomko forthcoming.

2 See Kriegsman 1981 and also Tomko forthcoming.

3 I have elaborated on this argument in Foster 1992.

4 The kinds of movement qualities, spacing, and timings I describe here are meant to be suggestive of categories of movement analysis rather than as systematic or exhaustive lists of gendered characterstics. They take inspiration from but do not claim the kind of comprehensiveness argued for by the early twentieth-century movement theorist Rudolph Laban. A description of his system for analysing gendered movement can be found in Bartinieff 1980: 58–9 and 92–3. An alternative and very thoughtful systematization of gender in relation to movement styles is provided in Young 1990.

Sally Banes

ENVOI: RECENT DEVELOPMENTS IN DANCE

From: *Dancing Women* (London: Routledge, 1997).

[. . .]

MODERN DANCE HAD BEEN A FEMINIZED FIELD SINCE ITS FOUNDING at the turn of the century, by a generation of 'fore-mothers' (the early modern dancers, including Isadora Duncan, Loïc Fuller, and Ruth St Denis), and its systematization by a second generation of predominantly female teachers and choreographers (including Mary Wigman, Doris Humphrey, Katherine Dunham, and Martha Graham). So the women choreographers of the 1960s needed no special dispensation to enter the field. And yet, ironically, after two generations of female domination, American modern dance in the Fifties had been led by men – Alwin Nikolais, José Limón, Merce Cunningham, Erick Hawkins, Alvin Ailey, and Paul Taylor. These men specifically departed from the precepts of the modern dance colossi. That is, often they were the rebellious sons of the domineering mothers (aesthetically speaking).

For several of those men, it was dance's concern with emotion that needed change. That, to some, was a deeply feminine concern. Nikolais, for instance, explained that 'the early modern dance explored the psyche', but that the time had come to move on. He proclaimed,

> the male is far more inclined toward the abstract, and the field of dance is overpoweringly female and matriarchal. I hope fervently for the time when the socio-dynamic climate will re-establish the male in a more just position in the modern dance world.
>
> (Nikolais 1966: 64–5)

But just then, a new generation of women choreographers was coming to the fore, often making dances that put gender in the foreground. And they questioned whether emotion should be the primary concern either of dance or of women choreographers. Both men and women participated in the Judson events.[1] In that sense, the group was egalitarian and gender-integrated. But several of the dominant figures in the group – like Yvonne Rainer, Judith Dunn, Elaine Summers, Lucinda Childs, Deborah Hay, Trisha Brown, and Carolee Schneemann – as well as Simone Forti (never a member of the Judson group) refeminized dance in a new key by claiming it as open territory for serious women artists.

Merce Cunningham's choreography in the 1950s and 1960s often gave dancers similar tasks to perform, whether they were male or female. His dancers, working with pure movement in an abstract, non-narrative form, at times became completely androgynous figures in an environment where the dancing 'task' required no gendered image. Both men and women took large leaps and executed detailed, brilliant footwork. But in his use of part-nering, Cunningham could not, or would not, escape the heritage of classical ballet. For all his radical reworkings of choreography and movement, men usually still supported and lifted women in his pas de deux in quite tradi-tional ways. Men did not partner men, nor did women lift or support women.

But the cohort that followed Cunningham questioned these conventions, reimagining women's identity and gender relations on stage with gusto, in much the same way that their generation refashioned them in life. Not simply a reflection of political life, these developments in dance kept pace with changes in the feminist movement and feminist theory. [. . .]

The late 1960s and the 1970s: the intelligent female body

[. . .] Modern dance had once been engaged in formal experimentation, but it had also always been closely linked with emotional expression. John Martin, the *New York Times* dance critic and leading apologist for modern dance in America, stated categorically in 1933 that 'emotional experience can express itself through movement directly', and that, through 'metakinesis' and 'muscular sympathy', modern dance had reinstated the ancient Greek tragic mode of conveying through the dancing body 'the "inexpressible residue of emotion" which mere rationality – words and pantomime – could not convey' (Martin 1965 [1933]: 18, 14).

But by the postwar years, modern dance had become for many a pompously over-inflated, histrionic artform. Agonies and ecstasies were indeed the reigning emotional registers, and usually the feeling states represented – jealousy, anger, fear, and sometimes even joy – were the tortured passions of love. *The Moor's Pavane* (1949), José Limón's distillation of Shakespeare's *Othello* and one of the major works of the modern dance canon, is a perfect example. So is Martha Graham's *Cave of the Heart* (1946), based on the Greek

myth of Medea. Anna Sokolow's *Rooms* (1955), about the angst and alienation of contemporary society, did not deal specifically with love, but still portrayed the tortured sensibilities of the inner life of individuals. [. . .]

In early postmodern dance, the performers often expressed a spontaneous *joie de vivre* that had to do with the immediate exhilaration of moving. They did not 'perform' or represent emotion in terms of character, narrative, or even abstraction. For instance, in Simone Forti's early pieces, based on children's games and play, the performers displayed an infantile, joyous high energy. In *Rollers* (1960), two performers sang while seated in unstable boxes, while six other performers pulled them by means of three ropes attached to each of the two wagons. Forti describes the situation:

> The three ropes fastened to the boxes seem to create a situation of instability, and in no time the boxes are careening wildly. For the singers in the boxes, this produces an excitement bordering on fear, which automatically becomes an element in their performance.
>
> (1974: 44)

In permitting this sort of spontaneous and 'authentic' expression to flood the performance, the postmodern choreographers were unusual, for even Cunningham's dancers at the time usually wore a tightly controlled facial mask, complete with glazed eyes. [. . .]

People like Rainer, Steve Paxton, and others tried to make dancing bodies into 'neutral "doers"', rather than agents of affect (Rainer 1974: 65). Perhaps influenced by Bertolt Brecht, they attempted to drain the emotional catharsis of drama from their performances. Rainer was deeply influenced by the film comedian Buster Keaton, 'the great stone face', – in particular, his impassive visage and his close attention to performing specific tasks. For the most part, the postmodern dancers did not act or represent characters, but sought to *present* movement for its own sake. Rainer wrote:

> The artifice of performance has been re-evaluated in that action, or what one does, is more interesting and important than the exhibition of character and attitude, and that action can best be focused on through the submerging of the personality.
>
> (Ibid.)

[. . .] When the postmoderns performed emotion, they did so in ways that were distanced and framed, as in a Brechtian *Verfremdungseffekt*.[2] In this regard, they used similar strategies to those of the Pop Artists who were their contemporaries. Roy Lichtenstein, for instance, ironized emotion by monumentalizing it beyond proportion, blowing up frames from romance comics to underscore just how exaggerated they made the melodramatic passions of love appear. Through repetition, Andy Warhol flattened emotion, reducing the horror of an event like a car crash to a banal monotone. Surely the

choreographers were also influenced by film-makers of the French New Wave, like Jean-Luc Godard in *Breathless*, who (directly influenced by Brecht) also distanced emotions and ironized them through exaggeration and allusion. [. . .]

The postmodern dancers explored a range of alternative emotional expressions in the 1960s. But as the 1960s moved into the 1970s, postmodern choreographers became more and more interested in blotting out emotion altogether. In Deborah Hay's *No. 3* (1966), three assistants toppled and dragged three stacks of bricks while Hay ran evenly in circles. Rainer wrote an essay about the dance, in which she stated that its importance lay in the dancer's neutrality (in contrast to balletic 'glamour, apotheosis, or accentuated vagaries of the prima donna, prima ballerina, and prima starrinarosa' (1966: n.p.). What was crucial to Rainer was that in *No. 3* the emphasis was on the movement, rather than the mover. Being moved, emotionally, was replaced by movement *qua* physical action. [. . .]

Rainer's *Trio A* (1966) was also known as *The Mind Is a Muscle, Part I*. It later became the nucleus for the evening-length work *The Mind Is a Muscle* (1968) and appeared in many other works by Rainer, as well as in performances of the improvisational group The Grand Union. *Trio A* was not by any means created as a feminist dance – in the final version of *Mind*, the trio was danced by three men as well as in a solo version by Rainer. Nevertheless, when danced by a woman, *Trio A's* messages about the economy and skill of the human body became a vision of the intelligence, competency, and strength of the female body in contrast to the way the female body was generally regarded in the culture at the time – as feminine, delicate, dainty, weak, and an object rather than an actor on the intellectual stage. The title itself implied a whack at Cartesian dualities that divide mind/body, thinker/dancer. But the dance actually proposes, instead, a new split – one that divorces the body from the emotions – thereby suggesting an alternative category of representation in which the dancing body might be engaged.

[. . .] When Rainer said 'no to seduction of spectator by the wiles of the performer' (1974: 51), she was not speaking of sexual seduction, but rather of the intense emotional, metakinetic identification that, according to Martin and the modern dance establishment, formed the bedrock of modern dance.

In much the same way that Rainer substitutes analytic intelligence for emotional inspiration and manipulation, Brown shows in her solo *Accumulation with Talking Plus Water Motor* (1979) that dancing can be an act of intelligence rather than an arena where, as Copeland puts it, 'women are reduced to (and equated with) their bodies' (1993: 143). In *Ordinary Dance* (1962), Rainer had shocked spectators by talking while dancing – by restoring the speaking voice to the dancer, who had once been banished to a world of silence. Brown took the issues of envoicement and of the intelligent dancing body to new heights in *Accumulation with Talking Plus Water Motor*. In this dance, Brown splices together two earlier dances – *Accumulation* (1971), a series of repeating straightforward gestures strung together according to a

complex mathematical progression, and *Water Motor* (1978), a fluid synco-pated, sensual strand of off-balance movements like falling and diving. As in Rainer's *Trio A*, in *Water Motor* Brown's body often seems to move in two different directions at once, but here the energy is explosive rather than smooth. In addition to intercutting between these two quite different dances, Brown also tells two distinct, alternating autobiographical stories, one of which concerns the making of the dance. Thus, while concentrating on the dance sequences and using enormous physical effort to execute them, she must also keep the narrative flow going and find the breath to talk. At every juncture, she must keep track of four end-points – one for each dance and one for each story. [. . .] So complete was the postmodern division between dancing and the passions by the early Seventies that when Rainer became interested in exploring emotion in her art, she forsook dance in favour of cinema. [. . .]

The issue of difference within gender – the diversity of women in terms of class, race, and ethnicity – came to the fore in the women's movement of the 1980s and 1990s. Concurrently, in both American dance and perfor-mance art, women staged the politics of complex identities inscribed on, in, and by the body. Jawole Willa Jo Zollar and the Urban Bush Women, a group of African American women who combine speech, song, and dance, often work with folklore of the African diaspora, from African village women's songs and dances of bitterness to girl groups of 1960s rock and roll, to drill teams in contemporary black urban centres. Zollar's *Bones and Ash: A Gilda Story* (1995), based on a novel by Jewelle Gomez, spins a fantasy chronicle of benevolent lesbian vampires, connected to Afro-Brazilian spirit powers, who survive slavery and live on into the era of the civil rights move-ment, migrating north from a bordello in nineteenth-century New Orleans to a beauty parlour in 1950s Boston. It offers an utopian vision, in which strong women magically save the world, but it is also a celebration of the real communities that have enabled black women's survival.

The 1980s and 1990s: bad girls

The exploration of gender identity as a social, rather than biological, construc-tion in the 1980s collided with political resistance and an avant-garde urge to shock the bourgeoisie, as women artists in the 1980s and 1990s began to use parody to both flaunt and criticize notions of femininity. To be 'bad' was seen as a way to cast off all the shackles society has traditionally used to 'keep women in their place'. Deliberately transgressing the rules of polite discourse about female bodies, joyously espousing bad manners and bad taste, these artists use a blend of humour and aggression to push ques-tions about gender in the arts and in society to the outer limit. Madonna's parodic hyper-sexuality is only the mainstream tip of the iceberg of this school, which embraces Karen Finley, Holly Hughes, and Annie Sprinkle in

performance art, Joan Braderman in video, and Cindy Sherman and the Guerrilla Girls in the visual arts. [. . .]

If in the last three decades, feminism in the United States has explored a range of options – including liberal feminism, cultural feminism, and materialist feminism – then one can see a parallel, related, and not simply reflectionist evolution in the concerns of postmodern choreographers. Focusing alternatively on gender equality, the specificity of women's experience, and the limitations of patriarchal constructions of female identity, postmodern choreographers have offered us what may seem to some to be contradictory visions of feminism. But I would argue that these are not contradictory; rather, they are intimately related parts of an evolving vision – stages or steps towards a comprehensive, complex, and rounded view of the past, the present, and the future of women's emergence from patriarchy, not only in dance, but in the culture at large.

Notes

1 Concerts staged by the postmodern dance group, the Judson Dance Theatre. – Eds.

2 See the extract from Brecht (Chapter 15, above), for more on the *Verfremdungseffekt*.

Political theatres, post-coloniality, and performance theory

Phillip B. Zarrilli

INTRODUCTION TO PART SEVEN

THE ESSAYS THAT FOLLOW EXPLORE THE COMPLEX
AND VEXING INTERSECTIONS between politics, cultures,
nations, selves/identities, post-coloniality, performance, and theory. In her
introduction to the recently published *Crucible of Crisis: Performing Social
Change*, Janelle Reinelt asks the following questions of relevance to both
'political theatre' in general and post-colonial theatre in particular:

> What is the relationship of politics to culture? How does social change
> result in cultural change – or can various cultural practices initiate or
> precipitate change? If a simple base/superstructure model inadequately
> explains the dynamics of art and society, then how do they articulate?
> (1996: 1)

These kinds of questions have often been asked, and many have attempted to
answer them. One notable set of answers to questions such as these was offered
some years ago, for instance, in Terry Eagleton's book-length discussion.
Eagleton argues that 'the rationalist view of ideologies as conscious, well-
articulated systems of belief is clearly inadequate', and therefore defines
ideology as 'a matter of "discourse" rather than of "language" – of certain
concrete discursive effects, rather than of signification as such' (1991: 21).
Eagleton is interested in that place of 'relational' intersection where negotia-
tion ceaselessly occurs for the human subject where one is 'always conflictively,
precariously constituted' (ibid.). Recognizing the 'lethal grip', 'tenacity and
pervasiveness of dominant ideologies', Eagleton goes on to argue that

there is one place above all where such forms of consciousness may be transformed almost literally overnight, and that is in active political struggle. This is not a Left piety but an empirical fact. When men and women engaged in quite modest, local forms of political resistance find themselves brought by the inner momentum of such conflicts into direct confrontation with the power of the state, it is possible that their political consciousness may be definitively, irreversibly altered. If a theory of ideology has value at all, it is in helping to illuminate the processes by which such liberation from death-dealing beliefs may be practically effected.

(1991: 223–4)

The 'theatres' explored here are those that self-consicously attempt to transform consciousness and initiate active political struggle. 'Political theatre', 'theatres of crisis', 'post-colonial theatre', or theatre made for 'social change' are those publicly enacted events that often take place during, and/or inspired by periods of social and political crisis and/or revolution. By 'theatre' I mean not only theatre narrowly defined as the performance of dramas whose content stages a social crisis or revolution, but also that wide range of 'theatres' of public spaces and events such as rallies, meetings, marches, protests, and the like which stage a revolution as it is happening everywhere from the streets, to meeting halls, to paddy fields. I am thinking here of those types of public events which, as anthropologist Don Handelman asserts, are 'a reflection not of frozen cultural ideals, but of the turbulence that wracks social order during that time and place ... [I]t becomes a direct extension of ongoing or emergent struggle that coopts any and all venues for their conflicts' (1990: 60), and therefore where the staging of dramas of social crisis and revolution doubly stage the revolution as it is happening, both as representation, and as one among a number of strategic public interventions. 'For the ethnographer, public events are privileged points of penetration into other social and cultural universes' (Handelman 1990: 9).

At times, there is an active interpenetration between the staging of dramas and the concurrent playing out of the social drama which is the subject-matter of representation on the theatre's stage. Among the many examples that might be given, this was the case in Kerala, South India, where I have conducted ethnographic research on traditional and contemporary modes of cultural performance since 1976. Necessitated by the wrenching socio-political and economic disruptions of British colonial rule, during its formative period from the turn of the century through its first democratic election of a state government in 1957, Malayalis in Kerala experienced a near-constant period of profound crisis and turmoil – a revolution through which the entire cluster of identity formations, relational networks, and social conventions on which personal and social identities and economic livelihood depended were

fundamentally altered and changed, i.e., how one related to others in public and private social spaces from within the traditional caste hierarchy; whom one might marry and how to marry; what constituted one's family – extended or nuclear; for whom one might work and on what basis – all were in crisis, transition, and renegotiation. The hitherto 'formal [social] order . . . articulated in the rules and laws of social organization' of 'old' Kerala and 'enforced by the specification of penalties . . . applied to those who do not conform' (Chaney 1993: 13), were set in flux toward new, as yet unarticulated sets of rules and laws of social and political organization. Not only were personal and social identities being renegotiated, but as South Asians struggled to resist British colonial rule, three sometimes conflicting identity formations associated with the movement toward freedom, independence, and new political structures were also in the (re)making – what it meant to have a caste name and 'identity', what it meant to have a (new) 'national' identity as an Indian, and what it meant to have a (new) distinctive regional and linguistic identity as a 'Malayali'.

The larger study of which these few paragraphs are a brief summary, focuses on the relationship that drama, theatre, and related public events played in the 'staging' of the social, economic, and political 'revolutions' which have transformed Kerala over the past one hundred years. I will briefly describe two of the seminal dramas of this half-century which were part of this process of socio-political transformation. One was *Rental Arrears,* written in 1937 and performed before large audiences throughout Malabar district. Banned for a time by the government since it focused on issues of land reform, this play aroused great controversy. In the play, Kuttunni, mainstay of a tenant family, is forced by poverty to become a thief. Caught stealing red-handed, he is put in gaol for six months. In his absence, his mother, sister, and little brother are evicted by the landlord and his agents for not paying the rent in arrears. The play follows the trials and tribulations of the now homeless family – the Mother dies on the road from starvation and ill-health. The Sister becomes a prostitute to earn enough for her little brother to eat. When Kuttunni is released from gaol, at first he is outraged. But his outrage ultimately leads to his vow to work for a complete change in the social system: 'If poverty is to disappear, then the government we have today must change . . . We should refashion the social structure.' C. Achutha Menon asserts that the play

> was written with the express purpose of serving the revolutionary peasant movement in Malabar. By portraying the sufferings of a poor peasant family, faced with eviction from its homestead, it gave indirectly a ringing call for the abolition of the evil system of landlordism. The play was enacted in the villages on hastily improvised stages without the aid of sophisticated theatrical techniques, very often the leaders

> themselves becoming the actors ... [T]he play was staged in hundreds of villages with resounding success.
>
> (1979: 10)

Modest, local, amateur stagings of dramas like *Rental Arrears* with their radical/revolutionary content were part of the progressive literary movement in Kerala that helped bring into the public arena for the first time issues and models of social consciousness and change. They also played a significant role between the 1930s and late 1950s in articulating a political agenda of social reform. Indeed, the drama and theatre of Kerala's most noted and prolific leftist playwright and director, Toppil Bhasi (1924–92), helped move Kerala politics toward socio-political change, and no doubt helped shape public opinion which resulted in the election of the communists in Kerala's first state election in 1957.

Bhasi's dramas have been staged by the Kerala People's Arts Club since 1952. They could be described as dramas of transformational consciousness since they focus on the emotionally, highly charged, (melo)dramatic moments of 'irreversible' transformation of an individual's consciousness, dramatizing what Terry Eagleton calls, 'modest, local forms of political resistance' (1991: 223–4) which included using the traditional arts and modern drama to carve out a distinctive Malayali identity (Zarrilli 1996). With its very loose structure, and with characters who literally burst into song at unexpected moments during the course of the story, Bhasi's first and most important play, *You Made Me a Communist*, enacts the struggles of agricultural labourers and poor peasants for a better life by focusing on how Paramu Pillai, a conservative farmer, finally makes the decision to become a communist. The play might best be described as a drama of transformative consciousness in which the audience is witness to Paramu Pillai's transformation *into* a radical/revolutionary 'everyman'.

The play calls for the revolutionary overthrow of the entrenched system of landlordism, and propagandizes for an overtly communist agenda. With songs composed by O.N.V. Kurup, recognized today as one of the outstanding lyricists in Malayalam, and set to rousing and singable music by the gifted composer, Devarajan, which meant that its songs remained 'on the lips of street boys and peasant urchins for quite a few years after the play was put out for the first time' (Menon 1979: 15), the play in production had many of the trappings of then popular Tamil musical dramas which meant that it could easily reach the 'masses of the ordinary people with whom [Bhasi] had very live contact at that time' (Menon 1979: 14). So popular was *You Made Me A Communist* that it

> swept like a storm ... throughout the length and breadth of the land continuously for months together before enthusiastic audiences. So great

and spectacular was the success that for the time being critics were silenced. Those who came to find fault went back applauding.

(Menon 1979: 15)

Inevitably many in each audience rose at the end of each production to join the actors on stage in raising their clenched fists in protest and solidarity toward social and political change. Indeed, so important a role did KPAC and this production play in the popular spread of the communist point of view during 1952–54 that some commentators have suggested that the election of the communists in 1957 would never have happened without the impact that this production had on the political concerns and popular imaginations of Malayalis during the 1950s. As Harry Elam has recently (1997), and very persuasively argued regarding the US social protest theatre of the 1960s, for the committed social activist as social and dramatic actor, and/or as activist audience member whose clenched fist is an embodied act of solidarity with those of the actors onstage, dramas of social protest are sites of corporealized, vicarious, public affirmation which can in certain contexts *in extremis,* be 'really' dangerous, i.e., participation can and does lead to repression, beatings, arrest, and even death.

As I write this introduction between January and March of 1999 in London, another extraordinary example of this interpenetration is taking place. *The Colour of Justice* – Richard Norton-Taylor's dramatization of the inquiry surrounding the racist murder of eighteen-year-old Stephen Lawrence in Eltham, South London, on the night of 22 April 1993 – opened in January at the Tricycle Theatre, and then moved on to performances at the Theatre Royal Stratford East, and finally the Victoria Palace.[1] The five white suspects in the murder have not been convicted. After internal inquiries into police incompetence were whitewashed, and it became clear that racism had clearly played a role in the bungled investigation as well as the internal police inquiry, Home Secretary, Jack Straw, invited a public inquiry chaired by Sir William Macpherson, a former High Court judge. The Macpherson Report is released as the play is still running. Stephen Lawrence's mother and father appear almost nightly on the evening news and in the daily newspapers, responding to the ongoing, unfolding social drama being played out in their lives, in the lives of others in the Black and Asian communities who suffer racism, and within the halls of justice, policing, and government in general as questions and accusations of endemic/institutional racism are raised. The dramatization, *The Colour of Justice,* brought to the stage and therefore into public discourse and visibility not a fictive, dramatic re-presentation of an imagined event, but a staging of an event *as it has been happening. The Colour of Justice* and the earlier examples from Kerala both exemplify the convergence between the staging of social/political dramas and the playing out of social dramas. They exemplify the process by which dramas do not simply

'reflect' or hold up a 'mirror' to the social or political, but are instantiated in the *potential to effect a process of change* in the individual and/or social consciousness.

Post-colonial theatre, politics, and theory

The first two essays that follow focus on post-colonial theatre, and specifically address that set of relationships in which the politics of culture, nationhood, identity, and performance have become self-consciously explicit as a self-reflexive means of critiquing the hitherto ahistorical, essentialist ways in which the West has usually approached performance in 'other' cultures. In their introduction to *Post-Colonial Drama*, Helen Gilbert and Joanne Tompkins explain many of the vexing definitional, geographical, and historical problems with defining and writing about post-colonial theatre. They rightfully point out that post-colonialism is not a temporal concept, but rather is 'an engagement with and contestation of colonialism's discourses, power structures, and social hierarchies'. In their case studies of a series of post-colonial dramatists/theatre makers, *An Introduction to Post-Colonial Theatre*, Brian Crow and Chris Banfield point out how 'central to their experience of life – and thus to their art – is the knowledge that their people and culture have not been permitted a "natural" historical development, but have been disrupted and dominated by others' (1996: xiii). Consequently, even after 'independence', issues of consciousness and identity formation in reaction to colonial/imperial histories and interventions remains central in much post-colonial drama and theatre.

> If colonialism involved the direct political and economic control of a subject territory, in the period of neo-colonialism since independence control has typically been exercised indirectly, by means variously of unequal trade relations, indebtedness, and the threat (and sometimes the reality) of military or economic force.
>
> (Crow and Banfield 1996: 15)

One of the most important sites where post-colonial theatre has been constantly in the (re)making is South Africa (Crow and Banfield 1996; Gunner 1994). Miki Flockemann's new essay, 'South African Perspectives on Post-Coloniality in and through Performance Practice', reflects the complex set of debates and practices in contemporary South African theatre as it has moved from opposition and protest through solidarity and resistance inspired by Black Consciousness, and into an exploration of new modes and processes through which theatre in the new South Africa will serve its increasingly diverse constituencies and their voices. It focuses in particular

on one of the most important modes of post-colonial theatre-making, the hybrid, creolized work.

The methods and means of acting in response to and/or against colonialisms' discourses, power structures, and social hierarchies take place across everything from overtly or explicitly 'political' forms of resistance such as protests, revolutionary actions, or dramas of resistance, to implicit modes of resistance, such as silence. As public acts or events, post-colonial drama and theatre are usually direct interventions which engage, at a local, context-specific level, one or more of the insidious dimensions of colonialism or its insidious legacies of oppression and/or disempowerment. Therefore, while 'all post-colonial performance is political . . . not all political theatre is post-colonial'. Since all post-colonial theatre operates explicitly and/or implicitly as a site of resistance, it must be studied and/or practised within particular contexts and histories in order to understand both its politics and its strategic mode(s) of resistance; however, as Brian Crow and Chris Banfield explain, 'because of linguistic ignorance, the remarkable range of literature and performance in indigenous languages that articulated criticisms and resistance to colonial rule and its characteristics' still remain largely unknown to Western readers (1996: 7). Perhaps in the future more such histories will be written to illuminate a fuller range of post-colonial theatre's impact in specific locales and regions.

Issues of definition, translation, and identity in intercultural and 'third theatre' performance research and practice

The final two essays by Watson and Ness explore the intersections between politics, performance, culture, and identity in quite different ways from the often explicitly political and ideological stance of post-coloniality. Ian Watson's contribution on 'Third Theatre' describes one of the most significant forms of theatre work to emerge since the 1950s – theatrical and/or para-theatrical activities which have emerged at the edges and boundaries of nations, cultures, and recognized theatrical genres. These modes of theatre-making are difficult to define and describe precisely because they don't easily 'wear' our ready-made categories. They have emerged out of the fissures in cultures, geographies, and identities which are part and parcel of the political turmoil of the transition from colonial to 'post'-colonial rule. The fixing of 'nations' into states with fixed geographies has meant the disempowerment of many indigenous peoples, and theatrical and para-theatrical activities have often been used as modes and means of making voices heard about issues of identity and/or socio-economic/political discrimination that are otherwise unheard.

Sally Ann Ness's essay explores the very important and constantly vexing methodological intricacies of attempting to learn 'across cultural divides',

i.e., issues of difference and translation which must be negotiated in any attempt to articulate difference in performance and/or through performance and research on performance. Although focusing on dance, the issues Ness invites us to consider face all practitioner/researchers examining performance in 'their own' and/or 'other' cultures. She calls attention to the need for a high degree of reflexivity as we approach work in, through, and/or about performance in its cultural and political locations.

Note

1 Sarah Daniels also discusses this production in the foreword to this volume.

Helen Gilbert and Joanne Tompkins

POST-COLONIAL DRAMA: THEORY, PRACTICE, POLITICS

From: *Post-Colonial Drama: Theory, Practice, Politics* (London and New York: Routledge, 1996).

Re-acting (to) empire

IN 1907, *THE THEATRE*, **A SHORT-LIVED SYDNEY NEWS-PAPER**, reported on 'Seditious Drama' in the Philippines. It noted that the Filipinos, governed at that time by the United States, had 'turned their stage to a seditious purpose, though the authorities [had] not seen fit to censor it, except for the more daring of the dramas intended to stir up the native spirit' (Anon. 1907: 17). As a common device to thwart American propaganda, the Filipinos used politized costumes:

> [They are] so coloured and draped that at a given signal or cue the actors and actresses rush together, apparently without design, and stand swaying in the centre of the stage, close to the footlights, their combination forming a living, moving, stirring picture of the Filipino flag. Only an instant or so does the phantom last, but that one instant is enough to bring the entire house to its feet with yells and cries that are blood-curdling in their ferocious delight, while the less quick-witted Americans in the audience are wondering what the row is about.
>
> (Ibid.: 17)

Such a display, understood in political terms by the Filipinos in the audience and *mis*understood by the Americans – the targets of the act of political resistance – provides an example of theatre's politicality in a post-colonial context in which performance functions as an anti-imperial tool. [. . .]

Post-colonialism

Post-colonialism is often too narrowly defined. The term – according to a too-rigid etymology – is frequently misunderstood as a temporal concept meaning the time after colonization has ceased, or the time following the politically determined Independence Day on which a country breaks away from its governance by another state. Not a naïve teleological sequence which supersedes colonialism, post-colonialism is, rather, an engagement with and contestation of colonialism's discourse, power structures, and social hierarchies. Colonization is insidious: it invades far more than political chambers and extends well beyond independence celebrations. Its effects shape language, education, religion, artistic sensibilities, and, increasingly, popular culture. A theory of post-colonialism must, then, respond to more than the merely chronological construction of post-independence, and to more than just the discursive experience of imperialism. In Alan Lawson's words, post-colonialism is a 'politically motivated historical-analytical movement [which] engages with, resists, and seeks to dismantle the effects of colonialism in the material, historical, cultural-political, pedagogical, discursive, and textual domains' (1992: 156). Inevitably, post-colonialism addresses *reactions to* colonialism in a context that is not necessarily determined by temporal constraints: post-colonial plays, novels, verse, and films then become textual/cultural expressions of resistance to colonization. As a critical discourse, therefore, post-colonialism is both a textual effect and a reading strategy. Its theoretical practice often operates on two levels, attempting at once to elucidate the post-coloniality which inheres in certain texts, and to unveil and deconstruct any continuing colonialist power structures and institutions. [. . .]

Post-colonial *theatre's* capacity to intervene publicly in social organization and to critique political structures can be more extensive than the relatively isolated circumstances of written narrative and poetry; theatre practitioners, however, also run a greater risk of political intervention in their activities in the forms of censorship and imprisonment, to which Rendra in Indonesia, Ngũgĩ wa Thiong'o in Kenya, and countless South African dramatists can attest. While banning books is often an 'after the fact' action, the more public disruption of a live theatre presentation can literally 'catch' actors and playwrights in the act of political subversion.

Post-colonial studies are engaged in a two-part, often paradoxical project of chronicling similarities of experience while at the same time registering the formidable differences that mark each former colony. Laura Chrisman cautions that criticism of a nation's contemporary literature cannot be isolated from the imperial history which produced the contemporary version of the nation (1990: 38). Shiva Naipaul, a Trinidadian writer, puts it more succinctly: 'No literature is free-floating. Its vitality springs, initially, from its rootedness in a specific type of world' (1971: 122). Post-colonial criticism must carefully contextualize the *similarities* between, for example, the influence of ritual on the Ghanaian and Indian theatrical traditions, at the same

time as it acknowledges significant *divergences* in the histories, cultures, languages, and politics of these two cultures. It is the particular attention to 'difference' that marks post-colonialism's agency. [. . .]

Post-colonialism and drama

[. . .] When Europeans settled a colony, one of the earliest signs of established culture/'civilization' was the presentation of European drama which, according to official records, obliterated for many years any indigenous performance forms:[1] in 1682, for instance, a playhouse was established in Jamaica and functioned until slaves were freed in 1838 (Wright 1937: 6). India boasted a proliferation of grand proscenium-arch theatres from 1753, and five full-size public theatres by 1831, the popularity of which prompted the erection of many rival private theatres financed by rajahs (Mukherjee 1982: viii; Yajnik 1970: 86). Neither the Jamaican theatre nor the Indian theatres were designed for the indigenous peoples or transported slaves; rather, they were built for the entertainment of the British officers. The first play staged in Canada was Marc Lescarbot's 1606 *Théâtre Neptune en la Nouvelle France*, presented by French explorers. It included words in various native Canadian languages, as well as references to Canadian geography, within a more typically French style of play (Goldie 1989: 186). The nature of theatre designed for colonial officers and/or troops (and the nature of colonialism itself) required that the plays produced in these countries be reproductions of imperial models in style, theme, and content. Various elements of 'local colour' were of course included, so that an early settler play might position a native character in the same way that the nineteenth-century British theatre figured the drunken Irishman: as an outsider, someone who was in some central way ridiculous or intolerable. While it may have appeared that the deviations from the imperial plots were generally isolated to issues of setting and occasional minor characters, sometimes the plays produced in the colonies transformed mere 'local colour' into much more resistant discourses. In the case of Australia, the performance of the first western play in 1789, George Farquhar's *The Recruiting Officer*, provided an early opportunity for political resistance. The cast, composed of transported convicts, used the play's burlesque trial and military theme as an apt expression of life in a colony that was itself predicated on punishment, and they also wrote a new epilogue to Farquhar's play, calling attention to their plight. Colonial theatre, then, can be viewed ambivalently as a potential agent of social reform and as an avenue for political disobedience.

Even though Ola Rotimi, a Nigerian playwright, maintains that drama is the best artistic medium for Africa because it is not alien in form, as is the novel (1985: 12), most post-colonial criticism overlooks drama, perhaps because of its apparently impure form: playscripts are only a part of a theatre experience, and performance is therefore difficult to document.[2] Given that

dramatic and performance theories, particularly those developed in conjunction with Brechtian, feminist, and cultural studies criticism, have much to offer post-colonial debates about language, interpellation, subject-formation, representation, and forms of resistance, this marginalization of drama suggests a considerable gap in post-colonial studies. [. . .] Theories of drama and performance have much to add to debates about how imperial power is articulated and/or contested. [. . .]

Markers of post-colonial drama

The apparent unity of the British Empire (iconized by such devices as the vast pink surfaces on many classroom maps indicating the dominion of the Queen of England) has been substantially denied by post-colonial texts. Often, post-colonial literatures refuse closure to stress the provisionality of post-colonial identities, reinforcing Helen Tiffin's comment that 'Decolonization is process, not arrival' (1987: 17). The absence of a 'conclusion' to the decolonizing project does not represent a failure; rather it points to the recombinant ways in which colonized subjects now define themselves. Situated within the hybrid forms of various cultural systems, such subjects can usefully exploit what Diana Brydon calls 'contamination' (1990), whereby the influence of several cultures can be figured as positive rather than negative, as for instance, is miscegenation.

For the purposes of this study, we define post-colonial performance as including the following features:

- acts that respond to the experience of imperialism, whether directly or indirectly;
- acts performed for the continuation and/or regeneration of the colonized (and sometimes pre-contact) communities;
- acts performed with the awareness of, and sometimes the incorporation of, post-contact forms; and
- acts that interrogate the hegemony that underlies imperial representation.[3] [. . .]

A provisional conclusion

[. . .] Theatre acts as a resonant site for resistance strategies employed by colonized subjects. The reclamation of, for example, pre-contact forms of performance, ritual, song, music, language, history, and story-telling facilitates the foregrounding of indigenous cultures in spite of imperial attempts to eradicate that which was not European and ostensibly civilized and controllable. The revisioning or reproducing of 'classical' texts deconstructs the hegemonic authority embedded in the original text. The syncretic

combination of indigenous and colonial forms in the post-colonial world also contributes to the decentring of the European 'norm'. Hybrid theatrical forms recognize that colonialism can never be erased entirely to restore a pre-contact 'purity'; rather, hybridity reinforces the fact that hegemonic processes require continual deconstruction. The often uneasy amalgamation of colonial and pre-contact traditions in post-colonial drama admits the uses of a variety of forms in the construction of relevant, politically astute theatre that privileges a multiplicity of views and power structures to avoid the entrenchment of any one approach or authority. Examples of neo-colonialism on the post-colonial stage stress the need for further decolonizing activities.

[Gilbert and Tompkins end with the following summary of issues which they could only briefly mention in their book, and which they urge post-colonial scholars to consider:]

- The ways in which Indian theatre forms have, in many cases, maintained an extremely strong sense of diversity and autonomy of space, form, language, spirituality, and ancient historicity in the face of extensive bureaucratic and educational control, both by colonial and internal powers.

- The ways in which imperialism's authority extends from the physical and cultural spheres to include the more metaphoric space of the mind. These psychic effects of colonialism are obvious in most post-colonial states, but more particularly in the settler-invader cultures like Canada, Australia, New Zealand (and, with reservations, South Africa), where most non-indigenous colonial subjects continue to be implicated in some existing imperial ministrations. Figured on the stage in terms of yet another location that must be actively *decolonized*, the psychic space of the mind can become a potentially productive site for releasing – through theatrical experimentation – imperialism's hold on the colonized subject.

- The ways in which New Zealand's bicultural society signifies differently from the other, more 'multicultural' settler societies.

- The many other ways in which the body can signify on stage. These can include ritual scarification or tattooing, which, if rendered in paint, signify differently than permanent cultural markings of an actor's body. Another body coding is torture, a not uncommon mechanism of control in colonial *and* post-independent countries. Depictions of torture can communicate very strongly to an audience, particularly if viewers are aware of the local, politically coded referents. An actor whose body (or mind) has actually suffered torture immediately signifies even more powerfully than an actor who enacts a tortured body.

- The ways in which postmodernist and radical feminist theatrical practices impact on post-colonial performative theories.

- The ways in which global political realignments – such as the North American Free Trade Association (NAFTA) and the Association of South

East Asian Nations (ASEAN) – will alter the traditional trade and political alliances which countries of the former British Empire (specifically Canada, Australia, and New Zealand) have forged.

- The ways in which South Africa's 1994 elections and the introduction of a democratic state there will affect the country's drama. For at least the two or three decades leading up to Nelson Mandela's 1990 release from prison, a vast majority of the country's plays were structured by a binary opposition of apartheid and 'freedom'. The shifts in the nature of the metaphoric, literal, and theatrical struggles in South African drama will be particularly worth following.

- The ways in which government-imposed censorship of art, and persecution of artists and other citizens alike, continues in countries such as Burma (Myanmar) and former 'colonies' like East Timor.

- The ways in which post-colonialism still faces – perhaps ineffectively or helplessly – cries of post-imperialism like the attempted genocide in Rwanda in 1994.

Post-colonial theatre is, of course, not static. The transformations, refinements, and even the elimination of certain aspects of post-colonial performance are highly revealing. The Kwagh-Hir puppet theatre practised by the Tiv people in eastern Nigeria provides a chronicle of social and technological changes the community has witnessed: the introduction of new puppets to the existing locally known collection of familiar figures marks various significant moments 'such as when the first motor bike was ridden in Gboko or the first policewoman emerged or modern dress styles of European design gained local acceptance' (Enem 1976: 41).

Decolonization is an ongoing process. [. . .] Decolonization and persistent attempts to deal with struggles in the post- and/or neo-colonial world remain issues that will be played out on the stages of Australia, India, Africa, Canada, the Caribbean, New Zealand, and other former colonies in increasingly innovative and conflicting styles, languages, and forms. And, undoubtedly, post-colonial drama will continue to find new means of reacting to the containing and constraining borders which attempt to delimit the empire and its constructions of gender, race, and class.

Notes

1 In all probability, they were still happening underground.

2 Our definition of drama and our theoretical discussions also incorporate other performance events (such as dance).

3 In order to schematize our study, this generalized definition is inevitable. There are undoubtedly many examples of post-colonial performance which exceed the parameters outlined here and we encourage readers to pursue such works.

Miki Flockemann

SOUTH AFRICAN PERSPECTIVES ON POST-COLONIALITY IN AND THROUGH PERFORMANCE PRACTICE

IN VIEW OF RAYMOND WILLIAMS'S (1989) OBSERVATION that we live in a dramatized society where intolerable contradictions are 'performed', it is useful to explore how this is articulated in theatrical trends in post-election South Africa. There has of course been some scepticism about the appropriateness of the term 'post-colonial' to the South African situation as it is argued that this glosses over the continuing colonial legacy that, as Walder (1998) points out, persists even to the post-election era in interesting ways. While its harshest critics suggest that the term is merely a neo-colonial mystification or a product of eurocentric scholarship, as used here, it is imbricated in the processes of decolonization, political independence, and democratization. In other words, post-colonial in this sense describes a process rather than an achieved state, and is associated with the concept of cultural creolization. This refers to the dialectical interaction between cultures within a wider interculturative process (see Huggan, 1998)[1] and here involves both the colonization of indigenous subjects and the settler-invader inhabitants, described by Lawson as located in an 'awkward "second-world"' relation to the (in this case first Dutch then British) imperial rulers (Gilbert and Tompkins 1996: 6).

Over the last few decades there has been a shift from an oppositional and initially liberal protest tradition which highlighted the plight of the black underclass, to solidarity and resistance theatre inspired by the ideology of Black Consciousness. However, the current processes of post-coloniality are performed on a variety of levels. For instance, the emergence of 'minor' voices, as woman, gay, coloured, or belonging to various cultural minorities, can be seen as attempting to construct a 'new' space from which to

speak, often in one-man/woman shows which claim subjective experience previously subsumed in public political narratives. At the same time, there have been nostalgic evocations of the past, particularly in musical dramas which attempt to reconstruct lost communities (such as Junction Avenue Theatre Company's *Sophiatown* or the popular Petersen/Kramer production, *District Six – The Musical*). Then there have been reruns or reworkings of older productions, perhaps most notably early works by Athol Fugard, some of which, as Colleran argues, can be seen as even more pertinent in the post-revolutionary period than when they first appeared as 'transgressive or resistant cultural acts', for the way they perform the construction and far-reaching effects of the diseased body politic (1995: 39).[2]

While oppositional discourses of protest and resistance have been replaced by an emphasis on social issues within, rather than between communities – often presented in satirical form – the influence of theatre for development projects is also becoming an increasingly strong post-election trend. As writer and theatre practitioner Zakes Mda (1998a) points out, theatre for development can only function in post-colonial societies when popular politics has come to an end. Some of these works, like Thulani Mtshali's *Weemen* (1998) have long runs, touring widely through township areas and involving the audience in debating issues such as African customary law and domestic violence against women.

Not surprisingly, one of the most significant trends from the 1980s onwards has been the use of the actor's body to represent both the inscription of apartheid legislation and its subversion through the performance of multiple roles by the same actors, initially in predominantly all-male, work-shopped productions which combined African oral narrative traditions with the ideas of European theatre practitioners like Grotowski, Brecht, and Brook. As Gilbert and Tompkins remind us, the colonized body is not only inscribed, it also moves, and 'interacts with other stage signifiers, including the audience' (1996: 203), and this clearly goes some way towards explaining why dance drama has played an important part in the development of a new South African theatre aesthetic. According to Fleishman, the importance of consciously achieved physical images in South African theatre is that these are 'essentially dialogical', and he counters the notion that using the body itself as text suggests a dangerous anti-intellectualism, instead, he says, it 'opens up new meaning, presents alternatives and possibilities' (1997: 213), which in turn also demands individual and imaginative responses (and choices) from the audience.

However, one of the most interesting recent aspects of such experimentation with eclectic performance styles and traditions is the way these have been employed in attempting to represent the unrepresentable, or to say the unsayable concerning the atrocities of the past which have come to light through Truth Commission testimonies. This has been successfully attempted in *Ubu and the Truth Commission* (1997) – a stunningly innovative collaborative production which employs visuals by William Kentridge, a script

by Jane Taylor and the Handspring Puppet Company, and also incorporates victim/survivor testimony from the public domain. Significantly, an increasing number of new works explore previously hidden or alternative cultural and, more recently, spiritual dimensions which in the past were regarded with some suspicion, in view of apartheid efforts to retribalize urbanized black South Africans. These attempts at constructing a new – post-colonial and creolized – theatre aesthetic have given rise to equally divergent critical responses to new works by South African theatre practitioners.

A case in point is Brett Bailey's provocatively titled *Ipi Zombi?* ('Where are the Zombies?') a spectacular work involving a large cast, including sangomas (diviners), a live chicken, priests, a church choir, cross-dressing men, and zombi children. The work involves a play of constantly shifting realities produced both by physical image and theatrical tableaux. An earlier version of the play (*Zombi*, 1996) was performed on a floor- and wall-mat made up of red and white washing-powder packets worked into a pattern, suggesting the containment of the domestic, consumer and other-worldly contexts. In his most recent production, however, the play was performed in a cavernous and smoky disused powerhouse outside Grahamstown, where it premiered on an earth floor around an open fire. This had the effect of drawing the audience into an 'other' world, rather than destabilizing the familiar township environment. In an early scene, after a powerfully drummed trance dance by the sangomas with what appeared like a Christianized altar in the background, the cloth used to cover the 'host' was removed to reveal a white plinth crowned by a polished ebony statue of the upper torso of an African gracefully holding a carved fruit-bowl on his head – something one would associate with a colonial drawing room rather than a church – and just when the spectators are adjusting to this aesthetically achieved incongruity, the aesthetic literally takes off when the 'statue' shuffles off with small steps, the actor's body confined by the white box plinth.

Although the actors constantly remind us that this is a play, we are also told that this is a true story based on an event that happened in August 1995 near Kokstad in the Eastern Cape, where twelve schoolboys were killed in a combi-taxi accident, and subsequent rumours of witchcraft resulted in the brutal killing of two women. Perceived as one of its most controversial aspects is the way the work simultaneously performs the 'constructedness' of the claims of witchcraft in relation to various interest groups in the community, but also presents us with the 'reality' of the existence of the zombies: 'this is a hungry story', the audience is told, 'we live in hungry times, the roads are eating our children'.

The critical responses to works like *Ipi Zombi?* are also indicative of some of the debates around the concept of post-colonialism in the post-election context. These views range from seeing the work as another manifestation of the exoticizing 'ipitombification'[3] of South African culture by self-serving directors, which results in white spectators 'with gaping mouths and googoo eyes' gazing at black performers 'portrayed like savage

morons . . . in trance-like states moving and talking like doped-up freaks'
(Mohamed 1998: 3). On the other hand, Zakes Mda refers to the work as
total theatre that combines many traditions predominantly harvested from
African ritual, but 'redefined in a most creative manner that leaves one breath-
less'. He concludes: 'This is a work of genius that maps out a path to a new
South African theatre' (1998b: 6). Responding to Mohamed's critique,
Solomon Makgale argues that in the face of attitudes like that expressed by
a Kokstad farmer, that the Zombi incident is 'a load of kaffir bullshit', Bailey's
play 'is a true picture of African spirituality'. Moreover, says Makgale, the
performance is 'realistic' (1998: 4). Thus, while Bailey's work is seen by
some as fostering colonial stereotypes, others see his work as a powerful
anti-colonial statement which exports images and ideas back from third to
the first world. For instance, Darryl Accone argues that while colonialism
denies the ideas and beliefs of the colonized, these alternative beliefs are here
granted legitimacy, and the contradictions performed in works like *Ipi Zombi?*
and another play by Bailey, *iMumbo Jumbo* (1997), provide 'therapy and
discovery for the nation' (Accone 1997: 12).[4]

Some of these debates are also reflected in the visual material used to
advertise the piece, again pointing to the way works like *Ipi Zombi?* perform
'intolerable contradictions' during a time of transition. For instance, in a
photograph by Obie Oberholtzer accompanying an article about the play,
three bare-breasted women (sangomas/witches?) with colourful cotton
sarongs around their waists – but with masked and obscured faces – are situ-
ated in apparent dancing stances in front of towering cactuses (*Supplement,
Mail and Guardian*, June/July 1998: 1). This photograph provides an inter-
esting subtext – or is it confirmation? – of the way women become fetishized
objects, the target of the witchhunts depicted in the play. In the 1996 produc-
tion, the slaying of the first woman targeted by the community was
represented in slow motion, suggestive of a brutal and brutalizing, ritualized
rape, and in view of the prevalence of violence against women in South
Africa, this suggests another angle to Accone's comment about the play
providing 'therapy and discovery for the nation'.

It is significant that *Ipi Zombi?*, despite its 'out of town' location was
celebrated as one of the main attractions of the 1998 Grahamstown Arts
Festival – which is also the largest arts festival in the Southern Hemisphere.
Seeing *Ipi Zombi?* in relation to other theatrical trends evident at the festival
foregrounds the complex processes of transition. The 'mainstreaming' of
Bailey's play suggests that the Main/Fringe programme dichotomies which
originally marked a distinction between major (usually western-orientated
music, ballet, and theatre) and minor (usually local, student, experimental,
ethnic, or independent) productions, appear to have been eroded. However,
this is contextualized by the setting of Grahamstown itself, a university town
with attractive colonial architecture and a plethora of church and educational
structures, surrounded by townships where unemployment figures are
amongst the highest in South Africa, while dotted along the streets of the

town, children form informal groupings singing songs like 'Shosholoza', iron-ically associated with nation-building sport spectacles, hoping to earn money from more affluent festival goers.

As suggested earlier, among some of the most notable trends at the festival has been the increase in one-person shows, and viewing these in rela-tion to one another also points to some of the contending discourses prevalent during this transitional period. For instance, in a rerun of her *Love Child* (first performed in the late 1980s), Gcina Mhlophe translates the indigenous *ntsomi* storytelling tradition into a contemporary setting. On the other hand, in *Solomon's Pride* (1997), performed and written by Bheki Mkhwane, an old man tells his life story, with Mkwhane moving easily between indigenous and imported theatrical styles.

These performances by Mhlophe and Mkhwane are offset by, for instance, Greig Coetzee's award-winning *White Men with Weapons*, based on Coetzee's own experiences in the South African Defence Force in the late 1980s. The play consists of a series of occasionally hilarious but also chilling vignettes in which Coetzee enacts various army 'types' in order to expose the way myths of identity (in this case that of the white South African male), are manipu-lated in an attempt to 'fix' identity in order to maintain some semblance of power and avoid moral and political accountability. Significantly, Coetzee's work was playing to packed houses at a time that coincided with horrifying testimony at the Amnesty Hearings about state collusion in nefarious 'Third Force' killings. What is also interesting about works like *White Men with Weapons* is the way Coetzee skilfully appropriates some of the theatrical strate-gies South African audiences have come to associate with the theatres of protest and resistance, such as the bare stage of Grotowski's Poor Theatre, and the stripping away of individual identity and humanity so that the soldier/victim is represented as a puppet responding to the voice of unseen surveillance.

A different perspective on the way in which myths of identity can be subverted or negotiated is dramatized in *Framed* (1997) by Jagged Dance, a small, independent, all-woman but mixed-race company.[5] The spatial divi-sion between performers and audience, the private and public, is elided as the spectators are themselves moved around by the movement of the dancers. A 'guide' takes the audience through a self-reflexive retrospective of a female artist's work, and the dancers slide in and out of psycho-sexual, social, and political states of coming to consciousness as part of the young woman's rite of passage that deconstructs myths of motherhood, marriage, and art, and constantly encroaches also on the spectator's space. This fluidity neatly unfixes the hierarchy of the gaze of the spectator, and as suggested by the title, there is a playful refusal to be situated within conventional aesthetic and ideolog-ical hegemonies represented by the empty frames of absent 'Old Masters'.

Clearly, performance trends from *Ipi Zombi?* to *Framed* point to the need to view these as part of a larger dialogue where contending discourses coexist but have not yet hardened into 'new' hegemonies. This increasing diversity

currently manifesting itself in the post-election period is significant for several reasons. First, it suggests that fears expressed about the 'crisis' in theatre now that the old totalizing apartheid enemies no longer serve as informing principles are being dispelled, since trends which emerged tentatively in the interregnum between 1990 and 1994 are developing into a number of distinctive directions. Second, this very diversity serves to perform some of the contradictions inherent in the transitional process itself. This has seen some radical realignments of political and other interest groups, and the push towards nation-building coexists with a simultaneous and apparently paradoxical resurgence of discourses around race, difference, and regionalism – as well as, more recently, a renewed interest in psychic, in addition to material reconstruction. While one can see these trends as part of the difficult processes of democratization and reconciliation, I have argued here that this also involves cultural creolization as an integral aspect of the much debated condition of South African post-coloniality.

Notes

1 According to Huggan, cultural creolization involves 'the interrogation, displacement and ironic refiguration of the hegemonic practices of European culture' (1998: 31).

2 For instance, the restaging of Fugard's *Statements after an Arrest under the Immorality Act* originally performed during the 1970s, recalls 'those features of social relations within the diseased body politic that cannot or should not be healed by excising them from the collective memory' (Colleran 1995: 41).

3 This is a reference to the immensely successful musical *Ipi Tombi* which toured extensively during the 1970s, presenting commodified images of carefree Africans in the then Bantustans.

4 Bailey's 1997 production *iMumbo Jumbo*, like *Ipi Zombi?* is based on a recent, much publicized historical event: Chief Gcaleka's journey to England in 1996 (covered by Sky TV) to retrieve the skull of a nineteenth-century paramount chief, King Hintsa KaPhalo.

5 The Cape Town-based Jagged Dance company was founded in 1994 by Debbie Goodman, Jacki Job, and Geli Schubert, who were previously associated with the Jazzart Company.

Ian Watson

TOWARDS A THIRD THEATRE

From: *Towards a Third Theatre: Eugenio Barba and the Odin Teatret* (London: Routledge, 1993).

Third theatre

BARBA'S IDEAS ON THE SOCIOLOGY OF THEATRE are encapsulated in what he refers to as 'third theatre', a concept which he defines in relation to institutionalized theatre and the avant-garde:

> A theatrical archipelago [third theatre] has been forming during the past few years in several countries. Almost unknown, it is rarely subject to reflection, it is not presented at festivals and critics do not write about it.
>
> It seems to constitute the anonymous extreme of the theatres recognized by the world of culture: on the one hand, the institutionalized theatre, protected and subsidized because of the cultural values that it seems to transmit, appearing as a living image of the creative confrontation with the texts of the past and the present – or even as a 'noble' version of the entertainment business; on the other hand, the avant-garde theatre, experimenting, researching, arduous, or iconoclastic, a theatre of changes, in search of a new originality, defended in the name of necessity to transcend tradition, and open to novelty in the artistic field and within society.
>
> (1986: 193)

Despite the fact that Barba's definition of third theatre has been adopted by many groups because it both acknowledges their significance and defines their character, the concept is not without its critics. Most of this criticism stems

from the definition's logic of negation, and from the connoted relationship between third theatre and the Third World.

The third theatre is a concept arrived at through negation. A particular type of theatre exists, it is not part of the institutional theatre, it is not part of the avant-garde. If it is not the first or second theatre, what is it? It is the *third* theatre. For some, this line of argument highlights the negative profile of a theatre living a hand-to-mouth existence, lacking a sense of its own identity, and barely surviving in the shadows of the first and second theatres which it secretly wishes to be part of.

This criticism of third theatre is a misreading of Barba's definition. He certainly derives the concept of third theatre through a process of elimination, but the concept itself is hardly negative. One only has to read the paragraphs following his argument quoted above to appreciate the positive nature of third theatre for Barba:

> The Third Theatre lives on the fringes, often outside or on the outskirts of the centres and capitals of culture. It is a theatre created by people who define themselves as actors, directors, theatre workers, although they have seldom undergone a traditional theatrical education and therefore are not recognized as professionals.
>
> But they are not amateurs. Their entire day is filled with theatrical experience, sometimes by what they call training, or by the preparation of performances for which they must fight to find an audience.
>
> (1986: 193)

In a 1977 interview, Barba stated that his concept of third theatre grew out of his attempts to explain significant deviations from the theatrical mainstream, such as Spain's independent theatre movement (Teatro Independiente) which consisted of over ninety groups at the time, a similar movement in Italy which boasted hundreds of groups, the fledgling group theatre movement in Denmark, and the explosion of group theatre in Latin America (1977: 1–2). That is, his argument begins with an implicit positive statement: 'A' (the independent theatre movement) exists. He then reasons that it is neither 'B' (the institutional theatre) nor 'C' (the avant-garde), the two most common types of theatre, and concludes that it must therefore be a separate entity. Nowhere in his argument does he state that 'A' is inferior to either 'B' or 'C', nor is there anything in his professional career, which has been devoted to the third theatre, that indicates he feels it is inferior.

In the same interview, Barba acknowledged the Third World connotations in his concept of third theatre. However, he argued that these connotations owe their origin to the discrimination found in both, rather than in equating third theatre with a Third World sense of inferiority, or its citizens' desire to become part of the First World (1977: 2–3). In the late 1970s Barba even went so far as to identify discrimination as a defining characteristic of third theatre: 'The groups that I call Third Theatre do not belong to a lineage, to a

theatrical tendency. But they do all live in a situation of discrimination: personal or cultural, professional, economical or political' (1979: 160–1).

In a recent article in which he reconsiders the third theatre in light of developments in the 1980s and the dawning of the 1990s, however, he denies that discrimination is any longer the defining characteristic (Barba 1991: 3). For Barba, the modern third theatre is one in which its members are concerned with meaning: 'Today [1991] it is clear to me that the essential character of the Third Theatre is the autonomous construction of meaning which does not recognize the boundaries assigned to our craft by the surrounding culture' (1991: 8). That is, the members of the third theatre are those concerned with exploring and cultivating a language of performance that gives 'an autonomous meaning for the action of doing theatre' (Barba 1991: 4) rather than succumbing to commercial considerations or current trends in the avant-garde.

This change in Barba's thinking is not as far removed from his original understanding of third theatre as it may seem. In his first article on third theatre (originally published in French in 1976 and most recently in English in Barba, 1986: 193–94) he described ways in which members of the third theatre can survive. One is by entering the sphere of established theatre; the other could well be a definition of his later concept of autonomous meaning: 'groups can . . . survive by . . . succeeding through continuous work to individualize their own area, seeking what for them is essential and trying to force others to respect this diversity' (Barba, 1986: 193–94).

The sociology of third theatre

The sociological dimension of theatre is more important than aesthetics in the third theatre. Unlike either institutional theatre or the avant-garde, in which the emphasis is on producing, reflecting, and/or distributing culture, the focus in third theatre is on relationships: on the relationships between those in a particular group, on their relationship to other groups, and on their relationship with the audience. This focus on the network of relationships in third theatre has its foundation in the individual and his/her role in the collective.

In the third theatre there is little difference between a personal and professional life, since how theatre is made takes precedence over what is produced. For members of the third theatre, content and form are often less important than a group's socio-cultural philosophy and how that philosophy is realized in its daily work and reflected in its productions. The Odin Teatret, Barba's own group and the model for third theatre, has been criticized for lacking a political agenda in its productions. But these attacks fail to take into account the socio-political implications of group dynamics taking precedence over what is produced – the very foundation of Barba's approach to theatre. At the Odin he has encouraged a training process in which the actors both develop and are responsible for their own training. Similarly, the actors play a major part in creating mise-en-scènes during rehearsals, and they also

help design and build the sets for each production, as well as design and make costumes, and assist with publicity.

In addition to this internal ethic of collective creation and responsibility, Barba's group also places great emphasis on its relationship with others who share its approach to theatre. Members of the Odin retain personal contact with many groups and theatre scholars in Europe, Latin America, and to a lesser extent, the United States, through mail, through commenting on the performances of young actors when they are asked for such feedback, and running workshops for those who request them.

In keeping with this concern for personal contact, Barba prefers to have tours arranged by theatre groups and individuals the Odin knows, rather than to use professional tour organizers. In this way, he is encouraging these groups to arrange residencies for his company so that he and his actors can run workshops, show films about their work, and establish a greater contact with the theatre community than if they were just another troupe passing through on tour. Barba regards this networking not only as a means of establishing links but also as essential to the third theatre's survival. [. . .]

The third theatre is not an official organization with headquarters in one place and members who pay dues. It is an unofficial, voluntary alliance based primarily on informal contacts. The nearest those involved come to establishing formal links is in the third theatre gatherings initiated by Barba in 1976. The first meeting – which took place in Belgrade, Yugoslavia – has been followed by seven subsequent gatherings to date (1991): in Bergamo, Italy (1977); Ayacucho, Peru (1978); Madrid and Lekeito, Spain (1979); Zacatecas, Mexico (1981); Bahia Blanca, Argentina (1987); Cuzco, Peru (1987); and Chaclacayo, Peru (1988). And though each of these encounters, as Barba prefers to call them, was subtly different, they all followed the same basic format. [. . .] The formal part of the programme consisted of various training workshops led by master performers such as the Odin actors; lecture/demonstrations on training and dramaturgical methods led by Barba himself or by directors such as Mario Delgado who heads Peru's Cuatrotablas; seminars on various topics ranging from the role of violence in Peruvian society (by Juan Larco in Chaclacayo) to the use of Decroux's mime techniques as a source of training (Luis Octavio Burnier in Bahia Blanca); and performances by the groups. The most valuable aspect of these gatherings, however, has invariably been the informal encounters between members of the third theatre who rarely get to meet each other. [. . .]

Barter

Barter, a term Barba applied to the theatre in the early 1970s, is closely linked to the concept of 'relationship' which underlies the third theatre. As in economic barter, the defining principle of theatrical barter is exchange, but in theatrical barter, the commodity of exchange is performance: 'A'

performs for 'B' and, instead of paying 'A' money, 'B' performs for 'A'. A play is exchanged for songs and dances, a display of acrobatics for a demonstration of training exercises, a poem for a monologue, etc. [. . .]

Barter and cultural exchange

Barters are a point of contact between cultures. In any barter, the 'micro-culture' of one group (or individual) meets the 'micro-culture' of the other. This meeting is realized through the exchange of performances, that is, cultural products, but these products are not as important as the process of exchange itself. There is no question of an unequal exchange in barter since there is no pre-established value for what is to be exchanged. [. . .]

The precedence of process over product in barter calls the conventional value of theatre into question. In the traditional paradigm, theatrical performance (cultural product) is exchanged for money. [. . .] Performance is measured in terms of aesthetic quality and dollar-value per seat. This traditional paradigm is rejected in barter. Cultural product is exchanged for cultural product, rather than for money. Since the value of this exchange lies in the exchange itself, not in what is exchanged, aesthetics and dollar worth are irrelevant. [. . .]

The emphasis on cultural exchange in barter does not mean that it cannot have an agenda beyond that of an intercultural meeting. At the request of various village leaders in southern Italy during 1975, for instance, the Odin used barters to help local communities in different ways. In addition to the exchange of performances in the village of Gavoi, the Odin asked people to provide information for a proposed publication on the region. Similarly, in Monteisisi the young people of the town wanted a library, so the Odin asked each villager to bring a book to the barter and these contributions formed the basis of what eventually became the local library. And, at the suggestion of local leaders in Ollalai, villagers were asked to bring old musical instruments, stories they could recall about the village's past, as well as examples of local legends and traditions, all so that they could establish a village archive. [. . .]

The socio-cultural dynamic of group theatre

Barba defines theatres as a form of social action:

> What is theatre? If I try to reduce this word to something tangible, what I discover are men and women, human beings who have joined together. Theatre is a particular relationship in an elected context. First between people who gather together in order to create something, and then, later, between the creation made by this group and their public.
> (1988a: 292)

This definition identifies what Barba regards as the dual bases of group theatre, the social dynamic inside the group, and the group's relationship to those outside the group through its work.

Inside the group

For Barba, the internal dynamic is the most important aspect of group theatre. He maintains that since performance is temporally limited, both through each production being retained in the repertoire for a limited period and performance generally taking up no more than a few hours each day, and because it is the end product of a much longer process within the group, the process itself – that is, how the group creates its productions, the members' attitude to the work, to each other, to the collective, and to their professional life – is what is important (1986: 175). He further argues that it is this process which determines the group's place and influence in society because it provides the foundation for the group's survival strategies, its professional ethics, and its aesthetics (1986: 198–9). [. . .]

The group and its public

Despite his socio-political bent, Barba acknowledges that theatre cannot change society as a whole. Nevertheless, he maintains that it has the potential to change both those who do it, through making theatre a way of life rather than just a profession, and those who come in contact with people who have made theatre the focus of their lives:

> We've [the Odin] been building something autonomous, but it's changing all the time, and changing the view of theatre. In Europe and in many other countries, we are a factor which has changed many things. Theatre can change only theatre; it cannot change society. But if you change the theatre, you change a small but very important part of society. In the end, what did Stanislavski influence? The spectators or the age or the history of theatre which came after him? When you change theatre, you change for its audience a certain way of seeing, a change in perception, a special kind of perceptivity.
>
> (1985a: 17)

The social value of theatre for Barba is in the way those who make it go about their work, rather than in the socio-political content of productions. Even though several of the Odin's pieces have had their origins in political themes, the major socio-political thrust in the group's work comes from the contact made between its members and those who host them on tour.

The key to understanding Barba's approach to theatre is his emphasis on process. Even though he acknowledges the value of socio-political commentary and aesthetics, these are less important for him in the long term than

the process through which a group arrives at them. Barter, with its emphasis on the meeting of cultures is, in many ways, the quintessence of Barba's theatrical ideas. Sociologically speaking, he views theatre as a point of contact between cultures in which the exchange is as important as the quality or content of the product. It would be fair to say that one of Barba's major contributions to theatre history is his attempt to understand the social value of those who *make* theatre.

Chapter 40

Sally Ann Ness

OBSERVING THE EVIDENCE FAIL:
Difference arising from objectification in cross-cultural studies of dance

From: *Moving Words: Writing Dance*, ed. Gay Morris (London: Routledge, 1996).

D ANCE, AS AN OBJECT OF CROSS-CULTURAL STUDY, has produced a dazzling array of methodological activity. 'How might one best approach the task of understanding a dance (or "Dance" or "The Dance" in general, for that matter) that does not originate from or exist within one's own culture?' In the century or so that cross-cultural researchers and students of dance have been struggling with this question, no clear paradigm-setting answer has emerged. With respect to the question of how best to deal with the observable aspects of dance, for example – a key methodological question in this field of study – answers have ranged from a 'no attention necessary' stance (the 'and then they danced' ethnographic approach that has been so thoroughly critiqued in contemporary culturally focused dance research),[1] to the employment of elaborate perception-enhancing instruments, both conceptual and technological, intended to ensure a rigorous 'objectivity' with respect to the culturally different dancing in question (an interest now also subject to critique from postcolonial, poststructural, and critical cultural studies sectors). The methodological range in the specific area of cross-cultural dance observation has been so great that a common ground for discussion and debate has been difficult to achieve.

Variations notwithstanding, however, the task of learning, across cultural divides, what it means and what it is to dance has always entailed some method of identifying, conceptualizing, or constructing a recognizable and documentable 'thing' or referent called '(the) dance'. This conceptual 'dance-object', generally speaking, has become knowable to the researcher during the research process via a variety of attributes, some of them perceptual,

some symbolic, some historical, some otherwise defined. Ultimately, the dance-object becomes evidence, in some or all of these respects, for or against various theories – of dance more and less general, or of dance as a part of culture, of history, of human communication, of cultural symbolism, or of dance in relation to some other interest generated by the researcher's particular cross-cultural learning agenda. The activity of objectifying (i.e., creating a conceptual object out of) dance cross-culturally has had and continues to have practical, ethical, and theoretical consequences for the field of study, and, in this regard alone, its methodological variations (and the research agendas driving them) have merited careful attention and scrutiny.[2]

It is the variable history of this activity of objectifying dance in a cross-cultural research context, and then, of making certain kinds of evidence or knowledge out of 'its' study, that I wish to reflect on in this essay. It is now such a rich and complex history that I cannot even begin to make a sketch of it in its totality, but can only examine closely a few (to me) extraordinary moments. I do so, not to find order in the chaos, or to recommend one objectification over the others. Instead, I raise these cases in point, out of the past and of the present, to reflect upon their differing capacities for representing moments of cultural difference in acts of dance.

What I am calling 'cultural difference' occurs at that moment when a conceptual object – in this case the dance-object – however preconceived, *fails* to represent the researcher's understanding of the very practices they seek to identify by it and to study. These moments of failure register nothing other than the brute fact of difference, differences in world view, differences in what Bourdieu (1977: 72–95) has called *habitus* or what Wittgenstein might have called logic – differences in the conceptual results of the understandings gained from participating in given socio-cultural environments. When such failures are themselves defined and included in a researcher's record as a significant finding, they document the limits of cross-cultural comprehension and/or cultural translation.

Such recordings of cultural difference are of profound importance to cross-cultural study. They make visible, however imperfectly, the unstable, confused, and dynamic territory of cross-cultural working experience, the process of the *crossing* of cultural divides. The 'territory' of the cultural divide, that which lies in between the researcher's own cultural productions and those of the dance they seek better to comprehend, which they understand as different from their own, become apparent in these representational failures. [. . .]

Differences via anti-subjectivity: E.E. Evans-Pritchard's study of Azande dance

A landmark moment in cross-cultural dance history occurred in 1928 with the publication of E.E. Evans-Pritchard's short article, 'The Dance'. Published

in volume 1 of the international journal *Africa*, by one of British social anthropology's most highly respected leading figures, this article set forth the radical proclamation that dance had been given a marginal place in ethnological inquiry which was 'unworthy of its social importance' (1928: 446). By its own exemplary though self-consciously abridged analysis of the *gbere buda* 'beer dance' of the Azande people of Sudan the article provided a substantial justification for the general pursuit of cross-cultural dance research as a viable inroad for cultural study.

Evans-Pritchard's study proposed an anti-subjective strategy of dance-object making, 'anti-subjective' with respect to the *researcher's* subjective participation in the learning process. The forms of cultural difference produced by this strategy in Evans-Pritchard's work were both embodied and symbolic. They precluded any potential for the researcher, implicitly defined as bodily unqualified, ever to experience the dance as an authentic culture bearer might. Evans-Pritchard's anti-subjective approach to cross-cultural study also, paradoxically, constructed a dancing body of the culturally different dancer that was unproblematically observable, and in its observable characteristics, assumed to be universal as an essentially anatomical object. While the dancing experience he studied was cross-culturally unassumable, and evidence of its distinctive effects could only be gathered by discussion with participants and attendance at dance occasions, the dancing body was transculturally, transparently, and immediately available for cross-cultural analysis. [. . .]

Semiotic objectivity: Judith Lynne Hanna's model of dance communication

Judith Lynne Hanna's models of dance and dance communication, published most prominently in the 1979 book, *To Dance Is Human: A Theory of Nonverbal Communication,* emerge from an attempt to develop an over-arching analytical understanding of dance of pan-cultural magnitude and scope. The dance-object Hanna conceptualizes endeavours to integrate the widest possible range of theoretical perspectives on 'dance' into a single, all-encompassing model of dance and its meaning-making movements. [. . .]

Hanna argues that dance in all cultures is *communicative* behaviour, comparable to a non-verbal 'text' or 'coding device' which can be modelled in relationship to its cultural 'content'. This dance-object is integrated into what Hanna defines as a cross-culturally viable semiotic model of human communication.

While Hanna's model is fashioned so as to suppress evidence of cultural difference in favour of producing a discourse of cultural translation, ultimately, I would argue, the semiotic network of the dance-object is very effectively designed to produce evidence of cultural difference as well. Hanna's study itself, as predominantly 'translated' as it is, foregrounds some

organizing moments of cultural difference. The very notion of 'dance' that Hanna defines, for example, fails to represent adequately the specific practices of [her research object] the Ubakala. Hanna is brought by her own translating efforts to a recognition that what the Ubakala do merits the label 'dance-play' instead of simply 'dance'. The hyphenated concept, its hyphen foregrounding its own conceptual imperfection, [confounds] common-sense definitions of both concepts and [joins] them in a manner that illuminates an absence of reason, reason not available without crossing into a different cultural reality. [. . .]

Structuralist objectivity: the ethnoscientific model of Adrienne Kaeppler

There is, perhaps, no scholar in the field of cross-cultural dance study whose work has been more effective in illuminating the richness of cultural difference made visible via the representational failures of a dance-object than Adrienne Kaeppler. Kaeppler, working also from a perspective of rigorous anti-ethnocentric objectivism, probed the limits of that orientation by challenging the general capacity of the concept 'dance' to serve as a vehicle of cross-cultural representation and understanding. 'Dance', Kaeppler has argued – most forcefully in her 1985 article, 'Structured Movement Systems in Tonga' – is an inherently ethnocentric concept. To attempt to involve it in the study of practices of cultures in which it does not originate is to risk a distorted view of those practices. However, Kaeppler's studies of the (non) dance practices of Tonga have demonstrated lucidly that the failure of the 'dance' concept can be extremely productive. Its (mis)application can open up a cross-cultural research process to a consideration of alternative conceptualizations of the practices that a dance-oriented culture bearer might potentially construe as 'dance'. The limitations of the dance-object in Kaeppler's Tongan studies enables the introduction of a wide array of Tongan concepts into her analytical discussion. These repeatedly jar and torque the anti-ethnocentric cultural frame of reference and create a profoundly cross-cultural textual domain. The approach also allows Kaeppler to attempt, at least in theory, to give Tongan cultural discourse the last conceptual word. [. . .]

Subjective means to difference: the reflexive dance-object of Avanthi Meduri

[. . .] Despite their differences, Evans-Pritchard, Hanna, and Kaeppler all share in their writing a similar cultural predicament. All are self-defined as culturally different from the dance they study. All seek to gain understanding via the observation of dancing bodies also defined as culturally different from their own. All value forms of non-subjectively defined observation as methods

ensuring the least distorted understandings possible in their cross-cultural endeavours. All encounter cultural difference via the failures of such an anti-subjective/objective pursuit. In the reflexive subjective work of dance theorist Avanthi Meduri, however, a radically different cross-cultural project ensues. Meduri's strategy, which I will discuss as it is represented in her article, 'Bharatha Natyam – What are You?', identifies the dance-object and the body it involves as culturally her own. In this crossing, the researcher who crosses is herself a dancing subject. Dance is not the object of a foreigner's gaze alone. The dance-object is characterized as existing in foreign cultures, both in contemporary India and in non-Indian European and American contexts, but it is also situated within a familiar body, a cultural 'self'. The dance-object is the potential, though failing, bridge of a cultural crossing that moves in the reverse direction from those discussed previously. Even more important, Meduri identifies the differing cultural contexts between which cultural difference becomes apparent as also respectively her own. Her study thus includes no object or territory marked as culturally mysterious or unfamiliar.

Despite the lack of exotic territory, however, questions regarding the nature of the dance-object and the cultural difference its study produces do not disappear. Cultural difference is encountered and illuminated subjectively, and the dance-object becomes an object of an even more problematic and ambiguous sort as it becomes evidence of this cultural difference. In Meduri's essay, dance is evidence of cultural difference via its practice, as opposed to its direct and formal observation. [. . .]

Conclusion

[. . .] The divergent strategies reviewed above reveal the vital fact that 'dance' typically has been made into a conceptual object as it has been thought onto bodies, living human subjects. Differences in approach notwithstanding, the cultural difference made visible (or invisible) via such dance writing is cast in terms of the human being itself. The field of study in general produces awareness of cultural difference at very personal, one might even say intimate, levels.

In Meduri's essay, cultural difference, as well as dance, becomes a personally felt experience. Difference becomes a pain in the heart; it produces headaches and disturbs peace of mind. In Kaeppler's kinemic approach, difference is located in the study of personal, culturally conscious action, in the webs of understanding that interrelate activities involving the culturally structured participation of arms, legs, torsos, feet, and hands. It is difference acted out in the gestures and postures of Tongan-speaking and Tongan-moving human bodies. In Evans-Pritchard's writing, difference is expressed in part as a personal conceptual experience, as Evans-Pritchard struggles in vain within his own thought process to come to terms with the dance-object through standard English concepts. Evans-Pritchard also locates cultural

difference in the dancing individuals he, ultimately, can only study as an observer and can never himself personally know or subjectively become. The dancing person Evans-Pritchard conceptualizes is one in which the experiences of being a self residing permanently in a specific cultural community motivate and define the occasion happening in the dancing. Finally, in Hanna's semiotic model, difference is potentially located in any of the vehicles or channels of signification that entail the dance-object and its dancing bodies. This entailment is not conceived as a superficial association or involvement of the dancing participants, but rather one achieved via communicative linkages that engage the most fundamental aspects of the dance movement patterning and its bodily agents of production – the 'grammar' or 'syntax' of choreography constituted by foot steps, head turns, hand shakes, and other such corporeal manoeuvres.

Cross-cultural dance research presents great potential for the study of cultural difference. It illuminates the diversity of cultural experience in profoundly personal terms. It reveals, in the most concrete discourse conceivable, the talk of physical experience – body talk – the impossibilities of merging culturally defined systems of understanding human thought and action. It foregrounds that manner in which bodily participation in given forms of symbolic action produce forms of wisdom, necessarily distinctive, necessarily culturally specific in their interpretation, forms of human understanding without corresponding representation across cultural divides. In so doing, cross-cultural dance research raises the possibility that the most basic forms of human wisdom can only be deeply (and perhaps never fully) understood 'cross-culturally' when the limits of their translation are defined through interactive failures. Moreover, the active grounds of cross-cultural translation and the origination of such understandings must be studied for their own sake, in their own terms, that is to say, choreographically.

Notes

1 See for example the critical discussions of Royce (1977: 38), Novack (1990: 7), Cowan (1990: 5), Kaeppler (1978), and Ness (1992: 239).

2 For discussions of methodological issues arising in cross-cultural dance research, see Kurath (1960), Royce (1977, especially pp. 38–63), Hanna (1979a), Spencer (1985: 1–46), and Ness (1992: 236–40).

Post-linearity and gendered performance practice

Susan Kozel

INTRODUCTION TO PART EIGHT

Refiguring linearity

F FWD. RWD. STOP. PLAY. Audio and video tapes add a certain flexibility of movement to linearity. Forward. Backward. Stop. Like turning on your heel. From forward to backward: the U-turn is perfected with the video tape or the audio cassette. Spin to the end. Don't forget to rewind. The beginning is sacrosanct, almost as important as the closure of the end. Linearity plus velocity equals analogue magnetic tape. Better systems are faster, quieter, but still linear.

Eject. Eject: the foreshadowing of post-linearity within linear systems. Plastic casing and magnetic tape slipping awkwardly sideways out of the narrative confines of the analogue deck. Or being trapped inside. Tape destroyed as a penalty for stepping off the linear track?

Go to. Repeat. CDs. No need to make the journey through unwanted material, even at high speed. Simply point your digital finger and go directly to the track you desire. Go there again and again. No loss of quality (so they say). CD-Roms. Follow your whim. Leap forward, backward, laterally, diagonally. Follow the web of paths provided for you by the designer, accessing a variety of media, sound, photos, short movies, audio, text.

Insert. Now you add to what is given. Your voice. Where you want it to appear. No longer passive, no longer the silent witness of someone else's creative narrative. The prefix 'inter' takes centre stage: interactivity, interface, intervention. Interesting? Not always.

Delete. Eliminate. Remove. Wipe (accidentally or deliberately). Hack. Censor: you of others' voices, them of yours.

Quit. End of narrative. Lost the plot.

Linearity and the artefacts of culture

This narrative of linearity illustrated with media technologies implies that analogue is linear and digital is post-linear. It also implies that most citizens of Western market economies are intimately familiar with the practices of linearity and post-linearity through the artefacts of popular culture such as the tape played in a walkman, the VHS video, the CD, the computer game, and the Internet. We currently live at the juncture where the physical actions of pressing buttons give way to the myths spun by the marketplace. Paradoxically, the embodied process of engaging with these cultural artefacts both generates myths and is shaped by – sometimes distorted by – these myths. How many people are forced to believe that computer interface is intuitive or that the Internet is interesting simply because this is what we are told to believe, primarily by advertising. This juncture is political and embodied; it is shaped by desire, despair, seduction, and control.

Our engagement with new media technologies is not introduced here merely as a metaphor for how we respond to live performance. Performance has always been technologically intensive, and practitioners of dance and theatre are rapidly integrating so-called 'new media technologies' into their creative projects. At the lower-tech and fairly accessible end of the spectrum, video is used to facilitate rehearsals, video projections are frequently seen as part of live performance, and CD-Roms are used to archive and disseminate. Video-conferencing is used to explore interaction across distances, either simply and cheaply through the Internet or using faster connections such as ISDN or ATM lines. At the higher end, motion-tracking and motion-capture systems are used for animation or to generate alternative portrayals of human movement, approaching artificial life forms.

Linearity and clear narrative structures have been associated with conventional or 'mainstream' theatre. Politically they have been associated with totalitarianism or, on the softer side, simple conservatism. The performance invited by linearity (as either an actor or a citizen) is one of 'following the line', whether this be dictated by tradition, a political party or a playwright. Post-linearity has been associated with postmodernism and a radical explosion of meaning. This translates into a fragmentation of histories and language where it is up to the reader of multiple social texts to create meaning. The result seems to be a scavenger hunt for meaning, hither and thither, under bushes of convention, behind fractured syntax and fragmented tradition.

But is this really what post-linear performance is about?

When the post-linear is equated oversimplistically with the absence of structure and defined as the opposite of linear narrative it is reduced to the non-linear. But post-linear performance is not a negation of narrative. It contains linear narrative, playing with the space, time, and context of narration. Like a flood, post-linear performance ignores the boundaries of the river of theatrical convention and engulfs the many positions of the viewers, the actors, the critics. Post-linear performance acknowledges that the play plays on after the curtain goes down and began long before the audience took their seats.

In trying to understand the complicated performances that fall under the category of the post-linear, there is a tendency to think geometrically. Lines, triangles, spider webs, or particle clusters are evoked to assist in the understanding of how meaning is generated by live performance. These geometries were used above to understand how we navigate through our analogue and digital media technologies. How often have we been told to think of the CD-Rom as non-linear, with the data stored in a splay resembling a web rather than a path? The 'information superhighway' is one of the most inappropriate metaphors for describing the Internet, because a highway assumes rapid linear traffic. The 'information spaghetti junction' is more intuitively accurate, but somehow does not seem slick or fast enough. My suggestion is to side-step the geometrical approach by thinking instead of the pattern of bodies involved in any post-linear encounter, whether this is a performance or a personal journey through a CD-Rom. These body patterns include the lives, histories, politics, perspectives, senses, and voices of relevant communities. Adopting an embodied perspective to understand post-linear performance recognizes that the bedrock of live performance is the body, more specifically, the bodies of the audience in the act of deciphering, assimilating, or enjoying the experience provided by the alchemy of bodies and technologies 'onstage'.

The post-linear: bodies, territories, histories

Linearity or post-linearity can be understood in terms of territories, bodies, and histories rather than simply an abstraction of narrative. Simplistic critiques of postmodernism see the post-linear as an utter fragmentation, but the authors included in this part of the *Reader* provide further dimensions to our understanding of post-linear performance. Loveless considers how digital practice has changed the nature of performance practice and collaboration between practitioners. Schneider reminds us of the role for cultural histories, Case introduces bodies and deterritorialization into the matrix of the Internet, Goodman charts a role for replay and reterritorialization, while Kaye calls attention to the subversive potential inherent in this approach to performance.

Nick Kaye's vivid analysis of Karen Finley's performances exemplify how she works within the structures of traditional theatre practices in a subversive and post-linear way. Food, humour, and gut-wrenching personal narratives of abuse show that the 'unity' of autobiographical narrative is spurious. The power resides instead in Finley confronting the audience with a play across the 'real' and the 'theatrical' which pulls at the many layers of our psyches and lived experience. The non-linearity of her performances threads its way into the non-linearity of our lives and makes her performances impossible to dismiss as hyperbole or irrelevant.

Spiderwoman, as described by Rebecca Schneider, use counter-memory and counter-mimicry to expose the perspectival nature of conventional historical narratives. Lisa Mayo, Gloria Miguel, and Muriel Miguel of Spiderwoman ironically play across white North American accounts of American Indian culture. Counter-memory is 'the residual or resistant strains [of memory] which withstand official versions of historical continuity' (below, p. 264). Counter-memory is not linear or singular, it achieves a 'multiplication of meaning through the practice of vigilant repetitions' (below, p. 264). When counter-memory is combined with counter-mimicry the 'truth' of how a colonialized culture is represented in art or in historical narratives is called into question. Mimicry (or mimesis) can never be an exact representation of an original, it can only be an extension, distortion or recreation of its source material. In Homi Bhabha's words representation follows a circle of 'almost the same but not quite . . . almost the same but not white' (Bhabha 1984: 126, cited in Schneider, below p. 265 and 266). History and tradition are not denied, but multiplied through the fun-house mirrors of mimesis.

Post-linear performance can be understood in terms of passivity and activity. It often operates contrary to the belief that performance exists as escapist, feel-good entertainment. Post-linear performance can be hard work for the audience. Effort is required to dispel confusion and understand what is going on, and discomfort can be the result of being presented with a distopian picture of a particular slice of our social and political reality. This is particularly evident in the work of Finley and Spiderwoman.

Through post-linearity gaps are provided for us to insert our views, our experiences, or for us to self-consciously chart our own course through material based on our likes, dislikes, or habits. These habits become clear through the process of active engagement. In this sense, post-linear performance can be called generative performance. If a distopia is presented (for example racial prejudice or sexual abuse) it is rarely presented as fatalistic and unchangeable. Instead, it is presented as a strident revelation: 'look at this – did you know this is happening?!' followed by an implicit: 'do something about this!' From time to time a suggestion is offered but generative performance, in addition to letting viewers play an active role in creating meaning for themselves, lets us decide what to do about it. It is political, but it avoids being prescriptive.

Generative performance using new media technologies

In what way is post-linear performance political? It is political by engineering a confrontation between the present and the absent, the visible and the invisible. The power of live performance is the friction between the undeniable material presence of the actors and dancers, and the elusive nature of the alternative presences that are opened up. These alternative presences can be future utopias, histories revisited, imaginative constructs or hints of the unconscious. Live performance is never simply present in the here and now. It arcs and swings across a range of temporal and spatial registers. Performances that bend backward and forward, reaching laterally out to include the personal input of the audience or spilling sideways into exposed wings or onto the street are based upon the mutability of the body. And nowhere is this more evident than in performance which draws directly upon new media technologies.[1] Sue-Ellen Case describes the inventions, interventions and spatio-temporal subversions of lesbians using the web. She characterizes the vagaries of Internet existence in terms of performance practices inspired by Gertrude Stein and the poetic presence of Sappho. 'Steining the screen, Sapphing the net is the lesbian's signature two-step – her body' (below, p. 280). The spatial existence of communities on the web involves the mechanisms of disguise including encryption and masquerade, never estranged from the body.

Case's drawing of encryption down to the level of personal, desiring practices evokes and subverts the principal uses for encryption. As a way of protecting digital data, it is central to personal but also governmental and commercial uses of the net. Governments and large corporations spend millions to protect their data, but seek to limit the extent to which individuals can encrypt their own digital information or decipher the information of others. Creating and breaking through these 'disguises of data' is the preoccupation of hackers. Steining the screen and Sapphing the net is about a form of sexual hacking existing simultaneously in cyberspace and IRL ('in real life'.) Presence is altered, but is still bodied. Dialogue is screen-bound, but it is ultimately political discourse.

Richard Loveless' example of the Intelligent Stage demonstrates how the use of new media radically alters the power balance between participants in a collaboration, by shifting power away from the choreographer and placing independent responsibilities on the individual dancers. He also discusses the 'Mirrors and Smoke' project which demonstrates some of the implications of such a shift in the balance of power between artists: this three-way collaboration is likened to 'three storms at sea. Our proximity created a fourth storm which is where the piece began to take form' (below, p. 285).

Lizbeth Goodman offers the expression 'replay culture' to describe how theatre events can be 'revisited, recorded and reviewed . . . by anyone with

a video player' (below, p. 289). Echoing Schneider's debates on mimicry, her suggestion that we dwell within replay culture does not imply that we are left with thin reproductions of authentic experience. The conscious act of replaying amounts to playing anew across divergent narratives and sites of physical presence. Where Case saw the deterritorialization of the Internet as a powerful present/absent site for lesbian practices, Goodman sees the digital spaces of the web as drawn back into the ebb and flow of performance practices. Reterritorialization takes the sci-fi glow off cyberspace and gets it 'dirty', through our gendered, bodily, theatrical practices.

FLOW. REFIGURE. REPLAY. DISPERSE.

Post-linear performance is porous. Meaning flows through tiny apertures, like the pores of our skin or the spaces between our words. Furthering the theme of replay culture means identifying how performance experimentation takes us beyond the narrow confines of the 'Fast-Forward, Rewind, Eject, Delete, Insert, Quit' approach to our physical engagment with the linear and the post-linear. Looking to audio-visual tapes and CD-Roms for clarification of how we currently experience the linear and the post-linear is a short-term strategy to enhance understanding, but departing from this metaphor is crucial for inspiration into how we might embody and generate new linearities when we experiment with new media technologies.

Contours is an installation/performance which exists across dance, real-time image projections, and computer programming.[2] The software uses an infrared camera and a computer to read changes in bodily movement. What is projected into the performance space is not a filmic representation of full bodies, but the real-time digitized contours of those parts of the body that are moving. Body parts that are immobile are neither picked up nor projected. Stillness equals invisibility. So if the dancer chooses to move nothing but one leg and one hand, only these will appear in the projection. The dance develops across visibility and invisibility. The images become porous, with the gaps conveying as much meaning as the bodily contours. The environment is one of liquid light. Movement ripples as if the performance space were a still pool of water responding to the unpredictable movement of a bather. The digital territory of the body is the fluid world of light transforming into water.

What makes this performance post-linear is the way corporeal identity forms, dissolves, and reforms through engagement between the dancer and the computer. Interface is through full bodily movement, initiating and responding to the computer-mediated images. Fast-forward becomes flow, rewind becomes refigure, play becomes replay, and eject becomes disperse. 'Flow, Refigure, Replay, Disperse' can be the new starting point for understanding post-linear performance in the context of new technologies.

Notes

1 'The purpose of inquiry into the digital arts is not to affirm what is, but to promote the becoming of what is not-yet, the grounds of the future as they exist in the present' (Cubitt 1998: x).

2 *Contours* by Mesh Performance Partnerships, is a collaboration between Kirck Woolford (software design and imagery) and Susan Kozel (choreography and performance). It was premiered in June 1999 at Fabrica, Brighton, prior to an international tour. The piece has been discussed in Kozel and Woolford's article in the 'Online' issue of Performance Research edited by Scott delaHunta and Ric Alsop (1999); further information about the performance can be accessed via the website for the Institute for New Media Performance Research: *http://www.surrey.ac. uk/SPA/I.N.M.P.R./index/html* and from Mesh's *http://www.mesh.org.uk*

Rebecca Schneider

SEEING THE BIG SHOW

From: *The Explicit Body in Performance* (London: Routledge, 1997); a version of this chapter was published as 'See the Big Show: Spiderwoman Theater Doubling Back', in *Acting Out: Feminist Performances*, ed. Lynda Hart and Peggy Phelan (Ann Arbor: University of Michigan Press, 1993).

Vigilant repetitions, the comic turn, and counter-mimicry

1 990. THEATER FOR THE NEW CITY. We sit in the dark waiting for *Reverb-ber-ber-rations* [by Spiderwoman Theatre] to begin.[1] A loud, very loud, drumming assaults us and continues in the dark for some time. There is also a scuffling of feet. When the lights come up we see that the drum is a garbage can. Spiderwoman had been clumsily stumbling around in the dark. 'I gotta pee!' says Muriel [Miguel]. The sisters Broadway-belt Cole Porter: 'Like the beat beat beat of the tom tom when the jungle shadows fall . . .'. What stands between the drum, the tom-tom, and the trash-can? Does the space between them generate a counter-memory?

Natalie Zemon Davis and Peter Starn define counter-memory as the 'residual or resistant strains that withstand official versions of historical continuity' (1989: 2). Foucault's translator defines counter-memory as the name of an 'action that defines itself, that recognizes itself in words – in the multiplication of meaning through the practice of vigilant repetitions' (Bouchard in Foucault 1977: 9). Can counter-memory be an action that defines not only in words, but in the vigilant repetitions of a body or an object, as in the visceral 'words' of a performer's gesture or the violent vibrations of a drum which repeats itself, doubling as both trash-can and tom-tom?

Vigilant repetitions. The dark drumming and the trash-can scene are repeated later in the show. So are the jokes and ribald humour. So are the knife-in-the-heart stories of loss. So are the reflexive tea scenes. So are the women themselves as the features of one sister can be seen, almost the same

but not quite, on the body of another sister. 'Just what did you tell those people?' they ask each other again.

Since 1981, Lisa Mayo, Gloria Miguel, and Muriel Miguel [three Native American sisters], have been the core of Spiderwoman. Theater for the New City and the American Indian Community House, both on the Lower East Side of Manhattan, generally host Spiderwoman's work before they tour. *Sun, Moon, Feather* (1981) was followed by *The Three Sisters From Here to There* (1982) – a take-off on Chekhov; *3 Up, 3 Down* (1987); *Winnetou's Snake Oil Show from Wigwam City* (1988); and *Reverb-ber-ber-rations* (1990). [. . .] There is a depth to Spiderwoman's exploration of identity – the differences they explore, like the realities they explore, are rarely limited to the strictly visible ones. In fact, things that 'ought' to be different – such as a trash-can and a tom-tom – are constantly bombarded against each other and against audience expectations. More often than not it is the 'appropriate' which is challenged. In a segment of *Reverb-ber-ber-rations* titled 'Vincent', Lisa Mayo enters the stage chanting: 'Hey, hey, dooten day, dooten day, hey, hey, dooten day, dooten day'. Suddenly she weaves into her chant the lyrics from a pop tune – 'Starry, Starry Night' – and her words become impossibly intertwined, miscegented, with the popular Don Maclean lyrics about Van Gogh. [. . .]

What to make of such syncretism, such hybrid perspective in which categories of difference lose their clean edges, their appropriate delineations? Cultivating 'details and accidents', counter-memory, closely linked to the notion of genealogy, always already 'attaches itself to the body' (Foucault 1977: 148–9). But *the* body? Here problems proliferate like rashes, grammatical blemishes, slips of the tongue. What is 'the' body to which the details and accidents of counter-memory attach – especially when redoubled in such a tumult of blatant and insistent syncretism? The beat of Audre Lorde's words: *See whose face it wears*. In the blindspots of the abluted body of the 'appropriate', the inappropriate reverberates in a concatenation of resemblances, a circle of 'almost the same but not quite' (Bhabha 1984: 126), always, it seems, just beyond the field of appropriation. And yet the challenge demands a recognition of terror: *See whose face it wears. See whose face it wears. See whose face it wears.*

Spiderwoman practise double vision. 'Turning' a white into a native and marking that identity across the body by means of a photograph held in front of the face, they turn upon a mimicry that has colonized, fixed, commodified, and natural-historified Indian identity as a product of colonial representational practices. They make explicit the ways their bodies have been staged, framed by colonial representational practices, and delimited. Here, they turn upon that historical representation of the native, upon colonial mimicry of native identity, with what might be called counter-mimicry.

Exploring the historical mechanisms of colonial power, Homi Bhabha uncovered what he called a comic turn. The colonizers constructed their colonial subject through representation which presented the colonial project as noble by presenting the native as ignoble or, more to the point, as deficient,

partial, or incomplete. The 'nobility' of the civilizing mission was erected through the 'primitivizing' of the Other, and that primitive was produced through mimicry – textual effects which split that subject into both 'human and not wholly human', into almost the same but not quite. Thus the self-proclaimed noble intentions of the colonizer's construction of the colonial subject ironically hinged upon the ignoble literary effects of repetition, mimicry, and farce to create the colonial subject's deficiency. This literary flip which creates nobility through creating deficiency is what Bhabha calls the 'comic turn' of colonialism.[2] As Bhabha notes, historically, white recognition of a member of another race as human was always already insidiously coupled with a disavowal of that Other as 'wholly human'. Through the coupling of recognition with disavowal, that Other emerged as a split subject – a 'partial subject' – not wholly human in the eyes of colonizers – 'almost the same but not white'. The Other exists then in a strange space of ambiguity, oddly doubles with him/herself: both the same *and* different, subject and object at once. Bhabha defines mimicry as a complex strategy of representation, repeating or doubling the image of the Other in a shroud of the authentic, continually producing the delimiting difference through a strategy which ' "appropriates" the Other as it visualizes power' (Bhabha 1984: 126).

But mimicry has an edge. If mimicry can be articulated as the discipling gaze which doubles its subjects, then the menace of mimicry is in fact the potential return or ricochet of that gaze. As Bhabha puts it: 'The menace of mimicry is its double vision which in disclosing the ambivalence of colonial discourse also disrupts its authority.' Thus, 'the reforming, civilizing mission is threatened by the displacing gaze of its disciplinary double' (1984: 128). The view from the blind spot. In this displacing gaze, the tables are turned on the 'appropriate', showing the mimicry inherent in its construction. Under the stress of double vision, 'the body' appropriate becomes a scrim. Making that body explicit as scrim can throw into relief the concealment or erasure of other bodies – specific, detailed, and multiple.

Counter-mimicry. In *Sun, Moon, Feather* Gloria and Lisa play 'Indian Love Call' in their living room. But they don't act out the Indian parts – the virile, near-naked, dancing brave or the dark Indian princess – they fight over who gets to be be-ringleted, vaseline-over-the-lens Jeanette MacDonald and who has to play stalwart, straight-backed Canadian Mountie Nelson Eddy. They are not re-playing, re-membering, or re-claiming native images, but counter-appropriating the appropriate. They sing beautifully: 'When I'm calling you-ooo-ooo.' Lisa is Nelson. She wears a low-cut slip and a wide-brimmed hat. Gloria stands on a chair as Jeanette. They gaze into each other's eyes as they sing. Silent clips from the movie are interwoven with their scene so that the mouths of MacDonald and Eddy seem to lip-synch the lilting voices of Lisa and Gloria, whose bodies repeat upon the Hollywood lovers, doubling back.

Doubling-back, myriad 'appropriates' are recognized as they are disrupted.[3] The inappropriate bodies of Lisa and Gloria appropriate the bodies

of Jeanette and Nelson and expose a hot-bed of error. First, the lovers Nelson and Jeanette are supposed to be male and female, not female and female. Nelson isn't supposed to wear a slip that exposes a healthy cleavage. Second, in a Wild West fantasy whites aren't supposed to be non-whites (though Native Americans have been played by whites in ruddy make-up, one doesn't find 'real' natives playing whites in pancake). Third, and importantly, heavy women aren't supposed to be so clearly free and comfortable with their bodies. And fourth, a native performance troupe isn't supposed to mirror 'mainstream' performance traditions, though the mainstream can mimic native traditions (the native dances in *Girl of the Golden West* itself a case in point). A native troupe is expected to chase after a vanishing point marked as 'loss', the 'authentic' rendered by colonialist nostalgia as stuck in time, dislocated, pre-contact. [. . .]

Yet, if the colonial project turned from 'high ideals' to its 'low mimetic literary effect', as Bhabha would have it, Spiderwoman conversely turns from the low mimetic effect to a searing critique. 'People are laughing. Then – POW! – we get them with the real stuff.' In fact, if Spiderwoman did not incorporate another turn from the parody of counter-mimicry to the 'hit' of 'real-stuff' – or rather, if they did not make explicit the reality effects of mimicry – then the bite of their critique might slide into a whirlpool of mimesis for mimesis' sake, re-enacted without critical commentary across their own bodies. The seemingly endless concatenation of resemblances and counter-resemblances, in which mimesis repeats again and again and again, is interrupted by Spiderwoman by something they insist on as 'real'. Here, the re-doubling of representation does not erect a Baudrillardian hall of mirrors in which others mimic others mimicking others till the Different supposedly collapses with the Same under the label 'representation is all'. Instead Spiderwoman insist upon an interruption: 'POW! – we get them with the real stuff.' The punch of the literal in the face of the symbolic.

But what is the 'real stuff' that interrupts? What is the literal which exceeds the boundaries of its service to the Symbolic Order? Gloria and Lisa are not doubling back over Jeanette and Nelson to lose themselves in an endless concatenation of mimicry. In fact, something more strikingly heretical is occurring: they are telling a story about real effects on real lives and they have an agenda pitched toward change. They are 'going back into the before to use for the future'.[4] Their doubling back in fact bears a double meaning. On the one hand, it is a repetition of the technique of mimesis upon the dominant culture that has mimicked them (as if to say, you've doubled me now I'll double you back). But, on the other hand, it is a significant histor-ical counter-analysis, a doubling back as in a retracing of steps to expose something secreted, erased, silenced along the way. The audience laughs with the sisters at their antic remembering of the double, but in the next instant find that we rub up against the silenced side of the double – the 'real stuff'. Stories of their father's alcoholism, his violence and his death, sober stories of their mother's embattled Christianity, and stories of their deep, deep anger

repeat upon the spoof of the authentic. In one moment the 'authentic' is distanced, exposed as corrupted by colonialist nostalgia, but in the next it (painfully) 'alters' becomes a detail, a vital memory, a *literal* reality – their mother, themselves, their grandmother – very much alive in literal reverberations across their daily experience. [. . .]

The irruption of 'real stuff' and the politic of sacrality

Counter-mimicry, vigilant repetition, and the painful irruption of 'real stuff'. All of this tremors and repeats with other feminist explicit body performance art in obvious and fundamental ways. The insistence upon *literal* effects of symbolic systems is integral to and powerful in Spiderwoman's work. These performers play back legacies of symbolic identity across their literal bodies, counter-appropriating the 'appropriate' as Jeanette and Nelson embrace between sisters, and mimicking the ways natives have been mimicked. Their bodies are the literal ground of the 'real stuff'. But their stories, too, carry the weight of the real that Benjamin marked as overly possible, 'wreckage upon wreckage'. Yet Spiderwoman's insistent 'real stuff' extends not only to the too often dismissed social details of alcoholism and abuse intimated earlier, nor to just a literality tied to explicit materiality, but into a reverberating realm of the sacred – to the *real* stuff of the *spirit* world.

By doubling their parodies with serious interlude segments, as in *Winnetou*, that beckon toward sacred experience, by folding their criticisms of nostalgia over upon their own invocations of ghosts, Spiderwoman unleash multiple and seemingly conflicting reverberations into the space between performer and spectator. An invocation of ghosts that does not succumb to the logic of an insatiable and inaccessible vanishing point is an invocation which fully expects the ghosts to respond as present (in terms of both time and space). The real is not lost, just as *loss is very 'real stuff'* – not displaced but accessible, ready to be encountered as a blind spot that is not blind. Here, neither 'real stuff' nor 'dream stuff' is dictated by insatiability, marked as impossible to access. Rather 'real' and 'dream' are every bit as tangible, exigent, sensual, and accessible as ghosts of ancestors.

In considering the politic of the sacred in Spiderwoman's work – for indeed, in their work, the 'political' and 'sacred' are not mutually exclusive – it is important to note that Spiderwoman's invocation of the sacred functions as theatrical interruption, tightly woven into the fabric of the parodic. The sacred is embedded in the parodic, both standing in distinction to the comic turn, the doubling back, *and* part and parcel of that parody. As interruptions, such moments of serious invocation present a challenge to the audience. These 'sacred' moments interrupt the profanity of parody as if to cast cracks into the criticism (or weave errors into the fabric) through which another vision, another experience might breathe. Brecht used interruptions in order to add critical distance, to point to or underscore the social gest of

a situation. While Spiderwoman's interruptions may not add distance in precisely a Brechtian manner, they do ask the viewer to 'think again' – to take a second look, like second sight, into the deeper complexities at work in their parodies. Here, the beauty of the interludes invoking ancestors – 'digging, digging, digging for bones' – provide the audience with the recognition of the layer upon layer of sediment (and sentiment) stirred up by the storm of Spiderwoman's own parodic critique.

Notes

1 Unless otherwise indicated, all quotes from *Reverb-ber-ber-rations* appearing in this article appear in the printed text of the show in *Women and Performance* 5, 2 (1992).
2 'In this comic turn from the high ideals of the colonial imagination to its low mimetic literary effect, mimicry emerges as one of the most elusive and effective strategies of colonial power and knowledge' (Bhabha 1984: 126).
3 The performance technique I'm trying to articulate here under the rubric 'doubling back', or counter-mimicry, can be placed in relation to French ethnographer and dissident surrealist Michel Leiris's notion of 'writing back', first articulated in the early 1950s in relation to the work of Aimé Césaire. See Clifford 1988: 255–6.
4 From the text of *Reverb-ber-ber-rations.*

Nick Kaye

TELLING STORIES:
Narrative against itself

From: *Postmodernism and Performance* (Basingstoke: Macmillan, 1994).

The response we make when we 'believe' a work of the imagination is that of saying: 'This is the way things are. I have always known it without being fully aware that I knew it. Now in the presence of this play or novel or poem (or picture or piece of music) I know that I know it.'

(Wilder 1987: 7)

[. . .]

KAREN FINLEY'S APPROPRIATIONS OF LANGUAGES OF ABUSE, denigration, and pornography have provoked a sharply divided critical and popular response. Since *The Constant State of Desire* (1986), in particular, Finley's work has been read both as a capitulation to male violence and objectification, and a powerful transgression and challenge to the construction of sexual difference (see, for example, Fuchs 1989). More controversially, the piece has been condemned, despite acknowledgements of Finley's 'feminist intentions', first as an exploitation of the popular taste for obscenity and secondly for relying on arcane references to feminist theory incapable of 'full comprehension' by the 'average' spectator (see particularly Schuler 1990).

The Constant State of Desire is typical of the fractured nature of Finley's performances, consisting of a series of monologues punctuated by improvised exchanges with the audience. Her published text breaks the piece down into five sections: *Strangling Baby Birds*, *Enter Entrepreneur*, *Two Stories*, *Common Sense*, and *The Father in All of Us*. As in much of Finley's other work, these

stories intertwine painful descriptions of sexual abuse with, by turns, an angry and despairing mourning for the dying implicitly bound up with the consequences of AIDS. In the course of this, Finley's concerns spill over towards racism and the abuse of minorities, to the abandonment of the homeless, of addicts, and to the marginalized. In her later monologue, *We Keep Our Victims Ready* (1990), these broader political concerns become explicit as accounts of sexual abuse, the persecution of AIDS victims, and of artists themselves are set against images of the Nazi death camps.

Rather than offer a coherent critique of a process of marginalization, or of sexual objectification, subordination, and abuse, however, Finley's performances operate first and foremost on a direct and powerful emotional level, though by no means one which is straightforwardly cathartic. In particular, Finley's appropriations of pornographic imagery and language serve to call into question not only the distance and perspective an audience might wish to establish in an address to such material, but her own implication in the processes of objectification and abuse she ostensibly attacks. [. . .]

[For example, in the final monologue of *The Constant State of Desire*], *The Father in All of Us*, which is divided into several parts, Finley readdresses the concerns running through the piece but in a more graphic and difficult way. 'My First Sexual Experience' sets out a violent parody of the privileging of Oedipal drives and desires and the definition of woman in terms of lack. The piece begins with Finley's description of birth itself as a sexual experience, after which she takes on the mantle of a male 'motherfucker' who uses a baby as a substitute penis to abuse his indifferent mother. This is followed by 'Refrigerator', which returns to a description of sexual abuse, setting out a distressing account of a father's assault on his daughter. Sitting her in the refrigerator:

> he leans down to the vegetable bin, opens it and takes out the carrots, the celery, the zucchini, the cucumbers. Then he starts working on my little hole, my little, little hole. My little girl hole. Showing me 'what it's like to be mamma' . . . Next thing I know I'm in bed crying, bleeding. I got all my dollies and animals around me. I've got Band-Aids between their legs. If they can't protect me, I'll protect them.
>
> (Finley 1990: 20–1)

'The Father in All of Us' then turns explicitly to AIDS as Finley [. . .] gives voice to the son whose sexuality and death is rejected by his father. Images of violent sexual abuse are then set against accounts of addicts and the homeless abandoned on the street. Finally, in a gentler tone but no less bitter a parody, Finley speaks as a yuppy in search of a 'religious experience', but who finds only dying friends and a 'White Man's Guilt', a self-indulgent discomfort born of exploitation and privilege.

[. . .] *The Constant State of Desire* is constructed through shifting perspectives, while Finley's relationship to the material she engages with remains an ambivalent one. Through her rehearsal of violent and even pornographic

imagery and language, Finley couches her performance and her presentation of herself in the terms of a violent sexual objectification and abuse. Paradoxically, and despite her verbal assaults on the abusers, Finley's performances have been read as capitulating through the very terms by which she tells her stories with that which she bitterly attacks. Indeed, one may even argue that any such engagement can only be politically self-destructive as, by its nature, an appropriation of male languages of objectification and abuse speaks to a male audience first and is bound in its reception by the assumptions that generate and sustain its terms. For a critic such as Jill Dolan, powerful as Finley's performances evidently are, they remain limited, even self-defeating:

> There is not much potential for radical change in Finley's work because . . . she is still caught within the representational system to which she refers. Although male spectators are challenged and confronted in Finley's work, her aims are achieved by absuing herself under representational terms that remain operative from the male point of view. Finley perverts the stripper's position, but remains defined by its traditional history.
>
> (Dolan 1988: 67)

Yet the very extreme and surprising nature of Finley's appropriations, as well as the shifting and fragmented nature of her monologues, can be read as resisting such an accommodation. Far from offering herself as a passive object, Finley takes on and incorporates these languages into her performance in such a way that she becomes active through them. Here, one can argue, by re-enacting the violence of the male subject she subverts the terms of his objectification, appropriating the language that would define her as a passive victim and throwing it back at her audience. Importantly, too, as she engages in this process Finley effects a continual change of ground and identity, taking on and disposing, variously and unpredictably, of male and female voices, and the personas of abused, abuser, victim, and protagonist. In doing so, she overtly resists the spectator's reading of 'character' as a unifying force, and particularly a reading of herself as an empathetic figure or victim in relation to which the various experiences she recounts might be placed.

In performance, the tensions between these poles become even more apparent, as Finley's shifts of narrative voice and the clash between texts are themselves framed within improvised and revealing exchanges with the audience (Robinson 1987). This rapport looks toward a dual effect, at once standing in tension with the aggressive and sometimes abusive nature of her monologues while evidencing the process of her performance, the construction of the 'act' itself. At the time of her performance of *The Constant State of Desire* Finley articulated this tension, making a distinction in her work between 'experimental theatre', material which had become fixed and was repeatable, and a 'performance procedure' which can be prepared for but is not rehearsed (Schechner 1988b: esp. 155).

Caught between these two poles, Finley's performances of her mono-logues set themselves against conventional theatrical and dramatic criteria. [. . .] Charged with presenting a 'bad' performance, Finley has responded by arguing that in such circumstances the exposure of her own struggle to perform becomes part of her subject-matter:

> for that reason I thought it was the best night: people could see me as I am. I showed that a performance is really hard to do. I think it's my duty as a performer to be completely honest, to show them what I'm going through.
>
> (Robinson 1987: 44)

Such a reading of Finley's performance begins to turn away from an attention simply to the material she appropriates and towards a framing and treatment of this material through formal strategies. From this point of view [her] work can be usefully set against treatments of narrative defined through self-conscious appropriations of conventional theatre forms and figures. Here, narrative is treated as a figure with certain formal consequences, and one whose effect is to be questioned through its displacement in an address to its place and effect in an active negotiation over identity and meaning.

Resisting narrative

Yvonne Rainer's final theatre-piece was a two-hour multi-media performance, *This is the story of a woman who . . .*, first presented in March 1973. [. . .] This presentation pursued the increasingly open address to dramatic convention that characterized the development of her work through performance and toward an exclusive concern with film. Yet despite open references to narrative, 'persona', and an interaction between 'characters', in this work Rainer's use of conventional form and figure is always qualified by a displacement or subversion of the continuities such elements would seem to look towards.

Set in a simply defined rectangular space, *This is the story of a woman who . . .* incorporates film and slide projections, before which the three performers, originally Rainer herself, Shirley Soffer, and John Erdman, vari-ously interact with each other and tell their stories to the audience. While Rainer and Erdman alternate between sitting on a pair of chairs at the rear, interacting with each other around the space and on a mattress placed down-stage right, Soffer sits before a microphone near the audience, ostensibly taking on the role of narrator. [. . .]

The elements constituting the performance continually invite a reading of narrative continuity and yet resist the actual construction of a single or even predominant narrative. Ironically, this disruption of the reading of narra-tive is achieved first of all through the clear and specific claim of each narrative voice. In this piece, individual voices and texts re-narrativize each other,

either directly or through the re-drawing of analogous events, experiences, and themes. As if to compound this, the particular identity of these voices proves to be elusive. Repeatedly, what is narrated are the experiences, feelings, and points of view of the 'other', which may or may not be Rainer, Erdman, or Soffer's 'characters'. Thematically, this may be read as an evasion of responsibility, a measuring of one's own actions in terms of another's. Formally, however, it means that the narrative voice fails to identify its own position, but concerns itself with re-drawing the position of others. Paradoxically, only Soffer, as the external voice of the 'narrator', speaks of herself directly, intruding [. . .] into that which she would ostensibly draw a frame around and lead the audience through.

The equivocal nature of this invitation to read the 'story' of a woman or her experiences is echoed, too, in the relationship between narrative and the performers' actions and interactions. In the first scene, incorporating Erdman's 'dance' *Inner Appearances*, Rainer suggests, 'The dance consisted of cleaning, vacuuming the performance space. Drama and psychological meaning were conveyed by slides of typescript dealing with the state of mind of a character . . . The dancer becomes a persona related by spatial proximity to the projected texts' (Hulton 1978: 5–6).

Erdman presents his dance while his proximity to the projected texts invites a reading of the dancer as 'persona'. The nature of the text, which announces its own construction of a fiction and use of cliché, at once extends an invitation to read his presence through its terms and yet maintains a self-conscious distance from Erdman's activities. Typically, this scene does not offer unequivocal representations of character or dramatic incident but actions, texts, images, and commentaries which stand in self-conscious, uncertain, and shifting relationships to one another. [. . .]

In this piece, then, Rainer's elements repeatedly invite the reading of a narrative. At the same time, though, the sequence of claim and counterclaim, of parallel and reversal, within which these narrative appropriations and conventions are bound, continually undercut and displace the ground on which such a narrative might be followed through. Here, ironically, it is the very narrative voices that invite a reading of the piece in terms of an unfolding whole that resist integration into such a whole, that speak for others and will not be spoken for.

In fact, for Rainer, it seems that the more such figures come into play, the more sharply their unifying effect should be resisted. Rainer has argued that 'the more meanings get spelled out for an audience in terms of specific narrative information, the stronger the need for "opening up" things at another level with ambiguous or even ambivalent clues and signs' (Hulton 1978: 12). As narrative strategies emerge and develop in Rainer's work, so the particular narrative comes to be shadowed by that which it cannot encompass. Competing narrative voices displace one another, to be exposed as figures which would establish a continuity through which the 'other' would be silenced or spoken for. Narrative patterns are revealed by events which escape

their logic, undermining the transparency of cause-and-effect. Overt quotations intrude formally and thematically, setting the narratives against which they are placed in relation to others beyond the piece itself.

Rainer's late performances offer examples of a range of work that in incorporating narrative comes to interrogate the nature and consequence of the act of narration. Here, the reading of representation and continuity is at once invited and disrupted, as the act of narration is revealed to be the act of reading one element through another, of having one voice speak for another. [. . .]

In [. . .] *This is the story of a woman who* . . . [. . .] narratives and narrative conventions are presented in such a way that their claim to authority is challenged. Yet this challenge to narrative is not simply a matter of competing or conflicting narratives, or even the successive displacement of one narrative by another. Here narratives are resisted or disrupted in such a way that the nature of their move toward unity and containment is made visible. Ironically, this work reveals the formal function and effect of the narrative voice by setting narrative elements against the move towards narrative closure, by deploying narrative voices against each other in such a way that the *event* of narration, the move toward containment, is frustrated and so made apparent. [. . .]

A postmodern politics?

Such a struggle between narrative claims is not a matter of articulating political meanings, but of making visible a politics of who speaks and who is spoken for. In this way, and far from reading the collision between texts as an attempt to shrug off responsibility for meaning, the paradoxical positions this work repeatedly strikes may be read as precipitating an 'event' with regard to meaning; the contesting of meaning, the struggle between narrative possibilities. [. . .]

In *The Constant State of Desire*, Finley, too, provokes such a struggle. [. . .] Her continual shifts of voice and narrative mode operate not simply on a thematic but a formal level, undercutting the position of the spectator and drawing her into a conflict between narratives and representations. So Finley's various narrative voices put each other into question, while her attack upon the 'sexuality of violence' (Schechner 1988b: 153) is made through an appropriation of languages whose rehearsal threatens to invite a reading through the very terms she would condemn.

[. . .] The space these conflicting narratives threaten to occupy is that marked out by Finley herself. At stake in *The Constant State of Desire* is a reading or construction of Finley as an active subject of her objectification and abuse through the terms she replays. In this context Finley's mode of performance gains a special significance. Rather than present a simple sequence of monologues, Finley shadows their presentation by her own steps

in and out of a performance, her vacillations between formal and informal relationships with the audience. Here, Finley's concern to show that 'performance is hard to do', to trace out the *act* of performance, puts into question the claim of her various narratives to the ground she herself occupies. *The Constant State of Desire* not only offers differing voices and perspectives, threatening to block together conflicting narrative possibilities, but shadows this with the *event* of her telling, an event which is beyond the terms of any narrative. Through these means Finley moves to stave off a narrative closure, to place herself beyond the reach and so terms of the languages she uses and, in using, parodies. [. . .]

Clearly, [. . .] Karen Finley's performances are constructed towards a dangerous instability with regard to their meanings. Yet these presentations engage in a decidedly political resistance to narrative closure and, with this, a making visible of the nature and consequences of the narrative act. The effect of such a resistance is not to be found in a particular import or articulation of a point of view, but occurs as a destabilizing of that which is 'assumed', of that which would appear to the audience as something which is already 'known'. Operating in this way, as a series of intrusions and disruptions, this performance also resists the attempt to divorce its 'meanings' or political value from its immediate contexts. [. . .]

Sue-Ellen Case

THE COMPUTER COMETH

From: *The Domain-Matrix: Performing Lesbian at the End of Print Culture* (Bloomington and Indianapolis: Indiana University Press, 1996).

FOR MORE THAN A DECADE, MANY ACADEMIC THEO-RISTS have been composing their work on the computer, yet the experience of the screen seems to remain unattended in their theorizing. They write as if at a typewriter, or with a pencil, retaining the structures that those engines of text inscribe. Considering the computer as a different material condition of writing reorganizes fundamental concepts about the organization of intellectual and physical functions. This section deals with the new tricks certain pet theories must learn. It does so in the context of sitting at the computer, imagining the import of familiar functions on its screen. [. . .]

[From Part E: turbo-lesbo]

Much of the writing of this text occurred in the midst of major software problems for me, which caused a deep level of panic about 'saving' my writing, 'finding' it again, and being able to 'print it out'. Technological decisions consumed most of my time and anxiety, which occasioned e-mail queries to help-lines and a performance of crisis across several bulletin boards. A butch lesbian, secure in performances of drag, I was regendered into the helpless, feminized role of petitioning young men who could drive the hot rods of software to scale my 486 turbo tower and rescue me from its failure to open my files. As I proceeded out into the world of software and even hardware, I discovered a world almost completely dominated by young men, who replicated their gender and sexual performance anxieties in the functions they created as well as in their modes of problem solving. Wandering through various sources on computer lore,

I found my solutions to the problems of producing this text nested alongside new devel-opments in software pornography, and vicious interactive games with racist and misogynist narratives. I sought refuge along the way in electronic communities which promised shelter from that world, such as the cyber-reconstruction of Sappho — a bulletin board of writing lesbian.

[. . .] Sappho is an electronic bulletin board focused on lesbian issues and identities. 'Women' from around the world participate in this virtual commu-nity, primarily, it seems, through the Internet, which includes university campuses in the United States and Europe, but also NASA and the Jet Propulsion Lab. Some members, who work for companies such as munic-ipal utilities, sign on from commercial nets. Others may join through their subscriptions to CompuServe or MCImail. Sappho evidences the new cyber-community, or social 'body', now possible for lesbians. Access to the bulletin board is particularly useful for the lesbian isolated, perhaps even closeted, at her job, or one geographically isolated from lesbian communal activities. On Sappho she finds an ongoing conversation about current concerns at her finger-tips. She 'meets' other lesbians, thus able to keep 'abreast' of activist projects, subcultural fashions, and sex-radical pleasure practices on the 'privacy' of her own screen. However, in contrast to [the 1970s separatist space of women's bookstores and presses, where the lesbian body was 'safely' produced], writing across computer networks requires a privilege of access. Whereas early lesbian feminist publishing might have been produced by a mimeograph machine in the basement, these women write from within positions at insti-tutions which can afford the massive computer hardware to make the Internet available to their workers. One might argue that access to reading and writing and the technologies of cultural production have always required privilege, such as education, leisure time, and the material means of distribution. Yet the concentration of capital required for the computer 'banks' out into the Internet makes a sharper distinction between economic classes than the mimeograph machine might. Access to these secured pools of capital/infor-mation requires the advanced education, the disciplined personality, and the consequent lifestyle that permits integration into complex bureaucratic, hierarchical institutions. 'Sappho', then, is partially an effect of the profes-sionalization of many of its subscribers. [. . .]

'Performing lesbian', in this instance signifies the composition of Sappho's virtual body/community in its dialogic, electronic space. The virtual nature of this body, however, has inspired anxieties about the eligibility of its member-ship. Constituted as lesbian, but identified only by electronic address, how can the members be certain that no man is on-line with them? No heterosexuals? Defining itself as a kind of separatist community, in the specificity of its deno-tation, the problem of membership on Sappho resides in determining who is behind the words on screen. How to screen the lesbian? How to deny access – to protect against the voyeur? In this case, masquerading as lesbian requires only a fabricated address and an imitation of lesbian concerns and issues. On the other side of the issue, when a specifically 'lesbian' address does cross the

lines, it requires a certain protection when travelling through generally accessible nets [where it] is surrounded by the hot rod bodies of racist, sexist cyberporn. Moreover, right-wing Fundamentalists, already organized on Christian bulletin boards, may, in different ways, abuse the knowledge of lesbian dialogue and address. While a certain postmodern lesbian critique applauds the destabilized condition of this identity, and the primary status of masquerade, the spread of the anti-homosexual Right agenda makes masquerade a potentially dangerous, violent act.

If, in the world of electronic communities, masquerade provides not only pleasure, but also the opportunity for a kind of invasive terrorism, then perhaps a different kind of encrypting the lesbian address might better serve as a security system. Now, there are encrypting programs available that scramble messages. 'Cyberpunks', a group in Silicon Valley, has produced cryptography freeware that it has distributed over the Internet. Yet the federal government has already suggested something called the 'Clipper chip' that would be installed in computers to open a back door to all data sent and received. It is, in other words, an inbuilt scrambler that acts like the old phone taps. This means the scrambling messages may likely be too simple to break.

Looking [. . .] to performance texts for a model of subversive screenic practices, certain operations in the inventions of Gertrude Stein may be identified as pertinent. Although Stein was not strictly cyber, the Cubist element in her experiments made spatial organization central to her writing. These spatial subversions were not mere formal folly to Stein, but a component of her lesbian security system. In Stein's script, the spatial traditions of meaning inscribe not so much the problem of late capitalism as high heterosexism, which is laid, like land mines, within the linear prescriptions of grammatical conventions. The one-way street of print grammar terrifies Stein, who, according to the lore, when she did not know how to put her new car in reverse, rather than ask for help (probably from a man, who could drive the machine) abandoned the car and walked home. Spatial reorganizations divert this drive to heterosexist coupling, helping to create an encrypted lesbian address. Along with textual choreography, Stein's performance texts vociferously and repetitively circulate meaning in the system of representation while keeping its denotation unavailable. Stein does not want to give out her address, for the production of meaning in print grammar depends upon the reproduction of heterosexual mating rituals Stein calls 'dating'. [. . .]

How might the cyberlesbian borrow this strategy from Stein? Perhaps rather than imagining encrypting her address as a masquerade of personae, she might, like Stein's Cubist counterparts, 'sign' the screen by her organization of space on it, and the indirect way in which meanings are assigned upon it. Her visual writing style, then, like Stein's would in this case 'screen' the lesbian and make it more difficult for others to simply masquerade through a fake address. This strategy suggests a style of screen composition that would break with the nineteenth-century realist conventions that hold to the present sense of images on screen. Writing would not conform to the pressures to 'data',

or information, but would tease 'out' lesbian as embedded in spatial encryption. Is this strategy merely a mode of modernist practices writ large on the postmodern screen? Perhaps. But consider the appearance of screen icons as they are now conceived. Consider also the pressure to 'data'. Has the old regime of realism found a new performance, bearing, once again, the status quo? Were not those modernist 'abstractions' or 'detractions' – the spaces of Cubism or even Abstract Expressionism – shifting the social screen? If [. . .] Dollimore (1991: 310) makes camp into a hollowing, flattening process, masquerade, illumination, interpermeable skin/screens abound in subcultural practices, then Steining the screen, Sapping the net is the lesbian's signature two-step – her body. [. . .]

[From Part F: the hot rod bodies of cybersex]

In the chat room for new members on America Online, the conversation soon turned to the password for a certain porn bulletin board. Upon receipt of the password, half the people exited. I followed them, to find myself in a world of sexist remarks and the kind of talk that reminded me of dirty phone calls. I remembered reading about the first 'rape' in cyberspace, where a woman was accosted by a violent, sadistic scenario someone sent to her before asking her permission. I looked up at the menu, where I saw the button that would censor incoming data, in case I had children in my house with access to the computer.

[. . .] The chat rooms on America Online are humming with lesbian encounters. The lesbian or queer dyke sex-radical project of the last decade or so has been to write sex. An interactive sex-writing site promises the pleasures of fantasy scenarios, roles, and appearances. Online sex seems to provide much of the pleasure that the sex-radical movement seeks. Group sex takes on a whole new dimension. A friend of mine reported having on-line sex with someone who was in her office in Hong Kong, before the work day began, and at the same time with another who was enjoying a break in Australia. [. . .] The status of the virtual is tested by on-line sex. The regime of the flesh is tested as well. Writing sex finds a lively format.

The promise, problems, and possible threats inherent in on-line sex have already raised a number of familiar issues. Should the 'hot' lines be censored? [. . .] There are no international tribunes for [the management of cyberspace]. Nevertheless, the United States has just passed the Telecommunications Reform Act (February 1996), which includes a Communications Decency Act. The law bans materials considered 'obscene' as well as making it illegal to display 'patently offensive' material in a manner in which it could be seen by children. The ACLU has already filed a suit against the act, but President Clinton has already signed it. The frontier phase of the net may be over – its very organization tried through considerations of writing sex.

Feminists will recall the anti-porn debates that raged throughout the 1980s and into the 1990s. On one side were Andrea Dworkin and Catherine

MacKinnon, who would pass legislation against pornographic materials in support of victims of sexual violence and of the porn industry; on the other were those who would protect freedom of communication between consenting adults and provide lesbians, who were historically denied access to writing their sex, the freedom to do so. [. . .] The materials to be censored [by anti-pornography legislation] were not only those produced by the familiar porn industry, but, in the case of Canadian laws, the photographs of the lesbian/ queer dyke subculture shot by Della Grace and the photo/theory books published by the lesbian collective called Kiss and Tell. The historical irony of laws encouraged by feminists shutting down lesbian sexual discourse still guides debates in the 1990s. [. . .]

Trouble, the protagonist of [Melissa Scott's novel,] *Trouble and Her Friends* [. . .] was driven underground by a similar international law that legislated and thus delimited the net. The lesbian couple in the novel illustrate the two choices remaining after such legislation: Trouble drops out, withdrawing into a small artist's commune, and abandoning her expertise in hacking; Cerise joins a global corporation, where she uses her expertise to develop programs designed to keep hackers out. Trouble lives on the brink of poverty and Cerise in the luxury that global corporations can provide. The novel concludes within the last outlaw village on the net. The lesbian couple reunites by cleaning up the town, where the outlaw Trouble will become the next mayor. [. . .]

[From Part H: tripping into cyber-revolution]

If the interface with machine and tool is coded as masculine and that with 'interior' electronic surround as feminine, perhaps the play of proximity might be deployed in ways suggested by earlier feminist critics, such as Kristeva in her notion of the semiotic, or Irigaray's and Cixous's notions of contiguity and proximity. [. . .] Something like the 1970s feminist project of imagining a matriarchal society anterior to the patriarchal one, in order to displace its single power and to open another space for imagining social relations, might be used here to posit a 'feminine' construction of an interface as *posterior* to the masculinist, mechanical one. Could the strategies for women writing be deployed within the screenic culture?

Constructing cyberspace foregrounds social space as a shared one. Only the pooling of vast resources can construct the superhighway. Its production and use are nothing if not crowded. Individualism, the individual subject, single units of private property are already merely citations of an earlier capitalist mode. [. . .] On the web, the individual is represented, perhaps, by a web page – a billboard for one's own persona [. . .]. Moreover, the pleasure in the process is in inhabiting multiple personae. Now, as a corporate structure, all of these multiple, proximate aspects of the new space are aimed toward profit. But profit is merely something imagined to found the value of the space. If debts can be forgiven, if bankruptcy can be filed by individuals,

corporations, and even nations, if the world bank can 'forgive', say, Brazil's debt and movement within the system can restore its health, what is profit? If the nature of focus, the structures of learning, and the role of work can be challenged; if play can make major 'profits'; if space is collectively produced; if the interface 'feels' contiguous; why imagine it as a realm aimed in any direction, why imagine it as having 'owners' who identify by corporate logos, or national ones? [. . .]

[In the street protests of the 1960s,] people imagined that the streets were theirs, marching in Lesbian and Gay Pride parades down the major avenues of the urban centres, founding People's Park as a collectively owned space in Berkeley; they imagined that the institutions were theirs, inaugurating ethnic studies and women's studies into the universities and colleges; they imagined that jobs were theirs, inventing and supporting affirmative action, founding collectively-owned food companies, bookstores – this on the heels of the Eisenhower era, the McCarthy witch-hunts – one of the most oppressive decades in US history.

[In the hippie era, making communes] de- and reterritoralizing the land and its buildings, accompanied a style of music, clothing, graphic arts, hairstyles, dancing, and hallucinating. LSD rearranged the perception of space through hallucination. The 'user' could, through a chemical interface, redesign the colours, proportions, and significations of space. It is no accident that one of the pioneers of cyberspace, Jaron Lanier, was also involved in experimenting with LSD. Through that interface, hippies deterritorialized urban and rural environments by wandering (unlike Benjamin's flâneur, somewhat like the Situationists' dérive) through them, settling upon them, playing their music where they would, etc. These were experiments in redesigning social space. [. . .] How much easier to redesign a space that foregrounds itself as a fiction. Hackers are hackers because they are isolated in their attempts – together it would be a form of social sculpture.

Combining hippie and underground tactics with feminist ones in imagining the redesign of cyberspace may be a way in which to secure the coming millennial space as habitat rather than as the playground of the virtual class.

Richard L. Loveless

TIME PAST . . . TIME PRESENT . . . TIME FUTURE:

Re-envisioning the aesthetic in research for human performance[1]

THE TERM TECHNOLOGY ORIGINATES FROM THE GREEK ROOT 'TECHY', which means making quality marks. The end of the twentieth century marks a most significant moment in time for performing arts and technology. As we join in celebrating the closing hours of this century of accelerated change, our challenge is to imagine a future for the arts that extends well beyond the human imaginations that have shaped them in our lifetime. No matter what the time or place of our birth during the first half of this century, we all arrived as analogue babies, enriched, and yet encumbered by traditions in the arts that were formed by a myriad of cultures. These traditions gave way to new trends, and in time were embraced by the immigration patterns that formed our nations. The last half of the century is another story; the new arrivals are digital babies, and while many analogue artists liked the first half best, the digital presence offers a clear promise: the future isn't what it used to be!

When Farnsworth, the inventor of the first picture tube, was questioned on where his idea originated for transporting light signals over a series of linear pathways, he answered: 'Well, when I was out ploughing a field at the age of fourteen, I noticed how the furrows left marks behind in the earth.' The analogue experience of rearranging the soil transformed through imagination, nourished a particularized sensibility for inventing a form of artificial light that in time became the media phenomenon we know as television. Others extended his vision from analogue to the current digital reality, and through the magic of new technological innovations that have issued since, the furrows have now been extended to create globally networked

communities through binary codes, fashioning a new reality that was undreamed of mid-way through this century.

How does the new digital presence challenge our preconceptions of performance practice? How do these realities redefine the nature of the creative process . . . the birthing of new work? Is there a new vision for aesthetic research in human performance; a vision that amplifies and extends the immediacy of live real-time sensory engagement to mediated, synthetic, or virtual experience? How can performance reshape the space between here to there whether in proximal, remote or distant places? The challenge, as artist Toni Dove puts it, is 'to invent an uncanny interface'; one that is capable of multiple mediated streams of experience. In this new context, space becomes narrative and media becomes spatialized.

A search through the archival materials at the Institute for Studies in the Arts would reveal nearly eight years of intense effort in dealing with these questions. I would like to reflect on just two aspects of this ongoing research that will reveal in quite different ways the challenges that face all performance artists.

The Intelligent Stage

The Intelligent Stage, a creation of computer scientist Robb Lovell and composer John Mitchell, has been well documented in the dance and technology literature. Movement-sensing systems for integration into human performance have been in development for several years. So what is so special or unique about the Intelligent Stage? Permit me to address that question in three parts: how the system works; how working in the system re-forms the nature of collaboration in the creative process; and finally how intelligent human beings extend the attributes of the system for other forms of aesthetically driven research.

One dancer described the Intelligent Stage as a place where the performance at times seems to take on a life of its own. It must be admitted at the outset that the Intelligent Stage has no inherent life of its own without human performers interacting with and teasing meaning out of its invariant structure. All apparitions of the performance environment I shall call 'spatialized media': lighting, sound, and visual elements converse interdependently in a virtual box we call the 'global controller'. The narrative created by the physical presence of the dancers, musicians, and/or actors navigating through a three-dimensional space creates an human interface with the system. The space becomes a virtual instrument that can, in theory, be fine-tuned and played differently for each performance. This is accomplished by the presence of an array of invisible triggers defined by three to four video surveillance cameras that track the motion of the performers. A dancer once expressed her experience this way: 'It's like having other invisible dancers out their beside us . . . and that is a nice feeling to have!'

How then does this experience change the creative process in ways that redefine collaborative roles for inventing new work? First, it demands an alternative form of collaboration between all of the participants. The choreographer must relinquish initial control as the singular visionary who will determine the outcome of any performance piece. Secondly, it challenges the dancers to go well beyond an independent responsibility for the whole of the performance, to participate in the interdependent control of every element of the mediated environment. Thirdly, it changes the roles of collaborators and audiences from the very beginning in conceptualizing the piece, and reorders the decision-making process for all aspects of the production. The creation of visual materials and the imaging systems to deliver them, the creation of the sound elements and their storage in non-linear sequences, the lighting functions in balance with integrated media pathways and projection surfaces; all become an initial and continuing part of the collaboration for conceptualizing the work. While there is usually a designated leader for any such collaboration, it also follows that an exceptional performance is the outcome of a collective vision by all the participants.

What are some other forms of aesthetic research that have issued from the Intelligent Stage? Christine Woolsey, a regional architect, has used the Intelligent Stage to analyse and record the movement needs and desires of clients, incorporating the data into her designs in what she terms 'experienced-based architecture'. The renowned somatic choreologist, Glenna Batson, used the Intelligent Stage to research performance injuries and develop practices for retraining. Dancer Jean Denny put dancers on the Intelligent Stage to test Laban's theory of space harmony scales and their potential to develop an individualized pedagogy for dancers. Composers have been commissioned to create new works that integrate live musicians with electronic scores accessed by dancers as part of the performance ensemble. In future research we anticipate working with poets and linguists to integrate voice recognition and speech synthesis techniques for mediated performance.

'Mirrors and smoke': a non-linear performance in virtual space

'Mirrors and Smoke', a work-in-progress, is the result of a three-year collaboration between Philip Mallory Jones, a media artist; Ralph Lemon, a choreographer and dancer; and John D. Mitchell, a composer and musician. The impetus for the project grew from a mutual regard for each other's work and the opportunity afforded by the ISA to explore the process of creative collaboration. Periodically for two years the artists met for exhaustive discussions to find their common artistic ground: exploring subject-matter for the piece and debating the form it would take. Jones states that 'these sessions, and our process, are analogous to three storms at sea. Our proximity created a fourth storm which is where the piece began to take form.' The artists' intention was

to create a work that took each artist where he had not gone before, and which could not be accomplished separately.

Central to the concept and development of 'Mirrors and Smoke' are the journals that Ralph Lemon kept during travels in Haiti, West Africa, and India. These writings provide a ground upon which to build a shared vision and direction. The observations in the entries collapse time and place in sensory experience, memory, and visions. Lemon initiated the next step, performing movement and thematic ideas catalysed by collaborative discussions about his travel experiences. These were videotaped by Jones in a variety of locations including a Sonora desert, the Salt river, a black box studio, a bathroom, and under eight feet of water. Mitchell recorded audio of Leman reciting passages from his journals. Issues of form and performance then came into question. Should the final piece be a live performance with interactive media elements for stage, or a gallery presentation, or a web event, or a disc, or none of the above? Considerations of space and time, budget, intended audience, and the capabilities of accessible technology led to a decision to create a disc-based project, initially to be published in CD-Rom format, and subsequently in DVD format.

Following the recording sessions, Jones began designing, modelling, and animating a virtual 3D environment in which to present the performance materials. The viewer will be able to self-navigate the space, choosing direction of movement, which performance tableau to view, and for how long. As the animation sequences are created Mitchell is composing a surround-a-sound audio component. Katherine Milton, designer and interactive authoring specialist, is devising the interface, navigation, and complex scripting that will synthesize all of the parts.

The process of collaboration has, from the beginning, been as important as the product. Hours of audio recordings that document the twisting path of discovery exist in ISA archives as part of our ongoing research into creative collaboration.[2]

While attending graduate school thirty-five years ago, I read an essay by Margaret Mead in which she suggested that there would come a time when it would no longer be feasible for the old to teach the young. I believe she referred to 'pre-figurative' and 'co-figurative' cultures. Her notion was that the acceleration of change that one would have to adapt to in the first fifty years of this century would nurture a generation far different from that of our parents, and those who preceded them. Yet, I doubt that Margaret Mead could have imagined the change that would issue in the last half of the twentieth century. Nor could anyone . . . much less the changes that will occur in the next five years. At about the same time that Mead made her observations, there was a movement in the USA called EAT: Education, Art, and Technology: an attempt on the part of artists and scientists to collaborate in what then was primarily an analogue environment. When the scientists were asked why most collaborations failed, they replied: 'The artists believe in magic, and we have no experience with that.'

Artists have always believed in magic, and that is a constant that threads together the benefits of intergenerational wisdom. As you invent yourself you invent the future . . . and thus a new generational wisdom . . . I think this is a myth worth perpetuating.

Notes

1 Some of the ideas in this essay are explored in more depth in the collaboratively written article, 'Live and Media Performance: The Next Frontier' by R. Loveless and L. Goodman, forthcoming in *Performance Research*, on-line issue, 1999. A version of this essay was also delivered as the opening session of the IDAT (International Dance and Technology Conference) at ASU in March 1999, and a related paper/presentation was given at the PSI (Performance Studies International) Conference in Wales, April 1999.

2 Images from the projects described in this essay may be viewed on the Internet, on http://researchnet.vprc.asu.edu/isa

Lizbeth Goodman

THE POLITICS OF PERFORMATIVITY IN THE AGE OF REPLAY CULTURE[1]

Replay and the politics of performance

WHAT FUTURE FOR THEATRE IN THE AGE OF REPLAY CULTURE, when the 'mainstream' is redefined daily, based on economic realities, political contingencies, and rapid shifts in new technology? When I coined the term 'replay culture' I was searching for a phrase to describe the general state in which we live, characterized by the particular impulse to hit the 'rewind' control on the remote control wand, even when we are watching, or experiencing, an event in 'real time'. That is, I use the term 'replay culture' to refer to the state of play at the end of the twentieth century, when a new generation has learned to write and compose on word processors (where 'cut' and 'paste' options allow for endless reconfigurations of text and of ideas) – an age in which the ability to fast-forward and replay using home video controls has altered our everyday ways of being in and seeing the world. So accustomed have we become to being able to replay images and taped events, we sometimes forget that everyday life can't be so easily replayed. As a result, it often seems that we no longer live so much in the moment, but rather live in the frame of a media-orientated world-view. These days, when web-based discussion groups on subjects such as the use of computers in distance learning and business abound, and when studies of 'the digerati' have begun to appear, the focusing of attention in theatre performance, mediated performances, and everyday life is complicated. Meanwhile, critical studies continue to refocus attention on the spectacular presence – or communication from absence – of the 'cyber elite'

(see Brockman 1996). Focus has begun to shift to consideration of the 'death of distance' (see Cairncross 1997): the coming together of people and ideas across spaces, both virtual and real.

The personal and political seem, in some contexts, to be giving way to the powers of the portable PC and Mac. Concern about *how* we present our work may take more time, money and energy than we can afford to give to *what* we present. This situation affects those of us who work in the 'theatre' sector where funding is increasingly difficult to find, and equally those who work in the area of new media performance where access to equipment, expertise, and time are hard to come by and, often, difficult to share. Thus, the future of theatre in the age of replay culture is inextricably connected to advances in new technology, and to redefinitions of the broad outlines of performance studies including dance, music, installation art, and many forms of visual arts, as well as what is broadly known as 'theatre'. Princess Diana's funeral, for instance, was framed as theatre by the media, with in-built catharsis for the nation (and the world). It was recorded in many media, replayed in many forms and many forums, until every viewer and listener had a chance to internalize and make that story her or his own. The event is recorded and replayable in many forms, too. So too can some 'proper theatre' events or plays be revisited, recorded, and reviewed by cultural critics, academics, and anyone with a video player.

Many of the authors whose work appears in this *Reader* have taken positions on the political aspects of the performative. In these pages, a dialogue has developed between authors and practitioners who don't normally 'converse'. The dialogue is limited to the extent that not all the authors gathered in the same conference venue (whether in 'real' or 'virtual' space), in the process of putting this book together. It offers what is, at one level, an artificial dialogue across generations and critical perspectives. The dead and the living seem to speak to each other and with each other, but in fact only some of the authors (the part editors) had real control over inclusions and had the power of replay in editing and framing the work of others. This is not an ideal situation. Interactivity and power are not shared equally. But they are shared, insofar as that is possible in a book which uses the medium of print on paper. Within those limitations, this invites readers to engage in a debate about politics and performance. It sets out, at the same time, to replicate and share some sense of energy: the energy of experimentation and debate, the energy of many different attempts to convince, cajole, and create. The book attempts to perform its mission, and invites each reader to respond and interpret, to select readings and reading strategies.

The book is an artefact that aims to evaluate and document the playability of its subject: 'politics and performance'. In this effort, the *Reader* has traversed many subject areas, from performance practice and acting theory to Marxist critical analysis of 'drama in a dramatized society' through many and varied fields of critical and practical debate. Ideas which might at first seem to hold each other in opposition can inform and enrich each other in

surprising ways once we leave behind the 'geometries' and other standard-ized sign systems and maps for coding communicative interactions and look instead to create and perform intertextual and multi-modal performance prac-tices, in what Kozel (in the introduction to this part) calls 'post-linear' culture. For instance, the working techniques advocated for live performance workshops by Jerzy Grotowski can be seen to overlap and enrich the digital performance practices experimentally and experientially designed by Hill and Paris in their interactive performance of the quotidian: in their drive across Route 66 as both 'real life' event and performative encounter staged for seen participants and unseen audiences via the Internet.[2] At the 'live' level, the Route 66 enacts Grotowski's principals of 'poor theatre' with no sets, no props, no make-up or stage lighting: just two women driving a car and talking to the people they meet along the road. At another level, though, the Route 66 performance is shared via a performance paradigm that Grotowski did not code in his juxtaposition of 'poor', 'rich', and 'total' theatres. Digital performance presence is not something any of us 'counted on' or encoun-tered, much less engendered in our work, until very recently. It's all new. And it's changing so quickly that it will be old hat by the time this book reaches its audience in print form. Poor theatre meets new technology, and both concepts are enriched, if only transiently, by their collision in post-linear space and time.

Digital performance presence

We now live and work in an age when it is possible to literalize the metaphor of 'dancing with data', as dance-technologist Susan Kozel does in her work with telematics and 'electromythologies' and in her more recent work on 'contours' and 'figments' (see Chapter 41). In dance and other types of performance, the live event now questions its own ephemeral nature; the moment of performance is complicated by asynchronous participation by audi-ences and collaborations, while any event is increasingly likely to be represented, shared, archived, and stored in digital form. The struggle of the performer and artist today, then, must include battles with the real and the virtual, with ways of making work which are informed by knowl-edge of 'new media' and respect for more traditional and visceral live art practices. The same might be said for those who wish to study 'sexuality in performance': the spaces in which our bodies and senses of identity are 'performed' and 'replayed' will influence the forms of representation as well as the types of reception. Sexuality is process; performance is process; to replay gender in theatre and culture is continually to reconsider the place of our bodies in many different kinds of space, and to replay our own embod-iment(s) in both physical and intellectual terms, on a daily (performed but still 'real') basis.

In her book on time-based arts, Andrea Phillips argues that: 'performance and technology have been intimately bound up since photo-mechanical means enabled firstly, static, and then, durational representation to turn around our notions of the real, literally re-focusing our idea of our bodies and, consequently, ourselves' (Phillips 1998: 11). This acute and succinct statement summarizes a number of the concerns addressed in the first few chapters of my book *Sexuality in Performance: Replaying Gender in Theatre and Culture* (1999), wherein Walter Benjamin's notion of 'the work of art in the age of mechanical reproduction' is considered with reference to still images, then video, and then live performance. Peter Wollen has taken up a similar debate in his book *Raiding the Icebox: Reflections on Twentieth-Century Culture* (1993: 35–72). Wollen applies Benjamin's ideas about art and mechanical reproduction to the development of cinema which, Wollen argues, 'can be condemned as a simulacrum, a masquerade, a display'. The focus in *Sexuality in Performance* is not so much on the nature of that display or on any given aesthetic or philosophical questions, but rather on the content of the 'display' (sexuality, representations of gender) and with the context in which all such 'displays' are replayed: i.e., contemporary theatre and culture, in an age when we have all come to terms with the fact that we can, if we so desire, take control of the basic media of recording and replay so that we frame our own experiences of interaction as 'theatre'.

Jeff Ross, in his book *The Semantics of Media* (1997) offers an inspiring analysis of the ways in which we use spoken and written language to describe media, along with discussion of 'possible worlds' and semantics for analysis of implicit and explicit content in multi-media. Ross's book includes discussion of the ways in which we see, and describe what we see, in films and other performative and representational dynamics, paving the way for further exploration of the semantics of virtual performance. Intriguing work on sign language and the grammar of gestural communication (see for instance Lillo-Martin 1991) might be applied in exciting ways to the field of performance, while research bridging the fields of computers, 'natural language' and visual communications is opening up new areas of interest to those of us making and writing about live and virtual performance (see for instance McKevitt 1995).

In *Computers as Theatre*, Brenda Laurel argues that the intensity of contemporary response to and debate about VR (virtual reality)

> mirrors the nature of the medium itself: by inviting the body and the senses into our dance with our tools, it has extended the landscape of interaction to new topologies of pleasure, emotion, and passion. A similar transformation occurred in the Middle Ages, when theatre exploded out of the textual universe of the monastery into the sensory fecundity that gave rise to Commedia Dell'Arte, the robust improvisational theatrical form that emerged in Western Europe in the fifteenth and sixteenth centuries. In the same historical period, the monolithic

Christian content of the drama was bathed in a wave of sensory, passionate, and archetypal imagery. It was this coming together of text, body and narrative polyphony that opened the way for Shakespeare, Grand Opera, and all the vital permutations of the dramatic impulse that have come down to our day.

(1993: 213–14)

But what is 'our day' and how do we connect these ideas about VR to a study of interactive theatre, politics, and performance in contemporary replay culture? For a start, we must be cautious about using 'dance' and 'drama' as metaphors . . . and I am always uncertain about the phrase 'the dramatic impulse', which strikes me as a vague term to cover all manner of imprecise impulses. I see VR, not so much as a medium to mirror reality, but more as a type of performance. Call it computer-assisted performance. It differs mechanically and therefore functionally from other performances, whether on stage or in the streets and private spaces (however defined and limited) of daily life.

There is much in what Laurel proposes, many intriguing routes are opened up into the terrain of interactive performance. As Helen Paris observes, with reference to the interactive drive across America's Route 66 which she and Leslie Hill performed under the title *I Never Go Anywhere I Can't Drive Myself* (1998):

The contact with the virtual audience had its own unique dynamism. . . . Updated every few hours, our performance on the site engendered remarkably similar feelings to live performance, high pressure and high adrenalin. In live performance, however, there is always the reassuring certainty that if you make a mistake, you are likely to be the only one to be aware of it. Here in our virtual venue, one missed-out dot or a misplaced '<' could render communication with the audience impossible, and the presence of our virtual audience was a constant one, even when they were absent, so to speak.

We might apply Laurel's ideas to the experiences of interactive performance described by artists Leslie Hill (whose essay on suffragist theatre is included earlier in this volume: Chapter 24) and Helen Paris. Their work tangles with and builds in an analysis of the possibilities and problems of interactive theatre, of experiments with gender and crossings of boundaries in space and cyberspace. These two artists are also adept at summarizing their own positions, in words (the necessary medium for books) as well as in other media. Hill and Paris's interactive drive project strikes me as a perfect example of a piece which is both live and virtual, immediate and replayable, about gender identity and sexuality, yet open enough to allow for any number of other contextualized readings and interpretations as well.

Replay and the right to reply

Over the years of production of this *Reader* and related texts, it has been my great privilege to work with many others whose work crossed disciplinary borders and media formats. For all of us who make theatre and write about it, who create new media programmes and analyse them or teach with them, these have been heady, busy, exhausting years. Many paths have crossed on any number of different stages, in various recording studios, media labs, and in the pages of numerous texts. Inevitably, it is the work I have been involved in making with which I can engage most fully, both imaginatively and with a sense of 'product' arising from process. So it will be for each artist, each reader, each critic. The work of our bodies informs the work of our minds. How we share that work with others remains a conundrum, a concern, for many of us as we move from solo to collaborative performance-making intended to include the audience, not only as 'spect-actors' (in Boal's terms) but as creators of the work in progress. Yet there are many choices to make, each of them charged with issues of ethics, economics, and politics: in what terms, in what media, in live or asynchronous performance contexts, in co-present or mediated spatial relationships, will any artist or academic choose to work? Which formats will allow for the energized exploration of 'politics' and 'performance' in the next century?

Leslie Hill poses the questions with which I close *Sexuality in Performance* and begin investigations of a practical kind; these are also appropriate in offering an open-ended closure to this book:

> Can you really 'perform' on the Internet? Considering that futurists predict that the most profound shift to occur in the twenty-first century will be the shift from a place-oriented to a 'placeless' society, this is something I want to know. As we conduct more and more of our communication, research and commerce on-line and as the world around us shifts from analogue to digital, physical location becomes less and less of a determining factor in our ability to do our work, access information. . . . These musings bring me back again and again to Walter Benjamin's observation that the contextual integration of art in tradition found its expression in the cult, and that, 'even the most perfect reproduction of a work of art is lacking in one element: its presence in time and space, its unique existence in the place where it happens to be.'
>
> (Hill, Foreword to *I Never Go Anywhere I Can't Drive Myself*, 1998)

In applying Brenda Laurel's ideas about 'computers as theatre' to the experiences of Hill and Paris (stored in digital form on the web, for continued replay and interaction by distant audiences), possibilities and parallels abound. The window into 'Pandora's Box' which Laurel sees opening with VR, I see as opening with replay culture. Indeed, I think the age of replay culture has

jammed that window open. It is up to each of us, in our own ways, to decide when and where and how to look. Even then, we will all see something different.

What we do, how we choose to act and interact and 'spect-act', perform and play and replay, will differ for each of us, at each moment, and for many political and personal reasons. One thing only is certain: we will be faced with such choices in 'real life' and in any number of digital or virtual performative spaces as well – even in our own imaginations and dreams: in the spaces of our own desires.

As I said at the outset, this book was replayed many times in the process of performing its own role. Like any performance, it is incomplete until it is shared. All of the authors took part in the making, and re-playing of the book. The ultimate re-play is now in your hands.

Notes

1 These arguments are developed in detail in the book from which this short article takes it main premise: *Sexuality in Performance: Replaying Gender in Theatre and Culture* (Routledge, 2000).

2 The two roads that Hill and Paris 'drove themselves' were the 'real' space of Route 66, the early American highway leading West from Chicago to California, and the virtual space of the road trip web site: [http://www.edutv.org/drive/billboard.html]. Zara Waldeback designed the site and Huw Williams updated it each night, for posting to the Internet. I was fortunate to play a part in the facilitation of this cross-cultural, cyberspatial collaboration.

Adeola Agbebiyi

OPEN AIR THEATRE:
A performance poem by way of an afterword

Flow, with the river
wide, unburdened
one in the stream.
Carry pleasure boats
packed, we hope
as Atlantic sardines
lightly oiled
jostling for the best view on the deck.

 Roll up roll up ladies and gents!
 Take a trip with us.
 Roll open the doors behind your eyes.
 Share with us Events
 from an Alternate Reality.

 See a house, an ordinary house
 with whitewashed walls
 and peeling window frames.
 The curtains part, to reveal
 the world inside, now outside.
 A couple, caught in a looped moment
 unfold their lives on our journey.

Gerardo's wife Paulina stands waiting
for her husband, for her story,
for us all to Witness.
She has a gun.

There are no boundaries,
only conventions:
lover, fairy, dancer, ghost,
boxer, monster, soldier, priest,
salesman, singer, beggar man, king,
hero, slayer, loser wins.
We are all players
and rules were made to be
broken.

Crack, snap, twigs fracture
between a rock and a strong current
but the wave flows on
greeting the bank like an old friend.
Atom to atom
nuclear recognition.
In a dirt dark undertone
the bank answers
shifting in its seat
yielding itself up to the muddy mixing.
Tosses leaves, confetti, wrappers and empty cans
into the swelling concourse.

In the water
electric shoals of salmon
tail fins beating
scales flashing in the sun
leap upstream
struggle to meet, mate and move on
to the next season's job well done.

Hands whip swiftly
casting a long line through the silent air.
Nets hang waiting
to catch a rushing school at 3 o'clock.

In the teacher's pack you'll find
the king is played by a queen.
Brothers will be sisters
and pronunciation
received as from the breast:
mother tongue.

Tides tug
words tumble
babbling wet over stones
rippling through the surface of rock pools
disturbing the peace
gathering everything
in one swirling embrace.

It is a political act to play without race.
Play has no colour, because play has every colour;
spectrum diffusion out of white noise.
The sepia story is in an other place.
Here, halleluia, we are not judged by the colours of skin
but that tale goes untold.

Sometimes I stand on an island
naked
naked in the storm
 res miranda.
The wooden boards of the jetty
creak beneath my winged feet
 knotted hearts uncurling.
I have danced, bounced with Air Nike sureness
tripped tongue to teeth, tap to tap
 slave to the rhythm.
I have moaned and carried on the breeze
become a scream
 naked in the storm
 Miranda.

Breath, so sure
the message is in the e motion
we are all held, complicit.
In the space between thought and word

we breathe
then dive headlong
cascade in torrents
tumble inexorably
towards that single point
and come together
exhilarated,
triumphant
and breathless.
Thank you.

Bibliography and suggested further reading

Anon. (1907) 'Seditious Drama: The Play in the Philipines [sic]: What a Recent Visitor Has to Say', *The Theatre* (Sydney), 1 February: 17.

Abelove, H., Barale, M.A., and Halperin, D.M. (eds) (1993) *The Lesbian and Gay Studies Reader*, London: Routledge.

Accone, D. (1997) 'iMumbo Jumbo opts for a selective reality in devising theatre for the millennium', *The Sunday Independent* (South Africa), 9 November 1997: 12.

Althusser, L. (1969) *For Marx*, London: Allen Lane.

—— (1971) 'Ideology in the State', in *Lenin and Philosophy, and Other Essays*, London: New Left Books.

Appiah, A. (1992) *In My Father's House*, Oxford: Oxford University Press.

Apter, E. (1996) 'Acting Out Orientalism: Sapphic Theatricality in Turn-of-the-Century Paris', in E. Diamond (ed.) *Performance and Cultural Politics*, London: Routledge.

Artaud, A. (1958 [1936]) *The Theater and its Double*, tr. M.C. Richards, New York: Grove Press.

—— (1968–74) *Complete Works*, tr. V. Corti, London: Calder and Boyars.

—— (1989) *Artaud on Theatre*, ed. C. Schumacher, London: Methuen.

Auslander, P. (1994) *Presence and Resistance: Postmodernism and Cultural Politics in Contemporary American Performance*, Ann Arbor: University of Michigan Press.

Austin, J.L. (1975 [1962]) *How to Do Things with Words*, Cambridge, MA: Harvard University Press.

Bakhtin, M. (1968) *Rabelais and his World*, tr. Helene Iswolsky, Cambridge, MA: MIT Press.

Banes, S. (1997) *Dancing Women*, London: Routledge.

Barba, E. (1967) 'The Kathakali Theatre', *Tulane Drama Review* 2, 4 (T36): 37–50.

—— (1977) 'An Offense Against Nature', interview with Per Moth, *Rampelyset* (Denmark).

—— (1979) *The Floating Islands*, Holstebro, Denmark: Odin Teatret Forlag.

—— (1981) *Il Brecht dell' Odin*, Milan: Ubulibre.

—— (1982) 'Theatre Anthropology', *The Drama Review* 26, 2 (T94): 5–32.

—— (1985a) 'Interview with Gautam Dasgupta', *Performing Arts Journal* (January): 8–18.

—— (1985b) *The Dilated Body*, Rome: Zeami Libre.

—— (1985c) 'The Nature of Dramaturgy: Describing Actions at Work', *New Theatre Quarterly* 1, 1: 75–8.

—— (1986) *Beyond the Floating Islands*, New York: Performing Arts Journal Publications.

—— (1987) 'The Actor's Energy: Male/Female versus Animus/Anima', *New Theatre Quarterly* 3, 11: 237–40.

—— (1988a) 'The Way of Refusal: The Theatre's Body in Life', *New Theatre Quarterly* 4 (16): 291–9.

—— (1988b) 'Eurasian Theatre', *The Drama Review* 32, 3 (T119): 126–30.

—— (1988c) 'Eugenio Barba to Phillip Zarrilli: About the Visible and the Invisible in the Theatre and about ISTA in Particular', *The Drama Review* 32, 3 (T119): 7–14.

—— (1989) 'The Fiction of Duality', *New Theatre Quarterly* 5, 20: 311–14.

—— (1990) 'Four Spectators', *The Drama Review* 34, 1 (T125): 96–101.

—— (1991) 'The Third Theatre: The Legacy from Us to Ourselves', *New Theatre Quarterly* 8 (29), 3–9.

Barba, E. and Flaszen, L. (1965) 'A Theatre of Magic and Sacrilege', *Tulane Drama Review* 9, 3: 172–89.

Barba, E. and Savarese, N. (1991) *A Dictionary of Theatre Anthropology: The Secret Art of the Performer*, tr. R. Fowler, London: Routledge.

Bartinieff, I. (1980) *Body Movement, Coping with the Environment*, New York: Gordon and Breach Science Publishers.

Bartra, R. (1992) *El Salvaje en el Espejo*, Mexico: Ediciones Era S.A. de C.V.

Bartram, G. and Anthony, W. (eds) (1982) *Brecht in Perspective*, London and New York: Longman.

Battersby, M. (1969) *Art Nouveau*, Feltham, Middlesex: Paul Hamlyn.

Belsey, C. (1980) *Critical Practice*, London: Methuen.

Bennett, S. (1990) *Theatre Audiences: A Theory of Production and Reception*, London: Routledge.

Berger, P., and Luckmann, T. (1967) *The Social Construction of Reality*, New York: Anchor.

Berry, C. (1993) *Voice and the Actor*, London: Virgin.

Best, D. (1992) *The Rationality of Feeling*, Brighton: Falmer.

Bhabha, H. (1984) 'Of Mimicry and Man: The Ambivalence of Colonial Discourse', *October* 28: 125–33.

—— (1990) 'The Other Question: Difference, Discrimination and the Discourse of Colonialism', in R. Ferguson, M. Gever, T.T. Minh-ha, and C. West

(eds) *Out There: Marginalization and Contemporary Culture*, Cambridge, MA: MIT Press.

—— (1994) *Location of Culture*, London: Routledge.

Bharucha, R.D. (1992) 'A View from India', in D. Williams (ed.) *Peter Brook and the Mahabharata*, London: Routledge.

Bhasi, T. (1996) *Memories in Hiding*, tr. J. George and P.B. Zarrilli, Calcutta: Seagull Press.

—— (1991 [1952]) *Nanalenee Kamunisttaki*, Kottayam: D.C. Books.

Bland, L. (1995) *Banishing the Beast: English Feminism and Sexual Morality, 1885–1914*, Harmondsworth: Penguin.

Blau, H. (1982) *Blooded Thought: Occasions of Theater*, New York: Performing Arts Journal Publications.

—— (1987) 'The Universals of Performance', in *The Eye of Prey*, Bloomington and Indianapolis: Indiana University Press.

—— (1992) *To All Appearances: Ideology and Performance*, New York and London: Routledge.

Boal, A. (1979) *Theatre of the Oppressed*, New York: Theatre Communications Group.

—— (1992) *Games for Actors and Non-Actors*, tr. A. Jackson, London and New York: Routledge.

Bomford, K. and Leighton, R. (1990) *Art in the Making: Impressionism*, London: National Gallery.

Bornstein, K. (1994) *Gender Outlaw: On Men, Women and the Rest of Us*, New York: Routledge.

Bourdieu, P. (1977) *Outline of a Theory of Practice*, Cambridge: Cambridge University Press.

Bowlby, R. (1983) 'The Feminine Female,' *Social Text*, 42.

Brecht, B. (1964) *Brecht on Theatre: The Development of an Aesthetic*, ed. and tr. J. Willett, New York: Hill and Wang.

—— (1965) *The Messinghauf Dialogues*, tr. J. Willett, London: Methuen.

Bristow, J. (1995) *Effeminate England: Homoerotic Writing After 1885*, Buckingham: Open University Press.

—— (1997) *Sexuality*, London: Routledge.

—— (ed.) (1992) *Sexual Sameness: Textual Differences in Lesbian and Gay Writing*, London: Routledge.

—— and Wilson, A.R. (eds) (1993) *Activating Theory: Lesbian, Gay, Bisexual Politics*, London: Lawrence and Wishart.

Brock, B. (1995) 'The Fiction of Cultural Identity', *Ballet International/Tanz Aktuell* 8/9: 21–3.

Brockman, John (1996) *Digerati: Encounters with the Cyber Elite*, London: Orion Books.

Brook, P. (1968) *The Empty Space*, New York: Atheneum.

—— (1988) *The Shifting Point: Forty Years of Theatrical Exploration, 1946–87*, London: Methuen.

—— (1993) *The Open Door: Thoughts on Acting and Theatre*, New York: Pantheon Books.

Brooker, P. (1994) 'Key Words in Brecht's Theory and Practice of Theatre', in P. Thomson and G. Sacks (eds) *The Cambridge Companion to Brecht*, Cambridge: Cambridge University Press.

Brydon, D. (1990) 'The White Inuit Speaks: Contamination as Literary Strategy', in I. Adam and H. Tiffin (eds) *Past the Last Post: Theorizing Post-Colonialism and Post-Modernism*, Calgary: University of Calgary Press.

Butler, J. (1990) *Gender Trouble*, New York: Routledge.

—— (1993) *Bodies that Matter: On the Discursive Limits of 'Sex'*, New York: Routledge.

Caillois, R. (1961) *Man, Play, and Games*, New York: Free Press.

Cairncross, Frances. (1997) *The Death of Distance: How the Communications Revolution Will Change Our Lives*, London: Orion Business Publishers.

Campbell, P. (ed.) (1996) *Analysing Performance: A Critical Reader*, Manchester: Manchester University Press.

Carlson, M. (1996) *Performance: A Critical Introduction*, London and New York: Routledge.

Case, S.-E. (1988) *Feminism and Theatre*, New York: Methuen/London: Routledge.

—— (1996) *The Domain-Matrix: Performing Lesbian at the End of Print Culture*, Bloomington and Indianapolis: Indiana University Press.

—— (ed.) (1990) *Performing Feminisms*, Baltimore: Johns Hopkins University Press.

Chaney, D. (1993) *Fictions of Collective Life: Public Drama in Late Modern Culture*, London: Routledge.

Chodorow, N. (1978) *The Reproduction of Mothering: Psychoanalysis and the Sociology of Gender*, Stanford: University of California Press.

Chrisman, L. (1990) 'The Imperial Unconscious? Representations of Imperial Discourse', *Critical Quarterly* 32, 3: 38–58.

Cixous, H. (n.d.) 'Le Rire de la Méduse,' *L'Arc* 61.

Clifford, J. (1988) *The Predicament of Culture: Twentieth-Century Ethnography, Literature, and Art*, Cambridge, MA: Harvard University Press.

Cockin, K. (1998) 'Women's Suffrage Drama', in M. Joannou and J. Purvis (eds) *The Women's Suffrage Movement*, Manchester: Manchester University Press.

Cohen, A.P. (1994) *Self Consciousness: An Alternative Anthropology of Identity*, London and New York: Routledge.

Cohen, E. (1996) 'Posing the Question: Wilde, Wit, and the Ways of Man', in E. Diamond (ed.) *Performance and Cultural Politics*, London: Routledge.

Colleran, J. (1995) 'Re-Situating Fugard; Re-Thinking Revolutionary Theatre', *South African Theatre Journal* 9, 2: 39–49.

Collier, P. 'Artaud on Aran', *Irish Times*, 14 August 1997.

Connell, R. (1987) *Gender and Power*, Cambridge: Polity Press.

Constantino, R. (1978) *Neocolonial Identity and Counter-Consciousness: Essays on Cultural Decolonization*, London: Merlin Press.

Copeland, R. (1993) 'Dance, Feminism, and the Critique of the Visual', in H. Thomas (ed.) *Dance, Gender, and Culture*, London: Macmillan.

Counsell, C. (1996) *Signs of Performance: An Introduction to Twentieth-Century Theatre*, London: Routledge.

Cowan, J.K. (1990) *Dance and the Body Politic in Northern Greece*, Princeton, NJ: Princeton University Press.

Crow, B. with Banfield, C. (1996) *An Introduction to Post-Colonial Theatre*, Cambridge: Cambridge University Press.

Cubitt, S. (1998) *Digital Aesthetics*, London: Sage Publications.

Daly, A. (1996) *Done into Dance*, Bloomington: Indiana University Press.

Darlrymple, L. (1987) 'Explorations in Drama: Theatre and Education – A Critique of Theatre Studies in South Africa', unpublished PhD thesis, Durban: University of Natal.

Davis, J. (1997) 'Now You See Her, Now You Don't: The Lesbian in Theatre Studies', in G. Griffin and S. Andermahr (eds) *Straight Studies Modified: Lesbian Interventions in the Academy*, London: Cassell.

Davis, N.Z. and Starn, P. (1989) 'Introduction', Special Issue on Memory and Counter-Memory, *Representations* 26 (Spring): 1–6.

de Certeau, M. (1984) *The Practice of Everyday Life*, tr. S.F. Rendall, Berkeley: University of California Press.

de Lauretis, T. (1994) *The Practice of Love: Lesbian Sexuality and Perverse Desire*, Bloomington: Indiana University Press.

de Man, P. (1979) *Allegories of Reading: Figural Language in Rousseau, Nietzsche, Rilke, and Proust*, New Haven: Yale University Press.

Derrida, J. (1982) *Margins of Philosophy*, tr. Alan Bass, Chicago: University of Chicago Press.

—— (1988) 'Signature Event Context', in *Limited, Inc.*, ed. G. Graff, tr. S. Weber and J. Mehlman, Evanston: Northwestern University Press.

Diamond, E. (1988) 'Brechtian Theory/Feminist Theory: Toward a Gestic Feminist Criticism', *The Drama Review* (Spring): 82–94.

—— (1989) 'Mimesis, Mimicry, and the "True-Real"', *Modern Drama*, 32.

—— (ed.) (1996) *Performance and Cultural Politics*, London: Routledge.

Dicker/sun, G. (1996) 'Festivities and Jubilations on the Graves of the Dead: Sanctifying Sullied Space', in E. Diamond (ed.) *Performance and Cultural Politics*, London: Routledge.

Doan, L. (1994) *The Lesbian Postmodern*, New York: Columbia University Press.

Dolan, J. (1987) 'The Dynamics of Desire: Sexuality and Gender in Pornography and Performance,' *Theatre Journal*, 39.

—— (1988) *The Feminist Spectator as Critic*, Ann Arbor: Michigan University Press.

—— (1989) 'In Defense of the Discourse: Materialist Feminism, Postmodernism, Poststructuralist . . . and Theory', *The Drama Review* 33.

—— (1993) 'Geographies of Learning: Theater Studies, Performance, and the "Performative"', *Theatre Journal* 45, 4: 417–41.

Dollimore, J. (1991) *Sexual Dissidence: Augustine to Wilde, Freud to Foucault*, Oxford: Clarendon Press.

Eagleton, T. (1991) *Ideology: An Introduction*, London: Verso.

Elam, H. (1997) *Taking it to the Streets: The Social Protest Theatre of Luis Valdez and Amiri Baraka*, Ann Arbor: University of Michigan Press.

Elam, K. (1980) *The Semiotics of Theatre and Drama*, London and New York: Routledge.

Eliade, M. (1967) *Myths, Rites, Symbols*, 2 vols, New York: Harper and Row.

Ellmann, R. (1964) *The Identity of Yeats*, New York: Oxford University Press.

Enem, E.U. (1976) 'The Kwah-Hir Theatre', *Nigeria Magazine* 120: 29–42.

Epstein, J. and Straub, K. (eds) (1991) *BodyGuards: The Cultural Politics of Gender Ambiguity*, London and New York: Routledge.

Esslin, M. (1987) *The Field of Drama*, London: Methuen.

Evans-Pritchard, E.E. (1928) 'The Dance', *Africa* 1: 446–64.

Fabian, J. (1990) *Power and Performance*, Madison: University of Wisconsin Press.

Fallon, G. (1967) 'The Abbey Theatre Acting Tradition', in S. McCann (ed.), *The Story of the Abbey Theatre*, London: New English Library.

Fanon, F. (1964) *The Wretched of the Earth*, New York: Grove Press.

Felman, S. (1983) *The Literary Speech Act*, tr. Catherine Porter, Ithaca: Cornell University Press.

Finley, K. (1990) *Shock Treatment*, San Francisco: City Lights.

Fischer-Lichte, E., Riley, J., and Gissenwehrer, M. (eds) (1990) *The Dramatic Touch of Difference: Theatre, Own and Foreign*, Tübingen: Günter Narr Verlag.

Flannery, J.W. (1976) *W.B. Yeats and the Idea of a Theatre*, New Haven and London: Yale University Press.

Fleishman, M. (1997) 'Physical Images in the South African Theatre', *South African Theatre Journal* 11/12: 199–215.

Forte, J. (1992) 'Focus on the Body: Pain, Praxis, and Pleasure in Feminist Performance', in J.G. Reinelt and J.R. Roach (eds) *Critical Theory and Performance*, Ann Arbor: University of Michigan Press.

Forti, S. (1974) *Handbook in Motion*, Halifax, Nova Scotia: The Press of the Nova Scotia College of Art and Design/New York: New York University Press.

Foster, S.L. (1992) 'Dancing Bodies', in J. Crary and S. Kwinter (eds), *Incorporations*, Zone 6, New York: Zone.

—— (1996a) 'Pygmalion's No-Body and the Body of Dance', in E. Diamond (ed.) *Performance and Cultural Politics*, London: Routledge.

—— (ed.) (1996b) *Corporealities: Dancing Knowledge, Culture and Power*, London: Routledge.

—— (1999) 'Choreographies of Gender', *Signs* 24, 1.

Foucault, M. (1977) *Language, Counter-Memory, Practice*, Ithaca: Cornell University Press.

—— (1978) *The History of Sexuality, Volume 1: An Introduction*, tr. R. Hurley, New York: Random House.

—— (1985) *The Use of Pleasure: Volume 2 of The History of Sexuality*, tr. R. Hurley, New York: Random House.

—— (1986) *The Care of the Self: Volume 3 of The History of Sexuality*, tr. R. Hurley, New York: Random House.

Frazier, A. (1990) *Behind the Scenes: Yeats, Horniman and the Struggle for the Abbey Theatre*, Berkeley: University of California Press.

Freud, S. (1948–74) *The Complete Psychological Works of Sigmund Freud: Standard Edition*, tr. under general editorship of J. Strachey, in collaboration with A. Freud, asst. by A. Strachey and A. Tyson, 24 vols, London: Hogarth Press.

—— (1949) *Three Essays on the Theory of Sexuality*, tr. J. Strachey, London: Imago.

Fuchs, E. (1989) 'Staging the Obscene Body', *Drama Review* XXXIII, 1: 33–58.

Fusco, C. (1997) *English Is Broken Here: Notes on Cultural Fusion in the Americas*, New York: New Press.

Garber, M. (1992) *Vested Interests: Cross-Dressing and Cultural Anxiety*, Harmondsworth: Penguin.

Garfinkel, H. (1967) *Studies in Ethnomethodology*, Englewood Cliffs, NJ: Prentice-Hall.

Gates, H.L., Jr (1993) 'The Black Man's Burden', in M. Warner (ed.) *Fear of a Queer Planet: Queer Politics and Social Theory*, Minneapolis and London: University of Minnesota Press.

Giddens, A. (1991) *Modernity and Self-Identity: Self and Society in the Late Modern Age*, Cambridge: Polity Press.

Gilbert, H. and Tompkins, J. (1996) *Post-Colonial Drama: Theory, Practice, Politics*, London: Routledge.

Godzich, W. (1988) 'The Further Possibility of Knowledge,' in M. de Certeau (ed.), *Heterologies*, Minneapolis: University of Minnesota Press.

Goffman, E. (1959) *The Presentation of Self in Everyday Life*, Garden City: Doubleday Anchor.

Goldie, T. (1989) *Fear and Temptation: The Image of the Indigene in Canadian, Australian and New Zealand Literatures*, Kingston, Ontario: McGill-Queen's University Press.

Goodman, L. (1999) *Sexuality in Performance: Replaying Gender in Theatre and Culture*, London: Routledge.

Goodman, P. (1976) 'Obsessed by Theatre' [Antonin Artaud], in E. Bentley (ed.) *The Theory of the Modern Stage*, Harmondsworth: Penguin.

Gramsci, A. (1971) 'The Intellectuals', 'Notes on Italian History', and 'The Modern Prince', in Q. Hoare and G. Nowell-Smith (eds) *Selections from Prison Notebooks*, London: Lawrence and Wishart.

Gregory, A. (1972) *Our Irish Theatre: A Chapter of Autobiography*, Gerrards Cross: Colin Smythe.

Griffin, G. and Andermahr, S. (eds) (1997) *Straight Studies Modified: Lesbian Interventions in the Academy*, London: Cassell.

Grotowski, J. (1968) *Towards a Poor Theatre*, ed. E. Barba, pref. by P. Brook, Holstebro: Odin Teatrets Forlag; repr. London: Methuen, 1969.

Gunner, E. (ed.) (1994) *Politics and Peformance: Theatre, Poetry and Song in Southern Africa*, Johannesburg: Witwaterstrand University Press.

Hall, S. (1974) 'Deviance, Politics, and the Media', in P. Rock and M. McIntosh (eds) *Deviance and Social Control*, London: Tavistock.

Halloran, J. (1970) 'The Social Effects of Television', in J. Halloran (ed.) *Effects of Television*, London: Panther.

Handelman, D. (1990) *Models and Mirrors: Towards an Anthropology of Public Events*, Cambridge: Cambridge University Press.

Hanna, J.L. (1979a) 'Movements toward Understanding Humans through the Anthropological Study of Dance', *Current Anthropology* 20, 2: 313–39.

—— (1979b) *To Dance Is Human: A Theory of Nonverbal Communication*, Austin: University of Texas Press.

Hart, L. and Phelan, P. (eds) (1993) *Acting Out: Feminist Performances*, Ann Arbor: University of Michigan Press.

Hayman, R. (1983) *Brecht: A Biography*, London: Weidenfeld and Nicolson.

Herdt, G. (1994) *Third Sex, Third Gender: Beyond Sexual Dimorphism in Culture and History*, New York and Paris: Zone Books.

Hewison, R. (1986) *Too Much: Art and Society in the Sixties – 1960–75*, London: Methuen.

Hilton, J. (ed.) (1993) *New Directions in Theatre*, London: Macmillan.

Huggan, G. (1998) 'Opting Out of the (Critical) Common Market: Creolization and the Post-Colonial Text', *Kunapipi* XI, 1: 27–40.

Huizinga, J. (1955) *Homo Ludens*, New York: Beacon Press.

Hulton, P. (1978) 'Fiction, Character and Narration: Yvonne Rainer', *Dartington Theatre Papers*, 2nd series, 7, Devon: Dartington Hall.

Innes, C. (1993) *Avant Garde Theatre 1892–1992*, London: Routledge.

Irigaray, L. (1985) 'The Power of Discourse', in *This Sex Which Is Not One*, tr. C. Porter with C. Burke, Ithaca, NY: Cornell University Press.

Jain, N.C. (1990) 'Contemporary Indian Theatre: Interface of Tradition and Modernity', in E. Fischer-Lichte *et al.* (eds) *The Dramatic Touch of Difference: Theatre, Own and Foreign*, Tübingen: Günter Narr Verlag.

Jeffreys, S. (1985) *The Spinster and her Enemies: Feminism and Sexuality 1880–1930*, London: Pandora Press.

—— (1994) *The Lesbian Heresy: A Feminist Perspective on the Lesbian Sexual Revolution*, London: Women's Press.

Jeyifo, B. (1990) 'The Reinvention of Theatrical Tradition: Critical Discourses on Interculturalism in the African Theatre', in E. Fischer-Lichte *et al.* (eds) *The Dramatic Touch of Difference: Theatre, Own and Foreign*, Tübingen: Günter Narr Verlag.

Joannou, M. and Purvis, J. (eds) (1998) *The Women's Suffrage Movement*, Manchester: Manchester University Press.

Kaeppler, A.L. (1972) 'Method and Theory in Analyzing Dance Structure with an Analysis of Tongan Dance', *Ethnomusicology* 16, 2: 173–217.

—— (1978) 'Dance in Anthropological Perspective', *Annual Review of Anthropology* 7: 31–49.

—— (1985) 'Structured Movement Systems in Tonga', in P. Spencer (ed.) *Society and the Dance: The Social Anthropology of Process and Performance*, Cambridge: Cambridge University Press.

Kafka, F. (1979) *The Basic Kafka*, New York: Washington Square Press.

Kaprow, A. (1968) 'Extensions in Time and Space', interview with Richard Schechner, *The Drama Review* 12, 3: 153–9.

Kaye, N. (1994) *Postmodernism and Performance*, Basingstoke: Macmillan.

Keller, H. (1980) *The Art of the Impressionists*, Oxford: Phaidon.

Kendall, E. (1984 [1979]) *Where She Danced: The Birth of American Art Dance*, Berkeley and Los Angeles: University of California Press.

Kenneally, M. (ed.) (1988) *Cultural Contexts and Literary Idioms in Contemporary Irish Literature*, Gerrards Cross: Colin Smythe.

Kent, S.K. (1990) *Sex and Suffrage in Britain 1860–1914*, London: Routledge.

Kershaw, B. (1992) *The Politics of Performance: Radical Theatre as Cultural Intervention*, London: Routledge.

Kilroy, T. (1977) 'Two Playwrights: Yeats and Beckett', in J. Ronsley, (ed.) *Myth and Reality in Irish Literature*, Waterloo, Ont.: Wilfrid Laurier University Press.

Kinsey, A., Pomeroy, W.B., and Martin, C. (1948) *Sexual Behavior in the Human Male*, Philadelphia: W.B. Saunders Company.

Kirschenblatt-Gimblett, B. (1995) 'Making a Difference: Mapping the Discursive Terrain of Multilculturalism', *Writings on Dance* 13: 55–61.

Klein, M. (1988a) *Love, Guilt and Reparation and Other Works 1921–1945*, London: Virago.

—— (1988b) *Envy and Gratitude and Other Works 1946–63*, London: Virago.

Koestenbaum, W. (1993) *The Queen's Throat: Opera, Homosexuality, and the Mystery of Desire*, New York and London: Poseidon Press.

Koestler, A. (1961) 'Some Aspects of the Creative Process', in S.M. Farber and R.H.L. Wilson (eds) *Control of the Mind*, New York: McGraw-Hill.

Kriegsman, S.A. (1981) *Modern Dance in America: The Bennington Years*, Boston: G. K. Hall.

Kurath, G.P. (1960) 'Panorama of Dance Ethnology', *Current Anthropology* 1: 233–54.

Kushner, T. (1995) *Thinking about the Longstanding Problems of Virtue and Happiness: Essays, a Play, Two Poems, and a Prayer*, London: Nick Hern.

Lacan, J. (1977) *Écrits: A Selection*, tr. A. Sheridan, London: Tavistock.

Laclau, E. and Mouffe, C. (1984) *Hegemony and Socialist Strategy: Towards a Radical Democratic Politics*, London and New York: Verso.

Laurel, B. (1993) *Computers as Theatre*, Reading, MA: Addison-Wesley.

Lawson, A. (1992) 'Comparative Studies and Post-Colonial "Settler" Cultures', *Australian–Canadian Studies* 10, 2: 153–9.

Lefebvre, H. (1968) *The Sociology of Marx*, New York: Random House.

Lévinas, E. (1972) *Humanisme de l'autre homme*, Fata Morgana.

Lillo-Martin, D.L. (1991) *Universal Grammar and American Sign Language: Setting the Null Argument Parameters*, The Netherlands, London and Boston: Kluwer Academic Publishers.

Lorde, A. (1984) *Sister/Outsider: Essays and Speeches*, Freedom, California: Cross Press.

Lyotard, J.-F. (1984) *The Postmodern Condition: A Report on Knowledge*, tr. G. Bennington and B. Massumi, Minneapolis: University of Minnesota Press.

Makgale, S. (1998) 'Tapping into the Power of the African Spirit', *Cue* 7 (July): 4.

Marranca, B. (1977) *Theatre of Images* (New York: Drama Book Specialists).

Martin, J. (1965 [1933]) *The Modern Dance*, New York: Dance Horizons.

Mason, P. (1993) 'A High Ambition', *Application to the Arts Council for a Grant-in-Aid to the National Theatre Society Ltd. for Year Ending 31 December 1994*, Dublin: Abbey Theatre.

—— (1998) 'Art and Culture: A Policy Statement', *Art and Culture: A Statement of Policy for the National Theatre Society Limited 1998 to 2000*, Dublin: Abbey Theatre.

Matejka, L. and Titunik, I.R. (eds) (1976) *Semiotics of Art*, Cambridge, MA: MIT Press.

McCauley, R. (1996) 'Thoughts on My Career, *The Other Weapon*, and Other Projects', in E. Diamond (ed.) *Performance and Cultural Politics*, London: Routledge.

McDonald, D. (1992) 'Unspeakable Justice: David Hare's *Fanshen*', in J.G. Reinelt and J.R. Roach (eds) *Critical Theory and Performance*, Ann Arbor: University of Michigan Press.

McKevitt, Paul (ed.) (1995) *Integration of Natural Language and Vision Processing: Recent Advances, IV*, London and Boston: Kluwer Academic Publishers.

Mda, Z. (1998a) 'Current Trends in Theatre for Development', in D. Attridge and R. Jolly (eds) *Writing South Africa*, Cambridge: Cambridge University Press.

—— (1998b) 'Zombi Magic Triumphs', *Cue* 4 (July): 6.

Meduri, A. (1988) 'Bharatha Natyam – What Are You?' *Asian Theatre Journal* 5, 1: 1–22.

Melucci, A. (1989) *Nomads of the Present: Social Movements and Individual Needs in Contemporary Society*, London: Radius.

Menon, C.A. (1979) 'Introduction' to *Capital* by T. Bhasi, Trichur: Kerala Sahitya Academy.

Merlin, Bella (1999) 'Albert Filozov and the Method of Physical Actions', *New Theatre Quarterly* 15, 3 (59).

Meyerhold, V. (1969) *Meyerhold on Theatre*, ed. and tr. E. Braun, London: Methuen.

Miller, J.H. (1991) *Tropes, Parables, Performatives: Essays on Twentieth-Century Literature*, Durham, NC: Duke University Press.

Mills, S. (1997) *Discourse*, London: Routledge.

Mishra, V. and Hodge, B. (1991) 'What Is Post(-)Colonialism?', *Textual Practice* 5, 3: 399–414.

Mohamed, Z. (1998) 'Cheap Tricks and White Lies', *Cue* 6 (July): 3.

Morris, G. (ed.) *Moving Words: Writing Dance*, London: Routledge.

Mukherjee, S. (1982) *The Story of the Calcutta Theatre 1753–1980*, Calcutta: Bagchi.

Munt, S. (1998) *Heroic Desire: Lesbian: Identity and Cultural Space*, London: Cassell.

Naipaul, S. (1971) 'The Writer without a Society', in A. Rutherford (ed.) *Commonwealth*, Aarhus, Denmark: University of Aarhus Press.

Navarro, D. (1987) *Cultura y Marxismo*, La Habana: Editorial Letras Cubanas.

Ness, S.A. (1992) *Body, Movement, and Culture: Kinesthetic and Visual Symbolism in a Philippine Community*, Philadelphia: University of Pennsylvania Press.

—— (1996) 'Observing the Evidence Fail: Difference Arising from Objectification in Cross-Cultural Studies of Dance', in G. Morris (ed.) *Moving Words: Writing Dance*, London: Routledge.

Neville, R. (1970) *Play Power*, London: Cape.

Nikolais, A. (1966) 'No Man from Mars', in S.J. Cohen (ed.) *The Modern Dance: Seven Statements of Belief*, Middletown, CT: Wesleyan University Press.

Novack, C.J. (1990) *Sharing the Dance: Contact Improvisation and American Culture*, Madison: University of Wisconsin Press.

Olaniyan, T. (1995) *Scars of Conquest, Masks of Resistance*, Oxford: Oxford University Press.

O'Toole, F. (1983) Interview with Kazimierz Braun, *Sunday Tribune*, 'Inside Tribune', 2 October.

Parker, A. and Sedgwick, E.K. (eds) (1995) *Performativity and Performance*, New York: Routledge.

Parker, A., Russo, M., Sommer, D., and Yaeger, P. (eds) (1992) *Nationalisms and Sexualities*, London and New York: Routledge.

Parkhomenko, Sergei (1990) 'The Theatre Will Die with the Last of the Actors', *New Theatre Quarterly* 6, 3 (23): 229–30.

Parry, B. (1987) 'Problems in Current Theories of Colonial Discourse', *Oxford Literary Review*, 9, 1–2.

Patraka, V.M. (1996) 'Spectacles of Suffering: Performing Presence, Absence, and Historical Memory at U.S. Holocaust Museums', in E. Diamond (ed.) *Performance and Cultural Politics*, London: Routledge.

Pavis, P. (1982) *Languages of the Stage: Essays in the Semiology of the Theatre*, New York: Performing Arts Journal Publications.

—— (1992) *Theatre at the Crossroads of Culture*, London: Routledge.

—— (ed.) (1996) *The Intercultural Performance Reader*, London and New York: Routledge.

Phelan, P. (1993) *Unmarked: The Politics of Performance*, London: Routledge.

Phillips, Andrea (ed.) (1998) *Out of Time: Hull Time Based Arts 1984–1998*, Hull: Hull Time Based Arts.

Plummer, K. (1995) *Telling Sexual Stories*, London and New York: Routledge.

Poggioli, R. (1968) *The Theory of the Avant-Garde*, Cambridge, MA: Harvard University Press.

Potter, Sally (1985) quoted in C. Elwes, 'Floating Femininity', in S. Kent and J. Morrow (eds) *Women's Images of Men*, London: Writers and Readers Publishing, p. 170.

Poulantzas, N. (1968) *Pouvoir politique et classes sociales*, Paris: Maspéro.

Prakash, G. (1992) 'Postcolonial Criticism and Indian Historiography', *Social Text* 10 (2–3)/31–32: 8–19.

Rainer, Y. (1966) 'Notes on Two Dances by Deborah Hay', unpublished manuscript, New York, 22 August.

—— (1974) *Work 1961–73*, Halifax, Nova Scotia: The Press of the Nova Scotia College of Art and Design/New York: New York University Press.

Read, A. (1993) *Theatre and Everyday Life: An Ethics of Performance*, London: Routledge.

Reinelt, J.G. (ed.) (1996) *Crucible of Crisis: Performing Social Change*, Ann Arbor: University of Michigan Press.

—— and Roach, J.R. (eds) (1992) *Critical Theory and Performance*, Ann Arbor: University of Michigan Press.

Rich, A. (1987) 'Compulsory Heterosexuality and Lesbian Existence', in *Blood, Bread and Poetry: Selected Prose 1979–85*, London: Virago.

Roach, J.R. (1992) 'Introduction', in J.G. Reinelt and J.R. Roach (eds) *Critical Theory and Performance*, Ann Arbor: University of Michigan Press.

—— (1996) 'Kinship, Intelligence, and Memory as Improvisation: Culture and Performance in New Orleans', in E. Diamond (ed.) *Performance and Cultural Politics*, London: Routledge.

Robinson, A. (1996) 'Forms of Appearance of Value: Homer Plessy and the Politics of Privacy', in E. Diamond (ed.) *Performance and Cultural Politics*, London: Routledge.

Robinson, M. (1987) 'Performance Strategies: Interviews with Ishmael Houston-Jones, John Kelly, Karen Finley, Richard Elovich', *Performing Arts Journal* X, 3: 31–56.

Rock P. and McIntosh, M. (eds) (1974) *Deviance and Social Control*, London: Tavistock.

Ross, J. (1997) *The Semantics of Media*, London and Boston: Kluwer Academic Publishers.

Roszak, T. (1969) *The Making of a Counter-Culture*, New York: Anchor Books.

Rotimi, O. (1985) Interview with D. Burness, in D. and M.L. Burness (eds) *Wanasema: Conversations with African Writers*, Athens, Ohio: Ohio University Center for International Studies.

—— (1990) 'Much Ado about Brecht', in E. Fischer-Lichte *et al.* (eds) *The Dramatic Touch of Difference: Theatre, Own and Foreign*, Tübingen: Günter Narr Verlag.

Royce, A.P. (1977) *The Anthropology of Dance*, Bloomington: Indiana University Press.

Ruyter, N.L.C. (1979) *Reformers and Visionaries: The Americanization of the Art of Dance*, Brooklyn: Dance Horizons Press.

Savigliano, M. (1995) *Tango and the Political Economy of Passion*, Boulder: Westview.

Savona, J.L. (1984) 'French Feminism and Theatre: An Introduction', *Modern Drama* 27.

Sayre, H. (1989) *The Object of Performance: The American Avant-Garde since 1970*, Chicago: University of Chicago Press.

Schechner, R. (ed.) 1982 'Intercultural Performance', *The Drama Review*, 26, 2, T 94.

—— (1985) *Between Theatre and Anthropology*, Philadelphia: University of Pennsylvania Press.

—— (1988a) *Performance Theory*, revised and expanded edition, New York: Routledge.

—— (1988b) 'Karen Finley: A Constant State of Becoming', *Drama Review* XXXII, 1: 152–8.

Schneider, R. (1996) 'After Us the Savage Goddess: Feminist Performance Art of the Explicit Body Staged, Uneasily, Across Modernist Dreamscapes', in E. Diamond (ed.) *Performance and Cultural Politics*, London: Routledge.

—— (1997) *The Explicit Body in Performance*, London: Routledge.

Schuler, C. (1990) 'Spectator Response and Comprehension: The Problem of Karen Finley's *The Constant State of Desire*', *Drama Review* XXXIV, 1: 152–8.

Scott, M. (1994) *Trouble and her Friends*, New York: Tom Doherty Associates.

Sedgwick, E.K. (1985) *Between Men: English Literature and Male Homosocial Desire*, New York: Columbia University Press.

—— (1993) 'Queer Performativity', *GLQ*, 1, 1.

Shearman, J. (1967) *Mannerism*, Harmondsworth: Penguin.

Sissons, M. and French, P. (eds) (1963) *Age of Austerity 1945–1951*, London: Hodder and Stoughton.

Smyth, C. (1992) *Lesbians Talk Queer Notions*, London: Scarlet Press.

Soyinka, W. (1976) *Myth, Literature and the Africa World*, Cambridge: Cambridge University Press.

—— (1988) *Art, Dialogue, and Outrage*, Ibadan: New Horn Press.

Spencer, P. (1985) 'Introduction', in P. Spencer (ed.) *Society and the Dance: The Social Anthropology of Process and Performance*, Cambridge: Cambridge University Press.

Spiderwoman Theatre (1992) 'Reverb-ber-ber-ations', *Women and Performance* 5, 2: 185–212.

Spivak, G. (1990) 'The Making of Americans, the Teaching of English, the Future of Colonial Studies', *New Literary History* 21, 4.

—— and Gunew, S. (1993) 'Questions of Multiculturalism', in S. During (ed.) *The Cultural Studies Reader*, London: Routledge.

Stanislavski, K. (1937) *An Actor Prepares*, tr. E.R. Hapgood, London: Geoffrey Bles.

—— (1968) *Building A Character*, tr. E.R. Hapgood, London: Methuen.

—— (1980 [1924]) *My Life in Art*, London: Methuen.

Stanley, L. (ed.) (1997) *Knowing Feminisms*, London: Sage.

Stedman Jones, G. (1972) 'The Marxism of the Early Lukács', *New Left Review* 70.

Thiong'o, N. (1983) *Barrel of the Pen: Resistance to Repression in Neo-Colonial Kenya*, London: New Beacon Books.

—— (1986) *Decolonizing the Mind: The Politics of Language in African Literature*, Nairobi: East African Educational Publishers.

—— (1993) *Moving the Centre: The Struggle for Cultural Freedom*, London: James Currey.

Tickner, L. (1987) *Spectacle of Women: Imagery of the Suffrage Campaign 1907–14*, London: Chatto and Windus.

Tiffin, H. (1987) 'Post-Colonial Literatures and Counter-Discourse', *Kunapipi* 9, 3: 17–34.

Tomko, L. (forthcoming) *Dancing Class*, Bloomington: Indiana University Press.

Turner, E. and Turner V. (1982) 'Performing Ethnography', *The Drama Review*, 26, 2, T 94.

Turner, V. (1969) *The Ritual Process: Structure and Anti-Structure*, London: Routledge and Kegan Paul.

—— (1982) *From Ritual to Theatre*, New York: Performing Arts Journal Publications.

Walder, D. (1998) 'Spinning out the Present: Narrative, Gender, and the Politics of South African Theatre', in D. Attridge and R. Jolly (eds) *Writing South Africa*, Cambridge: Cambridge University Press.

Watson, I. (1993) *Towards a Third Theatre: Eugenio Barba and the Odin Teatret*, London: Routledge.

Weeks, J. (1981/1989) *Sex, Politics and Society: The Regulation of Sexuality since 1800*, Harlow: Longman.

—— (1985) *Sexuality and its Discontents: Meanings, Myths and Modern Sexualities*, London and Boston: Routledge and Kegan Paul.

—— (1986) *Sexuality*, London: Tavistock.

—— (1991) *Against Nature: Essays on History, Sexuality, and Identity*, London: Rivers Oram Press.

—— (1995) *Invented Moralities: Sexual Values in an Age of Uncertainty*, Cambridge: Polity.

Wilder, T. (1987) *Our Town, The Skin of Our Teeth, The Matchmaker*, London: Penguin.

Williams, D. (1992) *Peter Brook and the Mahabharata*, London: Routledge.

Williams, R. (1974) *Drama in a Dramatized Society*, Inaugural Lecture, Cambridge: Cambridge University Press.

—— (1976) *Keywords: A Vocabulary of Culture and Society*, London: Fontana.

—— (1981) *Culture*, Glasgow: Collins/Fontana.

—— (1983) *Writing in Society*, London: Verso.

—— (1989) *Raymond Williams on Television: Selected Writings*, ed. A. O'Connor, London and New York: Routledge.

—— (1991) *Drama in Performance*, with a new introduction and bibliography by Graham Holderness, Buckingham: Open University Press.

Wollen, Peter (1993) *Raiding the Icebox: Reflections on Twentieth-Century Culture*, London: Verso.

Woolford, K. and Kozel, S. (1999) 'Utterance 5: MESH Performance Partnership', *Performance Research* 4, 21:61–3.

Wright, R. (1937) *Revels in Jamaica 1682–1838*, New York: Dodd Mead.

Yajnik, R.K. (1970) *The Indian Theatre: Its Origins and its Later Developments under European Influence*, New York: Haskell House.

Yeats, W.B. (1961a) *Essays and Introductions*, London: Macmillan.

—— (1961b) *Autobiographies*, London: Macmillan.

—— (1975) 'The Irish Literary Theatre', *Uncollected Prose by W.B. Yeats*, ed. J.P. Frayne and C. Johnson, London: Macmillan.

Yeats, W.B. and Moore, T.S. (1953) *Correspondence, 1901–1937*, New York: Oxford University Press.

Young, I.M. (1990) *How to Throw Like a Girl and Other Essays in Feminist Philosophy and Social Theory*, Bloomington: Indiana University Press.

Zarrilli, P.B. (1996) 'Introduction', *Memories in Hiding* by T. Bhasi, Calcutta: Seagull Press.

Index

Numbers in bold refer to individual chapters.

Abelove, H. 75
Accone, D. 238
Adamov, Arthur 74
Adshead-Lansdale, Janet xvii, 8, 11, **183–8**
Aeschylus 203
Agbebiyi, Adeola xvii, 13, **295–8**
Aidoo, Ama Ata 118; *Anowa*, 119, 122n.
AIDS 178–80, 271
Ailey, Alvin 213
alienation effect (a-effect) 86–7, **94–7**, 110–11;
 see also *Verfremdungseffekt* (V-effekt)
Alsop, Ric 263 n.
alternative theatre (in Britain) 113, 136–42
Althusser, Louis 54, 76, 79–81 & n., 168
American Indian Community House 265
American National Theatre of the Deaf 92
Amkpa, Awam xvii, 10, 114–15, **116–22**
Antheil, Georges 72
anthropology 26, 248–53
anthropology, theatre 9, 41–5, 112; see also
 International School of Theatre
 Anthropology
Appiah, Anthony 118, 119, 120
Apter, E. 67
Arden, John 127
Aristotle 88, 128; Aristotelian drama 86

Arrabal, Fernando 71
Artaud, Antonin xvii, 7, 10, 26, 27, 53, 68,
 71–2, 87–8, **98–101**, 105, 127
Art Nouveau, 125; defined, 129 n.
Association of South East Asian Nations
 (ASEAN) 233–4
Attlee, Clement 127
Auslander, P. 64
Austen, Jane 49
Austin, J.L. 62, 147–8, 167, 172–7
Australian Museum of Natural History 112,
 132
avant garde 198, 217, 241–3; theatre 53,
 70–4, 87, 105, 110; theory 160

Bagnold, Enid 127
Bailey, Brett 237–8, 240n.; *iMumbo Jumbo* 238;
 Ipi Zombi? 237–8, 239
Bakhtin, Mikhail 73
Bakunin 53, 70
Banes, Sally xvii, 183, 187, **213–18**
Banfield, Chris 226, 227
Barale, M.A. 75
Barba, Eugenio xviii, xxiv, 9, 18–20, 21,
 41–5, 71, 103, 241–7
Barker, Clive xviii, 3, 6, 8–9, 10, 13, **17–20**

Barker, Howard 127
Barrault, Jean-Louis 71
Barthes, Roland 68
Bartinieff, I. 212n.
Bartra, Roger 133
Bataille, Georges 160
Batson, Glenna 285
Battersby, M. 129n.
Baudrillard, Jean 267
Beck, Julian 68, 71, 88
Beckett, Samuel 52, 73, 125–6, 127, 202–4;
 Breath 203; Waiting for Godot 18, 58, 202
Béjart 105
Benjamin, Walter 268, 282, 291, 293
Bennett, Susan 138
Berger, P. 76–7
Bergman, Ingmar 203
Berliner Ensemble 114
Berry, Cicely xviii, 9, 18, **37–40**
Best, David 186–7
Bhabha, H. 118, 120, 133, 260, 265–7,
 269n.
Bharatha Natyam 252
Bharucha, R.D. 102
Bhasi, Topi 224; You Made Me a Communist
 224–5
Bing, Samuel 129n.
Black consciousness movement 141, 226, 235 ff.
Blau, H. 69 n.
Blin, Roger 71
Boal, Augusto xviii, 9, 18–19, **32–6,** 111, 113,
 293
Bourdieu, Pierre 249
Bowlby, Rachel 61
Braderman, Joan 218
Braun, Kazimierz 89
Brazilian theatre 9, 32
Brecht, Bertolt xviii, 10, 18, 49, 50, , 68,
 86–8, 89, **94–7,** 110–11, 114, 127, 167,
 183, 215–16, 218n., 232, 236, 268–9
Breton, André 73
Bristow, Joseph xviii, 10–11, 145–6, **157–61**
Brock, B. 186
Brockman, J. 289
Brontë, Emily 49
Brook, Peter xviii, 10, 21, 71, 85–9 passim.,
 90–3, 102–5 passim., 183, 236; Mahabharata

102; as director of Shakespeare plays,
 xviii–xix, 74, 88
Brooklyn Academy of Music 92
Brown, Norman O. 128
Brown, Trisha 209, 214, 216–17
Brydon, Diana 232
Büchner, Georg 124–5; Danton's Death 124,
 125
Bullin, Ed 68
Burnier, Luis Octavio 244
Burroughs, Edgar Rice 73
Bush, George 4
Butler, Judith xix, 11, 62–4, 69, 147–9, 161,
 167–71, 172
Byron, George Gordon, Lord: Cain 24; Don
 Juan 177

Caillois, Roger 196
Cairncross, Frances 289
Calderón de la Barca, Pedro 24
camp 149, 280
Carlson, Marvin xix, 9, 52, 54, **60–5**
Cartoucherie, Paris (performance space) 191
Case, Sue-Ellen xix, 12, 60–1, 259, 261–2,
 277–82
CD-Rom 257–9, 262, 286
Césaire, Aimé 269n.
Chaikin, Joseph 68, 71
Chaney, D. 223
Chapman, Tracy xxvi
Chávez, César 91
Childs, Lucinda 214
Chinese theatre 26–7, 86–7, 89; alienation
 effects in, 94–7
Chkhivadze 19
Chodorow, Nancy 146
choreography 184, 186, 208–12, 213–18, 253,
 261, 279, 285
Chrisman, Laura 230
cinema 18, 51, 56, 111, 126, 133, 217, 291;
 see also film
Cixous, Hélène 61, 281
Clifford, J. 269n.
Clinton, Bill 4, 280
Cobb, Lee J. 196
Cockin, Katharine xix, 8, 11, **145–9**
Cocteau, Clement Eugene 73

Coetzee, Greig: *White Men with Weapons* 239
Cohen, A.P. 164
Cohen, E. 67
Collège de Pataphysique 71
Colleran, J. 236, 240 n.
Commedia Dell'Arte 291
Community arts 190
community theatre 191; in Britain 113, 136–42; in Uganda 122n.
Connell, R. 164
Conrad, Joseph 73
Constantino, R. 116
Coote, Anna 123
Copeland, R. 216
Corpus Christi (play cycle) 55–6
Corti, Victor 98
Counsell, Colin xix, 11, 183–4, **202–7**
counter-identity 117
Covent Garden, London 112, 132
Cowan, J.K. 253n.
Coward, Noël 127
Cowper, William 158
Craig, Edith xix, 11
Crow, Brian 226, 227
Cuatrotablas (theatre group) 244
Cubitt, S. 263n.
cultural materialism 49 ff., 60
Cunningham, Merce 213–15

Daly, A. 212n.
dance 1, 2, 4, 8, 11, 12, 23, 41–5, 89, 90, 99, 100, 131, 183ff., 192, 198, 199, 213–18, 228, 258, 262, 274, 284, 289, 290–2; Balinese 72, 87; cross-cultural studies of 248–53; in South Africa, 236, 237, 239; recent developments in 208–12
Dance Umbrella festivals 185
Daniels, Sarah xix, **xxv–xxvii**, 4–5, 13, 228n.
Darlrymple, L. 105
Davis, Jill 149
Davis, Maudi Lee 179
Davis, Natalie Zemon 264
decadence 53, 70, 88, 100, 125
de Certeau, Michel 54, 63–4
Decroux, Etienne 42–3, 244

delaHunta, Scott 263n.
Deleuze, Gilles 160
Delgado, Mario 244
Delsarte 21
de Man, Paul 173
Denny, Jean 285
Derrida, Jacques 62–3, 68, 169, 172, 174
Descartes, René 185
Devarajan 224
deviance 53–4, 75–81
Diamond, Elin xix, 9, 52–3, 64–5, **66–9**
Diana, Princess of Wales 289
Dickens, Charles 49, 51
Dicker/sun, G. 67
Dinshaw, Carolyn 171n.
Dionysus, rituals pertaining to 55–6, 72, 73
disempowerment 163, 227
Doan, L. 303
Dolan, Jill 62, 64, 272
Dollimore, Jonathan 280
Dove, Toni 284
Drummond, Flora 155
Drury Lane Arts Lab xxi
Dullin, Charles 21, 27
Duncan, Isadora 213
Dunham, Katherine 213
Dunn, Judith 214
Durkheim, Emile 26, 76
Dworkin, Andrea 280

Eagleton, Terry xxiii, 53, 221–2, 224
Edge '92 Biennial (festival) 131
Einstein, Albert 126
Eisenhower, Dwight D. 282
Eisenstein, Sergei 125
Elam, Harry 225
Elam, Keir 184, 204–5
El Greco, 24
Eliot, T.S. 49, 74; *Burnt Norton* 124
Eliade, M. 72
Ellmann, R. 73
Enem, E.U. 234
'Environmental Theatre' 184, 192, 203
Epstein, J. 163
Erdman, John 273–4
Esslin, M. 140
Evans-Pritchard, E.E. 249–53

Fanon, F. 120
Farnsworth, Philo 283
Farquhar, George: *The Recruiting Officer* 231
Fellini, Federico: *8½*, 126, 129n.
Felman, S. 177n.
feminism 61–2, 64, 170, 185, 208, 218, 233, 278, 281, 282
feminist movement 141, 153 ff., 187
feminist performance 52–3, 60–5, 68–9, 214, 216, 264–9, 270–6
feminist performance criticism 68–9, 232
feminist theory 52–3, 60–5, 68–9, 146, 160–1, 214
Field Day Theatre Company 5
Field Museum, Chicago 132, 134
film 23, 24, 49, 50, 51, 55, 86, 111, 113, 126, 133, 146, 172, 176, 191, 202, 205, 215–16, 230, 244, 273, 291; *see also* cinema
Filozov, Albert 19
Finley, Karen 12, 150, 217, 260, 270–3, 275–6
Fischer-Lichte, E. 105
Flaherty, Robert 133
Flanagan, Bob: *Sick* 146
Flaszen, Ludwik 23
Fleishman, M. 236
Flockemann, Miki xx, 12, 226–7, **235–40**
Foreman, Richard 68
formalism 71, 86, 125, 204
Forte, J. 68
Forti, Simone 214, 215; *Rollers* 215
Foster, Susan Leigh xx, 11, 67, 183, 184–6, 188n., **208–12**
Foucault, Michel 146, 160–61, 167, 175, 176, 264, 265
French, P. 127
Freud, Sigmund 52, 60, 72, 88, 128, 145, 146, 159–60, 198, 199
Friel, Brian 5
Fuchs, E. 270
Fugard, Athol 236, 240n.
Fuller, Loïc 213
Fusco, Coco xx, 10, 110–14, **130–5**

Garfinkel, H. 75–6
Gaswerk, Copenhagen (performance space) 191
Gates, H.L. Jr. 165

gay rights movement 141, 147, 170
Genet, Jean 71
Giddens, Anthony 164, 305
Gilbert, Helen xx, 12, 226, **229–34**, 235, 236
Godard, Jean-Luc: *Breathless* 216
Godzich, Wlad 63
Goffman, E. 198, 201n.
Goldie, T. 231
Gomez, Jewelle 217
Gómez-Peña, Guillermo 111, 113, 130–5
Goodman, Debbie 240 n.
Goodman, Lizbeth **xi–xii**, xx, **1–13**, 259, 261–2, 287, 287n., **288–94**
Gorbachev, Mikhail 124
Govoni, Corrado 72
Grace, Della 281
Graham, Martha 213; *Cave of the Heart* 214–15
Grahamstown Arts Festival 238–9
Gramsci, Antonio 54, 78–80
Grierson, John 133
Grotowski, Jerzy xviii, xx, 6, 9, 18, 19, 20, **21–7**, 71, 103, 203, 236, 239, 290
Guattari, Félix 160
Guerrilla Girls 218
Gunner, E. 226
Gurawski 27

Hall, Sir Peter 17
Hall, Stuart xx, 9, 53–54, **75–81,** 165
Halloran, J. 77
Halperin, David M. 75, 171n.
Halprin, Anna 74; *Espozione* 195
Handelman, Don 222
Handspring Puppet Company 237
Hanna, Judith Lynne 250–1, 253 & n.
Hardy, Thomas 49
Hare, David: *Teeth and Smiles* 123
Hart, L. 264
Hawkins, Erick 213
Hay, Deborah 214; *No. 3* 216
Hayman, R. 87
Herdt, G. 165
Hewison, Robert 138
Hill, Leslie xxi, 11, 149, **150–6,** 290, 292, 293, 294n.
Holderness, Graham 50–1

omosexuality 162, 178–80; in US military
175–7 & n.; theorization of 146–7
Honzl, Jindrich 204
Huggan, G. 235, 240n.
Hughes, Holly 217
Hughes, Ted 88; *Orghast* 91
Huizinga, J. 196–7
Hulton, Peter 274
Humphrey, Doris 213
Hunter, N.C. 127

Ibsen, Henrik 49, 50, 56; *An Enemy of the
People* 28; *Hedda Gabler* 200
Identity 87, 88, 103, 106, 116, 119, 130, 145,
191–2, 203, 206, 209, 210, 214, 217, 218,
242, 262, 265, 268, 272, 273, 274, 279,
290, 292; and gender 185–87; and sexuality
11, 145–9, 162–6, 168–71, 175, 180;
cultural 130, 186–7, 222 ff., 239; national
67, 69; performance of 62; racial 10; *see
also* counter-identity
Ideology 2, 114, 137, 139, 141–2, 221–2,
227, 235, 239; dominant 79–81, 133; of
the avant garde, 53, 73
Imoru, Nike xxi, 8, 10, **109–15**
Innes, Christopher xxi, 9, 53, **70–4**
Institute for Studies in the Arts (University of
Arizona) xxi, xxii, 284
Institute of Contemporary Art (ICA), London
xxiii
International Centre of Theatre Research xviii,
71; projects undertaken by 90–3
International School of Theatre Anthropology
(ISTA) xviii, 103
Internet 258, 259, 261, 262, 277–82, 292,
293; *see also* World Wide Web
Ionesco, Eugène 71; *Victims of Duty* 195–6
Irele, Abiola 118
Irigaray, Luce 61, 64–5, 281

Jackson, Adrian 32
Jagged Dance 239, 240n.
Jain, N.C. 105
Jarry, Alfred 71
Jazzart Company 240n.
Jeyifo, B. 102, 105
Joannou, Maroula xix

Job, Jacki 240n.
Jones, Philip Mallory 285–6
Judson (dance company) 184, 214, 218n.
Juliani, John 71
Junction Avenue Theatre Company 236
Jung, Carl 26, 72

Kabuki 42
Kaeppler, Adrienne L. 251–3 & n.
Kafka, Franz 130
Kalidasa: *Shakuntala* 24
Kane, Sarah 6
Kaprow, Allan 195; *Calling* 201; *Fluids* 195
Kathkali 22
Kaye, Nick xxi, 12, 259–60, **270–6**
Keaton, Buster 215
Kendall, E., 212n.
Kentridge, William 236
Kerala People's Arts Club (KPAC) 224–5
Kershaw, Baz xxi, 10, 110, 112–14, **136–42**
King, Martin Luther 179
Kingsley, Charles 158
Kinsey, A. 163
Kirschenblatt-Gimblett, Barbara 186
Klein, Melanie 128, 146
Koestenbaum, Wayne 180
Koestler, Arthur 201n.
Kozel, Susan xxii, 8, 12, **257–63,** 290
Kriegsman, S.A. 212n.
Kristeva, Julia 61, 281
Kurath, G.P. 253n.
Kurup, O.N.V. 224
Kwagh-Hir puppet theatre 234
Kushner, Tony xxii, 11, 148, **178–80**

Laban, Rudolph 19–20, 212n., 285
Lacan, Jacques 52, 60, 62, 145, 146, 159–60
Laclau, E. 164
language 2, 3, 5, 6, 25, 69, 72, 76, 85,
90–1, 114, 127, 131, 145, 147, 157,
184, 191, 205, 221, 227, 233, 234, 257,
291; acquisition of 60–1; appropriation
of 270 ff.; Artaud's views on 87–8,
98–101; body 2, 92, 185; colonization
and 116–21, 230–1, 232; of performance
7, 41, 42, 243; philosophy of 167 ff.,
172 ff.; sign 92, 291

Lanier, Jaron 282
Lanzi, Luigi 129
Larco, Juan 244
Laurel, Brenda 291–2, 293
Lawrence, D.H. 51, 73; *Touch and Go* 123
Lawrence, Stephen xxvi–xxvii, 6, 225
Lawson, Alan 230, 235
Lefebvre, H. 81
Leiris, Michel 269n.
Lemon, Ralph 285–6
Lenin, Nicolai 125
Leninist–Marxist politics 110
Lescarbot, Marc 231
Lévinas, E. 106
Lévi-Straus, Claude 73
Lewis, Robert 35–6
Lichtenstein, Roy 215
Lillo-Martin, D.L. 291
liminality 61, 89, 119, 138–9, 188n.
Limón, José 213; *The Moor's Pavanne* 214
Littlewood, Joan xviii, 9
Living Theatre 68, 71, 88
Lloyd George, David 155
Lorde, Audre 63, 115, 265
Lovell, Robb 284
Loveless, Richard L. xxii, 12, 13, 259, 261, **283–7**
Lukács, Georg 53, 70
Luckmann, T. 76–7
Lyotard, J.-F. 173

Macbeth, Robert 68
MacGregor, Wayne 184
Mackie, Lindsay 123
MacKinnon, Catherine 280–1
Maclean, Don 265
Macpherson, William 225
Madonna 217
Mahabharata 102
Makgale, S. 238
Malina, Judith 68; *see also* Living Theatre
Malmgren, Y. 19
Mandela, Nelson 234
Mann, Thomas 27
Mannerism 125; defined, 129 n.
Marowitz, Charles 71
Marranca, B. 68

Martin, John 214, 216
Marx, Karl 88
Marxist approaches 70, 289
Marxist theory 50, 176
Matejka, L. 204
Mayo, Lisa 260, 265ff.; *see also* Spiderwoman Theatre
Mbowa, Rose 118, 122n.
McCarthy, Senator J.R. 282
McCauley, R. 67
McDonald, D. 87
McDougall, Gordon xxii, 10, 109–11, 113–14, **123–9**
McIntosh, Mary 75
McKevitt, Paul 291
McLuhan, Marshall 154
Mda, Zakes 236, 238
Mead, Margaret 286
Meduri, Avanthi 251–2
Mei Lan-Fang 86–7
Melucci, A. 166
Menon, C.A. 223–5
Mercat de les Flors, Barcelona (performance space) 191
Merlin, Bella 19
Meyerhold, V. 21, 27, 125
Mhlophe, Gcina: *Love Child* 239
Miguel, Gloria 260, 265ff.; *see also* Spiderwoman Theatre
Miguel, Muriel 260, 264, 265ff.; *see also* Spiderwoman Theatre
Mill, John Stuart 154
Miller, J. Hillis 173
Milton, Katherine 286
mimesis 64–5, 192, 196, 260, 267
mimicry 64–5, 149, 260, 262, 264 ff.
Mirii, Ngugi wa: *I'll Marry When I Want* 118–19, 122n.
Mitchell, John 284–6
Mkhwane, Bheki; *Solomon's Pride* 239
Mnouchkine, Ariane 71, 104–5
Mohamed, Z. 238
Monk, Meredith 74n.
Moore, T.S. 73
Moravia, Alberto 129n.
Morris, Gay 248
Morrison, Toni 179

motion-tracking and motion-capture systems 258, 284–5
Mouffe, C. 164
Mtshali, Thulani: *Weemen* 246
Muggeridge, Malcolm 123
Mugo, Micere 118, 122n.
Mukherjee, S. 231
Müller, Heiner 71
Murray, Christopher xxii, 6, 8, 10, **85–9**

Naipaul, Shiva 230
National Black Theater (US) 68
National Gallery (UK) 155
National Museum of Natural History (US) 132
NATO 6
Navarro, D. 105
Ness, Sally Ann xxii, 12, 227–8, **248–53**
Neville, Richard 128, 129n.
New Lafayette Theater 68
new technologies, performance and 257–63, 277–82, 283–7, 288–94; *see also* CD-Rom; internet; motion-tracking and motion-capture systems; World Wide Web
Nietzsche, F. 26
Nikolais, Alwin 213
Noh theatre techniques 22, 42, 73, 89
North American Free Trade Association (NAFTA) 233
Norton-Taylor, Richard: *The Colour of Justice* xxvi–xxvii, 225
Novack, C.J. 253n.

Oberholtzer, Obie 238
Odin Teatret xviii, 9, 21, 44, 241–7
Olaniyan, T. 116
Old Museum of Transport, Glasgow 191
O'Neill, Eugene 127
Ontological-Hysteric Theater 68
Open Space 71
Open Theatre, The 68
Oriental theatre 22, 23, 26, 42–3, 94–7, 98–9
orientalism 72, 89
Orlan 150, 187
Orrom, Michael 50
Orwell, George 49
Osborne, John: *Inadmissible Evidence* 127; *Look Back in Anger* 127

Osofisan, Femi 118–19, 121n.; *Once Upon Four Robbers* 119; *Morountodun* 121n.
Ostrovski *The Forest* 29
O'Toole, F. 309

Panigrahi, Sanjukta 43–4
Pankhurst, Emmeline 150, 153, 155
paratheatre xx, 203
parenting, dance pieces about 187
Paris, Helen 290, 292–3, 294n.
Parker, Andrew xxii, 11, 148, 162, **172–7**
Parkhomenko, Sergei 19
parody 149, 187, 217, 267–8, 271–2
Parry, B. 118
Patraka, V.M. 67
patriarchy 13, 52, 60–1, 65, 160, 179, 218, 281; heteropatriarchy 147
Pavis, Patrice xxiii, 10, 88–9, **102–6,** 184, 205
Paxton, Steve 215
Peking Opera 22, 44
Performance Group, the 203
performance spaces, non-traditional 111, 132ff., 191
performativity 11, 67, 69, 147–9, 167 ff., 172–7, 288 ff.
Performing Garage, The 68
Petersen/Kramer 236
Phelan, Peggy 66, 264
Phillips, Andrea 291
Pinter, Harold 127
Pioneer Players 11
Pirandello, Luigi 127
Piscator, Erwin 86
Plato 64, 66–7, 128
Plummer, K. 164
Poggioli, R. 70
pornography xxv, 5, 146, 160, 270; on the internet 280–1
post-colonial 10, 105, 112, 114, 186, 248; *see also* post-coloniality
post-colonial drama 229–34
post-coloniality 10, 12, 112, 186, 221–8; in Africa 116–22; in South Africa 235–40
Post-Impressionism 72
postmodernism 53, 67, 105, 258, 259, 270
power 10, 52, 54, 60–61, 67, 69, 105, 109 ff., 123, 128, 145–9, 160, 165–6, 176,

186, 191, 192, 230, 232, 239, 260, 266;
and ideology 77–81; bartering 196; balance
among collaborators 289; colonial 265; in
performance 43–4, 151, 261; of the state
222; performative 167 ff.; structures,
226–7, 233; symbolic 159
Prakash, G. 117
Prampolini, Enrico 72
pregnancy, dance pieces about 187
Priestley, J.B.: *An Inspector Calls* 18
primitivism 53, 72–4
psychoanalytic theory 60–1, 146–7, 159–1,
176, 198
Purvis, J. 306

Rainer, Yvonne 12, 214–17, 273–5
Rasmussen, Iben Nagel 45
Rattigan, Terence 127
Ravenhill, Mark *Shopping and Fucking* xxv
Rea, Stephen 5
Read, Alan xxiii, 11, 183, 184, **189–93**
Reagan, Ronald, 4
Regan, Stephen xxiii, 8, 9, **49–54**
Reinelt, J.G. 221
Rendra 230
Rental Arrears 223–4
resistance (political) 60–5, 88, 103, 120, 127,
133, 142, 155, 166, 217, 222, 224, 227,
229, 230, 232, 235, 236
Richardson, Mary 155
ritual 23, 52, 62, 67, 72–3, 79, 88, 104,
133, 138, 172–3, 187, 194–201, 230,
233, 238
Roach, J.R. 67, 89
Robins, Elizabeth: *Votes for Women!* 154
Robinson, A. 67
Robinson, M. 272–3
Rock P. 75
Rosicrucian mysticism 73
Ross, Jeff 291
Roszak, Theodore 141
Rotherhithe Theatre Workshop xxiii
Rotimi, Ola 105, 231
Royal National Theatre, London xix
Royal Shakespeare Company xviii, 9, 17
Royce, A.P. 253nn.
Rubin, Gayle 161

Rustavelli Theatre Company 19
Ruyter, N.L.C. 212n.

Said, Edward 89
Sappho (internet bulletin board) 261, 278
Starn, Peter 264
Sartre, Jean-Paul 23, 128, 129n.
Saturnalia (carnivals) 73
Savarese, Nicola 19, 41
Savigliano, M. 186
Savona, J.L. 61
Sayre, H. 66
Schechner, Richard xxiii, 11, 68, 183, 187,
194–201, 203, 272, 275
Schiller, J.C. Friedrich von 128, 129n.
Schmitt, Eric 177n.
Schneemann, Carolee 214
Schneider, Rebecca xxiii, 12, 67, 259, 260,
262, **264–9**
Schubert, Geli 240n.
Schuler, C. 270
Schumacher, Claude 98
Scott, Melissa 281
Searle, J.R. 62
Sedgwick, Eve Kosofsky xxiii, 11, **172–7,**
147–8, 161, 165, 167
semiotics of theatre 11, 50–1, 105, 184,
202–7
sexuality 10–11, 121, 145–80, 184, 185, 187,
217, 271, 275, 290, 291–2; and sexual
politics 172–7; definitions and theories of
157–61; performative nature of 167–71,
172–7; sexual identity and 162–6
Shafer, Murray 72
Shakespeare, William 85, 292; plays *Hamlet* 35;
Julius Caesar 125; *King Lear* 205; *Othello* 17,
214; *The Tempest* 13, 74; plays directed by
Peter Brook, xviii–xix, 74, 88
Shearman, J. 129n.
Shepard, Sam 71
Sherman, Cindy 218
Sissons, M. 127
Skelton, Ike 175
Smyth, C. 170
Soffer, Shirley 273–4
Sokolow, Anna: *Rooms* 215
Sondheim, Stephen 127

South African theatre 226–7, 230, 234, 235–40
Soyinka, Wole 117–119, 121n., 122n., 310; *Beatification of Area Boy* 119; *Death and the King's Horseman* 119, 121n.–2n.
Spencer, P. 253n.
Spiderwoman Theatre 12, 260, 264–9
Spivak, G. 115, 120, 171
Sprinkle, Annie 150, 217
Stadttheater 102
Stanislavski, Konstantin xxiii–xxiv, 9, 12, 17–20, 27, **28–31**, 32, 33, 87, 183, 246
Stanley, Liz 188n.
St Denis, Ruth 213
Stedman-Jones, G. 79
Stein, Gertrude 261, 279–80
Strasberg, Lee 183
Straub, K. 163
Straw, Jack 225
Strindberg, August 52, 71; *Dream Play* 71; *Road to Damascus* 58
suffrage campaign, women's xix, 11, 149, 150–6
Summers, Elaine 214
Suzuki 105

Taylor, Jane 237
Taylor, Paul 213
Teatro Campesino 91–2
Teatro Indepiendente 242
Teer, Barbara Ann 68
television 6, 18, 23–4, 49–50, 51, 55–6, 77–8, 109, 111, 131, 172, 179, 191, 197–9, 283
Terry, Ellen 153
Thatcher, Margaret xxvi, 1, 4
Theater for the New City (New York) 264, 265
Théâtre de Complicité 127
Theatre Laboratory xx, 9, 21, 22, 27
Théâtre National Populaire 73
Théâtre Nationaux 102
Theatre Royal Stratford East 225
Theatre Workshop see Littlewood, Joan
Thingspiel 73
Thiong'o, Ngugi wa 117–19, 121–2 n., 230; *I'll Marry When I Want* 118–19, 122n.; *Trials of Dedan Kimathi* 122n.

Third Theatre 227, 241–7
Tickner, Lisa 152
Tiffin, Helen 232
Titunik, I.R. 204
Tomko, L. 212nn.
Tompkins, Joanne xxiv, 12, 226, **229–34**, 235, 236
Tortsov 28–31
Traverse Theatre 123
Tricycle Theatre xxvi, 225
Truth Commission (South Africa) 236
Turner, Victor 89, 138–9
Tynan, Kenneth 127

Underground Theatre 184, 203
Urban Bush Women 217

Vakhtanghov 21
Van Gogh, Vincent 265
Velázquez, Diego de: *Rokeby Venus* 155
Verfremdungseffekt (V-effekt) 87, 94–7, 215, 218n.; *see also* alienation effect
Victoria Palace 225
video 111, 151, 218, 257–62, 284, 286, 288, 289, 291
Vilar, Jean 73
Vitrac, Roger 71

Waldeback, Zara 294n.
Walder, Dennis 235
Warhol, Andy 216
Watson, Ian xxiv, 12, 227, **241–7**
Weeks, Jeffrey xxiv, 10, 146–7, 158, **162–6**
Weiss, Peter: *Marat/Sade* xviii, 88
Whitman, Walt 180
Whitney Museum, New York 131–2, 134
Wigman, Mary 74n., 213
Wilde, Oscar 175
Wilder, T. 270
Willett, John 94
Williams, D. 102
Williams, Huw 294 n.
Williams, Raymond xxiv, 9, 49–54, **55–9**, 67, 104, 140, 235
Williams, Tennessee 127; *The Glass Menagerie* 127; *The Rose Tattoo* 124

Wilson, Robert 71,105, 183
Wittgenstein, Ludwig 187, 249
Wollen, Peter 291
women's movement 141, 217; *see also*
 feminist movement; suffrage campaign,
 women's
Woolf, Virginia: *Orlando* 45
Woolford, Kirck 263n.
Woolsey, Christine 285
Workcenter, Pontedera xx, 19
World-Wide Web 12, 261–2, 277–82, 288;

performance on, 151, 286, 292–3; *see also*
 internet
Wright, R. 231
Wyspianski, Stanislaw: *Akropolis* 24

Yajnik, R.K. 231
Yeats, W.B. 71, 73, 86, 89
Young, I.M. 212n.

Zarrilli, Phillip B. xxiv, 8, 12, **221–8**
Zollar, Jawole Willa Jo 217